REVISED EDITION

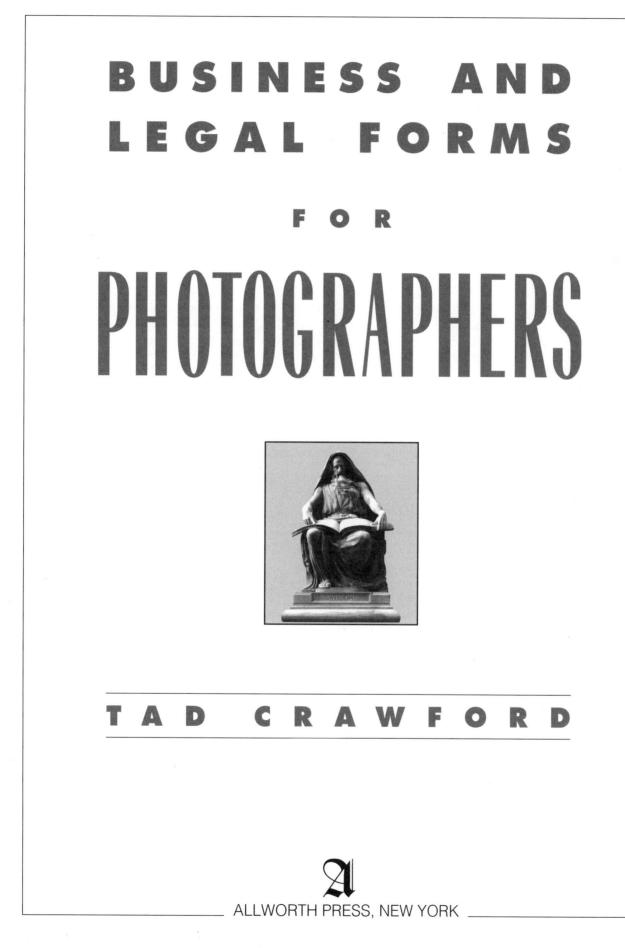

© 1991, 1997 by Tad Crawford

All rights reserved. Copyright under Berne Copyright Convention, Universal Copyright Convention, and Pan-American Copyright Convention. No part of this book, including the forms in electronic format on the accompanying CD-ROM, may be reproduced, stored in a retrieval system, or transmitted in any form, or by any means, electronic, mechanical, photocopying, recording, or otherwise, without prior permission of the publisher. Notwithstanding the foregoing, photographers may reproduce any form in this book without charge for the limited purpose of use in their business.

04 03 02 01 00 99 98 5 4 3 2

Published by Allworth Press, an imprint of Allworth Communications, Inc., 10 East 23rd Street, New York, NY 10010.

Library of Congress Catalog Card Number: 97-72216 ISBN: 1-880559-82-X Book design: Douglas Design Associates, New York Front cover photo: Tad Crawford

This book is designed to provide accurate and authoritative information with respect to the subject matter covered. It is sold with the understanding that the publisher is not engaged in rendering legal or other professional services. If legal advice or other expert assistance is required, the services of a competent attorney or professional person should be sought. While every attempt is made to provide accurate information, the author or publisher cannot be held accountable for errors or omissions.

Cover Photo -

From my office I can see across Madison Square Park to the west facade of the courthouse for the Appellate Division of the New York State Supreme Court, First Judicial Department. Completed in 1900, this extraordinary building is decorated by columns and statuary on its exterior and murals within. Portraying great law-givers and legal themes, the art impressed me as a natural complement to a book offering legal and business advice for photographers. I chose to photograph the statue of Wisdom by Frederick Wellington Ruckstuhl. Situated to the left of the entrance to the building, its inscription reads, "Every law not based on wisdom is a menace to the state." —T.C.

Table of Contents

Page 5

6

The Success Kit

Oral Contracts

Contracts and Negotiation

6	Letter Contracts
7	Standard Provisions
10	Volunteer Lawyers for the Arts
11	Organizations for Photographers
11	Using the Negotiation Checklists
12	The ASMP Code of Ethics
	How to Use the Forms
13	Form 1. Assignment Estimate/Confirmation/Invoice
21	Form 2. Wedding Photography Contract
27	Form 3. Portrait Photography Contract
33	Form 4. Photographer–Agency Contract for Assignments
39	Form 5. Book Publishing Contract
53	Form 6. Collaboration Contract
63	Form 7. Contract for the Sale of Fine Art Photography
67	Form 8. Delivery Memo
71	Form 9. Photographer–Gallery Contract with Record of Consignment and Statement of Account
81	Form 10. Photographer's Lecture Contract
85	Form 11. Licensing Contract to Merchandise Images
89	Form 12. Model Release
89	Form 13. Pocket Model Release
93	Form 14. Property Release
95	Form 15. Video Contract
101	Form 16. Contract to Create a Video for Transmission, Cassette Sales, or Rentals
106	Form 17. Stock Photography Delivery Memo
111	Form 18. Stock Photography Invoice
115	Form 19. Stock Agency Agreement
128	Form 20. Contract with an Independent Contractor
133	Form 21. Permission Form
136	Form 22. Nondisclosure Agreement for Submitting Ideas
139	Form 23. Copyright Transfer Form
142	Form 24. Application for Copyright Registration of Photography
150	Form 25. License of Rights
150	Form 26. License of Electronic Rights

(Continued)

The Forms (Tear-Out Section)

Page 159	Form 1	. Assignment	Estimate/0	Confirmation/	Invoice
----------	--------	--------------	------------	---------------	---------

- 161 Form 2. Wedding Photography Contract
- 163 Form 3. Portrait Photography Contract
- 165 Form 4. Photographer–Agency Contract for Assignments
- 167 Form 5. Book Publishing Contract
- 171 Form 6. Collaboration Contract
- 175 Form 7. Contract for the Sale of Fine Art Photography
- 177 Form 8. Delivery Memo
- 179 Form 9. Photographer–Gallery Contract with Record of Consignment and Statement of Account
- **183** Form 10. Photographer's Lecture Contract
- 185 Form 11. Licensing Contract to Merchandise Images
- 187 Form 12. Model Release
- 188 Form 13. Pocket Model Release
- **189** Form 14. Property Release
- 1.91 Form 15. Video Contract
- 193 Form 16. Contract to Create a Video for Transmission, Cassette Sales, or Rentals
- **195** Form 17. Stock Photography Delivery Memo
- 197 Form 18. Stock Photography Invoice
- 199 Form 19. Stock Agency Agreement
- 203 Form 20. Contract with an Independent Contractor
- 205 Form 21. Permission Form
- 207 Form 22. Nondisclosure Agreement for Submitting Ideas
- 209 Form 23. Copyright Transfer Form
- 211 Form 24. Application for Copyright Registration of Photography
- 215 Form 25. License of Rights
- 217 Form 26. License of Electronic Rights

219 Index

The Success Kit

A ttaining the knowledge of good business practices and implementing their use is an important step toward success for any professional, including the professional photographer. The forms contained in this book deal with the most important business transactions that any photographer is likely to undertake. At the back of the book is an extra copy of each form, perforated on 81/2-by-11-inch sheets so that the photographer can remove them from the book and make copies for use in his or her business. A CD-ROM is also included to make customization easier. The fact that the forms are designed for use and that they favor the photographer give them a unique value.

Understanding the business concepts behind the forms is as important as using them. By knowing why a certain provision has been included and what it accomplishes, the photographer is able to negotiate when faced with someone else's business form. The photographer knows what is and is not desirable. The negotiation checklists offer a map for the negotiation.

All forms, whether the photographer's or someone else's, can be changed. Before using these forms, the photographer should consider reviewing them with his or her attorney. This provides the opportunity to learn whether local or state laws make it wise to modify any of the provisions. For example, would it be best to include a provision for arbitration of disputes, or are the local courts speedy and inexpensive, making an arbitration provision unnecessary?

The forms must be filled out, which means that the blanks in each form must be completed. Beyond this, however, the photographer can always delete or add provisions on any form. Deletions or additions to a form are usually initialed in the margin by both parties. It is also a good practice to have each party initial each page of the contract, except the page on which the parties sign.

The photographer must ascertain that the person signing the contract has authority to do so. If the photographer is dealing with a company, the company's name should be included, as well as the name of the individual authorized to sign the contract and the title of that individual. If it isn't clear who will sign or if that person has no title, the words "Authorized Signatory" can be used instead of a title.

If the photographer will not be meeting with the other party to sign the contract, it would be wise to have that party sign the forms first. After the photographer gets back the two copies of the form, they can be signed and one copy returned to the other party. As discussed in more detail under letter contracts, this has the advantage of not leaving it up to the other party to decide whether to sign and thus make a binding contract.

If additional provisions that won't fit on the contract forms should be added, simply include a provision stating, "This contract is subject to the provisions of the rider attached hereto and made a part hereof." The rider is simply another piece of paper which would be headed, "Rider to the contract between ______

and _____, dated the _____ day of ____, 19___." The additional provisions are put on this sheet and both parties sign it.

Contracts and Negotiation

Most of the forms in this book are contracts. A contract is an agreement that creates legally enforceable obligations between two or more parties. In making a contract, each party gives something of value to the other party. This mutual giving of value is called the exchange of consideration. Consideration can take many forms, including the giving of money or a photograph or the promise to create a photograph or pay for a photograph in the future.

Contracts require negotiation. The forms in this book are favorable to the photographer, so changes may very well be requested. This book's explanation of the use of each form should help the photographer evaluate changes which either party may want to make in any of the forms. The negotiation checklists should also clarify what changes would be desirable in forms presented to the photographer. Keep in mind that negotiation need not be adversarial. Certainly the photographer and the other party may disagree on some points, but the basic transaction is something that both want. This larger framework of agreement must be kept in mind at all times when negotiating. Of course, the photographer must also know which points are nonnegotiable and be prepared to walk away from a deal if satisfaction cannot be had on these points.

When both parties have something valuable to offer each other, it should be possible for each side to come away from the negotiation feeling that they have won. Win-win negotiation requires each side to make certain that the basic needs of both are met so that the result is fair. The photographer cannot negotiate for the other side, but a wise negotiation strategy must allow the other side to meet their vital needs within a larger context that also allows the photographer to obtain what he or she must have.

It is a necessity to evaluate negotiating goals and strategy before conducting any negotiations. The photographer should write down what must be achieved and what can be conceded or modified. The photographer should try to imagine how the shape of the contract will affect the future business relationship with the other party. Will it probably lead to success for both sides and more business or will it fail to achieve what one side or the other desires?

When negotiating, the photographer should keep written notes close at hand concerning goals and strategy. Notes should be kept on the negotiations, too, since many conversations may be necessary before final agreement is reached. At certain points the photographer should compare what the negotiations are achieving with the original goals. This will help evaluate whether the photographer is conducting the negotiations according to plan.

Most negotiations are done over the telephone. This makes the telephone a tool to be used wisely. The photographer should decide when to speak with the other party. Before calling, it is important to review the notes and be familiar with the points to be negotiated. If the photographer wants the other party to call, the file should be kept close at hand so that there is no question as to where the negotiations stand when the call comes. If the photographer is unprepared to negotiate when the other side calls, the best course is to call back. Negotiation demands the fullest attention and complete readiness.

Oral Contracts

Although all the forms in this book are written, the question of oral contracts should be addressed. There are certain contracts that must be written, such as a contract for services that will take more than one year to perform, a contract to transfer an exclusive right of copyright (an exclusive right means that no one else can do what the person receiving that right of copyright can do), or, in many cases, a contract for the sale of goods worth more than \$500. So-without delving into the full complexity of this subject—certain contracts can be oral. If the photographer is faced with a breached oral contract, an attorney should certainly be consulted for advice. The photographer should not give up simply because the contract was oral.

However, while some oral contracts are valid, a written contract is always best. Even people with the most scrupulous intentions do not always remember exactly what was said or whether a particular point was covered. Disputes, and litigation, are far more likely when a contract is oral rather than written. That likelihood is another reason to make the use of written forms, like those in this book, an integral part of the business practices of any photographer.

Letter Contracts

If the photographer feels that sending a welldrafted form will be daunting to the other party, the more informal approach of a letter, signed by

Copyright Transfer Form

(hereinafter referred to as the "Assignor"), locate			
does hereby transfer and assign to			
assigns, the following rights:			trators, and
			copyrights
in the works described as follows:			
Title	Registration Number	Nature of Work	
N WITNESS WHEREOF, the Assignor has exe	ecuted this instrument on the	day of	, 19
As	signor		

both parties, may be adopted. In this case, the forms in this book will serve as valuable checklists for the content and negotiation of the letter contract. The last paragraph of the letter would read, "If the foregoing meets with your approval, please sign both copies of this letter beneath the words AGREED TO to make this a binding contract between us." At the bottom of the letter would be the words AGREED TO with the name of the other party so he or she can sign. Again, if the other party is a company, the company name, as well as the name of the authorized signatory and that individual's title, would be placed beneath the words AGREED TO. This

AGREED TO:

XYZ Corporation

would appear as follows:

By_

Alice Hall, Vice President

Two copies of this letter are sent to the other party, who is instructed to sign both copies and return one copy for the photographer to keep. To be cautious, the photographer can send the letters unsigned and ask the other party to sign and return both copies, at which time the photographer will sign and return one copy to the other party. This gives the other party an opportunity to review the final draft, but avoids a situation in which the other party may choose to delay signing, thereby preventing the photographer from offering a similar contract to anyone else because the first contract still may be signed.

The photographer can avoid this by being the final signatory, by insisting that both parties meet to sign, or by stating in the letter a deadline by which the other party must sign. If such a situation ever arises, it should be remembered that any offer to enter into a contract can always be revoked up until the time that the contract is actually entered into.

Standard Provisions

The contracts in this book contain a number of standard provisions, called "boilerplate" by lawyers. These provisions are important, although they will not seem as exciting as the provisions that relate more directly to the photographer and the photography. Since these provisions can be used in almost every contract and appear in a number of the contracts in this book, an explanation of each of the provisions is given here.

Amendment. Any amendment of this Agreement must be in writing and signed by both parties.

This guarantees that any changes the parties want will be made in writing. It avoids the possibility of one party relying on oral changes to the agreement. Courts will rarely change a written contract based on testimony that there was an oral amendment to the contract.

Arbitration. All disputes arising under this Agreement shall be submitted to binding arbitration before _______ in the following location _______ and shall be settled in accordance with the rules of the American Arbitration Association. Judgment upon the arbitration award may be entered in any court having jurisdiction thereof. Notwithstanding the foregoing, either party may refuse to arbitrate when the dispute is for a sum of less than \$_____.

Arbitration can offer a quicker and less expensive way to settle disputes than litigation. However, the photographer would be wise to consult a local attorney and make sure that this is advisable in the jurisdiction where the lawsuit would be likely to take place. The arbitrator could be the American Arbitration Association or some other person or group that both parties trust. The photographer would also want the arbitration to take place where he or she is located. If small claims court is easy to use in the jurisdiction where the photographer would have to sue, it might be best to have the right not to arbitrate if the disputed amount is small enough to be brought into small claims court. In this case, the photographer would put the maximum amount that can be sued for in small claims court in the space at the end of the paragraph.

Assignment. This Agreement shall not be assigned by either party hereto, provided that the Photographer shall have the right to assign monies due to the Photographer hereunder.

By not allowing the assignment of a contract, both parties can have greater confidence that the stated transactions will be between the original parties. Of course, a company may be purchased by new owners. If the photographer only wanted to do business with the people who owned the company when the contract was entered into, change of ownership might be stated as a ground for termination in the contract. On the other hand, money is impersonal and there is no reason why the photographer should not be able to assign the right to receive money.

Bankruptcy or Insolvency. If the Gallery should become insolvent or if a petition in bankruptcy is filed against the Gallery or a Receiver or Trustee is appointed for any of the Gallery's assets or property, or if a lien or attachment is obtained against any of the Gallery's assets, this Agreement shall immediately terminate and the Gallery shall return to the Photographer all of the Photographer's work that is in the Gallery's possession.

This provision seeks to protect the photographer against creditors of the gallery who might use the photographer's work or proceeds from that work to satisfy claims they have against the gallery itself. Because a provision of this kind does not protect the photographer completely, many states have enacted special consignment laws protecting photographers and their work. Such a provision should also appear in a publishing or licensing contract, although the bankruptcy law may impede the provision's effectiveness.

Complete Understanding. This Agreement constitutes the entire and complete understanding between the parties hereto, and no obligation, undertaking, warranty, representation, or covenant of any kind or nature has been made by either party to the other to induce the making of this Agreement, except as is expressly set forth herein.

This provision is intended to prevent either party from later claiming that any promises or obligations exist except those shown in the written contract. A shorter way to say this is, "This Agreement constitutes the entire understanding between the parties hereto."

Cumulative Rights. All rights, remedies, obligations, undertakings, warranties, representations, and covenants contained herein shall be cumulative and none of them shall be in limitation of any other right, remedy, obligation, undertaking, warranty, representation, or covenant of either party.

This means that a benefit or obligation under one provision will not be made less because of a different benefit or obligation under another provision.

Death or Disability. In the event of the Photographer's death, or an incapacity of the Photographer making completion of the Work impossible, this Agreement shall terminate.

A provision of this kind leaves a great deal to be determined. Will payments already made be kept by the photographer or the photographer's estate? And who will own the work at whatever stage of completion has been reached? These issues should be resolved when the contract is negotiated. **Force Majeure.** If either party hereto is unable to perform any of its obligations hereunder by reason of fire or other casualty, strike, act or order of a public authority, act of God, or other cause beyond the control of such party, then such party shall be excused from such performance during the pendency of such cause. In the event such inability to perform shall continue longer than _____ days, either party may terminate this Agreement by giving written notice to the other party.

This provision covers events beyond the control of the parties, such as a tidal wave or a war. Certainly the time to perform the contract should be extended in such an event. There may be an issue as to how long an extension should be allowed. Also, if work has commenced and some payments have been made, the contract should cover what happens in the event of termination. Must the payments be returned? And who owns the partially completed work?

Governing Law. This Agreement shall be governed by the laws of the State of _____.

Usually the photographer would want the laws of his or her own state to govern the agreement. However, laws vary from state to state. A number of states have enacted laws favoring photographers, especially in the area of consignments of art to a gallery. If the photographer's own state lacks this law, it might be preferable to have a gallery contract governed by the law of a different state that has such a consignment law. To find out if a state has such a law, refer to the volunteer lawyers for the arts section of this text, following the discussion of standard provisions.

Indemnify and Hold Harmless. The Purchaser agrees to indemnify and hold harmless the Photographer from any and all claims, demands, payments, expenses, legal fees, or other costs in relation to obligations for materials or services incurred by the Purchaser. This provision protects one party against damaging actions that may have been taken by the other party. Often, one party will warrant that something is true and then indemnify and hold the other party harmless in the event that it is not true. See the discussion of "Warranties" later in this section. A warranty is usually accompanied by an indemnity clause.

Liquidated Damages. In the event of the failure of XYZ Corporation to deliver by the due date, the agreed upon damages shall be \$ ______ for each day after the due date until delivery takes place, provided the amount of damages shall not exceed \$_____.

Liquidated damages are an attempt to anticipate in the contract what damages will be caused by a breach of the contract. Such liquidated damages must be reasonable. If they are not, they will be considered a penalty and held to be unenforceable.

Modification. This Agreement cannot be changed, modified, or discharged, in whole or in part, except by an instrument in writing, signed by the party against whom enforcement of any change, modification, or discharge is sought.

This requires that a change in the contract must be written and signed by the party against whom the change will be enforced. It should be compared with the provision for amendments that requires any modification to be in writing and signed by both parties. At the least, however, this provision explicitly avoids the claim that an oral modification has been made of a written contract. Almost invariably, courts will give greater weight to a written document than to testimony about oral agreements.

Notices and Changes of Address. All notices shall be sent to the Photographer at the following address:______

and to the Purchaser at the following address:

_. Each

party shall be given written notification of any change of address prior to the date of said change.

Contracts often require the giving of notice. This provision facilitates giving notice by providing correct addresses and requiring notification of any change of address.

Successors and Assigns. This Agreement shall be binding upon and inure to the benefit of the parties hereto and their respective heirs, executors, administrators, successors, and assigns.

This makes the contract binding on anyone who takes the place of one of the parties, whether due to death or simply to an assignment of the contract. Note that the standard provision on assignment in fact does not allow assignment, but that provision could always be modified in the original contract or by a later written, signed amendment to the contract.

Time. Time is of the essence.

This requires both parties to perform to the exact time commitments they have made or be in breach of the contract. It is not a wise provision for the photographer to agree to, since being a few days late in performance could cause the loss of benefits under the contract.

Waivers. No waiver by either party of any of the terms or conditions of this Agreement shall be deemed or construed to be a waiver of such term or condition for the future, or of any subsequent breach thereof.

This means that if one party waives a right under the contract, such as the right to receive the first of a series of payments on time, that party has not waived the right forever and can demand that the other party perform at the next opportunity. So the photographer would still have the right to be paid on time for the rest of the payments in the series. And if the client breached the contract in some other way, such as not giving name credit, the fact that the photographer allowed this once would not prevent the photographer from suing for such a breach in the future.

Warranties. The Photographer hereby warrants that he or she is the sole creator of the Work and owns all rights granted under this Agreement.

A warranty is something the other party can rely on to be true. If the photographer states a fact that is a basic reason for the other party's entry into the contract, then that fact is a warranty and must be true. For example, the photographer might state that he or she is the sole creator of certain photographs, owns the copyright therein, and has not infringed anyone else's copyright in creating the work. If this were not true, the photographer would be liable for damages caused to the other party under the indemnity clause of the contract.

Volunteer Lawyers for the Arts

There are now volunteer lawyers for the arts across the nation. These groups provide free assistance to photographers below certain income levels and can be a valuable source of information. If, for example, it is not clear whether a certain law to benefit photographers (such as a gallery consignment law) has been enacted in a state, the photographer should be able to find out by calling the closest volunteer lawyers for the arts group. To find the location of that group, one of the groups listed here can be contacted:

California: California Lawyers for the Arts, Fort Mason Center, Building C, Room 255, San Francisco, California 94123, (415) 775-7200; and 1549 11th Street, Suite 200, Santa Monica, CA 90401, (310) 395-8893.

Illinois: Lawyers for the Creative Arts, 213 West Institute Place, Suite 411, Chicago, IL 60610; (312) 944-2787 **New York:** Volunteer Lawyers for the Arts, 1 East 53rd Street, New York, NY 10022; (212) 319-2787.

A helpful handbook covering all legal issues which photographers face is *Legal Guide for the Visual Artist* by Tad Crawford (Allworth Press). Other good resources are *The Law* (*in Plain English*) for *Photographers* by Leonard DuBoff (Allworth Press) and *Licensing Art and Design* by Caryn Leland (Allworth Press).

Organizations for Photographers

Joining an organization of fellow professionals can be an important step in learning proper business practices and advancing the photographer's career. The following organizations have chapters across the country and are well worth belonging to. Students should inquire regarding special student rates for membership.

Advertising Photographers of America (APA) 7201 Melrose Ave., Los Angeles, CA 90046, (800) 272-6264 or (213) 935-7283.

Advertising Photographers of New York (APNY) 27 West 20th Street, Room 611, New York, NY 10011; (212) 807-0399. Quarterly newsletter.

American Society of Media Photographers (ASMP), 14 Washington Road, Suite 502, Princeton Junction, NJ 08550-1033; (609) 799-8300. The membership is comprised of editorial, corporate, industrial, and advertising photographers, with chapters nationwide. ASMP publishes a monthly newsletter and compiles the *ASMP Professional Business Practices in Photography* (Allworth Press).

National Press Photographers Association 3200 Croasdaile Drive, Suite 306, Durham, NC 27705; (919) 383-7246. The NPPA services include major medical, equipment insurance, and a variety of publications including *News Photographer Magazine*.

Professional Photographers of America (PPA) 57 Forsyth NW, Suite 1600, Atlanta, GA 30303; (404) 522-8600. Membership is available in portrait, wedding, commercial-corporate-advertising, video, art-technical, and digital imaging. PPA publishes *Professional Photographer Magazine* and *Photoelectronic Imaging Magazine* and offers a continuing education program.

Wedding Photographers International Box 2003, Santa Monica, CA 90406; (310) 451-0090. The organization has a monthly newsletter, print competitions, and an annual convention.

Using the Negotiation Checklists

These checklists focus on the key points for negotiation. When a point is covered in the contract already, the appropriate paragraph is indicated in the checklist. These checklists are also valuable to use when reviewing a form given to the photographer by someone else. If a point in the checklist does not refer to a paragraph number, it means that point is not covered in the contract but the photographer should be ready to handle the issue if it is raised in the negotiations

If the photographer will provide the form, the boxes can be checked to be certain all important points are covered. If the photographer is reviewing someone else's form, checking the boxes will show which points are covered and which points may have to be added. By using the paragraph numbers in the checklist, the other party's provision can be quickly compared with a provision that would favor the photographer. Each checklist for a contract concludes with the suggestion that the standard provisions be reviewed to see if any should be added to those the form provides.

Of course, the photographer does not have to include every point on the checklist in a contract, but being aware of these points will be helpful. After the checklists, the exact wording is provided for some of the more important provisions that might be added to the form. Starting with Form 1, the explanations go through each of the forms in sequence.

The ASMP Code of Ethics

A code of ethics serves the useful purpose of setting standards that can be looked to by photographers when dealing with clients, suppliers, and the public. The American Society of Media Photographers (ASMP) has once again played a leadership role by developing its own Code of Ethics. The Code is reproduced here by permission of ASMP.

Code of Ethics

A guide for ethical business dealings, protecting the profession, the photographer, vendors, employees, subjects, clients, and colleagues.

Responsibility to colleagues and the profession:

- 1. Maintain a high quality of service and a reputation for honesty and fairness.
- 2. Oppose censorship and protect the copyrights and moral rights of other creators.
- 3. Never advance one's own interests at the expense of the profession.
- 4. Foster fair competition based on professional qualification and merit.
- 5. Never deliberately exaggerate one's qualifications, nor misrepresent the authorship of work presented in self-promotion.
- 6. Never engage in malicious or deliberately inaccurate criticism of the reputation or work of another photographer.
- 7. Negotiate licensing agreements that protect the historical balance between usage fees and rights granted.
- 8. Never offer nor accept bribes, kickbacks, or other unethical inducements.
- 9. Never conspire with others to fix prices, organize illegal boycotts, nor engage in other unfair competitive practices.
- 10. Refuse agreements that are unfair to the photographer.
- 11. Never undertake assignments in competition with others for which payment will be received only if the work is accepted.
- 12. Never enter commercial competitions in which usage rights are transferred without reasonable fees.

13. Donate time for the betterment of the profession and to advise entry-level photographers.

Responsibility to subjects:

- *14. Respect the privacy and property rights of one's subjects.*
- 15. Never use deceit in obtaining model or property releases.

Responsibility to clients:

- 16. Conduct oneself in a professional manner, and represent a client's best interests within the limits of one's professional responsibility.
- 17. Protect a client's confidential information; assistants should likewise maintain confidentiality of the photographer's proprietary information.
- 18. Accurately represent to clients the existence of model and property releases for photographs.
- 19. Stipulate a fair and reasonable value for lost or damaged photographs.
- 20. Use written contracts and delivery memos with a client, stock agency, or assignment representative.
- 21. Consider an original assignment client's interests with regard to allowing subsequent stock use of that work by the client's direct competition, absent an agreement allowing such use.

Responsibility to employees and suppliers:

- 22. Honor one's legal, financial and ethical obligations toward employees and suppliers.
- 23. Never take unfair advantage of one's position as employer of models, assistants, employees or contract labor.

Responsibility of the photojournalist:

- 24. Photograph as honestly as possible, provide accurate captions, and never intentionally distort the truth in news photographs.
- 25. Never alter the content or meaning of a news photograph and prohibit subsequent alteration.
- 26. Disclose any alteration or manipulation of content or meaning in editorial feature or illustrative photographs and require the publisher to disclose that distortion or any further alteration.

Assignment Estimate/Confirmation/Invoice

FORM

Form 1, Assignment Estimate/Confirmation/ Invoice, combines three forms in one to streamline the photographer's paperwork. In an ideal world the client would describe the assignment and would then receive an estimate from the photographer. After agreeing to the specifications and terms of the estimate, both parties would sign a confirmation of assignment. When the assignment has been completed, the invoice would be given to the Client. Form 1 fulfills all of these functions by having the photographer check the appropriate box to indicate for which purpose the form is being used.

As we know, photographs are sometimes licensed without proper documentation. If the client calls for a rush job, the photographer wants to do the shoot by the deadline and may skip the paperwork. If the client has sent a purchase order, the photographer may feel that is sufficient documentation or be concerned about contradicting its terms.

The truth is that inadequate documentation is a disservice to the client as well as the photographer. There are a number of issues which the parties must resolve. The client as well as the photographer wants to know the rights being transferred. The rights must be adequate for the client's intended use of the photographs. The nature of the photographs to be done, the due date, the fee to be paid, and the amount of any advance are important to have in writing, since a talk on the phone can more easily be given different interpretations by the parties. The client as well as the photographer wants to deal with expenses, how payment will be made, what happens in the event of cancellation, and how reshoots will be handled. Some of the other provisions cover authorship credit, copyright notice, releases, ownership of the original photographs, and arbitration.

The photographer should resolve conflicts between his or her forms and those of the client immediately. If an estimate is given, work commences, and no other forms are used until an invoice is sent, the estimate will probably be found either to be a contract or, at least, to be evidence of an oral contract. On the other hand, if an estimate conflicts with the client's purchase order, it will be very difficult to know in hindsight what the parties agreed to on those points where the forms differ. So the photographer should point out and resolve such issues without delay. Or if the photographer has not given an estimate or confirmation of assignment, but disagrees with the terms of a purchase order, reliance on the invoice to resolve these issues would not be wise. It is unlikely, for example, that an invoice alone can govern the terms of a transaction, simply because it is given to the client after the transaction has been concluded.

Form 1, like most of the forms in this book, could be simplified as either a shorter form or a letter including only the terms which the photographer feels most important. Form 1 seeks to resolve issues which frequently arise and to protect the photographer. Certainly it is better to raise such issues at the outset of the assignment, rather than disagree later. Such disagreements are far more likely to cause the loss of clients than a frank discussion of the terms before any work has been done.

Filling in the Form

The photographer should include his or her letterhead. The appropriate box should be checked to show whether the form is being used as an estimate in seeking an assignment, a confirmation for an assignment that has been obtained, or an invoice for a completed assignment. Fill in the date, the client's name and address, the photographer's number for the job, the number of any purchase order given by the client, and the contact person at the client. The assignment should be described in detail and a due date specified (unless the form is being used as an invoice, in which case the description can be brief). The rights to be granted should be detailed, including the nature of the use; the particular product, project, or publication in which the use will be made; the territory; the time period or number of uses; and any other limitations. The box for adjacent credit should be checked, if agreed to, and the form for the credit shown (including copyright notice, if the photographer wants it). The fees and expenses should be detailed. Show whether expenses are to be marked up by indicating the percentage of the markup. Give the amount of any advance that will be or has been paid. In Paragraph 1 give a monthly interest rate. In Paragraph 4 state the number of days in which photographic materials must be returned after client's receipt of the materials. In Paragraph 9 fill in a number of hours for notice of cancellation in relation to the fee to be charged. In Paragraph 13 specify who will arbitrate disputes, where this will be done, and give the maximum amount which can be sued for in small claims court. In Paragraph 14 give the state whose laws will govern the contract. The photographer can then sign the front of the form. When there is agreement that the assignment will definitely go forward the client should also sign (in which case the form is being used as a confirmation of the assignment).

Negotiation Checklist

- Describe the assignment in as much detail as possible, attaching another sheet to the contract if necessary. (Front of form)
- Give a due date. (Front of form)
- If the client is to provide any reference materials, products, equipment, etc., the due date can also be expressed as a number of days after the photographer's receipt of these materials.
- Time should not be of the essence with respect to the due date, so that a small delay will not create grounds for a lawsuit by the client.
- State that illness or other delays beyond the control of the photographer will extend the due

date, but only up to a limited number of days.

- □ State that the grant of rights takes place when the photographer is paid in full. (Front of form)
- Limit the grant of rights to the photograph in the assignment description, so that the photographer owns all outtakes and any preliminary work product. (Front of form)
- □ Specify whether the client's use of the photograph will be exclusive or nonexclusive. Form 1 states that the use will be exclusive within a narrow scope, since clients giving an assignment presumably want exclusivity for their project. However, the photographer can certainly modify this when appropriate. (Front of form)
- □ Limit the exclusivity to the particular use the client will make of the photograph, such as for a book jacket, point-of-purchase ad, direct mail brochure, and so on. This leaves the photographer free to resell the photograph for other uses. (Front of form)
- Name the product, project, or publication for which the photograph is being prepared. This prevents the photograph from being used elsewhere by the client. (Front of form)
- Give a geographic limitation, such as local, regional, the United States, North America, and so on. (Front of form and Paragraph 3)
- □ Limit the time period of use. (Front of form and Paragraph 3)
- ❑ Another limitation might include the number of uses. One-time use, for example, means that the photograph can be used in one issue of a magazine. One-time use can be ambiguous, however, if used for a brochure or a book where additional printings are likely. If the intention is to limit the use to a certain quantity printed, this should be stated. Or the use might be restricted to one form of a book, such as hardcover, which would mean that

the photographer would receive re-use fees for subsequent use in paperback. Or the size of the photograph when used, such as a quarter-page or a full-page use, could be a limitation. The concept behind such limitations is that fees are based on usage. (Front of form)

- For contributions to magazines, the sale of first North American serial rights is common. (Paragraph 3) This gives the magazine the right to be the first magazine to make a one-time use of the photograph in North America. This could be limited to first United States serial rights. If no agreement about rights is made for a magazine contribution, the copyright law provides that the magazine has a nonexclusive right to use the photograph as many times as it wishes in issues of the magazine but can make no other uses.
- □ If the grant of electronic rights is included, consider whether an additional fee should be paid. This might take the form of a reuse fee and be a percentage, such as 25 or 50 percent, of the initial fee. If the electronic usage is the first and only use, of course, no reuse fee would be payable. If the electronic and non-electronic uses occur at the same time, the negotiation to set the initial fee might settle on an amount adequate to cover both types of usage. However, if one usage comes before the other (most likely nonelectronic before electronic), a reuse fee might be appropriate. (Front of Form)
- Make any grant of electronic rights subject to all the limitations as to type of use, language, product or publication, territory, time period, exclusivity or nonexclusivity, and other limitations. (Front of Form)
- Do not allow electronic usages to involve abridgements, expansions, or combinations with other works unless specified in the contract. This can be set forth under "Other Limitations." (Front of Form and Paragraph 3)
- □ If possible when electronic rights are given,

limit the form of the electronic usage to known systems such as CD-ROM, on-line, database, etc. (Front of Form)

- □ For electronic rights, seek to avoid a situation in which the party acquiring the rights will make work freely available to the public (for example, by allowing downloading from a Web site) unless that is intended. The restriction might take the form of a grant of "display rights only," so that the party acquiring the rights would not allow users to make digital copies. (Front of Form)
- □ If the client insists on all rights or work for hire, offer instead a provision stating, "Photographer shall not permit any uses of the Photograph which compete with or impair the use of the Photograph by the Client." If necessary to reassure the client, this might also state, "The Photographer shall submit any proposed uses to the Client for approval, which shall not be unreasonably withheld."
- Many photographers refuse to do work for hire, since the client becomes the author under the copyright law. In this sense, it can be pointed out to the client that work for hire devalues and can damage the creative process.
- □ In the face of a demand for all rights or work for hire, advise the client that fees are based on rights of usage. The fee for all rights or work for hire should be substantially higher than for limited usage.
- □ If the work is highly specific to one client, selling all rights for a higher fee would be more acceptable than for a work likely to have resale value for the photographer.
- □ If the client demands a "buyout," find out how the client defines this. It can mean the purchase of all rights in the copyright; it may be work for hire; it may or may not involve purchasing the original transparencies as well as the copyright; and it may or may not relate to outtakes. Transferring any transparencies can obviously be

damaging, since the client may compete with the photographer in the stock market and may be more tempted to make unauthorized uses. In any case, even a buyout can be limited as to its extent (such as a buyout for advertising uses only, but not for any other purpose).

- □ State whether the photographer will receive name credit adjacent to the photograph, including whether copyright notice will be included in the credit. (Front of form and Paragraph 6)
- □ The fee must be specified. (Front of form)
- For an assignment rate, specify an amount per photograph or a total fee for the number of photographs indicated in the assignment description. (Front of form)
- □ For a day rate, seek a guaranteed number of days. (Front of form)
- Magazines will have space rates, which may be negotiable if the photographer has unusual material. If a day rate is used, it will probably be an advance against the space rate. (Front of form)
- □ Give rates for preproduction days, travel days, and weather days. These rates are negotiable, but are likely to be in the range of 50 percent of the photographer's regular day rate. (Front of form)
- □ Give rates for cancellations. The cancellation fee should depend on the duration of the assignment and how long in advance notice of the cancellation is given to the photographer. Photographers might seek a full fee plus expenses if less than 48 or 72 hours' notice is given. Clients will want to negotiate this point and the photographer may sometimes have to accept less, perhaps a 50 percent fee plus all expenses. The greater the duration of the assignment, the greater the notice that should be required and the higher the percentage of the fee that should be paid for cancellation on short notice. (Front of form and Paragraph 9)

assignment by the client. While the photographer should certainly seek a full fee plus all expenses for this, clients may resist this and a compromise may have to be struck. (Front of form and Paragraph 8)

- □ If the need for a reshoot is not caused by the client, the photographer may do the reshoot for expenses only. (Paragraph 8)
- □ If a reshoot is necessary and the client has paid for contingency insurance to cover some expenses, such expenses would not be billed for the reshoot. (Paragraph 8)
- □ If an assignment will be very lengthy, perhaps requiring a number of sessions over a period of months, a schedule of payments should be used.
- Never work on speculation, which is a situation in which no fees will be paid in the event of cancellation or a failure to use the work.
- Any expenses which the client will reimburse to the photographer should be specified to avoid misunderstandings. (Front of form)
- □ If expenses are going to be marked up, this should be stated. The rationale for marking up expenses is because the photographer's funds are tied up until reimbursement and there is extra paperwork. (Front of form)
- □ If expenses will be significant, provide for an advance. (Front of form and Paragraph 2)
- □ Specify that any advance is nonrefundable.
- If the client insists on a binding budget for expenses, provide for some flexibility, such as a 10 percent variance, or for client to approve expense items which exceed the variance. (Paragraphs 7 and 14)
- □ If the client is to pay any expenses directly, this should be stated.
- e 🕴 🖵 Require that payment be made within a cer-
- Give rates for reshoots due to a change in the

tain period of time, such as 30 days after receipt of the invoice. (Paragraph 1)

- □ State that time is of the essence with respect to payment. (Paragraph 1)
- Choose an interest rate to charge for late payments. Make sure the rate is not usurious under state law. Even if this interest is not collected, it may encourage timely payment. (Paragraph 1)
- □ The obligation of the client to pay sales tax should be set forth. Many states charge sales tax on the transfer if a physical object is sold to or altered by the client, while sales of reproduction rights in which the photographer receives the photographs back without changes would not be subject to sales tax. However, the laws vary widely from state to state. The photographer must check the law in his or her state, since the failure to collect and pay sales tax can result in substantial liability. (Paragraph 1)
- □ Specify a time for the payment of any advance. (Paragraph 2)
- Specify that if the front of the form is not filled in as to territory and duration, the grant shall be for one year in the United States. (Paragraph 3)
- All rights not granted to the client should be reserved to the photographer. (Paragraph 3)
- Specify that if the photograph is not published within a certain time period, the rights shall revert to the photographer. This would avoid, for example, a situation in which a magazine purchases first North American serial rights but never uses the photograph. Since the photographer cannot make use of the photograph until after publication, the failure to publish would be damaging to the photographer.
- □ Reserve ownership of all transparencies and other photographic materials to the photographer. (Paragraph 3)

- Restrict the client from modifying the image without the permission of the photographer. Minor adjustments, such as digital enhancement of color or adding 1/4 inch of sky at a border, would of course be agreed to, but this provision gives the photographer the opportunity to consider the impact of more radical or distorting changes and to object if necessary. (Paragraph 3)
- Require that the client return the photographic materials within a certain period of time after use or, if the work isn't used, within a period of time after receipt. (Paragraph 4)
- □ Be certain that the return will be made in such a way that it can be traced. (Paragraph 4)
- □ Make time of the essence with respect to the return of the photographic materials. (Paragraph 4)
- □ Indicate a value for each transparency , which can serve as a basis for damages if it is not returned to the client. This may be done by use of a delivery memo. (Paragraph 4)
- □ While it is best to give a value for each transparency, state that any transparency for which no value is stated has a worth of \$1,500. This may not hold up in court as well as giving each transparency a value, but it would be better than not dealing with this issue at all. (Paragraph 4)
- □ Raise the standard of care which the client must give the photographic materials, such as making the client strictly liable as an insurer for loss, theft, or damage to transparencies or other materials while in the client's possession or even in transit. (Paragraph 4)
- Require that the client insure the transparencies and other materials at the value specified for them.
- □ If additional usage rights are sought by the client, the photographer's permission should be obtained and additional fees paid. (Paragraph 5)

- If it is likely that a certain type of additional usage will be made, the amount of the reuse fee can be specified. Or the reuse fee can be expressed as a percentage of the original fee.
- □ For editorial work, require authorship credit as the general rule. One of the values of editorial work is its promotional impact, so name credit is important. (See Paragraph 6)
- □ Specify that the type size for authorship credit shall be no smaller than the type around the photograph.
- □ Specify that the credit must be adjacent to the photograph. (Paragraph 6)
- □ If authorship credit should be given but is omitted, require the payment of an additional fee. (Paragraph 6)
- With respect to the assignment itself or reshoots, additional charges can be specified for work which must be rushed and requires unusual hours or other stresses. This might include a provision for overtime for assistants and freelance staff, if the photographer will have to pay overtime. (Paragraph 7)
- □ If a reshoot is necessary, give the photographer the first opportunity to do the reshoot. The client may want to negotiate this, especially if the schedule or location may create a problem. (Paragraph 8)
- □ State that the photographer shall own all rights in the original assignment in the event of a reshoot.
- Require that the client indemnify the photographer if the client does not request that the photographer obtain needed releases (such as for models) or uses the photograph in a way that exceeds the use allowed by the release. (Paragraph 10)

- □ Try not to give a warranty and indemnity provision, in which the photographer states the work is not a copyright infringement and not an invasion of privacy and agrees to pay for the client's damages and attorney's fees if this is not true.
- □ If the client insists on a warranty and indemnity provision, try to be covered under any publisher's liability insurance policy owned by the client and ask the client to cover the deductible.
- □ Specify that the photographer will receive two copies of the published photograph or tear sheet, since these samples have value as portfolio pieces. (Paragraph 11)
- Do not allow the client to transfer or assign usage rights without the consent of the photographer, since the client may benefit from reuse fees that more appropriately belong to the photographer. (Paragraph 12)
- □ Allow the photographer to assign monies due under the contract. (Paragraph 12)
- □ If the photographer is dealing with an advertising agency or design firm that is working for a client, seek to have both the agency and its client be liable under the contract. If, for example, the agency did not pay, its client would still be obligated to make payment. (Paragraph 12)
- Provide for arbitration, except for amounts which can be sued for in small claims court. (Paragraph 13)
- Allow for the client to give verbal authorization for additional fees and expenses, since decisions made at the shoot may necessitate this. (Paragraph 14)
- □ Compare the standard provisions in the introductory pages with Paragraph 14.

Date

< Photographer's Letterhead >

Assignment Estimate/Confirmation/Invoice

Client ____

Address		Estimate	
		Confirmation	
Client Purchase Order Number		💷 Invoice	
Client Contact			
Assignment Description			
		Due Date	
Grant of Rights. Upon receipt of fu	II payment, Photogra	apher shall grant to the Client the following excl	usive rights:
For use as			
Other limitations			
		ss specified to the contrary here	
		s that can be encoded, stored, and retrieved fr	
as computer disks, CD-ROM, com			omsuchneu
as computer disks, CD-ROM, com Credit. The Photographer 📮 shall		IU HELWUR SELVELS.	
U ,		n	
		luding reimbursement of the expenses as show	vn helow with
		shall be paid in the following circumstances	
Expenses		Fees	
Assistants	\$	Photography fee	\$
Casting	\$	Other fees	
Crews/Special Technicians	\$	Preproduction \$/day;	\$
Equipment Rentals	\$	Travel \$/day;	\$
Film and Processing	\$	Weather days \$/day	\$
Insurance	\$	Space or Use Rate (if applicable)	\$
Location	\$	Cancellation fee	\$
Messengers	\$	Reshoot fee	\$
Models	\$	Fee subtotal	\$
Props/Wardrobe	\$	Plus total expenses	\$
Sets	\$		\$
Shipping	\$		\$
Styling Traval/Transportation	\$		
Travel/Transportation	\$		\$
Telephone Other expenses	\$ \$	Less advances	\$
	⊅ tal \$	Balance due	\$
(Plus% marku			
	es \$	Client	
Total expens	υς ψ _{mathematical states and sta}	ClientCompany Name	
Photographer		By Authorized Signatory, Titl	e
		Authorized orgitatory, Th	-

Subject to All Terms and Conditions Above and on Reverse Side

Terms and Conditions

- 1. Payment. Client shall pay the Photographer within thirty days of the date of Photographer's billing, which shall be dated as of the date of delivery of the Assignment. The Client shall be responsible for and pay any sales tax due. Time is of the essence with respect to payment. Overdue payments shall be subject to interest charges of _____ percent monthly.
- 2. Advances. Prior to Photographer's commencing the Assignment, Client shall pay Photographer the advance shown on the front of this form, which advance shall be applied against the total due.
- 3. Reservation of Rights. Unless specified to the contrary on the front of this form any grant of rights shall be limited to the United States for a period of one year from the date of the invoice and, if the grant is for magazine usage, shall be first North American serial rights only. All rights not expressly granted shall be reserved to the Photographer, including but not limited to all copyrights and ownership rights in photographic materials, which shall include but not be limited to transparencies, negatives, and prints. Client shall not modify directly or indirectly any of the photographic materials, whether by digitized encodations or any other form or process now in existence or which may come into being in the future, without the express, written consent of the Photographer.
- 4. Value and Return of Originals. All photographic materials shall be returned to the Photographer by registered mail or bonded courier (which provides proof of receipt) within thirty days of the Client's completing its use thereof and, in any event, within ______ days of Client's receipt thereof. Time is of the essence with respect to the return of photographic materials. Unless a value is specified for a particular image either on the front of this form or on a Delivery Memo given to the Client by the Photographer, the parties agree that a reasonable value for an original transparency is \$1,500. Client agrees to be solely responsible for and act as an insurer with respect to loss, theft, or damage of any image from the time of its shipment by Photographer to Client until the time of return receipt by Photographer.
- 5. Additional Usage. If Client wishes to make any additional uses, Client shall seek permission from the Photographer and pay an additional fee to be agreed upon.
- 6. Authorship Credit. Authorship credit in the name of the Photographer, including copyright notice if specified by the Photographer, shall accompany the photograph(s) when it is reproduced, unless specified to the contrary on the front of this form. If required authorship credit is omitted, the parties agree that liquidated damages for the omission shall be three times the invoiced amount.
- 7. Expenses. If this form is being used as an Estimate, all estimates of expenses may vary by as much as ten (10%) percent in accordance with normal trade practices. In addition, the Photographer may bill the Client in excess of the estimates for any overtime which must be paid by the Photographer to assistants and freelance staff for a shoot that runs more than eight (8) consecutive hours.
- 8. Reshoots. If Photographer is required by the Client to reshoot the Assignment, Photographer shall charge in full for additional fees and expenses, unless (a) the reshoot is due to Acts of God or is due to an error by a third party, in which case the Client shall only pay additional expenses but no fees; or (b) if the Photographer is paid in full by the Client, including payment for the expense of special contingency insurance, then Client shall not be charged for any expenses covered by such insurance in the event of a reshoot. The Photographer shall be given the first opportunity to perform any reshoot.
- 9. Cancellation. In the event of cancellation by the Client, the Client shall pay all expenses incurred by the Photographer and, in addition, shall pay the full fee unless notice of cancellation was given at least _____ hours prior to the shooting date, in which case fifty (50%) percent of the fee shall be paid. For weather delays involving shooting on location, Client shall pay the full fee if Photographer is on location and fifty (50%) percent of the fee if Photographer has not yet left for the location.
- **10. Releases.** The Client shall indemnify and hold harmless the Photographer against any and all claims, costs, and expenses, including attorney's fees, due to uses for which no release was requested or uses which exceed the uses allowed pursuant to a release.
- 11. Samples. Client shall provide the Photographer with two copies of any authorized usage.
- **12. Assignment.** Neither this Agreement nor any rights or obligations hereunder shall be assigned by either of the parties, except that the Photographer shall have the right to assign monies due hereunder. Both Client and any party on whose behalf Client has entered into this Agreement shall be bound by this Agreement and shall be jointly and severally liable for full performance hereunder, including but not limited to payments of monies due to the Photographer.
- **13.** Arbitration. All disputes shall be submitted to binding arbitration before ______ in the following location ______ and settled in accordance with the rules of the American Arbitration Association. Judgment upon the arbitration award may be entered in any court having jurisdiction thereof. Disputes in which the amount at issue is less than \$______ shall not be subject to this arbitration provision.
- 14. Miscellany. The terms and conditions of this Agreement shall be binding upon the parties, their heirs, successors, assigns, and personal representatives; this Agreement constitutes the entire understanding between the parties; its terms can be modified only by an instrument in writing signed by both parties, except that the Client may authorize additional fees and expenses orally; a waiver of a breach of any of its provisions shall not be construed as a continuing waiver of other breaches of the same or other provisions hereof; and the relationship between the Client and Photographer shall be governed by the laws of the State of ______.

Wedding Photography Contract

FORM

Wedding photography involves clients who are almost invariably novices in the purchasing of photographic services. This requires the photographer to explain clearly his or her professional business practices. A carefully drafted contract can help in this educational process while, at the same time, eliminating questions that might arise later.

The contract has to resolve many issues. For example, who is the client? Is it the bride, the groom, the parents of the bride or groom or both, or someone else? If the bride and groom are minors, who should sign the contract with the photographer?

Who will appear in the photographs and in what combinations will people appear? When and where will the photographs be taken? How many photographs will the photographer show the client? Will the shots be formal, candid, or both? Are there certain poses that the photographer will be expected to shoot? Should a list of standard shots be discussed with the bride and groom and used as a checklist?

How will the fee be set? There are two basic methods. The first establishes a package fee. This covers the time and expenses necessary to do the photography as well as the cost of a certain number of photographs (which may be in the form of an album). The second method charges a fee to cover the session or sitting, but does not require the purchase of any prints. In either case, extra prints can be ordered for an additional fee. Prices for packages and prints should be specified on a Standard Price List for the studio, so prices can be adjusted from time to time. The contract should cover any likelihood of extra charges, such as a second sitting for the formal pose or retouching of some of the photographs.

Since the client is not a business, it is especially important to receive an advance payment. This

deposit is usually fifty percent of the total fee. The balance of the fee can be paid at the wedding, when the previews are returned, or when the order is filled. In some cases, part of the balance is paid when previews are returned and part when the order is filled.

Cancellation close to the date for the photography can cause a loss to the photographer. Certainly the contract should provide some recompense to the photographer. Of course, good will in the community may incline the photographer to be lenient, if possible. If another job is obtained for that time, the deposit should be returned (unless some expenses have been incurred).

Copyright law is confusing for many photographers. Naive clients may believe they own everything — copyrights, prints, negatives, etc. The photographer can help educate them about the legalities involved by means of the contractual provisions. If the photographer retains the copyright but agrees not to use the work for certain purposes, a reasonable balance is struck. The photographer will probably want to be free to use the work for samples, studio promotion displays, contests, exhibitions, and perhaps even editorial use. If the photographer has any additional usage planned, this should be thoroughly explored in advance. For advertising and trade uses, of course, model releases must be obtained from anyone who will appear in the pictures.

It is basic to the arrangement that the client must come back to the photographer for additional prints. This form can be used to order additional prints. If the space is insufficient, write "see attached form" and attach a continuation sheet with the headings for ordering prints. Photographers need to work tactfully and without interruption when shooting. This is the reason to exclude other photographers or, at least, require that friends or family who may be shooting not interfere with the photographer's work.

The photographer also needs protection in case he or she is prevented from doing the assignment (perhaps by a strike), the camera malfunctions, the lab loses or damages the film, the film fades over time, or similar large and small catastrophes occur that one would rather not think about. A determination should be made as to whether another photographer can be substituted to cover the wedding or, in the case of a larger studio, whether a particular photographer is expected to do the shooting.

Including an arbitration clause is probably wise, although each photographer should review this with his or her own attorney. If the photographer can use the local small claims court, this might be even better than arbitration (and cases involving amounts the photographer can sue for in small claims court should then be excluded from arbitration).

If the formal pose is to be published in the newspapers, the photographer may want his or her credit to accompany the photograph. This credit is marvelous publicity — and it's free.

Filling in the Form

Fill in the names and addresses of the client, bride, and groom, as well as the couple's future address. Check the boxes to show whether there will be a print for newspapers and who will be in such a print. Indicate how many previews or proofs will be shown to the client in color, black and white, or both. Check the boxes to show which locations will be used, including addresses and times for each. Then complete any special services to be provided (such as special shots, groupings, etc.) Fill in the fee, including any extra charges, subtract the deposit, and show the balance due. On the back of the form fill in the interest rate in Paragraph 2, the value of any materials supplied by the client in Paragraph 11, the arbitration provision in Paragraph 12, and which state's laws will control the contract in Paragraph 13. Have the client or clients and the photographer sign the form

Negotiation Checklist

- Identify the client. This can be an important issue, since a dispute between the bride and groom or their families can embroil the photographer seeking payment. (Front of form)
- □ If the client is a minor, require that the minor's parents also sign as clients.
- State that each person signing the form as the client is responsible for paying the full amount of the fee. (Front of form)
- Describe the photographic services to be provided in as much detail as possible. This ensures that the photography will match the couple's expectations. (Front of form)
- Specify whether a print will be taken for newspapers. If such a print is to be taken, indicate who will be portrayed. (Front of form)
- Give a minimum number of shots that will be shown as proofs or previews, breaking this down into color and black and white. (Front of form)
- Consider reviewing a list of standard poses with the client and determining which of these poses should be taken.
- Discuss any special poses or types of photography to be done. (Front of form)
- □ If the fee is for a package, state the package number as well as the fee. (Front of form)
- □ If the fee is without a package, simply state the fee. (Front of form)

- Develop a standard price list. This should show prices for the various packages as well as for prints or albums without packages. The photographer should include the full range of possibilities, such as slide shows or videos if the studio can create them.
- □ Whether the basic fee is with or without a package, list charges that might have to be made in addition to the basic fee. Depending on the photographer's policy, this might include resitting, special retouching, special finishing, rush services, overtime, or unusual travel. (Front of form)
- □ Require that everyone responsible for paying the bill sign the contract. (Front of form)
- Give copies of the contract to the client or clients. (Front of form)
- Specify that the photographer will have the exclusive right to take the photographs. (Paragraph 1)
- Restrict family and friends who want to photograph from either interfering with the photographer's duties or shooting any poses arranged by the photographer. (Paragraph 1)
- Require a deposit against the fee. This deposit is usually fifty percent of the fee. (Paragraph 2)
- □ Detail when the balance of the fee will be paid. The contract specifies that payment will be made when the order is completed, which may mean either previews or a full package depending on the payment plan selected (Paragraph 2). Of course, the photographer can choose other payment dates, such as requiring the balance be paid at the wedding or be paid in installments (with payments at the wedding, delivery of previews, or delivery of the final order).

- □ Decide whether to allow thirty days to elapse after payment is due before the client will be considered in default. (Paragraph 2)
- □ If the client breaches the contract regarding payment, specify an interest rate that will be charged on the balance due until payment is made. Be certain this interest rate is not usurious under state law. (Paragraph 2)
- Consider making the client responsible for collection costs, such as court costs and attorney's fees, if the client breaches the contract.
- □ Deal with cancellation by the client. The deposit will usually be refunded if the photographer is given notice of cancellation thirty days prior to the wedding date. If less notice is given, some part of the deposit may be kept as liquidated damages. Whether to keep part of the deposit, and how much to keep, will vary with the circumstances of the case and the photographer's desire to build good will with the clients and within the community. (Paragraph 3)
- Specify that the photographer owns all photographic materials, including proofs, previews, negatives, and transparencies. (Paragraph 4)
- □ State that proofs and previews are on loan to the client and must be returned within a certain time period. Failure to return these materials should result in charges to the client based on the prices in the standard price list for similar sized photographs. (Paragraph 4)
- Reserve all copyrights to the photographer. (Paragraph 5)
- Determine what the photographer can and cannot do with the photographs, such as promotional displays, brochures, exhibitions,

editorial use, and so on. This contract allows the photographer to make certain uses and requires the client's permission for other uses. (Paragraph 5)

- Although the client has no right to reproduce the photographs under the copyright law, this should be reinforced by being explicitly stated. (Paragraph 6)
- □ Indicate that the client may use the formal pose in the newspapers if that option has been selected, but that in such a case the client must request that the newspaper give credit to the photographer. (Paragraph 6)
- □ Free the photographer from liability in the event that causes beyond his or her control prevent the taking of the photographs. (Paragraph 7)
- Also exempt the photographer from liability in the event of film damaged or lost at the lab, lost through a camera malfunction, lost in the mail, and so on. (Paragraph 7)
- The photographer should review the studio's coverage with respect to the different ways in which the photographic materials might suffer loss or damage.
- □ If the photographer fails to perform without a good excuse, seek to limit liability to the amount that the photographer would have earned from the job. (Paragraph 7)
- □ If the photographer may substitute another photographer to cover the wedding, whether because of illness or scheduling problems, this should be made clear to the client. (Paragraph 8). If a studio does not assign a particular photographer to a wedding, this should also be brought to the client's attention.
- □ Release the photographer from any liability

due to fading of color from inherent vice in the prints. (Paragraph 9)

- If the client's expectation is that a particular photographer will cover the wedding, a provision should be included in the contract allowing substitutions in certain specified situations.
- ❑ The photographer should develop a standard price list for use with the contract (rather than fixing the prices in the contract). This will allow for future adjustments to the price list. (Paragraph 10)
- □ If the client is giving prints, negatives, or transparencies to the photographer for reproduction or framing, the photographer should limit his or her liability with respect to the value of the materials given by the client. (Paragraph 11)
- □ Consider whether arbitration would be better than suing in the local courts. If arbitration is desirable, decide whether amounts that can be sued for in small claims court should be excluded from the arbitration provision. Also, specify who will act as arbitrator and where the arbitration will take place. (Paragraph 12)
- Specify which state's laws will control the contract. (Paragraph 13)
- □ Compare the standard provisions in the introductory pages with Paragraphs 12-13.

< Photographer's Letterhead >

Wedding Photography Contract

lient		Date	
ddress			
		Order Numbe	er
ride's Name	Groom's Name		
Couple's future address			
escription of Photographic Services to be Provided			
Black and White print for Newspapers	only 🖵 Brid	te and Groom	
Number of previews or proofs to be shown to Client	Color	🗖 Black	and White
Locations for Photography	Studio	Date	Time
Home, address		Date	
Rehearsal, address		Date	Time
Ceremony, address		Date	Time
Reception, address		Date	Time
Special Services, if required			
 Charges. The package fee is based on the Photographer's S herein. If the fee is not based on a package but is a session a accordance with the Standard Price List. In addition to eith below shall be billed if and when incurred. Package Fee (Package number) 	er the package fe	e or the session \$	
 herein. If the fee is not based on a package but is a session a accordance with the Standard Price List. In addition to eith orth below shall be billed if and when incurred. Package Fee (Package number) Fee Without Package Extra Charges 	er the package fe	e or the session \$. \$	
 If the fee is not based on a package but is a session a accordance with the Standard Price List. In addition to eithorth below shall be billed if and when incurred. Package Fee (Package number) Fee Without Package Extra Charges Additional prints 	er the package fe	e or the session \$. \$. \$	
 herein. If the fee is not based on a package but is a session a accordance with the Standard Price List. In addition to eithorth below shall be billed if and when incurred. Package Fee (Package number) Fee Without Package Extra Charges Additional prints Resitting 	er the package fe	e or the session \$. \$. \$ \$	
 If the fee is not based on a package but is a session a accordance with the Standard Price List. In addition to eith orth below shall be billed if and when incurred. Package Fee (Package number) Fee Without Package Extra Charges Additional prints Resitting Special retouching 	er the package fe	e or the session \$. \$. \$ \$ \$	
 If the fee is not based on a package but is a session accordance with the Standard Price List. In addition to eithorth below shall be billed if and when incurred. Package Fee (Package number) Fee Without Package Extra Charges Additional prints Resitting Special retouching 	er the package fe	e or the session \$. \$ \$ \$ \$ \$	
 If the fee is not based on a package but is a session accordance with the Standard Price List. In addition to eithorth below shall be billed if and when incurred. Package Fee (Package number) Fee Without Package	er the package fe	e or the session \$. \$ \$ \$ \$ \$ \$ \$	
 If the fee is not based on a package but is a session accordance with the Standard Price List. In addition to eithorth below shall be billed if and when incurred. Package Fee (Package number) Fee Without Package	er the package fe	e or the session \$ \$ \$ \$ \$ \$ \$ \$ \$ \$ \$ \$ \$	
 If the fee is not based on a package but is a session accordance with the Standard Price List. In addition to eithorth below shall be billed if and when incurred. Package Fee (Package number) Fee Without Package	er the package fe	e or the session \$ \$ \$ \$ \$ \$ \$ \$ \$ \$	
 If the fee is not based on a package but is a session accordance with the Standard Price List. In addition to eithorth below shall be billed if and when incurred. Package Fee (Package number) Fee Without Package Extra Charges Additional prints Resitting Special retouching Special finishes Rush service Unreturned previews Overtime 	er the package fe	e or the session \$ \$ \$ \$ \$ \$ \$ \$ \$ \$ \$ \$ \$	
 If the fee is not based on a package but is a session accordance with the Standard Price List. In addition to eithorth below shall be billed if and when incurred. Package Fee (Package number) Fee Without Package. Extra Charges Additional prints Resitting. Special retouching Special finishes. Rush service. Unreturned previews Overtime Travel. 	er the package fe	e or the session \$ \$ \$ \$ \$ \$ \$ \$ \$ \$ \$ \$ \$	
 If the fee is not based on a package but is a session accordance with the Standard Price List. In addition to eithorth below shall be billed if and when incurred. Package Fee (Package number) Fee Without Package. Extra Charges Additional prints Resitting. Special retouching Special finishes. Rush service. Unreturned previews Overtime Travel. 	er the package fe	e or the session \$	
 If the fee is not based on a package but is a session accordance with the Standard Price List. In addition to eithorth below shall be billed if and when incurred. Package Fee (Package number) Fee Without Package. Extra Charges Additional prints Resitting. Special retouching Special finishes. Rush service. Unreturned previews Overtime Travel. 	er the package fea	e or the session \$	
 If the fee is not based on a package but is a session accordance with the Standard Price List. In addition to eithorth below shall be billed if and when incurred. Package Fee (Package number) Fee Without Package. Extra Charges Additional prints Resitting. Special retouching Special finishes. Rush service. Unreturned previews Overtime Travel. 	Subtota Sales tax Less deposi	e or the session \$	
 If the fee is not based on a package but is a session accordance with the Standard Price List. In addition to eithorth below shall be billed if and when incurred. Package Fee (Package number) Fee Without Package. Extra Charges Additional prints Resitting. Special retouching Special finishes. Rush service. Unreturned previews Overtime Travel. 	Subtota Sales tax Less deposi	e or the session \$	
 If the fee is not based on a package but is a session accordance with the Standard Price List. In addition to eithorth below shall be billed if and when incurred. Package Fee (Package number) Fee Without Package. Extra Charges Additional prints Resitting. Special retouching Special finishes. Rush service. Unreturned previews Overtime Travel. 	Subtota Sales tay Total Due Balance Due	e or the session \$ \$ \$ \$ \$ \$	fee, the extra charges
herein. If the fee is not based on a package but is a session in accordance with the Standard Price List. In addition to eith both below shall be billed if and when incurred. Package Fee (Package number) Fee Without Package Extra Charges Additional prints Resitting Special retouching Special finishes. Rush service. Unreturned previews Overtime Travel Other	Subtota Subtota Sales tay Total Due Less deposi Balance Due	e or the session \$	fee, the extra charges
The parties have read both the front and back of this Agree	Subtota Subtota Sales tay Total Due Less deposi Balance Due cment, agree to all ch person signing	e or the session \$	fee, the extra charges
The parties have read both the front and back of this Agree complete copy of the Agreement signed by both parties. Ea	Subtota Subtota Sales tax Total Due Less deposi Balance Due cment, agree to all ch person signing of this Agreement	e or the session \$	fee, the extra charges acknowledge receipt c shall be fully responsi

This Agreement is subject to all the terms and conditions appearing on the reverse side.

Terms and Conditions

- 1. Exclusive Photographer. The Photographer shall be the exclusive photographer retained by the Client for the purpose of photographing the wedding. Family and friends of the Client shall be permitted to photograph the wedding as long as they shall not interfere with the Photographer's duties and do not photograph poses arranged by the Photographer.
- 2. Deposit and Payment. The Client shall make a deposit to retain the Photographer to perform the services specified herein. At such time as this order is completed, the deposit shall be applied to reduce the total cost and Client shall pay the balance due. If the Client refuses delivery of the order or refuses to pay within thirty (30) days of this order, Client shall be in default hereunder and shall pay _____ percent interest on the unpaid balance until payment is made in full.
- 3. Cancellation. If the Client shall cancel this Agreement thirty (30) or more calendar days before the wedding date, any deposit paid to the Photographer shall be refunded in full. If Client shall cancel within thirty days of the wedding date and if the Photographer does not obtain another assignment for that date, liquidated damages shall be charged in a reasonable amount not to exceed the deposit.
- 4. Photographic Materials. All photographic materials, including but not limited to negatives, transparencies, proofs, and previews, shall be the exclusive property of the Photographer. The Photographer shall make proofs and previews available to the Client for the purpose of selecting photographs, but such proofs and previews shall be on loan and, if they are not returned within fourteen (14) days of receipt by the Client, shall be charged to the Client at the same rate as finished prints of the same size.
- 5. Copyright and Reproductions. The Photographer shall own the copyright in all images created and shall have the exclusive right to make reproductions. The Photographer shall only make reproductions for the Client or for the Photographer's portfolio, samples, self-promotions, entry in photographic contests or art exhibitions, editorial use, or for display within or on the outside of the Photographer's studio. If the Photographer desires to make other uses, the Photographer shall not do so without first obtaining the written permission of the Client.
- 6. Client's Usage. The Client is obtaining prints for personal use only, and shall not sell said prints or authorize any reproductions thereof by parties other than the Photographer. If Client is obtaining a print for newspaper announcement of the wedding, Photographer authorizes Client to reproduce the print in this manner. In such event, Client shall request that the newspaper run a credit for the Photographer adjacent to the photograph, but shall have no liability if the newspaper refuses or omits to do so.
- 7. Failure to Perform. If the Photographer cannot perform this Agreement due to a fire or other casualty, strike, act of God, or other cause beyond the control of the parties, or due to Photographer's illness, then the Photographer shall return the deposit to the Client but shall have no further liability with respect to the Agreement. This limitation on liability shall also apply in the event that photographic materials are damaged in processing, lost through camera malfunction, lost in the mail, or otherwise lost or damaged without fault on the part of the Photographer. In the event the Photographer fails to perform for any other reason, the Photographer shall not be liable for any amount in excess of the retail value of the Client's order.
- 8. Photographer. The Photographer may substitute another photographer to take the photographs in the event of Photographer's illness or of scheduling conflicts. In the event of such substitution, Photographer warrants that the photographer taking the photographs shall be a competent professional.
- 9. Inherent Qualities. Client is aware that color dyes in photography may fade or discolor over time due to the inherent qualities of dyes, and Client releases Photographer from any liability for any claims whatsoever based upon fading or discoloration due to such inherent qualities.
- **10.** Photographer's Standard Price List. The charges in this Agreement are based on the Photographer's Standard Price List. This price list is adjusted periodically and future orders shall be charged at the prices in effect at the time when the order is placed.
- 11. Client's Originals. If the Client is providing original prints, negatives, or transparencies owned by the Client to the Photographer for duplication, framing, reference, or any other purpose, in the event of loss or damage the Photographer shall not be liable for an amount in excess of \$_____ per image.
- 12. Arbitration. All disputes arising under this Agreement shall be submitted to binding arbitration before ______ in the following location ______ and the arbitration award may be entered for judgment in any court having jurisdiction thereof. Notwithstanding the foregoing, either party may refuse to arbitrate when the dispute is for a sum less than \$______.
- 13. Miscellany. This Agreement incorporates the entire understanding of the parties. Any modifications of this Agreement must be in writing and signed by both parties. Any waiver of a breach or default hereunder shall not be deemed a waiver of a subsequent breach or default of either the same provision or any other provision of this Agreement. This Agreement shall be governed by the laws of the State of ______.

Portrait Photography Contract

Portrait photography is similar to wedding photography in both the nature of the clients and the nature of the contract. The clients are likely to be novices in terms of dealing with photographers and a carefully drafted contract serves an educational purpose and prevents misunderstandings from arising later.

Fees are set in the same way that fees for wedding photography are established. The package fee is one approach. It covers the time and expenses necessary to do the photography as well as the cost of a certain number of photographs. The other approach is to charge by the session or sitting without any requirement that prints be purchased. In both pricing methods, extra prints can be ordered for an additional fee. The studio must develop a Standard Price List that specifies the prices for various packages and prints. The Standard Price List allows prices to be adjusted from time to time. If extra charges may be incurred, such as a second sitting, rush charges, or unusual travel, the contract should cover this.

A deposit should be required from the client, with the balance payable either at the session, when the proofs are reviewed, or when the prints are delivered. The payment schedule should allow the photographer to keep some part of the deposit in the event of a sudden cancellation by the client, unless the photographer can fit someone else into that session time.

The photographer should retain ownership of the copyright as well as negatives and transparencies. It is basic to the arrangement that the client come back to the photographer for additional prints. This form can be used to order additional prints and a continuation sheet can be attached to detail the order.

The client must understand that the portraits are created for the personal use and pleasure of the client, not for reproduction and sale. If there will be usage beyond personal usage, that should be stated under Special Usage Requirements and will be taken into account when determining the fee. In such a case, the photographer should seek to have his or her credit appear with the portrait when it is reproduced.

If the photographer may want to use the work for samples, studio promotion displays, contests, exhibitions, and perhaps even editorial use, the contract should indicate this. Any usage that might be unusual should be explored in advance with the client. Advertising and trade uses will require model releases from anyone who will be portrayed.

If forces beyond the photographer's control prevent completing the portrait, or if the film is lost or damaged without the photographer being at fault, the contract should protect the photographer from liability. Even if the photographer is at fault for the session not being completed or the film being lost or damaged, the contract should try to establish a limit on the photographer's liability.

Inclusion of an arbitration clause should be reviewed with the photographer's attorney. If the local small claims court is better than arbitration, cases for amounts the photographer can sue for in small claims court can be excluded from the arbitration provision.

Filling in the Form

Fill in the name and address of the client. Indicate who will be photographed, where, when, and how many previews or proofs will be shown to the client in color, black and white, or both. Complete any special services to be provided as well as any special usage requirements. If the client's main purpose is to publish the photograph in various media, Form 1 would be more appropriate to use. Then fill in the fee, including any extra charges (some of which will have to be billed later), subtract the deposit, and show the balance due. On the back of the form fill in the interest rate in Paragraph 1, the number of days for cancellation notices in Paragraph 2, the value of any materials supplied by the client in Paragraph 10, the arbitration provision in Paragraph 11, and which state's laws will control the contract in Paragraph 12. Have the client and the photographer sign the form.

Negotiation Checklist

- Describe the photographic services to be provided in as much detail as possible. (Front of form)
- Give a minimum number of shots that will be shown as proofs or previews, breaking this down into color and black and white. (Front of form)
- If the client plans to publish or reproduce the portrait in various ways, this should be noted under Special Usage Requirements and the fee adjusted accordingly. (Front of form)
- □ If the fee is for a package, state the package number as well as the fee. (Front of form)
- □ If the fee is without a package, simply state the fee. (Front of form)
- Develop a standard price list. This should show prices for the various packages as well as for prints without packages. The photographer should include the full range of possibilities, such as slide shows or videos if the studio can create them.
- Whether the basic fee is with or without a package, list charges that might have to be made in addition to the basic fee. Depending on the photographer's policy, this might in-

clude resitting, special retouching, special finishing, rush services, overtime, or unusual travel. (Front of form)

- □ Have the client sign and give a copy of the contract to the client. (Front of form)
- □ Require a deposit against the fee. (Paragraph 1)
- Detail when the balance of the fee will be paid. The contract specifies that payment will be made when the order is completed, which may mean either previews or a full package depending on the payment plan selected (Paragraph 1). Of course, the photographer can choose other payment dates, such as requiring the balance be paid at the session or be paid in installments (with payments at the session, delivery of previews, or delivery of the final order).
- Decide whether to allow thirty days to elapse after payment is due before the client will be considered in default. (Paragraph 1)
- □ If the client breaches the contract regarding payment, specify an interest rate that will be charged on the balance due until payment is made. Be certain this interest rate is not usurious under state law. (Paragraph 1)
- Consider making the client responsible for collection costs, such as court costs and attorney's fees, if the client breaches the contract.
- Deal with cancellation by the client. The deposit will usually be refunded if the photographer is given notice of cancellation a certain number of days prior to the session date. If less notice is given, some part of the deposit may be kept as liquidated damages. The number of days selected will depend on the photographer's own work situation. Whether to keep part of the deposit, and how much to keep, will vary with the circum-

stances of the case and the photographer's desire to build good will with the clients and within the community. (Paragraph 2)

- Specify that the photographer owns all photographic materials, including proofs, previews, negatives, and transparencies. (Paragraph 3)
- State that proofs and previews are on loan to the client and must be returned within a certain time period. Failure to return these materials should result in charges to the client based on the prices in the standard price list for similar sized photographs. (Paragraph 3)
- Reserve all copyrights to the photographer. (Paragraph 4)
- Determine what the photographer can and cannot do with the photographs, such as promotional displays, brochures, exhibitions, editorial use, and so on. This contract allows the photographer to make certain uses and requires the client's permission for other uses. (Paragraph 4)
- □ Although the client has no right to reproduce the photographs under the copyright law, this should be reinforced by being explicitly stated. (Paragraph 5)
- □ Indicate that the client may use the portrait for reproduction if this is shown under Special Usage Requirements, but that in such a case the client must request that credit be given to the photographer. (Paragraph 5)
- □ Free the photographer from liability in the event that causes beyond his or her control prevent the taking of the photographs. (Paragraph 6)
- □ Also exempt the photographer from liability in the event of film damaged or lost at the lab, lost through a camera malfunction, lost in the

mail, and so on. (Paragraph 6)

- □ The photographer should review the studio's insurance coverage with respect to the different ways in which the photographic materials might be damaged or lost.
- □ If the photographer fails to perform without a good excuse, seek to limit liability to the amount that the photographer would have earned from the job. (Paragraph 6)
- □ If the photographer may substitute another photographer to cover the job, whether because of illness or scheduling problems, this should be made clear to the client. (Paragraph 7)
- □ If a studio does not assign a particular photographer to a session, this should also be brought to the client's attention. If the client's expectation is to be photographed by a particular photographer, a provision should be included in the contract dealing with substitutions in certain specified situations.
- □ Release the photographer from any liability due to fading of color from inherent vice in the prints. (Paragraph 8)
- □ The photographer should develop a standard price list for use with the contract (rather than fixing the prices in the contract). This will allow for future adjustments to the price list. (Paragraph 9)
- □ If the client is giving prints, negatives, or transparencies to the photographer for reproduction or framing, the photographer should limit his or her liability with respect to the value of the materials given by the client. (Paragraph 10)
- □ Consider whether arbitration would be better than suing in the local courts. If arbitration is desirable, decide whether amounts that can be

sued for in small claims court should be excluded from the arbitration provision. Also, specify who will act as arbitrator and where the arbitration will take place. (Paragraph 11)

- □ Specify which state's laws will control the contract. (Paragraph 12)
- □ Compare the standard provisions in the introductory pages with Paragraphs 11-12.

< Photographer's Letterhead >

Portrait Photography Contract

Client	Telephone
address	- Order number
Description of Photographic Services to be Provided	
Portrait of	
Location for Photography	
Date	Time
Number of previews or proofs to be shown to Client	Black and White
Special Services, if required	
Special Usage Requirements	
Charges. The package fee is based on the Photographer's Standard Price I therein. If the fee is not based on a package but is a session fee, all photographer in accordance with the Standard Price List. In addition to either the package forth below shall be billed if and when incurred.	raphs shall be billed in addition to the fee an
Sales tax	\$ \$ \$ \$ \$ \$ \$ \$ \$ \$ \$ \$
Client	Date
Photographer	Date

This Agreement is subject to all the terms and conditions appearing on the reverse side.

Terms and Conditions

- Deposit and Payment. The Client shall make a deposit to retain the Photographer to perform the services specified herein. At such time as this order is completed, the deposit shall be applied to reduce the total cost and Client shall pay the balance due. If the Client refuses delivery of the order or refuses to pay within thirty (30) days of this order, Client shall be in default hereunder and shall pay _____ percent interest on the unpaid balance until payment is made in full.
- 2. Cancellation. If the Client shall cancel this Agreement ______ or more calendar days before the session date, any deposit paid to the Photographer shall be refunded in full. If Client shall cancel within ______ days of the session date and if the Photographer does not obtain another assignment for that time, liquidated damages shall be charged in a reasonable amount not to exceed the deposit.
- **3.** Photographic Materials. All photographic materials, including but not limited to negatives, transparencies, proofs, and previews, shall be the exclusive property of the Photographer. The Photographer shall make proofs and previews available to the Client for the purpose of selecting photographs, but such proofs and previews shall be on loan and, if they are not returned within fourteen (14) days of receipt by the Client, shall be charged to the Client at the same rate as finished prints of the same size.
- 4. Copyright and Reproductions. The Photographer shall own the copyright in all images created and shall have the exclusive right to make reproductions. The Photographer shall only make reproductions for the Client or for the Photographer's portfolio, samples, self-promotions, entry in photographic contests or art exhibitions, editorial use, or for display within or on the outside of the Photographer's studio. If the Photographer desires to make other uses, the Photographer shall not do so without first obtaining the written permission of the Client.
- 5. Client's Usage. The Client is obtaining prints for personal use only, and shall not sell said prints or authorize any reproductions thereof by parties other than the Photographer. If Client is obtaining a print for reproduction, Photographer authorizes Client to reproduce the print only as set forth under Special Usage Requirements on the front of this form. In such event, Client shall request that a credit for the Photographer be placed adjacent to the photograph on publication, but shall have no liability if the publication refuses or omits to do so.
- 6. Failure to Perform. If the Photographer cannot perform this Agreement due to a fire or other casualty, strike, act of God, or other cause beyond the control of the parties, or due to the Photographer's illness, then the Photographer shall return the deposit to the Client but shall have no further liability with respect to the Agreement. This limitation on liability shall also apply in the event that photographic materials are damaged in processing, lost through camera malfunction, lost in the mail, or otherwise lost or damaged without fault on the part of the Photographer. In the event the Photographer fails to perform for any other reason, the Photographer shall not be liable for any amount in excess of the retail value of the Client's order.
- 7. Photographer. The Photographer may substitute another photographer to take the photographs in the event of Photographer's illness or scheduling conflicts. In the event of such substitution, Photographer warrants that the photographer taking the photographs shall be a competent professional.
- 8. Inherent Qualities. Client is aware that color dyes in photography may fade or discolor over time due to the inherent qualities of dyes, and Client releases Photographer from any liability for any claims whatsoever based upon fading or discoloration due to such inherent qualities.
- **9.** Photographer's Standard Price List. The charges in this Agreement are based on the Photographer's Standard Price List. This price list is adjusted periodically and future orders shall be charged at the prices in effect at the time when the order is placed.
- 10. Client's Originals. If the Client is providing original prints, negatives, or transparencies owned by the Client to the Photographer for duplication, framing, reference, or any other purpose, in the event of loss or damage the Photographer shall not be liable for an amount in excess of \$_____ per image.
- 11. Arbitration. All disputes arising under Agreement shall be submitted to binding arbitration before ______ in the following location ______ and the arbitration award may be entered for judgment in any court having jurisdiction thereof. Notwithstanding the foregoing, either party may refuse to arbitrate when the dispute is for a sum less than \$______.
- 12. Miscellany. This Agreement incorporates the entire understanding of the parties. Any modifications of this Agreement must be in writing and signed by both parties. Any waiver of a breach or default hereunder shall not be deemed a waiver of a subsequent breach or default of either the same provision or any other provision of this Agreement. This Agreement shall be governed by the laws of the State of ______.

Photographer—Agent Contract for Assignments

An agent can be of immeasurable value to a photographer. Instead of seeking assignments, the photographer can devote full time to creative work and trust that the agent will provide marketing impetus. The cost to the photographer is the agent's commission, which is usually 25 percent, but the hope is that the agent will enable the photographer to earn more. The agent may have better contacts and be able to secure a better quality of client and more remunerative assignments. For contacts with stock picture agencies, see Form 19.

The agent should not be given markets in which the agent cannot effectively sell. For example, an agent in New York may not be able to sell in Los Angeles or London. Nor should the agent be given exclusivity in markets in which the photographer may want to sell or want to have other agents sell. The length of the contract should not be overly long, or should be subject to a right of termination on notice. While the agent may promise to use best efforts, such a promise is almost impossible to enforce. If the agent fails to sell, the photographer must take over sales or find another agent.

Promotion is an important aspect of the agent's work for the photographer. The photographer will have to provide sufficient samples for the agent to work effectively. Beyond this, direct-mail campaigns and paid advertising in promotional directories may gain clients. The sharing of such promotional expenses must be agreed to between the photographer and agent.

One sticky issue can be house accounts: clients of the photographer not obtained by the agent. Both the definition of house accounts and the commission paid to the agent on such accounts must be negotiated. Termination raises another difficult issue, since the agent may feel that commissions should continue to be paid for assignments obtained by the photographer after termination from clients originally contacted by the agent. There are several approaches to resolve this. The agent may be given a continuing right to commissions for a limited time depending on how long the representation lasted. Or the photographer may make a payout to the agent, either in a lump sum or in installments over several years. If the relationship was brief and unsuccessful, of course, the agent should have no rights at termination except to collect commissions for assignments obtained prior to termination.

The agent would usually handle billings and provide accountings. The photographer would want to be able to review the books and records of the agent. Since both the photographer and agent provide personal services, the contract should not be assignable.

A distinction has to be made between an agent obtaining assignments and obtaining a book contract. The agent for an author receives a commission of 10 to 15 percent, compared to the 25 percent charged by a photographer's agent. If an agent arranges an assignment for a book jacket or a limited number of photographs in a book, the 25 percent commission is reasonable. But if the photographer is to be the author or coauthor of a book, it might be fairer to reduce the commission to the 10 to 15 percent range. One consideration might be whether the photographer receives a flat fee or a royalty, since a royalty makes the photographer more like an author.

A good source to locate agents is the membership list for the Society of Photographer and Artist Representatives (SPAR), 60 East 42nd Street, Suite 1166, New York, NY 10165.

Filling in the Form

In the Preamble fill in the date and the names and addresses of the photographer and agent. In Paragraph 1 indicate the geographical area and markets in which the agent will represent the photographer and whether the representation will be exclusive or nonexclusive. In Paragraph 5 fill in the commission rates. In Paragraph 6 check the party responsible for billings. In Paragraph 7 indicate the time for payment after receipt of fees and the interest rate for late payments. In Paragraph 8 indicate how promotional expenses will be shared. In Paragraph 11 state when and for how long the agent shall have a right to commissions after termination. In Paragraph 13 give the names of arbitrators and the place for arbitration, as well as the maximum amount which can be sued for in small claims court. In Paragraph 17 fill in which state's laws will govern the contract. Both parties should sign the contract and, if necessary, fill in the Schedule of House Accounts by listing the names and addresses of clients.

Negotiation Checklist

- □ Limit the scope of the agent's representation by geography and types of markets, including coverage of electronic rights. (Paragraph 1)
- □ State whether the representation is exclusive or nonexclusive. (Paragraph 1) If the representation is exclusive, the agent will have a right to commissions on assignments obtained by other agents. Assignments obtained by the photographer would fall under the house-account provision in Paragraph 5.
- □ If the agent uses other agents for certain markets (for example, for foreign sales), review the impact of this on commissions.
- Limit the types of photography the contract covers.
- □ State that sales through galleries or sales of photographs as original art in general are not within the scope of the agency agreement.
- □ Any rights not granted to the agent should be reserved to the photographer. (Paragraph 1)
- □ Require that the agent use best efforts to sell the work of the photographer. (Paragraph 2)
- □ State that the agent shall keep the photographer promptly and regularly informed with respect to negotiations and other matters, and shall submit all offers to the photographer.

- □ State that a contract negotiated by the agent is not binding unless signed by the photographer.
- □ If the photographer is willing to give the agent power of attorney so the agent can sign on behalf of the photographer, the power of attorney should be very specific as to what rights the agent can exercise.
- Require that the agent keep confidential all matters handled for the photographer.
- Give the photographer the right to accept or reject any assignment obtained by the agent. (Paragraph 2)
- □ Specify the samples to be supplied to the agent by the photographer. (Paragraph 3)
- □ If the samples are valuable, agree as to their value.
- □ Require the agent to insure the samples at the value agreed to.
- □ Raise the agent's responsibility for samples to strict liability for any loss or damage.
- Provide for a short term, such as one year. (Paragraph 4). This interplays with the termination provision. Since termination is permitted on thirty days' notice in Paragraph 11, the length of the term is of less importance in this contract.
- □ If the contract has a relatively long term and cannot be terminated on notice at any time, allow termination if the agent fails to generate a certain level of sales on a quarterly, semiannual, or annual basis.
- □ If the contract has a relatively long term and cannot be terminated on notice at any time, allow for termination if the specific agent dies or leaves the agency.
- □ Specify the commission percentage for assignments obtained by the agent during the term of the contract. This is usually 25 percent

of the fee, and may be 2 1/2 to 5 percent higher for out-of-town assignments.

- Define house accounts, probably as accounts obtained by other agents prior to the contract or obtained by the photographer at any time, and specify the commission to be paid on such accounts. A reasonable commission might be 10 percent, especially if the agent does the billing. The photographer may not want to pay any commission on these accounts, while the agent may want the full commission. (Paragraph 5)
- □ List house accounts by name on the Statement of House Accounts. This can be supplemented if house accounts are developed after the contract is signed. (Paragraph 5)
- □ State that the commission shall be computed on the billing less any expenses incurred by the photographer. (Paragraph 5)
- □ State that commissions are not payable on billings which have not been collected. (Paragraph 5)
- Confirm that the agent will not collect a commission for the photographer's speaking fees, grants, or prizes.
- Distinguish between an assignment to contribute to a book and being the author or coauthor of a book. Agents representing authors charge 10 to 15 percent of proceeds from the book as the commission. While the dividing line may be a fine one, photographers likely to make substantial contributions to a book should consider whether treatment as an author may be appropriate in terms of the agent's commission rate. (Paragraph 5)
- □ In the case of an agent for a book, consider letting the agency do only that particular title or project.
- Determine who will bill and collect from the client. This would usually be a service provided by the agent. (Paragraph 6)

- □ Give the photographer the right to collect his or her share directly from clients. This might provide some protection against the agent's insolvency or holding of money in the event of a dispute. Usually, the photographer would want the agent to collect billings.
- □ Require payments to be made quickly after billings are collected. (Paragraph 7)
- □ Charge interest (at a rate legal under state law) on payments that are overdue. (Paragraph 7)
- Require the agent to treat money due the photographer as trust funds and to hold it in an account separate from the funds of the agency. (Paragraph 7)
- Share promotional expenses, such as directmail campaigns or paid page advertising in directories. The agent may contribute 25 percent or more to these expenses. (Paragraph 8)
- State that both parties must agree before promotional expenses may be incurred by the agent. (Paragraph 8)
- Require the agent to pay for a specified minimum amount of promotional expenses, perhaps without any sharing on the part of the photographer.
- □ If expenses incurred by the agent benefit several photographers, be certain there is a fair allocation of expenses to each photographer.
- Require the agent to bear miscellaneous marketing expenses, such as messengers, shipping, and the like. (Paragraph 8)
- □ If the agent insists that the photographer bear certain expenses, require the photographer's approval for expenses in excess of a minimum amount.
- □ State that the photographer shall receive a copy of the invoice given to the client at the time the photographer is paid. (Paragraph 9)

- Provide for full accountings on a regular basis, such as every six months, if requested. (Paragraph 9)
- Provide the right to inspect books and records on reasonable notice. (Paragraph 10)
- Allow for termination on thirty days' notice to the other party. (Paragraph 11)
- □ State that the agreement will terminate in the event of the agent's bankruptcy or insolvency. (Paragraph 11)
- □ If termination occurs, specify for how long, if at all, the agent will receive commissions from assignments obtained by the photographer from clients developed by the agent during the time the contract was in effect. (Paragraph 11). For example, if the agency contract lasted for less than a year, the agent might have such a right for three months after termination. If the agency contract lasted more than a year but less than two years, the right might continue for six months after termination. If the agent has a right to commissions after termination for too long a period, the photographer may find it difficult to find another agent.
- □ Instead of allowing the agent to collect commissions for some period of time after termination, a fixed amount might be stated in the original contract. For example, 20 percent of the average annual billings for the prior 3 years might be payable in 3 installments over a year. The percentages and payment schedule are negotiable, but the photographer must avoid any agreement which would make it difficult either to earn a living or find another agent. The percentage to be paid might increase if the agent has represented the photographer for a longer period (or decrease for a shorter period), but should be subject to a cap or maximum amount.
- Do not give the agent any rights to commissions from house accounts after termination.

- For book contracts, it is customary for the agent to continue to collect royalties and deduct the agent's commission even after termination of the agency contract. However, it would be better for the photographer to have the right to direct payment of his or her share after such termination.
- Do not allow assignment of the contract, since both the agent and the photographer are rendering personal services. (Paragraph 12)
- Allow the photographer to assign payments due under the contract. (Paragraph 12)
- □ If the agent represents photographers who are competitive with one another, decide what precautions might be taken against favoritism. Whether it is advantageous or disadvantageous to have an agent represent competing talent will depend on the unique circumstances of each case.
- If the agent requires a warranty and indemnity clause under which the photographer states that he or she owns the work and has the right to sell it, limit the liability of the photographer to actual breaches resulting in a judgment and try to place a ceiling on the potential liability.
- Provide for arbitration of disputes in excess of the amount which can be sued for in small claims court. (Paragraph 13)
- □ If there is an arbitration provision, consider specifying the Joint Ethics Committee in New York City or a similar group closer to the photographer's location to act as arbitrator.
- □ Compare the standard provisions in the introductory pages with Paragraphs 14-17.

The schedule of house accounts, which lists the names and addresses of clients, is not shown here. It is included with the tear-out form.

Photographer—Agent Contract for Assignments

AC (he	REEMENT, entered into as of ereinafter referred to as the "Pho	this day of	, 19	, between,
an	d			(hereinafter referred to as the "Agent"),
	cated at			
an Wi Wi NC	d HEREAS, the Agent is capable of HEREAS, the Agent wishes to re	es to have an agent represent l of marketing the photography present the Photographer; on of the foregoing premises a	him or her in ma	arketing certain rights enumerated herein;
1.			his or her rep	presentative to obtain assignments:
	(A) in the following geographic	cal area		
	(B) for the following markets:	Book publishing		Corporate Nagazines
	(C) to be the Photographer's	□ exclusive □ nonexclusive	agent in the ar	rea and markets indicated.
	as the sale of such rights is For purposes of this agree	s incidental to the sale of non ement, electronic rights are d	electronic righ efined as right	covered by this agency contract insofar hts D covered by this agency contract. ts in the digitized form of works that can ks, CD-ROM, computer databases, and
	Any rights not granted to the A	gent are reserved to the Phot	ographer.	
2.	of securing assignments for the but the Photographer may reje	Photographer. The Agent sha ct any assignment if he or sha	all negotiate the	
3.	for the purpose of securing as	ssignments. These samples s Agreement. The Agent shall ta	shall remain th ake reasonable	work as are from time to time necessary the property of the Photographer and be the efforts to protect the samples from loss the Agent's negligence.
4.		e effect as of the date first set f	forth above, an	nd remain in full force and effect for a term
5.	Commissions. The Agent shall during the term of this Agreement For purposes of this Agreement or obtained by another agent re- listed in the Schedule of House A coauthors, percent of the ro- It is understood by both par- or for which the Photographer for	I be entitled to the following co ent, percent of the billing t, house accounts are defined epresenting the Photographer Accounts attached to this Agre syalties or licensing proceeds p rties that no commissions shal fails to receive payment, rega	mmissions: (A g. (B) On hous as accounts o prior to the col ement. (C) For aid to the Photo I be paid on as irdless of the re	•) On assignments obtained by the Agent se accounts, percent of the billing. obtained by the Photographer at any time mmencement of this Agreement and are books which the Photographer authors or ographer by the publisher or its licensees. signments rejected by the Photographer eason payment is not made. Further, no illing that is due to expenses incurred by

the Photographer in performing the assignment, whether or not such expenses are reimbursed by the client. In the event that a flat fee is paid by the client, it shall be reduced by the amount of expenses incurred by the Photographer in performing the assignment, and the Agent's commission shall be payable only on the fee as reduced for expenses.

- 6. Billing. The D Photographer D Agent shall be responsible for all billings.
- 7. Payments. The party responsible for billing shall make all payments due within ______ days of receipt of any fees covered by this Agreement. Such payments due shall be deemed trust funds and shall not be intermingled with funds belonging to the party responsible for billing and payment. Late payments shall be accompanied by interest calculated at the rate of _____ percent per month thereafter.
- 8. Promotional Expenses. Promotional expenses, including but not limited to promotional mailings and paid advertising, shall be mutually agreed to by the parties and paid _____ percent by the Agent and _____ percent by the Photographer. The Agent shall bear the expenses of shipping, insurance, and similar marketing expenses.
- **9.** Accountings. The party responsible for billing shall send copies of invoices to the other party when rendered. If requested, that party shall also provide the other party with semiannual accountings showing all assignments for the period, the clients' names and addresses, the fees paid, expenses incurred by the Photographer, the dates of payment, the amounts on which the Agent's commissions are to be calculated, and the sums due less those amounts already paid.
- **10. Inspection of the Books and Records.** The party responsible for the billing shall keep the books and records with respect to payments due each party at his or her place of business and permit the other party to inspect these books and records during normal business hours on the giving of reasonable notice.
- 11. Termination. This Agreement may be terminated by either party by giving thirty (30) days' written notice to the other party. If the Photographer receives assignments after the termination date from clients originally obtained by the Agent during the term of this Agreement, the commission specified in Paragraph 5(A) shall be payable to the Agent under the following circumstances: If the Agent has represented the Photographer for _____ months or less, the Agent shall receive a commission on such assignments received by the Photographer within ______ days of the date of termination. This period shall increase by thirty (30) days for each additional _____ months that the Agent has represented the Photographer, but in no event shall such period exceed ______ days. In the event of the bankruptcy or insolvency of the Agent, this Agreement shall also terminate. The rights and obligations under Paragraphs 3, 6, 7, 8, 9, and 10 shall survive termination.
- **12.** Assignment. This Agreement shall not be assigned by either of the parties hereto. It shall be binding on and inure to the benefit of the successors, administrators, executors, or heirs of the Agent and Photographer.
- **13.** Arbitration. Any disputes arising under this Agreement shall be settled by arbitration before _______ under the rules of the American Arbitration Association in the City of _______, except that the parties shall have the right to go to court for claims of \$______ or less. Any award rendered by the arbitrator may be entered in any court having jurisdiction thereof.
- 14. Notices. All notices shall be given to the parties at their respective addresses set forth above.
- **15.** Independent Contractor Status. Both parties agree that the Agent is acting as an independent contractor. This Agreement is not an employment agreement, nor does it constitute a joint venture or partnership between the Photographer and Agent.
- **16.** Amendments and Merger. All amendments to this Agreement must be written. This Agreement incorporates the entire understanding of the parties.
- 17. Governing Law. This Agreement shall be governed by the laws of the State of _____

IN WITNESS WHEREOF, the parties have signed this Agreement as of the date set forth above.

Photographer___

Agent___

Book Publishing Contract

A book contract is worth celebrating, but it is like a celebration to mark the beginning of a long journey. The creation of the book may take years, the life of the book may span decades. And the book may be the source for innumerable spinoffs, such as a television series, films, and even the licensing of characters for merchandise.

The book contract offers opportunities and presents pitfalls. Photographers are well advised to seek expert assistance in negotiating these contracts. Since the book contract invariably originates with the publisher, the negotiation checklist will be especially valuable. Form 5 is worth study because it contains terms which are favorable to photographers.

Form 5 might also be used when a nonprofessional publisher asks a photographer to do a book. For example, a charity, chamber of commerce, or even a corporation might want to contract for a book of specialized interest. If neither party has a standard contract to offer, Form 5 could be adapted for use.

The grant of rights gives the publisher certain rights, which the photographer carefully seeks to limit with respect to medium, time period, territory, and language. Beyond this, however, the publisher also seeks subsidiary rights, which are simply rights of exploitation in markets not encompassed by the grant of rights. If the grant of rights covers only the publication of books, then the sale of film or audio versions would be a licensing of subsidiary rights.

The goal of the photographer in negotiating a book contract is to give the publisher only those rights that the publisher is capable of successfully exploiting. For those rights given to the publisher, fair compensation must be provided by the contract. Compensation usually takes the form of an advance and a royalty, so that the photographer profits from greater sales of the work. Advances are paid to the photographer in installments, often half when the contract is signed and half when the manuscript is turned in to the publisher. Accountings should take place on a regular basis and provide the photographer with as much information as possible.

Because compensation to the photographer is based on royalties, the computation of the royalty is crucial. First, is the royalty based on retail price or net price? Most publishers compute royalties based on retail price, which is best for authors. Net price is what the publisher receives from selling the book to wholesalers and bookstores, so net price is usually 40 to 50 percent less than retail price. The percentage rates for royalties are crucial. While these rates are subject to negotiation, somewhat standard rates are given in the negotiation checklist. And there is one important piece of information that many authors are not aware of. That is, royalty rates are reduced for a number of reasons, such as sales at a higher-than-normal discount. These reductions can have a devastating effect on royalties. The contract must be carefully reviewed to ascertain the impact of such royalty reduction provisions.

The photographer will want to have the work copyrighted in the photographer's name. The copyright lasts for the life of the photographer plus another fifty years and any publishing contract can be terminated after thirty-five to forty years under the termination provisions of the copyright law. To avoid any confusion as to who owns the copyright, the copyright notice in the book should be in the photographer's name.

The photographer will also want artistic control over the content of the book. No changes should be allowed without the photographer's approval. Certainly no advertising or unrelated content should be added without the consent of the photographer.

The publisher will request a warranty and indemnity provision from the photographer. In this provision the photographer states that the book contains no copyright infringements, no defamatory material, invades no one's privacy, and is not otherwise unlawful. If any of these warranties prove incorrect, the photographer agrees to reimburse the publisher for any damages and costs, including attorney's fees. Some publishers are now extending their publishers' liability insurance to cover photographers for these risks. In the absence of such insurance, the photographer should seek to set a dollar limit or percent-of-royalty-income ceiling on his or her liability to the publisher.

The publisher will also want the option to publish the photographer's next work and will want to restrict the photographer from publishing competing works. The photographer should certainly try to have both these provisions stricken from the contract, since they may impair the photographer's ability to earn a livelihood.

If a photographer is creating a book with an author, many publishers will simply have both the photographer and author sign a book contract which specifies the division of royalties. This is satisfactory for the publisher, but leaves unresolved many important issues between the photographer and author. They should have a collaboration agreement, such as that shown in Form 6.

Filling in the Form

In the Preamble, fill in the date and the names and addresses of the parties. In the first Whereas clause, briefly describe the subject of the book. In Paragraph 1 enter the title of the book and specify the rights granted to the publisher with respect to form (such as hardcover, quality paperback, mass market paperback), territory, language, and term. In Paragraph 3 fill in the deadline for delivery of the manuscript as well as the approximate length of the book. Provide the amount of time to do revisions if requested and, in the event of rejection of the manuscript, specify what will happen to advances which have been paid. In Paragraph 4 fill in whatever materials, such as photographs or an index, the photographer is also obligated to provide and specify a contribution by the publisher toward these costs. In Paragraph 5 specify a contribution by the publisher toward the costs of obtaining any permissions. In Paragraph 6 give the number of months in which the publisher must publish the book. In Paragraph 7 specify the royalty rates and situations in which royalties are discounted. In Paragraph 8 fill in the subsidiary rights which the publisher has the right to license and the division of income for each right. In Paragraph 9 specify the amount of the advance to the photographer. Indicate in Paragraph 10 how often the publisher will give accountings. In Paragraph 13 show the form of authorship credit which the photographer will receive. In Paragraph 14 place limits on how much the photographer can be forced to pay for a breach of warranty and how much the publisher can hold in escrow to cover the photographer's indemnity obligation. State in Paragraph 15 which artistic decisions will be determined by the photographer. In Paragraph 17 specify how many free copies the photographer will receive and give the discount at which the photographer may purchase additional copies. In Paragraph 24 state who will arbitrate and the place for arbitration. In Paragraph 28 fill in which state's law will govern the contract. Both parties should then sign the contract.

Negotiation Checklist

- □ Limit the grant of exclusive rights to publish with respect to medium, area, duration, and language, such as granting "book rights in the English language in the United States for a term of ten years." Note that publishers will want to expand the grant of rights and exploit the book over the long life of the copyright. (Paragraph 1)
- Consider reserving Canadian rights, in particular, for sale to a Canadian publisher.
- Specify with respect to medium whether the grant of rights covers hardcover, quality paperback, mass market paperback, etc.
- Reserve to the photographer all rights not specifically granted to the publisher. (Paragraph 2)

- □ Specify a date for delivery of the manuscript. (Paragraph 3)
- □ Do not make time of the essence with respect to delivery of the manuscript.
- □ Extend the deadline in the event of the illness of the photographer or other circumstances beyond his or her control which cause a delay.
- Provide for a margin of lateness in delivery, such as ninety days, before the publisher can terminate the agreement. (Paragraph 3). Any extensions of the time for delivery should be obtained in writing.
- Give the approximate length in words of the manuscript to be delivered. (Paragraph 3)
- Allow the photographer to deliver a "complete manuscript," rather than "a manuscript in form and content satisfactory to the publisher." (Paragraph 3 offers a compromise.)
- □ If the photographer must deliver a manuscript which is satisfactory to the publisher, make an objective standard of reasonableness such as "reasonably satisfactory."
- □ Attach an outline or detailed description of the book to the contract so the manuscript can be judged against the outline. (Paragraph 3)
- □ Require the publisher to give detailed suggestions for revisions and a reasonable time to do the revisions. (Paragraph 3)
- □ If the manuscript is rejected by the publisher, determine whether advances will be kept, paid back, or paid back only if another contract for the book is signed with a different publisher. (Paragraph 3)
- □ If the photographer is submitting portions of the work in progress, have the publisher confirm in writing that these portions are satisfactory.
- □ Specify whether the photographer shall be

responsible for delivering photographs, illustrations, maps, tables, charts, or an index, and give details as to the number and nature of any such additional items. (Paragraph 4)

- □ If the photographer must provide additional items which require the outlay of money, such as photographs or having an index created, state who will pay for this. (Paragraph 4)
- □ If the photographer is to pay for such additional items, such as an index or permission fees, have the publisher make a nonrefundable payment toward these costs. (Paragraph 4)
- □ If the photographer is to create the index, allow for a certain amount of time in which to do this after the photographer has the paginated galleys.
- □ If the photographer fails to deliver any required materials, allow for a certain period of time, such as thirty days after notice from the publisher, in which the photographer can provide what is missing.
- □ Require the publisher to publish the book within a certain time period, such as twelve or eighteen months. (Paragraph 6)
- □ If the publisher does not publish within the specified time period, give the photographer the right to terminate the contract and keep all money received. (Paragraph 6)
- □ Provide for royalties, which are usually preferable to a flat fee. (Paragraph 7)
- □ If a flat fee is offered, require a reuse fee after a certain number of books are printed so the flat fee becomes more like a royalty.
- □ Base the computation of royalties on suggested retail price, not net price which is what the publisher receives from wholesalers and bookstores. (Paragraph 7)
- □ If the contract provides for a freight pass-

through (in which a book is priced at a slightly higher price to reimburse the bookstore for freight costs which the publisher normally pays but is not, in fact, paying), indicate that the amount of the freight passthrough is to be subtracted from the retail price prior to the computation of royalties.

□ Have the royalty be a percentage of retail price, rather than a fixed dollar amount, since the price of the book may increase over time. (Paragraph 7)

All royalties are negotiable and the rates offered vary from one publisher to another, but what follows are general guidelines of what the photographer may expect:

- □ For an adult trade book in hardcover, a basic royalty of 10 percent of suggested retail price on the first 5,000 copies sold, 12 1/2 percent on the next 5,000 copies, and 15 percent on all copies sold in excess of 10,000.
- □ For a children's book in hardcover, a basic royalty starting at 10 percent and escalating to 15 percent after an agreed upon number of copies are sold (but the practice varies widely with respect to children's books).
- □ For a quality paperback published by the publisher of the hardcover edition or as a paperback original, a royalty of 6 percent of retail price on the first 10,000 copies (or the first print run if it is less than 10,000 copies) with an increase to 7 1/2 percent for copies sold in excess of 10,000. Some publishers may offer 8 to 10 percent as a royalty, while others may escalate their rates only after the sale of 25,000 copies.
- For a mass market paperback published by the publisher of the hardcover edition, a royalty of 6 percent of retail price on the first 150,000 copies sold with an increase to 8 percent thereafter. A mass market original may have a similar or somewhat higher royalty rate structure.

a royalty is likely to be based on net price (which is what the publisher receives) rather than retail price. The royalty should be at least 15 percent of the net price. For hardcover textbooks, the royalty should escalate to 18 percent after 7,500 or 10,000 books have been sold and go even higher thereafter.

- □ For textbooks which originate in paperback, the royalty should be in the range of 10 to 15 percent of net price.
- □ Whenever escalations in royalty rates are provided in a contract, review carefully which sales are counted to reach the number of copies necessary for the royalty to escalate.
- Review with special care any provisions which reduce royalties and find out how many sales are likely to come within these provisions.
- Establish that the reduced royalties will in no event be less than half or three-quarters of what the regular royalties would have been.

Sales causing reduced royalties may include:

- □ Sales at a higher than normal discount to wholesalers or retailers. A normal discount might be 40 percent, and some publishers reduce royalties when the discount reaches 48 percent or more. This reduction may be gradual, such as 1 percent of royalty for each percent in excess of 48 percent discount, but the impact can be great. Moving the starting point for reductions from a 48 percent discount to perhaps a 51 percent discount may minimize the loss to a large degree, depending on the sales structure of the particular publisher. If such discounts are due to purchasing large quantities of books, the photographer should also consider requiring that different titles not be cumulated together for these purposes. Such cumulation has little to do with the sale of the photographer's books.
- □ For professional, scientific, or technical books,

□ Sales by mail order or direct response adver-

tising may cause the royalty to be reduced to as little as half the regular royalty rate.

- □ Sales in Canada may cause the royalty to be reduced to two-thirds or even half of the regular royalty rate.
- □ Sales on small reprintings, such as 1,000 copies, may cause the royalty to be reduced to three-quarters of the regular rate. The photographer might allow this only if sales in the period prior to the reprinting were below a certain level and the reprinting did not take place until two years after first publication.
- □ Children's books require especially close attention to royalty reductions for sales in library bound editions outside normal trade channels.
- □ Sales for export, to reading circles, to book clubs, and to organizations outside regular bookselling channels, may, if the discount from retail price is 60 percent or greater, cause the royalty to be reduced to 15 percent (for bound copies) or 18 percent (for unbound sheets) of what the publisher actually receives.
- Sales as a remainder (when excess inventory is liquidated), if at a discount of 70 percent of more, may cause the royalty to be reduced to 10 percent of what the publisher actually receives (or no royalty at all if the price is less than the publisher's manufacturing cost).
- Limit the percentage of copies which can be treated as sold at a discount.
- □ For royalties based on what the publisher actually receives, do not allow any reduction for discounts or bad debts.
- □ Finally, with respect to reduced royalties, promotional copies, author's copies, and copies which are destroyed are royalty free.
- □ Consider requiring that the publisher of the hardcover not bring out a paperback version until one year after the hardcover publication.

- Determine as to each subsidiary right which party controls that right and what the division of proceeds will be. (Paragraph 8). Subsidiary rights cover many possible sources of income which the publisher will exploit through marketing to other companies. Licensing of subsidiary rights may include abridgments, book clubs, reprints by another publisher, first and second serializations (which are magazine or newspaper rights before and after book publication), foreign or translation rights, syndication, advertising, commercial uses, films, plays, radio shows, television, audio tapes, and other mechanical renditions.
- State that the publisher has no right to share in subsidiary rights if the publisher does not fulfill all of its obligations under the contract. (Paragraph 8)
- Determine for each right whether the photographer, agent, or publisher can best sell that right.
- □ Reserve to the photographer all rights the publisher is not set up to sell.
- □ Retain a right of approval over subsidiary rights to be sold by the publisher.
- Reserve to the photographer all nonpublishing rights, such as stage, audio tapes, television, film, and electronic rights. This should include commercial rights, such as the right to make photographs into posters, calendars, apparel, and other merchandise.
- □ For first serial sales (the sale of part of the book to a magazine before first publication of the book), the photographer should receive 100 percent of the income. If the publisher acts as agent, the publisher might receive 10 to 20 percent. This approach would also apply to nonpublishing rights if, in fact, the publisher does obtain a right to share in the proceeds.
- □ For paperback licenses, book club licenses, abridgments and selections, and second serializations (the sale of part of the book to a

magazine after first publication of the book), the photographer should seek 50 percent of the first \$10,000 of income, 60 percent of the next \$10,000, and 70 percent over \$20,000.

- □ For microfilm or computer uses, the photographer should seek 50 percent of the income.
- □ If the original publication is in paperback, the photographer should expect 50 to 75 percent of the income from licensing hardcover rights.
- □ For a paperback original, consider requiring that the paperback publisher wait a year before licensing hardcover rights.
- Allow the photographer 120 days to seek out a better offer for a paperback reprint.
- □ If the publisher insists on receiving part of the proceeds from licensing electronic rights, require that the negotiation for what the author will receive from the electronic license take place just before the electronic publication. This will allow a better assessment of the value of the electronic rights.
- □ If the publisher insists on having the right to license electronic rights, the author might seek a right of approval over all such licenses. This approval would be to ensure that quality is maintained and that the work is not shortened, lengthened, or combined with other works in a detrimental way.
- □ If the print publisher is to do an electronic version of a book, insist on receiving an advance and royalty for the electronic version.
- □ Insist that the print publisher doing an electronic version not change the work in any way without the author's permission (such as addition of a sound track, abridgement, or combination with other works).
- Limit electronic rights to existing formats, specify which formats, and seek to make the usage nonexclusive.

- Seek assurance from the publisher that it and its licensees will take reasonable measures to prevent copying of the author's work.
- Make certain that any provision reserving or reverting rights to the author covers electronic rights.
- Carefully scrutinize the definition of licensing income. The photographer should always seek to have no reductions from such income. If the publisher uses "net income," the photographer must check which expenses will be deducted.
- Require that the photographer receive copies of any licenses negotiated by the publisher.
- Provide for the pass-through of licensing income received (perhaps in excess of a specified minimum amount, such as \$100), so that such income is paid to the photographer within 10 days of receipt by the publisher and is not held for payment with other royalties.
- Provide for the payment of nonrefundable advances to the photographer, preferably paid in full at the time of signing the contract or half on signing the contract and half on delivery of the manuscript. (Paragraph 9)
- Provide that each book project is separate, so that money owed by the photographer on one book cannot be taken from money due to the photographer on another book.
- Consider whether income from licensing subsidiary rights, especially first serial rights, should be applied to unearned advances.
- Require periodic accountings at least every six months, which is common for the publishing industry, or as frequently as every three months if it can be negotiated. (Paragraph 10)
- Specify the information to be given in the accountings, so the photographer can appraise their accuracy. Ideally the accounting would show for the period and cumulatively to date

the number of copies printed and bound, copies sold and returned at each royalty rate, copies distributed free for publicity, copies lost or destroyed, copies remaindered, and royalties due to the photographer. (Paragraph 10)

- Income from subsidiary rights should also be accounted for on these statements, even if such income is passed through to the photographer on receipt by the publisher. Copies of licenses should be provided at this time, if they have not already been provided.
- □ If the publisher wishes to create a reserve against returns of books, the amount of this reserve should be limited to a percentage of royalties due in any period (such as 20 percent) and the reserve should not be allowed to continue beyond a specified number of accounting periods. Since sales on first publication are most likely to be returned, the reserve might last for 3 accounting periods after first publication. (Paragraph 10)
- □ Require that any sums owing on the statements of account be paid when the statements are given. (Paragraph 11)
- □ In a very unusual case, after careful consultation with a tax adviser, the photographer may want a provision which limits royalties each year and causes any additional royalties to be spread forward into the future. In general, this is unwise.
- □ State that the photographer has a right to inspect the books and records of the publisher and, if a discrepancy of more than 5 percent is found to the publisher's advantage, the publisher shall pay the cost of the inspection. (Paragraph 12)
- Do not allow the publisher to place a time limit, such as one or two years after the mailing of the statement of account, on the photographer's right to inspect the books and have errors corrected.

- □ Require that copyright notice appear in the name of the photographer. (Paragraph 13)
- □ Require the publisher to register the copyright. (Paragraph 13)
- □ Specify that the photographer shall receive authorship credit. If there is a coauthor, indicate the sequence of names and, if necessary, size and placement. (Paragraph 13)
- □ Seek to have the publisher cover the photographer under the publisher's liability insurance policy for copyright infringements, libel, and related violations of rights. This will safeguard the photographer against many of the dangers in the warranty and indemnity provisions of publishers' contracts.
- □ If the publisher covers the photographer with its insurance, seek to have the publisher also pay or at least share in the cost of any deduct-ible (which may be as high as \$50,000 or \$100,000) in the event of a claim.
- □ State that the photographer only warrants that to his or her knowledge the work does not libel anyone or violate their rights of privacy. (Paragraph 14)
- □ Limit the indemnification to final judgments after all appeals have been taken. Avoid indemnifying for alleged breaches of the warranties. (Paragraph 14)
- □ Reserve the right not to pay for the publisher's costs and attorney's fees if the photographer selects and pays for the attorney to defend the action. (Paragraph 14)
- Do not indemnify for materials inserted at the publisher's request. (Paragraph 14)
- □ Require that the publisher indemnify the photographer for materials inserted in the book or placed on the cover at the publisher's request or choice.

- □ Limit the amount of the photographer's indemnification to the lesser of a dollar amount or a percentage of amounts payable under the contract. (Paragraph 14)
- □ Limit the right of the publisher to withhold royalties on account of the lawsuit to the lesser of a percentage of amounts payable under the contract or the amount of alleged damages. (Paragraph 14). Alternatively, the photographer might seek the right to post a surety bond.
- □ Do not agree to let sums payable under one contract be used to pay for a breach of a warranty under another contract.
- Retain a veto power over any settlements to be entered into by the publisher, since the money to pay the settlement may be the photographer's.
- □ If there is a joint author, determine whether both photographer and author will be liable for a breach of warranty by one or the other. Review Form 6.
- □ Keep artistic control over the content of the book, including the right to do revisions if the publisher requests them. (Paragraph 15)
- Require licensees to agree not to add anything to the book, including advertising, without first obtaining the photographer's consent.
- Seek a right of consultation with respect to the price, print run, method of printing, publication date, design, paper, new printings, and similar matters. Most publishers will insist on having the ultimate control over these matters. (Paragraph 15)
- □ Agree to the book's final title, which can only be changed by the agreement of both parties.
- Give the photographer a veto power over material which the publisher wishes to place in the book or on the cover.

- Obtain the right to consult regarding the promotional budget, promotional campaign, or distribution of press releases and review copies. (Paragraph 15)
- Limit the amount of promotion the publisher can require the photographer to do.
- □ State that the photographer shall review proofs or galleys, and give a period of time in which to do this. (Paragraph 15)
- Most contracts require authors to pay for author's alterations once the manuscript is typeset, but this should be only in excess of a percentage of the typesetting cost (such as 15 percent), might be subject to a maximum dollar amount, and should exclude printer's errors or unavoidable updating.
- Require that the publisher send out a certain number of review copies to a list of people supplied by the photographer.
- □ Require the publisher to return the manuscript and all accompanying materials to the photographer within a certain time period after publication and to give the photographer page proofs if the photographer requests them prior to publication. (Paragraph 16)
- □ If valuable materials, such as photographic transparencies, are submitted to the publisher, require that the publisher insure them and be strictly liable for loss or damage.
- Provide for the photographer to receive ten or more free copies of the book and any subsequent editions in a different form, such as a quality paperback after original hardcover publication. (Paragraph 17)
- □ Allow the photographer to purchase additional copies at a 40 or 50 percent discount from retail price. (Paragraph 17)
- □ Allow the photographer to sell copies pur-

chased by the photographer.

- □ If the photographer wants to sell a large quantity of the book, ask for a discount schedule. For example, 1 to 99 copies might have a 50 percent discount, 100 to 250 copies a 55 percent discount, 251 to 499 copies a 60 percent discount, 500 to 999 copies a 65 percent discount, and 1,000 or more copies a 70 percent or higher discount. If the photographer can order prior to the publisher's print run, a high discount is even more justifiable.
- □ Require that the publisher pay royalties on copies sold to the photographer.
- □ The photographer should have the first option to revise the book at the publisher's request. However, the publisher will expect to have the right to have the revision done by someone else if the photographer cannot or will not do it. (Paragraph 18)
- □ If the book may be outdated quickly, state that the publisher must allow a revision within a certain time period, such as two or three years, and that the contract will terminate if the publisher refuses such a revision.
- □ If the photographer is to do a revision, state that an additional advance shall be negotiated and paid at that time.
- □ If a revision is done by someone else, the cost of this will come from royalties due the photographer. The cost should only come from royalties payable on the revised book, not the prior edition or other books done by the photographer for the publisher.
- Specify a minimum royalty which the photographer will receive, even if a revision is done by someone else, or cap how much royalties can be reduced to pay for the revision.
- Give the photographer the right to remove his or her name from the credits if the revision is not satisfactory.

- □ Make the agreement binding on successors and assigns of the parties. (Paragraph 19)
- Do not allow assignment by one party unless the other party consents to this in writing. (Paragraph 19)
- □ Allow the photographer to assign the right to royalties without obtaining the publisher's consent. (Paragraph 19)
- □ In the event of infringement, state that the parties can sue jointly and, after deducting expenses, share any recovery. If one party chooses not to sue, the other party can sue and, after deducting expenses, share any recovery. (Paragraph 20)
- □ With respect to rights retained by the photographer, the publisher should have no right to sue for an infringement.
- □ With respect to subsidiary rights in which the photographer receives more than 50 percent of income, the publisher's right to sue should be limited to the percentage the publisher would receive.
- □ Give the photographer the right to terminate the contract if the book remains out-of-print after a request by the photographer that it be put back in print. (Paragraph 21)
- □ Define out-of-print to include when in any 12 months sales are less than 750 copies or royalties are less than a specified amount.
- Define out-of-print to mean that the book is not available in bookstores, regardless of whether the publisher has copies.
- □ Define whether a book must be out-of-print in all editions or only those published by the publisher to be deemed out-of-print.
- Give the photographer the right to terminate if the publisher fails to give statements of account, fails to pay, or fails to publish the book. In such

cases the photographer would keep payments received from the publisher. (Paragraph 21)

- □ State that the contract will automatically terminate if the publisher goes bankrupt or becomes insolvent. (Paragraph 21)
- □ If the photographer fails to deliver a manuscript, the publisher will expect to receive back all payments. (Paragraphs 3 and 21)
- □ If the manuscript delivered in good faith is unsatisfactory to the publisher, the standard publishing contract will require the return of advances but the photographer can negotiate to retain them. (Paragraph 21)
- □ If possible, avoid any requirement to repay an advance if a book, after rejection by one publisher, is placed with another publisher.
- Provide for the reversion of all rights to the photographer upon termination. (Paragraph 21)
- □ Whatever the ground for termination, the photographer should have the right to purchase all production materials at scrap value and remaining copies at the lesser of cost or remainder value. (Paragraph 22)
- Allow the use of the photographer's name or picture to promote the work, but require that the promotion be in good taste. (Paragraph 23). The photographer might seek either to supply the biographical material or have a right of approval over such material.
- □ If the photographer signs the contract first, a provision might be made to withdraw the offer if the publisher does not sign within thirty or sixty days after receipt of the contract.
- □ The photographer should resist giving the publisher a security interest in the work, which might entitle the publisher to seize the manuscript and related materials for money owed to the publisher (such as unrecouped advances) under the contract.

- If the photographer has an agent, the contract may provide for payment to the agent. A better approach would be to make the contract subject to the photographer–agent contract. In any case, the photographer should have the right to receive direct payment of all monies due other than the agent's commission.
- □ If an agency clause gives the agent a right to act on behalf of the photographer, review which actions the agent may take.
- □ The photographer should strike from the contract any provision which limits the creation of competitive works, since this may impair the range of work the photographer may later create. If the publisher insists on such a provision, the photographer should narrowly limit its scope with respect to the same subject matter, the same audiences, the same forms of book publication, duration, and geographic extent, and state that such a provision would be enforceable only when the sales of the original book would be impaired.
- □ The publisher may also seek an option for the photographer's next book. Ideally this will be stricken from the contract. If it is not stricken, it should be an option for one work only on terms to be agreed to (not terms identical to the existing contract). The publisher must accept or reject the work within a limited time period, such as thirty or sixty days, based on an outline (not a complete manuscript).
- State that a noncompetition clause or an option clause will be valid only if the publisher is not in breach of the contract and the contract has not been terminated.
- □ Include an arbitration clause. (Paragraph 24)
- Review the standard provisions in the introductory pages and compare with Paragraphs 25 to 28.
- □ If there is a joint author, review Form 6.

Book Publishing Contract

	einafter referred to as the "Publisher"), located at(hereinafter referred to as the "Photographer"
oca	ted at
	EREAS, the Photographer wishes to create a book on the subject of (hereinafted
	rred to as the "Work")
	EREAS, the Publisher is familiar with the work of the Photographer and wishes to publish a book by the Photographe
nd	
	EREAS, the parties wish to have said publication performed subject to the mutual obligations, covenants, ar
	ditions herein.
	N, THEREFORE, in consideration of the foregoing premises and the mutual covenants hereinafter set forth and oth
	able considerations, the parties hereto agree as follows:
aiu	
	Grant of Rights. The Photographer grants, conveys, and transfers to the Publisher in that unpublished Work title
•	, certain limited, exclusive rights as follow
	(A) To publish the Work in the form of a book; (B) In the territory
	and (D) For a term ofyears.
	Reservation of Rights. All rights not specifically granted to the Publisher are reserved to the Photographer, includi
5	
	but not limited to electronic rights which are defined as rights in the digitized form of works that can be encoded, store
	and retrieved from such media as computer disks, CD-ROM, computer databases, and network servers.
	Delivery of Manuscript. On or before the day of, 19, the Photographer shall deliver
	the Publisher a complete manuscript of approximately words, which shall be reasonably satisfactory in fo
	and content to the Publisher and in conformity with any outline or description attached hereto and made part here
	The manuscript shall be delivered as double-spaced hard copy computer files (specify format
	The manuscript shall include the additional materials listed in Paragraph 4 (except that if an index is to be provid
	by the Photographer, it shall be delivered to the Publisher within thirty days of Photographer's receipt of paginat
	galleys). If the Photographer fails to deliver the complete manuscript within ninety days after receiving notice from
	Publisher of failure to deliver on time, the Publisher shall have the right to terminate this Agreement and receive ba
	from the Photographer all monies advanced to the Photographer pursuant to Paragraphs 4, 5, and 9. If the
	Photographer delivers a manuscript which, after being given detailed instructions for revisions by the Publisher a
	days to complete such revisions, is not reasonably acceptable to the Publisher, then monies advanced to
	Photographer pursuant to Paragraphs 4, 5, and 9 shall be retained by the Photographer prepaid to the Publish
	Duran sides the Dublish an apply in the subset the Dhote graph and upper graphy signed a contract with another Dublish
	I repaid to the Publisher only in the event the Photographer subsequently signs a contract with another Publish
	for the Work.
	for the Work.
	for the Work. Additional Materials. The following materials shall be provided by the Photographer
•	for the Work. Additional Materials. The following materials shall be provided by the Photographer The cost of providing the
-	for the Work. Additional Materials. The following materials shall be provided by the Photographer The cost of providing the additional materials shall be borne by the Photographer, provided, however, that the Publisher at the time of signi
•	for the Work. Additional Materials. The following materials shall be provided by the Photographer The cost of providing the additional materials shall be borne by the Photographer, provided, however, that the Publisher at the time of signi this Agreement shall give a nonrefundable payment of \$ to assist the Photographer in defraying the
	for the Work. Additional Materials. The following materials shall be provided by the Photographer The cost of providing the additional materials shall be borne by the Photographer, provided, however, that the Publisher at the time of signi this Agreement shall give a nonrefundable payment of \$ to assist the Photographer in defraying the costs, which payment shall not be deemed an advance to the Photographer and shall not be recouped as such
	for the Work. Additional Materials. The following materials shall be provided by the Photographer The cost of providing the additional materials shall be borne by the Photographer, provided, however, that the Publisher at the time of signi this Agreement shall give a nonrefundable payment of \$ to assist the Photographer in defraying the costs, which payment shall not be deemed an advance to the Photographer and shall not be recouped as such Permissions. The Photographer agrees to obtain all permissions that are necessary for the use of material
	Additional Materials. The following materials shall be provided by the Photographer The cost of providing the additional materials shall be borne by the Photographer, provided, however, that the Publisher at the time of signit this Agreement shall give a nonrefundable payment of \$ to assist the Photographer in defraying the costs, which payment shall not be deemed an advance to the Photographer and shall not be recouped as such Permissions. The Photographer agrees to obtain all permissions that are necessary for the use of materia copyrighted by others. The cost of providing these permissions shall be borne by the Photographer, provided and the provided by others.
	for the Work. Additional Materials. The following materials shall be provided by the Photographer The cost of providing the additional materials shall be borne by the Photographer, provided, however, that the Publisher at the time of signi this Agreement shall give a nonrefundable payment of \$ to assist the Photographer in defraying the costs, which payment shall not be deemed an advance to the Photographer and shall not be recouped as such Permissions. The Photographer agrees to obtain all permissions that are necessary for the use of material
	for the Work. Additional Materials. The following materials shall be provided by the Photographer The cost of providing the additional materials shall be borne by the Photographer, provided, however, that the Publisher at the time of signi this Agreement shall give a nonrefundable payment of \$ to assist the Photographer in defraying the costs, which payment shall not be deemed an advance to the Photographer and shall not be recouped as such Permissions. The Photographer agrees to obtain all permissions that are necessary for the use of materi copyrighted by others. The cost of providing these permissions shall be borne by the Photographer, provided
	for the Work. Additional Materials. The following materials shall be provided by the Photographer The cost of providing the additional materials shall be borne by the Photographer, provided, however, that the Publisher at the time of signing this Agreement shall give a nonrefundable payment of \$ to assist the Photographer in defraying the costs, which payment shall not be deemed an advance to the Photographer and shall not be recouped as such Permissions. The Photographer agrees to obtain all permissions that are necessary for the use of materi copyrighted by others. The cost of providing these permissions shall be borne by the Photographer, provide however, that the Publisher at the time of signing this Agreement shall give a nonrefundable payment of \$

- 6. Duty to Publish. The Publisher shall publish the Work within ______ months of the delivery of the complete manuscript. Failure to so publish shall give the Photographer the right to terminate this Agreement ninety days after giving written notice to the Publisher of the failure to make timely publication. In the event of such termination, the Photographer shall have no obligation to return monies received pursuant to Paragraphs 4, 5, and 9.
- 7. Royalties. The Publisher shall pay the Photographer the following royalties: _____ percent of the suggested retail price on the first 5,000 copies sold; _____ percent of the suggested retail price on the next 5,000 copies sold; and _____ percent of the suggested retail price on all copies sold thereafter. These royalty rates shall be discounted only in the following circumstances: ______

All copies sold shall be cumulated for purposes of escalations in the royalty rates, including revised editions, except for editions in a different form (such as a paperback reprint of a hardcover original) which shall be cumulated separately. Copies sold shall be reduced by copies returned in the same royalty category in which the copies were originally reported as sold.

In the event the Publisher has the right pursuant to Paragraph 1(A) to publish the Work in more than one form, the royalty rates specified above shall apply to publication in the form of a ______ book and the royalty rates for other forms shall be specified here:

8. Subsidiary Rights. The following subsidiary rights may be licensed by the party indicated and the proceeds divided as specified herein:

Subsidiary Right	Right to I		Division of Pr	
	Photographer	Publisher	Photographer	Publisher

If the division of proceeds for any subsidiary right changes after the sale of a certain number of copies, indicate which right, the number of copies required to be sold, and the new division of proceeds ______

The Publisher shall have no rights pursuant to this Paragraph 8 if Publisher is in default of any of its obligations under this Agreement. The right to license any subsidiary right not set forth in this Paragraph is retained by the Photographer. Licensing income shall be divided as specified herein without any reductions for expenses.

Licensing income shall be collected by the party authorized to license the right and the appropriate percentage remitted by that party to the other party within ten days of receipt. Copies of all licenses shall be provided to both parties immediately upon receipt.

- **9.** Advances. The Publisher shall, at the time of signing this Agreement, pay to the Photographer a nonrefundable advance of \$_____, which advance shall be recouped by the Publisher from payments due to the Photographer pursuant to Paragraph 11 of this Agreement.
- 10. Accountings. Commencing as of the date of publication, the Publisher shall report every _____ months to the Photographer, showing for that period and cumulatively to date the number of copies printed and bound, the number of copies sold and returned for each royalty rate, the number of copies distributed free for publicity purposes, the number of copies remaindered, destroyed, or lost, and the royalties paid to and owed to the

Photographer. If the Publisher sets up a reserve against returns of books, the reserve may only be set up for the four accounting periods following the first publication of the Work and shall in no event exceed 15 percent of royalties due to the Photographer in any period.

- **11. Payments.** The Publisher shall pay the Photographer all monies due Photographer pursuant to Paragraph 10 within thirty days of the close of each accounting period.
- **12. Right of Inspection.** The Photographer shall, upon the giving of written notice, have the right to inspect the Publisher's books of account to verify the accountings. If errors in any such accounting are found to be to the Photographer's disadvantage and represent more than 5 percent of the payment to the Photographer pursuant to the said accounting, the cost of inspection shall be paid by the Publisher.
- **13.** Copyright and Authorship Credit. The Publisher shall, as an express condition of receiving the grant of rights specified in Paragraph 1, take the necessary steps to register the copyright on behalf of the Photographer and in the Photographer's name and shall place copyright notice in the Photographer's name on all copies of the Work. The Photographer shall receive authorship credit as follows: ______.
- 14. Warranty and Indemnity. The Photographer warrants and represents that he or she is the sole creator of the Work and owns all rights granted under this Agreement, that the Work is an original creation and has not previously been published (indicate any parts that have been previously published), that the Work does not infringe any other person's copyrights or rights of literary property, nor, to his or her knowledge, does it violate the rights of privacy of, or libel, other persons. The Photographer agrees to indemnify the Publisher against any final judgment for damages (after all appeals have been exhausted) in any lawsuit based on an actual breach of the foregoing warranties. In addition, the Photographer shall pay the Publisher's reasonable costs and attorney's fees incurred in defending such a lawsuit, unless the Photographer chooses to retain his or her own attorney to defend such lawsuit. The Photographer makes no warranties and shall have no obligation to indemnify the Publisher with respect to materials inserted in the Work at the Publisher's request. Notwithstanding any of the foregoing, in no event shall the Photographer's liability under this Paragraph exceed \$______ percent of sums payable to the Photographer having breached his or her warranties under this Paragraph, the Publisher shall have the right to withhold and place in an escrow account ______ percent of sums payable to the Photographer having breached his or her warranties under this Paragraph, the Publisher shall have the right to withhold and place in an escrow account _______ percent of sums payable to the Photographer having breached his

exceed the damages alleged in the complaint.

15. Artistic Control. The Photographer and Publisher shall consult with one another with respect to the title of the Work, the price of the Work, the method and means of advertising and selling the Work, the number and destination of free copies, the number of copies to be printed, the method of printing and other publishing processes, the exact date of publication, the form, style, size, type, paper to be used, and like details, how long the plates or film shall be preserved and when they shall be destroyed, and when new printings of the Work shall be made. In the event of disagreement after consultation, the Publisher shall have final power of decision over all the foregoing matters except the following, which shall be controlled by the Photographer______.

_. No changes shall be made in the complete

manuscript of the Work by persons other than the Photographer, except for reasonable copyediting, unless the Photographer consents to such changes. Publisher shall provide the Photographer with galleys and proofs which the Photographer shall review and return to the Publisher within thirty (30) days of receipt. If the cost of the Photographer's alterations (other than for typesetting errors or unavoidable updating) exceeds ______ percent of the cost of the typography, the Publisher shall have the right to deduct such excess from royalties due Photographer hereunder.

- **16. Original Materials.** Within thirty days after publication, the Publisher shall return the original manuscript and all additional materials to the Photographer. The Publisher shall provide the Photographer with a copy of the page proofs, if the Photographer requests them prior to the date of publication.
- **17. Free Copies.** The Photographer shall receive _____ free copies of the Work as published, after which the Photographer shall have the right to purchase additional copies at a _____ percent discount from the retail price.

- **18. Revisions.** The Photographer agrees to revise the Work on request by the Publisher. If the Photographer cannot revise the Work or refuses to do so absent good cause, the Publisher shall have the right to have the Work revised by a person competent to do so and shall charge the costs of said revision against payments due the Photographer under Paragraph 11 for such revised edition. In no event shall such revision costs exceed \$______.
- **19.** Successors and Assigns. This Agreement may not be assigned by either party without the written consent of the other party hereto. The Photographer, however, shall retain the right to assign payments due hereunder without obtaining the Publisher's consent. This Agreement shall be binding on the parties and their respective heirs, administrators, successors, and assigns.
- 20. Infringement. In the event of an infringement of the rights granted under this Agreement to the Publisher, the Publisher and the Photographer shall have the right to sue jointly for the infringement and, after deducting the expenses of bringing suit, to share equally in any recovery. If either party chooses not to join in the suit, the other party may proceed and, after deducting all the expenses of bringing the suit, any recovery shall be shared equally between the parties.
- 21. Termination. The Photographer shall have the right to terminate this Agreement by written notice if: (A) the Work goes out-of-print and the Publisher, within ninety days of receiving notice from the Photographer that the Work is out-of-print, does not place the Work in print again. A work shall be deemed out-of-print if the work is not available for sale in reasonable quantities in normal trade channels; (B) if the Publisher fails to provide statements of account pursuant to Paragraph 10; (C) if the Publisher fails to make payments pursuant to Paragraphs 4, 5, 9, or 11; or (D) if the Publisher fails to publish in a timely manner pursuant to Paragraph 6. The Publisher shall have the right to terminate this Agreement as provided in Paragraph 3. This Agreement shall automatically terminate in the event of the Publisher's insolvency, bankruptcy, or assignment of assets for the benefit of creditors. In the event of termination of the Agreement, the Publisher shall grant, convey, and transfer all rights in the Work back to the Photographer.
- **22.** Production Materials and Unbound Copies. Upon any termination, the Photographer may, within sixty days of notification of such termination, purchase the plates, offset negatives, or computer drive tapes (if any) at their scrap value and any remaining copies at the lesser of cost or remainder value.
- **23. Promotion.** The Photographer consents to the use of his or her name, portrait, or picture for promotion and advertising of the Work, provided such use is dignified and consistent with the Photographer's reputation.
- **24.** Arbitration. All disputes arising under this Agreement shall be submitted to binding arbitration before ________ in the following location _______ and shall be settled in accordance with the rules of the American Arbitration Association. Judgment upon the arbitration award may be entered in any court having jurisdiction thereof.
- **25.** Notice. Where written notice is required hereunder, it may be given by use of first-class mail addressed to the Photographer or Publisher at the addresses given at the beginning of this Agreement and shall be deemed received five days after mailing. Said addresses for notice may be changed by giving written notice of any new address to the other party.
- 26. Modifications in Writing. All modifications of this Agreement must be in writing and signed by both parties.
- **27.** Waivers and Defaults. Any waiver of a breach or default hereunder shall not be deemed a waiver of a subsequent breach or default of either the same provision or any other provision of this Agreement.
- 28. Governing Law. This Agreement shall be governed by the laws of ______ State.

IN WITNESS WHEREOF, the parties have signed this Agreement as of the date first set forth above.

Photographer___

_Publisher____

Company Name

Ву_____

Authorized Signatory, Title

Collaboration Contract

FORM

Collaboration presents the challenge and reward of blending two or more creative efforts into a single work. For the photographer this often means creating the visual components of a book while an author writes the text. Publishers offer coauthors a publishing agreement to sign, but a publishing agreement does not resolve the issues likely to arise between the collaborators. That is why a collaboration agreement, such as Form 6, should also be entered into by the photographer and coauthor. Form 6 deals with a photographer providing photography and an author providing text, but it could easily be modified for a book in which two photographers each provided photography or two authors each provided text. The negotiation checklist, in fact, is a valuable starting point to use for collaborations on other creative projects, such as toys, posters, or games.

The first issue to be resolved is how the copyright in the collaboration will be owned. The copyright law provides that a joint work is "a work prepared by two or more authors with the intention that their contributions be merged into inseparable or interdependent parts of a unitary whole." The collaboration agreement can specify the intention of the parties.

If the copyright is owned jointly, either party can license the work as long as proceeds are equally shared. The collaboration agreement can override this, providing that the parties must agree before licensing the work or indicating that the income will not be equally shared. If one party dies, his or her heirs would inherit the rights in the copyright. Again, the collaboration agreement can alter this by stating that the surviving collaborator will own the entirety of the work and its copyright.

One advantage of a joint work is that the copyright term is the life of the survivor plus 50 years. The term for the collaboration agreement would usually be the same as the term of the copyright.

The responsibilities of the parties must be set out in the greatest detail possible. An outline or synopsis can be attached to the agreement, dividing these responsibilities and giving a schedule for the work.

The division of proceeds from sales of the work must be resolved, especially if the division is not equal or if different types of income will be shared differently. The contract can provide that both parties must agree to any disposition of rights, but it can also specify that one party will control certain rights. For example, the photographer might want to control licenses of merchandising rights, such as the use of images on apparel, ceramics, or posters, and receive all of the income from such licenses. The agreement should state that the parties are independent of each other and have not formed a partnership, since a partner can legally bind the partnership even if he or she acted outside the authority of the partnership agreement.

The parties must decide how to authorize and share expenses, and what will happen if expenses are incurred but the project is either never completed or never sold. The failure to complete or sell the work raises complicated issues as to how the rights will be treated. It is likely that each party would want to retain the rights in his or her portion of the book and be free to publish that portion by itself or as part of a longer work. Whether this is fair will vary from project to project.

The agreement must determine what will happen if one collaborator fails to complete his or her portion of the work. Likewise, if one collaborator becomes disabled or dies, it is still necessary to complete, market, and revise the work. How will this be done? Probably both artistic and financial control of the project should be given to the active party at this point, rather than involving heirs or other people who were not parties to the original agreement.

The agreement must also deal with how each

collaborator will avoid competing with the collaborative work, while not impairing either party's ability to earn a livelihood. For example, can one party create a similar work which might damage the market for the collaborative work? If not, should this be allowed after some period of time? Must the collaborators work together on sequels? Or can each one create his or her own sequels? Any agreement as to future works, whether written negatively as a noncompetition clause or positively as a right to collaborate on sequels, must be approached with the utmost caution. Otherwise the photographer may find that he or she has agreed to what amounts to lifelong self-censorship.

If an agent is to be used, the contract should specify who the agent is or, at least, whether both parties must agree to the choice of an agent.

Authorship credit should be specified in the agreement. It is important that the credits accurately reflect what the parties did. The credit could be "by A and B" or "photography by A and story by B." "As told to" indicates one person telling their story to another; while "with" suggests that one person did some writing and the other person, usually a professional author, shaped and completed the book. It is against public policy for someone to take credit for writing a book which, in fact, was written by someone else.

The parties will have to give a warranty and indemnity to the publisher. If this clause is breached, both parties will be liable. The collaborators should determine who, in the event of a breach, should pay the publisher: both parties or only the party who created that portion of the work (assuming he or she has sufficient assets to pay for damages and legal fees).

Arbitration may be helpful in collaboration agreements, because certain issues do not lend themselves to determination in advance. For example, should the work be completed if one party is disabled? If it is completed, how should the disabled party's right to share income be affected? Should the nature of the authorship credit change, especially if a third party has been brought in to do substantial work? These and similar questions require a look at what has actually taken place before a fair result can be obtained.

The collaboration agreement is part of a process which will require the collaborators to contract with yet another party who will market the work. In the case of a book, a publisher will market what the collaborators create. Not only must the collaboration agreement resolve the issues likely to arise between the collaborators, it must also be compatible with reaching agreement with the publisher, who will disseminate the work to its ultimate audience. Form 5, the Book Publishing Contract, is therefore helpful to keep in mind when negotiating Form 6 with a coauthor.

Filling in the Form

In the Preamble fill in the date and the names and addresses of the parties. In the second Whereas clause the tentative title of the work should be entered. In Paragraph 1 the work should be described and the appropriate boxes checked if a schedule, outline, or synopsis is attached to the agreement. In Paragraph 2 the obligations of each party should be described. In Paragraph 3 fill in the due date. In Paragraph 4 fill in a date for termination if no publishing agreement has been obtained. In Paragraph 5 fill in the first blank if the collaborators choose not to have a jointly owned copyright, and fill in the second blank if the parties choose either not to own jointly certain proprietary rights or not to work together on sequels. In Paragraph 6 provide a dollar limit for expenses for each party. Also in Paragraph 6 show how net proceeds will be divided for publishing and nonpublishing rights, filling in the final blank if certain rights are to be controlled or benefited from in a way which is an exception to the general approach of the paragraph. Specify the name of any agent in Paragraph 7 and, if there is no agent, check the appropriate box as to whether the parties wish to obtain one. In Paragraph 8 give the credit line and state if the size or color of the names shall ever differ between the

collaborators. In Paragraph 9 fill in the blank if one party is not to have artistic control over his or her portion of the work. In Paragraph 13 give the name of an arbitrator and a place for arbitration. In Paragraph 16 specify any limitations on the parties with respect to competitive works. In Paragraph 17 state how recoveries for infringements will be shared. In Paragraph 18 indicate which state's laws will govern the agreement. Have both parties sign.

Negotiation Checklist

- □ The project should be described in as much detail as possible. If an outline or synopsis exists, it can be attached to the contract. (Paragraph 1)
- □ Indicate precisely and in as much detail as possible the responsibilities of each party. (Paragraph 2)
- □ Specify a due date to complete the work. (Paragraph 3)
- □ If one party fails to complete his or her portion of the work by the due date, consider what should happen and whether there should be an extension, the other party should have the right to complete the work (or hire a third party to complete it), or the rights in each portion of the work should revert to the party creating that portion. (Paragraph 3)
- □ If the work is not completed and each party retains the rights in his or her portion, state that each party is free to do as he or she pleases with that portion.
- Specify a work schedule with a sequence of deadlines, so that missing any deadline would have the same consequences as missing the final due date. This may alert one party to difficulties that are developing with his or her collaborator and give an opportunity to reconcile differences.

- □ If the nature of the collaboration is such that each party will have some portion of work inextricably merged with the portion created by the other party, state whether such merged portions can or cannot be used by either party in the event the work is not completed.
- □ If either party could create a competitive work that would damage the market for the collaborative work, state that for a certain period of time neither party shall create such a work. (See other provisions.)
- State that the parties either have a publishing contract or agree to seek such a contract. (Paragraph 4)
- □ Indicate that any publishing contract must be acceptable to both parties, who must each sign it and obey its provisions. (Paragraph 4)
- □ If no publishing contract is obtained by a certain date, allow either party to terminate the contract on written notice to the other party and specify that each party shall keep the rights in the portion of the work that he or she has created. (Paragraph 4)
- □ Require each party to inform the other party regarding any negotiations. (Paragraph 4)
- State which party will control the disposition of the various rights, or whether the parties must both agree to any licensing of the work. (Paragraph 4)
- □ If one party negotiates all contracts and licenses, give the other party a veto right and require both parties to sign all documents.
- □ If there are three or more collaborators, state whether licensing, contracts, and artistic decisions will be controlled by one party, a majority vote, or unanimous agreement.
- □ Permit the use of a written power of attorney

by one party on behalf of the other in specifically enumerated circumstances.

- Require that each collaborator receive an original or, at least, a copy of any contract or license which is entered into. (Paragraph 4)
- Specify whether the copyright will be held jointly in the whole work, or whether each party will retain copyright in that portion which he or she has created. (Paragraph 5)
- □ If the copyright is to be jointly owned, state that this will only happen if each party completes his or her portion. (Paragraph 5)
- □ If the copyright is jointly owned, decide whether each party's right in the joint copyright will pass on to heirs in the event of death or become the property of the other party. No provision has to be made if the choice is to have the right be inherited.
- If the copyrights are to be separately held by each party, provide for appropriate assignments of rights from each party so rights in the whole work are available for publication and licensing.
- □ If the work creates a trademark, characters, situations, or other rights which might be used later in sequels, determine whether both parties own the trademark or other rights and whether both have the right to do sequels. (Paragraphs 5 and 12)
- If both parties have a right to do sequels, consider whether this right shall be limited to a certain number of years after publication (perhaps two to four years) or should expire as of a specific date.
- State whether materials created or purchased in the course of developing the books (including research, tapes, interviews, books, equipment, etc.) shall be owned by both parties or

by the party which obtained the material. (Paragraph 5)

- Specify how the expenses of the parties in creating the project will be shared, especially if the expenses are not shared in the same way income is or if different types of income are shared differently. (Paragraph 6)
- □ If the work is never completed, will one party have to contribute to cover expenses incurred by the other party? (Paragraph 3)
- □ Determine how income, including advances, will be divided. (Paragraph 6)
- Specify how advances will be paid back to a publisher if one party fails to complete his or her portion of the work and the entire work cannot be completed. (Paragraph 3)
- Determine whether different types of income should be divided differently. For example, should the writer share in income from sales of electronic rights in the photographs? Should the writer share in income from merchandising of the photographs on posters? (Paragraph 6)
- □ If one party sells certain rights, should that party receive an extra percentage as a reward?
- If one party has several capacities, such as being the photographer of the original work and the cinematographer for a film version, should that party be free to receive payment in each capacity?
- Specify who will receive money owed and how and when the money will be distributed to the collaborators. Ideally, payment should be direct to each collaborator. (Paragraph 6)
- Specify whether money received will be kept in a joint bank account and, if so, whether both parties must sign on that account.

- □ To avoid any conflicts if both parties have agents, determine whether the parties will use an agent, specify the agent if known, and require both parties to sign and obey the contract with the agent. (Paragraph 7)
- Specify authorship credit, including the order, size, and color of the names, and the use of the names on promotional or advertising materials. (Paragraph 8)
- □ Determine which party will have artistic control of the work, or whether each party will control his or her own portion. (Paragraph 9)
- □ Specify the conditions under which one party may make or authorize changes in the work of the other party. (Paragraphs 3, 9, and 12)
- Require each party to give a warranty and indemnity to the other party, so one party will have some protection against copyright infringements, invasions of privacy, and similar unlawful acts on the part of the other party. (Paragraph 10)
- Specify that each party will obtain any releases or licenses to use copyrighted materials in his or her portion of the work and determine how payment will be made for such materials. (Paragraph 10)
- Do not allow assignment of the contract, since the duties of a photographer or author are usually based on personal skills. (Paragraph 11)
- □ Consider carefully whether to allow assignment of money due under the contract, since a party who has no reward to look forward to may lose interest in the work. (Paragraph 11)
- □ If a party wishes to assign money to become due or any rights in the work, give the other party the first option to purchase this right by matching the best terms offered.

- □ In the event of the death or disability of a party prior to completing the work, decide if the other party should have the right to complete the work. (Paragraph 12)
- □ In the event of death or disability of a party, determine how revisions of the work can be done and how such revisions will be paid for. (Paragraph 12)
- □ If one collaborator dies, decide whether the survivor should control contractual and licensing decisions or whether the estate and heirs should be involved. (Paragraph 12)
- □ In the event of death or disability, create a formula for reallocating the shares of income.
- □ If all collaborators are deceased, provide for the heirs or personal representatives to make financial and artistic decisions. (Paragraph 12)
- □ An arbitration provision is probably wise, because it is usually quicker and less expensive than a court proceeding. (Paragraph 13)
- □ In addition to arbitration, include a mediation provision so that the parties will have an independent mediator seek to resolve disputes before going to arbitration. Unlike arbitration, mediation is not binding on either party.
- □ Specify the agreement's term. (Paragraph 14)
- □ State that the agreement does not create a partnership or joint venture between the parties. (Paragraph 15)
- □ If the promotional or marketing commitment of either party is important to the project, specify what activities that party must undertake.
- □ Have both parties agree to allow the use of their name, portrait, or picture to promote the work.

- If the parties agree not to compete with the work, the exact limitations must be specified. (Paragraph 16. See other provisions.)
- □ If the work is infringed by others, determine how to bring suit, share costs, and share any recovery. (Paragraph 17)
- Review the standard provisions in the introductory pages and compare to Paragraph 18.

Other Provisions that can be added to Form 6:

Exclusivity. This provision is designed for the situation in which a person tells his or her story to an author, so it is not likely to be relevant to a photographer.

Exclusivity. The parties hereto agree that this Agreement is an exclusive agreement in that neither party will enter into any other agreements for books or for magazine articles which will diminish the value of any of the parties' respective rights in this Agreement. The Photographer acknowledges that the following activities by the Coauthor do not violate the preceding sentence:

Further, the Photographer agrees that the Coauthor is free to sell the publishing and nonpublishing rights to his or her story if such sales will not diminish the value of the parties' respective rights and do not deal with those aspects of the Coauthor's story embodied in the Work, and that all proceeds derived by the Coauthor from the granting of such rights are the sole property of the Coauthor.

Noncompetition. The danger of such a noncompetition clause is that one party or the other may be barred from earning a portion of their livelihood. **Noncompetition.** The parties agree that for a period of ______ years neither party shall authorize the publication of any other work in book form which directly competes with and would significantly diminish the market for the Work. This noncompetition provision shall not apply in the following circumstances:

Collaboration Contract

u	(hereinafter referred to	as the "Coauthor"
	ach party is familiar with and respects the work of the other; and	
	ne parties hereto wish to collaborate on a book project tentatively titled	
	(hereinafter referred to as the "Work")	
	ne parties wish to have the creation of the Work governed by the mutual obligation	ons, covenants, an
nditions here	ein; FORE, in consideration of the foregoing premises and the mutual covenants hereinaf	tor oot forth and ath
	iderations, the parties hereto agree as follows:	ter set fortil and othe
Descriptio	on. The Work shall be approximately words on the subject of	
	and shall include	photograph
Materials of	other than text and photographs include	
	edule 🕒 outline 🕒 synopsis is attached to and made part of this agreement.	
Responsi	ibilities. The Photographer shall be responsible for creating approximately ghotographer shall be respons	otographs to accon
Responsi	ibilities. The Photographer shall be responsible for creating approximately photext, described more fully as follows:	otographs to accon
Responsi	ibilities. The Photographer shall be responsible for creating approximately ghotographer shall be respons	otographs to accon
Responsi	ibilities. The Photographer shall be responsible for creating approximately photext, described more fully as follows:	otographs to accon
Responsi	ibilities. The Photographer shall be responsible for creating approximately photext, described more fully as follows:	otographs to accon
Responsi	ibilities. The Photographer shall be responsible for creating approximately photext, described more fully as follows: Subject Number of color photographs	otographs to accon
Responsi	ibilities. The Photographer shall be responsible for creating approximately photext, described more fully as follows: Subject Number of color photographs Format/Reproduction size	otographs to accor
Responsi	ibilities. The Photographer shall be responsible for creating approximately photext, described more fully as follows: Subject Number of color photographs Format/Reproduction size Number of black and white photographs	otographs to accon
Responsi	ibilities. The Photographer shall be responsible for creating approximately photext, described more fully as follows: Subject Number of color photographs Format/Reproduction size Number of black and white photographs Format/Reproduction size Format/Reproduction size	otographs to accor
Responsi	ibilities. The Photographer shall be responsible for creating approximately photext, described more fully as follows: Subject Number of color photographs Format/Reproduction size Number of black and white photographs Format/Reproduction size Format/Reproduction size	otographs to accon
Responsi	ibilities. The Photographer shall be responsible for creating approximately photext, described more fully as follows: Subject Number of color photographs Format/Reproduction size Number of black and white photographs Format/Reproduction size Format/Reproduction size	otographs to accor
Responsi pany the t	ibilities. The Photographer shall be responsible for creating approximately photext, described more fully as follows: Subject Number of color photographs Format/Reproduction size Number of black and white photographs Format/Reproduction size Other specifications	
Responsi pany the t	ibilities. The Photographer shall be responsible for creating approximately photext, described more fully as follows: Subject Number of color photographs Format/Reproduction size Number of black and white photographs Format/Reproduction size Format/Reproduction size	
Responsi pany the t	ibilities. The Photographer shall be responsible for creating approximately photext, described more fully as follows: Subject Number of color photographs Format/Reproduction size Number of black and white photographs Format/Reproduction size Other specifications	
Responsi pany the te The Photo	ibilities. The Photographer shall be responsible for creating approximately photext, described more fully as follows: photext, described more fully as follows: Subject	
Responsi pany the te The Photo	ibilities. The Photographer shall be responsible for creating approximately photext, described more fully as follows: Subject Number of color photographs Format/Reproduction size Number of black and white photographs Format/Reproduction size Other specifications	
Responsi pany the te The Photo	ibilities. The Photographer shall be responsible for creating approximately photext, described more fully as follows: photext, described more fully as follows: Subject	
Responsi pany the te The Photo	ibilities. The Photographer shall be responsible for creating approximately photext, described more fully as follows: photext, described more fully as follows: Subject Number of color photographs Format/Reproduction size Number of black and white photographs	
Responsi pany the te The Photo	ibilities. The Photographer shall be responsible for creating approximately photext, described more fully as follows: photext, described more fully as follows: Subject Number of color photographs Format/Reproduction size Number of black and white photographs	

- 3. Due Date. Both Photographer and Coauthor shall complete their portions of the Work by ______, 19 _____, or by the date for delivery of the manuscript as specified in a publishing contract entered into pursuant to Paragraph 4. If such a publishing contract requires preliminary materials prior to the date for delivery of the manuscript, the party responsible for same shall provide it to the publisher. In the event either party fails to complete his or her portion of the Work by the due date for reasons other than death or disability, the parties may agree to an extension of the due date or agree to allow a nondefaulting party to complete the Work as if the other party were deceased or disabled. If no agreement can be reached, the arbitrator may award a nondefaulting party the right to complete the Work as if the other party were deceased or disabled or may convey to each party the rights of copyright in that party's completed portion of the Work and specify how the parties shall contribute to any expenses incurred and repay any advances.
- 4. Contracts and Licenses. If a contract for the Work has not already been entered into with a publisher, both Photographer and Coauthor agree to seek such a contract. Such publishing contract shall be entered into in the names of and signed by both the Photographer and the Coauthor, each of whom shall comply with and perform all required contractual obligations. If a mutually agreeable publishing contract for initial publication of the Work is not entered into with a Publisher by ________, 19_____, then either party may terminate this Agreement by giving written notice to the other party prior to such time as a mutually agreeable publishing contract for initial publications for such a publishing contract or with respect to the negotiation of any other licenses or contracts pursuant to this Agreement. The disposition of any right, including the grant of any license, shall require written agreement between both parties hereto. Each party shall receive a copy of any contract, license, or other document relating to this Agreement.
- 5. Copyright, Trademarks, and Other Proprietary Rights. Photographer and Coauthor agree that the Work shall be copyrighted in both their names, and that upon completion of the Work it is their intention that their respective contributions shall be merged into a joint work with a jointly owned copyright, unless provided to the contrary here:______. If either party does not com-

plete their portion of the Work, the nature of copyright ownership shall be governed by Paragraph 3. It is further agreed that trademarks, rights in characters, titles, and similar ongoing rights shall be owned by both parties who shall both participate in any sequels under the terms of this Agreement, unless provided to the contrary here:______. A sequel is defined as a work closely

related to the Work in that it is derived from the subject matter of the Work, is similar in style and format to the Work, and is directed toward the same audience as that for the Work. Material of any and all kinds developed or obtained in the course of creating the work shall be **D** jointly owned **D** the property of the party who developed or obtained it.

6. Income and Expenses. Net proceeds generated by the Work shall be divided as set forth in this Paragraph. Net proceeds are defined as gross proceeds from the sale or license of book rights throughout the world (including but not limited to serializations, condensations, and translations), including advances, minus reasonable expenses. Such expenses shall include agents' fees and the parties' expenses incurred in the creation of the Work, provided that the parties' expenses shall be supported by appropriate verification and shall not exceed \$_____ for the Photographer and \$_____ for the Coauthor. Each party shall provide verification for expenses to the other party within ten days of a written request. Unless otherwise provided, the parties' expenses shall be reimbursed from first proceeds received, including but not limited to advances.

Net proceeds from the sale or license of publishing rights shall be divided _____ percent to the Photographer and _____ percent to the Coauthor.

Net proceeds from the sale or license of electronic publishing rights shall be divided _____ percent to the Photographer and _____ percent to the Coauthor. For purposes of this agreement, electronic rights are defined as rights in the digitized form of works that can be encoded, stored, and retrieved from such media as computer disks, CD-ROM, computer databases, and network servers.

Net proceeds from the sale or license of nonpublishing rights in the Work (including but not limited to audio, merchandising, motion picture, stage play, or television rights to the Work), whether such sale or license occurs before or after initial publication of the Work, shall be divided ______ percent to the Photographer and ______ percent to the Coauthor, unless provided to the contrary here, in which case the following rights shall be treated with respect to division of net proceeds and control or disposition as follows:______

If possible, net proceeds shall be paid directly to each party in accordance with the divisions set forth in this Paragraph. If either party is designated to collect such net proceeds, that party shall make immediate payment to the other party of such amounts as are due hereunder.

- 7. Agent. If the parties have entered into an agency agreement with respect to the Work, it is with the following agent: ________. If a contract for the Work has not already been entered into with an agent, both Photographer and Coauthor agree □ to seek such a contract □ not to seek such a contract. Any agency contract shall be mutually acceptable to and entered into in the names of and signed by both the Photographer and the Coauthor, each of whom shall comply with and perform all required contractual obligations.
- 8. Authorship Credit. The credit line for the Work shall be as follows wherever authorship credit is given in the Work or in promotion, advertising, or other ancillary uses:

_____. The color and type size for such authorship credit shall be the same for both authors unless provided to the contrary here:_____

9. Artistic Control. Each party shall have artistic control over his or her portion of the Work, unless provided to the contrary here in which case artistic control of the entire Work shall be exercised by ______

______. The parties shall share ideas and make their work in progress available to the other party for discussion and coordination purposes. Except as provided in Paragraphs 3 and 12, neither party shall at any time make any changes in the portion of the Work created by the other party.

- **10.** Warranty and Indemnity. Photographer and Coauthor each warrant and represent to the other that the respective contributions of each to the Work are original (or that appropriate releases have been obtained and paid for) and do not libel or otherwise violate any right of any person or entity, including but not limited to rights of copyright or privacy. Photographer and Coauthor each indemnify and hold the other harmless from and against any and all claims, actions, liability, damages, costs, and expenses, including reasonable legal fees and expenses, incurred by the other as a result of the breach of such warranties, representations, and undertakings.
- **11. Assignment.** This Agreement shall not be assignable by either party hereto, provided, however, that after completion of the Work, either party may assign the right to receive money pursuant to Paragraph 6 by giving written notice to the other party.

- **12. Death or Disability.** In the event that either party dies or suffers a disability that will prevent completion of his or her respective portion of the Work, or of a revision thereof or a sequel thereto, the other party shall have the right to complete that portion or to hire a third party to complete that portion and shall adjust the authorship credit to reflect the revised authorship arrangements. The deceased or disabled party shall receive payments pursuant to Paragraph 6 pro rata to the proportion of his or her work completed or, in the case of a revision or sequel, shall receive payments pursuant to Paragraph 6 pro rata to Paragraph 6 after deduction for the cost of revising or creating the sequel with respect to his or her portion of the Work. The active party shall have the sole power to license and contract with respect to the Work, and approval of the personal representative, heirs, or conservator of the deceased or disabled party shall not be required. If all parties are deceased, the respective heirs or personal representatives shall take the place of the parties for all purposes.
- **13.** Arbitration. All disputes arising under this Agreement shall be submitted to binding arbitration before _______ in the following location _______ and shall be settled in accordance with the rules of the American Arbitration Association. Judgment upon the arbitration

award may be entered in any court having jurisdiction thereof.

- **14. Term.** The term for this Agreement shall be the duration of the copyright, plus any renewals or extensions thereof.
- **15. Independent Parties.** The parties to this Agreement are independent of one another, and nothing contained in this Agreement shall make a partnership or joint venture between them.
- **16.** Competitive Works. If the parties wish to restrict future activities to avoid competition with the Work, any such restrictions must be stated here: ______
- 17. Infringement. In the event of an infringement of the Work, the Photographer and Coauthor shall have the right to sue jointly for the infringement and, after deducting the expenses of bringing suit, to share in any recovery as follows:________. If either party chooses not to join in the suit, the other party may proceed and, after deducting all the expenses of bringing the suit, any recovery shall be shared between the parties as stated in the preceding sentence.

18. Miscellany. This Agreement shall be binding upon the parties hereto, their heirs, successors, assigns, and personal representatives. This Agreement constitutes the entire understanding between the parties. Its terms can be modified only by an instrument in writing signed by both parties. Each party shall do all acts and sign all documents required to effectuate this Agreement. A waiver of any breach of any of the provisions of this Agreement shall not be construed as a continuing waiver of other breaches of the same or other provisions hereof. This Agreement shall be governed by the laws of the State of ______.

IN WITNESS WHEREOF, the parties hereto have signed this Agreement as of the date first set forth above.

Photographer____

Coauthor____

Contract for the Sale of Fine Art Photography

his is a basic contract for the sale of a work of fine art photography to a collector. A number of provisions, included in the section on other provisions, can be added to Form 7 to govern the relationship of the photographer to the work after the sale. The section on other provisions includes a way to deal with the issue of uniqueness, which is always presented when photography enters the world of collectors and galleries.

Filling in the Form

In the Preamble fill in the date and the names and addresses of the parties. In Paragraph 1 describe the work. In Paragraph 3 fill in the price. In Paragraph 5 check the box to indicate who will arrange for delivery and fill in the location and time for delivery and who will pay the expenses for the delivery. In Paragraph 6 fill in when the risk of loss will pass from the photographer to the collector. In Paragraph 7 fill in the date for the copyright notice. In Paragraph 8 fill in the state whose laws will govern the sale. Both parties should then sign.

Negotiation Checklist

- □ Make certain title does not pass to the purchaser until the photographer has been paid in full. (Paragraph 2)
- □ Agree on the price and the payment of sales tax or any other transfer tax. (Paragraph 3)
- Agree on the payment of other charges, such as for framing or installation. If the photographer must travel to install the work, agree on a fee or reimbursement for the travel expenses.
- □ Agree on the time for payment. (Paragraph 4)
- □ If the sale is an installment sale, obtain the

right to a security interest in the work. (See the discussion under other provisions.)

- □ Specify the manner of payment, such as by personal check, certified check, cash, credit card, or money order.
- □ Specify the currency for payment. This might be necessary if the collector is foreign or if the photographer is selling work abroad.
- □ Agree on who arranges and pays for delivery, if the collector can't simply take the work when it is purchased. (Paragraph 5)
- □ Specify a time for delivery. (Paragraph 5)
- ❑ Agree when the risk of loss or damage to the work passes from the photographer to the collector. This risk usually passes on delivery, but the time when the risk passes can be altered by contract. If the collector buys the work but leaves it with the photographer, the risk of loss will not pass to the collector until the collector could reasonably have been expected to pick up the work. The photographer can avoid the uncertainty of this by providing that the risk of loss passes to the collector at the time of purchase, regardless of whether the work has been delivered. (Paragraph 6)
- □ Agree whether the work will be insured and, if so, by whom. (Paragraph 6)
- Reserve all reproduction rights to the photographer. (Paragraph 7)
- Require copyright notice in the photographer's name for any reproductions approved by the photographer. (Paragraph 7)
- Review the standard provisions in the introductory pages and compare to Paragraph 8.

Other Provisions which can be added to Form 7:

□ Installment sale. If the photographer wants to sell the work on an installment basis, the following provision could be added:

 Installment Sale. The price shall be paid in installments, payable \$_____ on ______, 19____; \$____ on ______, 19____; and \$_____ on ______, 19____.

Security interest. If the photographer allows the collector to purchase the work on an installment basis, the photographer may want the right to have a security interest in the work until payment is made in full. This means that the photographer would have a right to the work ahead of any of the collector's creditors. Such a provision would state:

Security Interest. Collector grants to the Photographer, and the Photographer hereby reserves, a security interest under the Uniform Commercial Code in the work and any proceeds derived therefrom until payment is made in full to the Photographer. Collector agrees to execute and deliver to the Photographer, in the form requested by the Photographer, a financing statement and such other documents which the Photographer may require to perfect its security interest in the work. The Collector agrees not to transfer, pledge, or encumber the work until payment has been made in full, nor to incur any charges or obligations in connection therewith for which the Photographer may be liable.

To perfect a security interest (which means the formalities have been completed so the photographer can take precedence over the collector's creditors) requires the filing of Uniform Commercial Code Form 1 with the secretary of state or local agency for filing such as the county clerk. Since the collector will usually have to sign what is filed, the contractual provision requires the collector to provide whatever documents the photographer may need. If large sums are involved or the collector's finances are questionable, these documents might be required at the time of signing the contract of sale.

Nondestruction. The photographer may want to obligate a collector to return work if the collector no longer wants the work and intends to dispose of it. The Visual Artists Rights Act of 1990 prohibits the destruction of fine art photography of "recognized stature" if the work is unique or part of an edition of 200 copies or less.

Nondestruction. The Collector shall not destroy the Work or permit the Work to be destroyed without first offering to return ownership of the Work to the Photographer or his or her successors in interest.

□ Integrity and Attribution. This is the heart of the photographer's moral rights. It gives the photographer the right to be acknowledged as the creator of his or her work, to have the work be unaltered, and, if the work is altered, to remove the photographer's name from the work. The Visual Artists Rights Act offers this protection to unique works or editions of 200 copies or less regardless of whether the work is of "recognized stature."

Integrity and Attribution. The Collector shall not distort, mutilate, or otherwise alter the Work. In the event such distortion, mutilation, or other alteration occurs, whether by action of the Collector or otherwise, the Photographer shall, in addition to any other rights and remedies, have the right to have his or her name removed from the Work and no longer have it attributed to him or her as its creator.

Right to Exhibit. The photographer may very well wish to borrow work which has been sold for purposes of exhibition. This provision allows that. It would not be unreasonable to have the right to borrow the work for sixty days every five years. **Right to Exhibit.** The Photographer may borrow the Work for up to _____ days once every _____ years for exhibition at a nonprofit institution. The Photographer shall give the Collector written notice no later than 120 days before the opening and shall provide satisfactory proof of insurance and prepaid transportation. All expenses of the loan to the Photographer shall be paid for by the Photographer.

Restoration. The photographer may want to oversee any restoration to work which has been sold. If the photographer cannot do the restoration, he or she may nonetheless want the right to consult about the restoration or even approve the restorer. The photographer might consider expanding this provision by offering to replace any damaged work that is returned. Of course, the negative or transparency would have to be in the photographer's possession and the collector would have to pay for expenses and any work done by the photographer.

Restoration. In the event of damage to the Work requiring restoration or repair, the Collector shall, if practicable, offer the Photographer the first opportunity to restore or repair the Work and, in any case, shall consult with the Photographer with respect to the restoration or repairs.

Resale Proceeds. Following laws which exist in many countries, California enacted an artresale-proceeds law. This gives an artist the right to a part of the proceeds on a profitable sale of his or her art by a subsequent owner. The provision given below seeks to create such a right by contract, but applies only to the first collector to buy the work. To try and bind subsequent owners would require the first collector to agree to include in any contract of sale a provision that the next owner would agree to such a resale proceeds right and also agree to bind the following owner to comply with the provision. **Resale Proceeds.** On resale or other transfer of the Work for a price or value in excess of that paid in Paragraph 3, the Collector agrees to pay the Photographer _____ percent of the gross sale price received or, if the Work is transferred other than by sale, to pay _____ percent of the fair market value of the Work as of the date of transfer.

Uniqueness. The value of photography in the fine art context depends, in part, on whether it is one of a kind, part of a limited edition, or one of an unlimited number of copies. Since photography can be reproduced in multiple copies, photographers should take steps to reassure collectors as to the unique nature of what is being sold. This issue is not only whether exact duplicates exist, but whether the photographs have been used in another size, or perhaps in black and white instead of color, or in conjunction with other images, to make other works of art that are so similar as to lessen the value of the work the collector wants to buy. A simple solution is the warranty contained in the contract that "The Photographer warrants that this work is unique." However, this doesn't allow for the possibility of more sophisticated variations of the work, which would not, strictly speaking, be considered a limited edition (which the contract also covers). The photographer might consider changing the warranty to read as follows:

Uniqueness. This work is unique, which is defined to mean that the image or images appearing in it have not been used in any other work or in any other form, whether as single images, in a derivative form, or as part of a larger work. If the work is deemed unique by the Photographer but the image or images appearing in it have been used in any manner in another work, that use shall be set forth here by the Photographer:

Contract for the Sale of Fine Art Photography

AGREEMENT made as of the day of, 19, between
(hereinafter referred to as the "Photographer"), located at
, and(hereinafter referred to as the "Collector"),
located at, with respect to the
sale of an artwork (hereinafter referred to as the "Work").
WHEREAS, the Photographer has created the Work and has full right, title, and interest therein; and
WHEREAS, the Photographer wishes to sell the Work; and
WHEREAS, the Collector has viewed the Work and wishes to purchase it;
NOW, THEREFORE, in consideration of the foregoing premises and the mutual obligations, covenants, and conditions hereinafter set forth, and other valuable considerations, the parties hereto agree as follows:
1. Description of Work. The Photographer describes the Work as follows:
Title
Medium
Size
Framing or Mounting
Year of Creation
Signed by Photographer: Signed by Photographe
The Photographer warrants that this work is unique (one of a kind):
 If the Work is part of a limited edition, indicate the method of production; the size of the edition; how many multiples are signed; how many are unsigned; how many are numbered; how many are unsigned; how many are unsigned; how many are unsigned; how many are unsigned; the quantity of any prior editions; and whether the master image has been cancelled or destroyed □ yes □ no. 2. Sale. The Photographer hereby agrees to sell the Work to the Collector. Title shall pass to the Collector at such time as full payment is received by the Photographer pursuant to Paragraph 4 hereof. 3. Price. The Collector agrees to purchase the Work for the agreed upon price of \$, and shall also pay any applicable sales or transfer taxes. 4. Payment. Payment shall be made in full upon the signing of this Agreement. 5. Delivery. The □ Photographer □ Collector shall arrange for delivery to the following location: no later than, 19 The expenses of delivery (including, but not limited to, insurance and transportation) shall be paid by 6. Risk of Loss and Insurance. The risk of loss or damage to the Work and the provision of any insurance to cover such loss or damage shall be the responsibility of the Collector from the time of
 7. Copyright and Reproduction. The Photographer reserves all reproduction rights, including the right to claim statutory copyright, in the Work. The Work may not be photographed, sketched, painted, or reproduced in any manner whatsoever without the express, written consent of the Photographer. All approved reproductions shall bear the following copyright notice: © by (Photographer's name) 19 8. Miscellany. This Agreement shall be binding upon the parties hereto, their heirs, successors, assigns, and personal representatives. This Agreement constitutes the entire understanding between the parties. Its terms can be modified only by an instrument in writing signed by both parties. A waiver of any breach of any of the provisions of this Agreement shall be governed by the laws of the State of IN WITNESS WHEREOF, the parties hereto have signed this Agreement as of the date first set forth above.
Photographer Collector

Delivery Memo

he photographer often needs to leave photographs with someone else. Perhaps an assignment has been completed, images must be duped, or a slide tray must be left so work can be considered for exhibition by a gallery. It is crucial that photographs (especially original transparencies) be preserved in good condition when in someone else's possession. Anyone holding the photographs in the course of their regular business dealings will have a duty of reasonable care. The photographer may want to raise this standard of care or require insurance coverage to protect the value of the photographs.

Another problem with letting photographs out of the photographer's hands is the risk of infringement by unauthorized reproductions. Form 8 makes explicit the restrictions against this. Of course, the photographer's copyright protects against unauthorized reproductions and displays. Use of Form 8 alerts the recipient of the photographer's determination to prevent such unauthorized uses.

The holding fee is designed to ensure that the photographs not be kept for an unreasonable period of time. Of course, a holding fee may be impractical in many situations (such as when the photographer is giving photographs for framing or is leaving them with a gallery that has not solicited the photographs for review). Parties entrusted with photographs may also not be willing to agree to a high standard of care or to the insuring of the works. In such cases, the value of Form 8 is to alert the photographer to the risks faced in giving the photographs to the other party.

Form 8 is an all-purpose delivery memo. Form 17, Stock Photography Delivery Memo, serves a similar function but is particularly designed for the submission of stock pictures. Its negotiation checklist is certainly worth reviewing in connection with Form 8.

Filling in the Form

Fill in the date, the name and address of the recipient, the delivery memo number, the number of any purchase order, the name and telephone number of anyone who requested the photographs, a return date for the photographs, and the purpose of turning the photographs over to the recipient. Specify the value, quantity, format or size, whether the photograph is an original or a dupe, a description or file number, and whether it is in color or black and white. Give a total count for color and for black and white. Have the recipient sign and date the form. On the back in Paragraph 4 check the boxes to show the duration of recipient's liability and indicate the method of return transportation. In Paragraph 5 check the box regarding insurance. State when the photographs are to be returned in Paragraph 6 and, if relevant, specify the number of days and holding fee. In Paragraph 7 give the small claims court limit on claims and specify an arbitrator. In Paragraph 8 indicate which state's laws will govern the agreement.

Negotiation Checklist

- Recite the purpose for leaving the photographs with the other party. (Front of form and Paragraph 1)
- Specify that the recipient accepts the information provided on the form to show there is no dispute as to how many photographs were delivered and their values. (Front of form and Paragraph 2)
- Require immediate, written notification of any dispute as to the listing of photographs or

their values and provide that if no objection is made within ten days it shall be considered accepted. (Paragraph 2)

- □ Reserve ownership of the physical photographs to the photographer. (Paragraph 3)
- Reserve ownership of the copyright and all reproduction rights to the photographer. (Paragraph 3)
- □ Require that the photographs be held in confidence. (Paragraph 3)
- Provide that the recipient shall be strictly liable in the event of loss, theft, or damage, and indicate the duration of this responsibility. (Paragraph 4)
- Require return of the photographs to the photographer at the expense of the recipient. (Paragraph 4)
- □ Require recipient to pay for the transportation from the photographer to the recipient.
- □ Specify the method of transportation. (Paragraph 4)
- □ Require wall-to-wall all risks insurance be provided by the recipient. (Paragraph 5)
- Make the photographer a named beneficiary on any insurance policy protecting the photographs.
- Provide for the payment of a holding fee to the photographer if the photographs are kept beyond a certain period of time. (Paragraph 6)
- □ Give the photographer a security interest in the photographs to protect against claims by creditors of the recipient. This might be relevant, for example, if the photographs were placed on consignment with a gallery.

- State that the photographer's written permission is required for any reproduction, display, sale, or rental of the photographs. This in essence requires another contract which would deal specifically with the relevant issues in each of those arrangements and provide for fees and appropriate limitations. (Paragraph 3)
- □ Compare the standard provisions in the introductory pages with Paragraphs 7-8.
- □ Review the negotiation checklist for the Stock Photography Delivery Memo.

Delivery Memo

Recipient	Date	
Address		
	Purchase Order No	
Per Request of	Telephone	
Photo Return Due	Extension Granted	
Purpose of Delivery		
	ginal Description/File Number	BW/Color
	* Value is in case of loss, theft, or damage.	
Total Color	Total Black and White	
	irm that the count is accurate by returning one sigr return mail, the Recipient shall be considered to ac	
on this form as accurate and that the p	photographs are of a quality suitable for reproduc	tion.
		to
Acknowledged and Accepted	Da	e

Subject to All Terms and Conditions Above and on Reverse Side

Terms and Conditions

- 1. Purpose. Photographer hereby agrees to entrust the photographs listed on the front of this form to the Recipient for the purpose specified. "Photographs" are defined to include transparencies, prints, negatives, digitized encodations, and any other form in which the images can be stored, incorporated, represented, projected, or perceived, including forms and processes not presently in existence but which may come into being in the future.
- 2. Acceptance. Recipient accepts the listing and values as accurate if not objected to in writing by return mail immediately after receipt of the photographs. If Recipient has not signed this form, any terms on this form not objected to in writing within 10 days shall be deemed accepted.
- **3.** Ownership and Copyright. Copyright and all reproduction rights in the photographs, as well as the ownership of the physical photographs themselves, are the property of and reserved to the Photographer. Recipient acknowledges that the photographs shall be held in confidence and agrees not to display, copy, or modify directly or indirectly any of the photographs submitted, nor will Recipient permit any third party to do any of the foregoing. Reproduction, display, sale, or rental shall be allowed only upon Photographer's written permission specifying usage and fees.
- **5.** Insurance. Recipient does does not agree to insure the photographs for all risks from the time of shipment from the Photographer until the time of delivery to the Photographer for the values shown on the front of this form.
- 6. Holding Fees. The photographs are to be returned to the Photographer within _____ days after delivery to the Recipient. Each photograph held beyond _____ days from delivery shall incur the following weekly holding fee: \$_____ which shall be paid to the Photographer when billed.
- **7. Arbitration.** Recipient and Photographer agree to submit all disputes hereunder in excess of \$______ to arbitration before ______ at the following location ______ under the rules of the American Arbitration Association. The arbitrator's award shall be final and judgment may be entered on it in any court having jurisdiction thereof.
- **8. Miscellany.** This Agreement contains the full understanding between the parties hereto and may only be modified by a written instrument signed by both parties. It shall be governed by the laws of the State of______.

Photographer—Gallery Contract with Record of Consignment and Statement of Account

FORM

Many photographers who sell their work through galleries rely on trust instead of contracts. Trust is fine when everything is going smoothly, but it is of little value after disputes arise and neither party is truly certain which contractual terms originally bound the photographer and gallery together. Contracts with galleries can vary from a simple consignment of one piece of work to an ongoing representation arrangement, under which the gallery has certain rights to represent more of the photographer's work.

A basic rule is: never give the gallery rights to sell work that the gallery has no capacity to sell. This means that the scope of the representation must be carefully scrutinized. Also, since the work will be in the possession of the gallery, the issues of damage, loss, and repairs must be resolved.

One danger facing the photographer is the possibility that the gallery may go bankrupt. If this happens, creditors of the gallery may have a right to seize consigned artwork. Many states have enacted laws to protect the photographer from such seizures. However, the photographer must check on a state-by-state basis to determine the status of the law. One way to do this is to contact the nearest group of volunteer lawyers for the arts.

Insofar as possible, the photographer must verify that the gallery is stable financially. Of course, it can be difficult to know what goes on behind the scenes at an apparently successful enterprise. But late payments to other photographers or suppliers certainly suggest economic difficulty. In any case, one might want to obtain a security interest in the work in order to have a right to the work even if the gallery does go bankrupt.

One other important issue is the identities of the purchasers of the photographer's work. If the photographer does not know who purchased the works and where the purchasers live, a retrospective exhibition and even access to take photographs are nearly impossible. The gallery may resist giving these names on the theory that the photographer will then sell directly to the gallery's clients. One solution might be to have a neutral third party hold the names and contact the purchasers for reasons specified in the contract, such as a retrospective exhibition.

The commission for the gallery varies in the range of 25 to 50 percent of the retail sale price. Reasons for a higher commission would certainly include higher costs to the gallery in making the sales, such as those incurred in extensive promotion and foreign travel. A related issue is: who will bear the various expenses of exhibitions and promotion? While it is a fair assumption that the gallery will usually carry these expenses, it nonetheless bears review. If the gallery pays for frames or similar items, who will own them after the exhibition?

The photographer should not be bound for too long a period of time by a contract with a gallery. What was appropriate at one time may no longer serve the photographer as he or she grows in terms of both aesthetic and financial success. One way to deal with this is to provide for a right of termination after a certain time period, such as one or two years.

Highly successful photographers may receive a stipend each month from the gallery. This is an amount of money that the photographer receives regardless of sales. If sales are made, the amounts paid as a stipend are subtracted from the amounts due to the photographer. Problems can arise when sales are not made and the gallery takes artworks to cover the stipend. If the gallery ends up with too many of the photographer's works, it is as if the photographer has an alter ego. The gallery may be tempted to sell its own works by the photographer ahead of works by the photographer that are on consignment.

The photographer may want to create a network with a number of galleries, setting limitations with each as to the types of work, areas, and exclusivity. The mechanism to do this would be a coherent series of contracts that protect the photographer, while giving the galleries the rights and art that they need to make representing the photographer remunerative.

The photographer may also deal with consultants or dealers who do not have galleries. For example, reps who sell fine art to corporate America use sales tools such as slides and portfolios, but do not necessarily have galleries. Nonetheless, the same considerations apply to contracts with such representatives as apply to contracts with galleries. Instead of specifying the nature of the exhibition to be given, such a contract might specify the efforts to be made on behalf of the photographer, or, at least, require best efforts on the part of the representative.

Filling in the Form

In the Preamble give the date and the names and addresses of the parties. In Paragraph 1 specify whether the agreement is exclusive or nonexclusive, and indicate the geographic area covered, as well as which media will be represented. In Paragraph 2 give the term of the agreement and indicate special grounds for termination, such as the death of a particular employee of the gallery or a change of location by the gallery. In Paragraph 3 indicate how long the photographer's solo exhibition will be and where the exhibition will take place. Then show how expenses will be shared and who will own any property created from these expenses. In Paragraph 4 give the gallery's commission rate for its own sales as well as the commission rate for the photographer's sales, if applicable. In Paragraph 7 fill in how often an accounting will be given and when such accountings will commence. In Paragraph 10 specify how much insurance will be provided. In Paragraph 14 give the name of an arbitrator or arbitrating body and fill in the maximum small claims court limit so lawsuits can be brought in small claims court for small amounts. In Paragraph 16 specify which state's laws will govern the agreement. Both parties should sign the agreement. The photographer should also fill in the Record of Consignment and have a representative of the gallery sign it. The Record of Consignment can be used each time the photographer delivers additional works to the gallery. The Statement of Account will be filled out by the gallery when accountings are due (for example, every three months).

Negotiation Checklist

- State that the photographer is the creator and owner of the consigned artworks and, if required, warrant this to be true.
- Determine whether the gallery should have an exclusive or nonexclusive right to represent the photographer. (Paragraph 1)
- □ Whether the representation is exclusive or nonexclusive, limit the geographical area in which the gallery will represent the photographer. (Paragraph 1)
- □ Specify the media which the gallery will represent for the photographer. (Paragraph 1)
- If the representation is exclusive, limit the work subject to the contract to that work produced during the term of the contract, not work created before or after the contract. (Paragraph 1)
- Require signed documentation of all artwork consigned to the gallery. (Paragraph 1 and the Record of Consignment)
- □ Specify a reasonable term, which should not be too long unless there is also a right to terminate the contract. (Paragraph 2)
- Give a right of termination on thirty or sixty days' notice to either party. (Paragraph 2)
- □ Provide for termination in the event of the

gallery's bankruptcy or insolvency. (Paragraph 2)

- Provide for termination if a particular person dies or leaves the employment of the gallery. (Paragraph 2)
- Provide for termination in the event of a change of ownership of the gallery.
- Provide for termination in the event the gallery moves to a new area. (Paragraph 2)
- Provide for termination in the event of a change of the form of ownership of the gallery.
- Provide for termination if a specified level of sales is not achieved by the gallery over a certain time period.
- Decide whether the death of the photographer should cause a termination.
- □ In the event of termination, require the gallery to pay the expenses of immediately returning all the consigned artworks to the photographer. (Paragraph 2)
- □ Require that the gallery keep confidential all transactions on behalf of the photographer.
- □ Require that the gallery exercise best efforts to sell the photographer's work.
- Specify the efforts to be exercised by the gallery, such as providing an exhibition for a certain number of days during the exhibition season. (Paragraph 3)
- Give artistic control over the exhibition and any reproductions of the work to the photographer. (Paragraph 3)
- □ State that the gallery shall pay all expenses for the exhibition, including the cost of wall-to-wall insurance.

- □ If the gallery will not pay all the expenses of the exhibition, which should be enumerated in any case, determine how the payment of various expenses will be divided between the gallery and the photographer. (Paragraph 3)
- □ Consider having the gallery pay for the construction of expensive pieces.
- □ Consider having the gallery advance money to pay for construction of expensive pieces. These advances, which should be nonrefundable, would later be recouped by the gallery from sales of the work or by taking ownership of some of the work.
- □ Consider specifying a budget for certain important items, such as promotion, and even detailing how the money will be spent.
- □ State who will own frames and other property created as an expense of the exhibition. (Paragraph 3)
- □ If the photographer is to provide his or her mailing list to help in the promotion of the exhibition, consider requiring that this list be kept confidential and not be used for other promotional purposes.
- Give the commission rate on retail price to be paid to the gallery for each piece sold. (Paragraph 4)
- Do not agree to a "net price" commission, under which the gallery agrees to pay a fixed amount to the photographer when the work is sold, since this will allow the gallery to charge higher prices and, in effect, pay a lower commission rate.
- □ If the gallery is selling works in different media, consider whether the commission should vary from one medium to another.
- □ If sales are substantial, review whether the

commission rate should decrease as the volume of sales increases.

- □ If the gallery gives a discount on certain sales, try to have the discount deducted from the gallery's commission rather than shared between the gallery and the photographers. (Paragraph 4)
- □ If the representation is exclusive as to area or types of work, decide if the photographer must pay a commission to the gallery on sales by the photographer. If so, which types of sales will be covered and how much will the commission be. It should certainly be less than what the gallery would receive from sales due to the gallery's own efforts. (Paragraph 4)
- If the photographer is to pay a commission on certain sales by the photographer, exclude transfers by gift or barter from sales subject to such a requirement.
- If the photographer is to pay a commission on certain sales by the photographer, consider excluding a certain dollar amount of sales from this requirement.
- □ If the gallery will sell through other galleries, resolve the issue of double commissions.
- □ Specify the retail prices and allowable discounts for sales of the work. (Paragraph 5 and the Record of Consignment)
- Require that the gallery pay the photographer as soon as possible after sale. (Paragraph 6)
- Require the photographer's consent to sales on approval or credit. Sales on approval basically involve loaning the work to a collector who has agreed to purchase the work if he or she approves of it after the loan period. This may also be in the form of a sale with a right to return the work during a specified period

of time, in which case payment might not be made in full until that time period had elapsed. (Paragraph 6)

- □ Have the gallery guarantee sales on credit.
- Have first proceeds from sales on approval or credit paid to the photographer. (Paragraph 6)
- □ Consider having the gallery purchase work outright, instead of taking it on consignment.
- Consider asking for a stipend, an amount paid every month regardless of sales, which would be nonrefundable and paid back by sales of art to the gallery if amounts due the photographer from sales to collectors were insufficient. (See other provisions.)
- □ If the gallery is buying work outright, or is paying a stipend which may result in the gallery buying work, consider specifying the price at which the work must be sold. State that the photographer shall receive a part of the resale proceeds if the work is sold for a higher price.
- Require periodic accountings by the gallery which include all the information the photographer needs to know that the payment is correct and where the art is. (Paragraph 7 and Statement of Account)
- Require a final accounting upon termination of the agreement. (Paragraph 8)
- Make the gallery strictly responsible for loss or damage from the receipt of the work until it is returned to the photographer. (Paragraph 9)
- □ If possible, have the gallery arrange shipment from the photographer to the gallery and make the gallery responsible for loss or damage during that time period.
- □ Provide that in the event of loss or damage

that cannot be restored, the photographer shall receive the same monies that would be due if the work had been sold. (Paragraph 9)

- Give the photographer control over any restoration of work. (Paragraph 9)
- Require the gallery to insure the work for a portion of the retail price, presumably enough to pay the photographer in full in the event of loss or damage. (Paragraph 10)
- □ Make the photographer a named beneficiary of the gallery's insurance policy with respect to the photographer's work and provide proof of this insurance to the photographer.
- Review which risks are covered by any insurance and which risks may be excluded, such as loss by mysterious disappearance or damage due to frequent handling.
- □ Give the photographer a security interest to protect the work from creditors of the gallery and require the gallery to execute any documents necessary to perfect the security interest. Security interests are reviewed in the discussion of Form 7. (Paragraph 12)
- Require the gallery to post a sign stating that the photographer's work is on consignment, since this will protect the work from creditors of the gallery.
- Provide for title to pass from the photographer directly to any purchaser and, if that purchaser is the gallery, only after full payment has been received by the photographer. (Paragraph 12)
- □ Have the gallery agree not to encumber the consigned art in any way for which the photographer may be liable. (Paragraph 12)
- □ Compare the standard provisions in the introductory pages with Paragraphs 13-16.

□ Keep in mind that state laws vary greatly with respect to photographer–gallery relationships, so the choice of which state's law will govern may be far more important than is the case in most contracts. (Paragraph 16)

Other Provisions that can be added to Form 9:

□ Stipend. The regular flow of income to the photographer can be very important. This is what a stipend provides, whether it is paid on a weekly, monthly, or other periodic basis. Such a stipend should always be stated to be nonrefundable. However, the stipend must still be repaid, either by reducing sums payable to the photographer from sales, or by having the gallery purchase work from the photographer. A somewhat less sophisticated approach would be to have the gallery simply pay one sum as an advance against future sales. Such an advance usually would be paid on signing the contract. If the gallery is purchasing art to pay back an advance or stipend, it will only credit the photographer with what the photographer would have received had the art been sold (not the full retail price, since the gallery's commission would have been subtracted from that). The following provision is one approach to a contract with a stipend:

Stipend. The Gallery shall pay the Photographer the nonrefundable sums of \$______monthly, commencing with the first payment on the signing of this Agreement and continuing with payments on the first day of each month for the term of this Agreement. All funds paid the Photographer hereunder shall be deemed advances which are to be recouped by the Gallery as follows: (1) By subtracting such advances from sums due the Photographer for sales of art under this Agreement; or (2) In the event sums due the Photographer do not equal or exceed such advances, by purchasing a sufficient number

of consigned artworks that sums due the Photographer equal or exceed such advances. If the Gallery is purchasing artworks hereunder, the Photographer shall be credited for the amount which the Photographer would have received had the work been sold by the Gallery to an outside purchaser at the retail price specified in the Record of Consignment.

Best Efforts. The requirement that the gallery use best efforts is hard to make into a legal issue, since best efforts is a rather subjective term. It is really better to try and specify exactly what the gallery is required to do. However, there may be some value to include a best efforts provision such as the following:

Best Efforts. The Gallery shall use its best efforts to fulfill its obligations pursuant to this Agreement.

Photographer—Gallery Contract with Record of Consignment and Statement of Account

hereinafter referred to as the "Photographer"), located at and		
at		Gallery), located
WHEREAS, the Photographer is a professional photographer of g	good standing; and	
NHEREAS, the Photographer wishes to have certain artworks re		
NHEREAS, the Gallery wishes to represent the Photographer un	der the terms and conditions of this	Agreement,
NOW, THEREFORE, in consideration of the foregoing premises a	nd the mutual covenants hereinafter	r set forth and othe
valuable consideration, the parties hereto agree as follows:		
1. Scope of Agency. The Photographer appoints the Gallery to		
gallery in the following geographic area artworks in the following media		
completed by the Photographer while this Agreement is in fo	orce and shall apply only to physica	al artworks, not the
licensing of reproduction rights (whether for an assignment cli		
document receipt of all works consigned hereunder by sig Consignment in the form annexed to this contract as Append		aprier a necoru c
2. Term and Termination. This Agreement shall have a term of		ated by either part
giving sixty days' written notice to the other party. The Agree	ment shall automatically terminate w	vith the death of th
Photographer, the death or termination of employment of		
of the area of, or if the Gallery becomes bank		II works consigne
hereunder shall immediately be returned to the Photographe		
3. Exhibitions. The Gallery shall provide a solo exhibition for the	Photographer of days betw	een
	Photographer of days betw which shall be exclusiv	een vely devoted to th
 Exhibitions. The Gallery shall provide a solo exhibition for the and in the exhibition space located at 	Photographer of days betw which shall be exclusiv notographer shall have artistic contro	een vely devoted to the exhibitio
 Exhibitions. The Gallery shall provide a solo exhibition for the and in the exhibition space located at Photographer's exhibition for the specified time period. The Photographer's exhibition for the specified time period. 	Photographer of days betw which shall be exclusiv notographer shall have artistic contro for promotional or advertising purpo	een vely devoted to the exhibition
3. Exhibitions. The Gallery shall provide a solo exhibition for the and in the exhibition space located at Photographer's exhibition for the specified time period. The Photographer of his or her work and the quality of reproduction of such work	Photographer of days betw which shall be exclusiv notographer shall have artistic contro for promotional or advertising purpo	een vely devoted to the
3. Exhibitions. The Gallery shall provide a solo exhibition for the and in the exhibition space located at Photographer's exhibition for the specified time period. The Photographer's exhibition for the specified time period. The Photographer's exhibition for the quality of reproduction of such work of the exhibition shall be paid for in the respective percentage.	Photographer of days betw which shall be exclusiv notographer shall have artistic contro for promotional or advertising purpo ges shown below: Photographer	een vely devoted to th ol over the exhibitio ses. The expense
 Exhibitions. The Gallery shall provide a solo exhibition for the and in the exhibition space located at Photographer's exhibition for the specified time period. The Photographer's exhibition for the specified time period. The Photographer's exhibition for the quality of reproduction of such work of the exhibition shall be paid for in the respective percentage Exhibition Expenses 	Photographer of days betw which shall be exclusiv notographer shall have artistic contro for promotional or advertising purpo ges shown below: Photographer	een vely devoted to th ol over the exhibitio ses. The expense
 Exhibitions. The Gallery shall provide a solo exhibition for the and in the exhibition space located at Photographer's exhibition for the specified time period. The Photographer's exhibition for the specified time period. The Photographer's exhibition for the quality of reproduction of such work of the exhibition shall be paid for in the respective percentage Exhibition Expenses Transporting work to gallery (including insurance and packing) 	Photographer of days betw which shall be exclusiv notographer shall have artistic contro for promotional or advertising purpo ges shown below: Photographer	een vely devoted to th ol over the exhibitio ses. The expense
 Exhibitions. The Gallery shall provide a solo exhibition for the and in the exhibition space located at Photographer's exhibition for the specified time period. The Photographer's exhibition for the specified time period. The Photographer's exhibition shall be paid for in the respective percentage Exhibition Expenses Transporting work to gallery (including insurance and packing) 	Photographer of days betw which shall be exclusiv notographer shall have artistic contro for promotional or advertising purpo ges shown below: Photographer	een vely devoted to th ol over the exhibitio ses. The expense
 Exhibitions. The Gallery shall provide a solo exhibition for the and in the exhibition space located at Photographer's exhibition for the specified time period. The Photographer's exhibition for the specified time period. The Photographer's exhibition shall be paid for in the respective percentage Exhibition Expenses Transporting work to gallery (including insurance and packing) Advertising	Photographer of days betw which shall be exclusiv notographer shall have artistic contro for promotional or advertising purpo ges shown below: Photographer	een vely devoted to th ol over the exhibitio ses. The expense
 Exhibitions. The Gallery shall provide a solo exhibition for the and in the exhibition space located at Photographer's exhibition for the specified time period. The Photographer's exhibition for the specified time period. The Photographer's exhibition shall be paid for in the respective percentage of the exhibition shall be paid for in the respective percentage Exhibition Expenses Transporting work to gallery (including insurance and packing) Advertising 	Photographer of days betw which shall be exclusiv notographer shall have artistic contro for promotional or advertising purpo ges shown below: Photographer	een vely devoted to th ol over the exhibitio ses. The expense
 Exhibitions. The Gallery shall provide a solo exhibition for the and in the exhibition space located at Photographer's exhibition for the specified time period. The Photof his or her work and the quality of reproduction of such work of the exhibition shall be paid for in the respective percentage Exhibition Expenses Transporting work to gallery (including insurance and packing) Advertising Catalogs Frames 	Photographer of days betw which shall be exclusiv notographer shall have artistic contro for promotional or advertising purpo ges shown below: Photographer	een vely devoted to th ol over the exhibitio ses. The expense
 3. Exhibitions. The Gallery shall provide a solo exhibition for the and in the exhibition space located at Photographer's exhibition for the specified time period. The Photographer's exhibition for the specified time period. The Photof his or her work and the quality of reproduction of such work of the exhibition shall be paid for in the respective percentage Exhibition Expenses Transporting work to gallery (including insurance and packing) Advertising Catalogs Frames Special installations 	Photographer of days betw which shall be exclusiv notographer shall have artistic contro for promotional or advertising purpo ges shown below: Photographer	een vely devoted to th ol over the exhibitio ses. The expense
 3. Exhibitions. The Gallery shall provide a solo exhibition for the and in the exhibition space located at Photographer's exhibition for the specified time period. The Photographer's exhibition for the specified time period. The Photof his or her work and the quality of reproduction of such work of the exhibition shall be paid for in the respective percentage Exhibition Expenses Transporting work to gallery (including insurance and packing) Advertising Catalogs Frames Special installations Photographing work 	Photographer of days betw which shall be exclusive hotographer shall have artistic contro for promotional or advertising purpo ges shown below: Photographer 	een vely devoted to th ol over the exhibitio ses. The expense
 3. Exhibitions. The Gallery shall provide a solo exhibition for the and in the exhibition space located at Photographer's exhibition for the specified time period. The Photographer's exhibition for the specified time period. The Photographer's exhibition shall be paid for in the respective percentage Exhibition Expenses Transporting work to gallery (including insurance and packing) Advertising Catalogs Announcements Frames Special installations Photographing work Party for opening 	Photographer of days betw which shall be exclusive hotographer shall have artistic control for promotional or advertising purports ges shown below: Photographer 	een vely devoted to th ol over the exhibitio ses. The expense

No expense which is to be shared shall be incurred by either party without the prior written consent of the other party as to the amount of the expense. After the exhibition, the frames, photographs, negatives, and any other tangible property created in the course of the exhibition shall be the property of

- 4. Commissions. The Gallery shall receive a commission of _____ percent of the retail price of each work sold. In the case of discount sales, the discount shall be deducted from the Gallery's commission. If the Gallery's agency is exclusive, then the Gallery shall receive a commission of _____ percent of the retail price for each studio sale by the Photographer that falls within the scope of the Gallery's exclusivity. Works done on a commissioned basis by the Photographer □ shall □ shall not be considered studio sales on which the Gallery may be entitled to a commission.
- **5. Prices.** The Gallery shall sell the works at the retail prices shown on the Record of Consignment, subject to the Gallery's right to make customary trade discounts to such purchasers as museums and designers.
- 6. Payments. The Gallery shall pay the Photographer all proceeds due to the Photographer within thirty days of sale. No sales on approval or credit shall be made without the Photographer's written consent and, in such cases, the first proceeds received by the Gallery shall be paid to the Photographer until the Photographer has been paid all proceeds due.
- 7. Accounting. The Gallery shall furnish the Photographer with an accounting every _____ months in the form attached hereto as Appendix B, the first such accounting to be given on the first day of ______, 19_____. Each accounting shall state for each work sold during the accounting period the following information: the title of the work, the date of sale, the sale price, the name and address of the purchaser, the amounts due the Gallery and the Photographer, and the location of all works consigned to the Gallery that have not been sold. An accounting shall be provided in the event of termination of this Agreement.
- 8. Inspection of Books. The Gallery shall maintain accurate books and documentation with respect to all transactions entered into for the Photographer. On the Photographer's written request, the Gallery will permit the Photographer or the Photographer's authorized representative to examine these books and documentation during normal business hours of the Gallery.
- 9. Loss or Damage. The Gallery shall be responsible for the safekeeping of all consigned artworks. The Gallery shall be strictly liable for loss or damage to any consigned artwork from the date of delivery to the Gallery until the work is returned to the Photographer or delivered to a purchaser. In the event of loss or damage that cannot be restored, the Photographer shall receive the same amount as if the work had been sold at the retail price listed in the Record of Consignment. If restoration is undertaken, the Photographer shall have a veto power over the choice of the restorer.
- **10. Insurance.** The Gallery shall insure the work for _____ percent of the retail price shown in the Record of Consignment.
- **11. Copyright.** The Gallery shall take all steps necessary to ensure that the Photographer's copyright in the consigned works is protected, including but not limited to requiring copyright notices on all reproductions of the works used for any purpose whatsoever.
- **12. Security Interest.** Title to and a security interest in any works consigned or proceeds of sale under this Agreement are reserved to the Photographer. In the event of any default by the Gallery, the Photographer shall have all the rights of a secured party under the Uniform Commercial Code and the works shall not be subject to claims by the Gallery's creditors. The Gallery agrees to execute and deliver to the Photographer, in the form requested by the Photographer, a financing statement and such other documents which the Photographer may require to perfect its security interest in the works. In the event of the purchase of any work by a party other than the Gallery, title shall pass directly from the Photographer to the Other party. In the event of the purchase of any work by the Gallery, title shall pass only upon full payment to the Photographer of all sums due hereunder. The Gallery agrees not to pledge or encumber any works in its possession, nor to incur any charge or obligation in connection therewith for which the Photographer may be liable.

4. Arbitration. All disputes ari	sing under this Agreeme	nt shall be submitted to bind	ding arbitration befo
		ocation	
and the arbitration award may b foregoing, either party may refu			
5. Modifications. All modifications constitutes the entire understan	-		parties. This Agreeme
6. Governing Law. This Agreeme	ent shall be governed by the	laws of the State of	
I WITNESS WHEREOF, the partie	s hereto have signed this A	greement as of the date first se	t forth above.
Photographer		Gallery Company Nam	
		Company Nam	16
		By Authorized Signator	n. Title
PPENDIX A: Record of Consig	jnment	Authorized Signator	y, nue
his is to acknowledge receipt of the	e following works of art on c	onsignment:	
his is to acknowledge receipt of the Title	e following works of art on c Medium	onsignment: Description	Retail Price
nis is to acknowledge receipt of the Title	e following works of art on c Medium	onsignment: Description	Retail Price
nis is to acknowledge receipt of the Title	e following works of art on c Medium	onsignment: Description	Retail Price
nis is to acknowledge receipt of the Title	e following works of art on c Medium	onsignment: Description	Retail Price
nis is to acknowledge receipt of the Title	e following works of art on c Medium	onsignment: Description	Retail Price
his is to acknowledge receipt of the Title	e following works of art on c Medium	onsignment: Description	Retail Price
his is to acknowledge receipt of the Title	e following works of art on c Medium	onsignment: Description	Retail Price
his is to acknowledge receipt of the Title	e following works of art on c Medium	onsignment: Description	Retail Price
his is to acknowledge receipt of the Title	e following works of art on c Medium	onsignment: Description	Retail Price
his is to acknowledge receipt of the Title	e following works of art on c Medium	onsignment: Description	Retail Price

Ву _____

Authorized Signatory, Title

BUSINESS AND LEGAL FORMS FOR PHOTOGRAPHERS

APPENDIX B: Statement of A	Account				
Date, 19 Accounting for Period from The following works were sold du		_, through	, 19		
Title	Date Sold	Purchaser's Name and Address	Sale Price	Gallery's Commission	Due Photographer
2					
3					
4 The total due you of \$					
The following works remain or Title		vith the gallery:	Locatio	n	
3					
4 5 6					
~ 7 8					
9		lery	Company Name		
	By	Α	Authorized Signatory		

Photographer's Lecture Contract

Many photographers find lecturing to be an important source of income as well as a rewarding opportunity to express their feelings about their photography and being a photographer. High schools, colleges, museums, photography societies, and other institutions often invite photographers to lecture. Slides will probably be shown during these lectures and, in some cases, an exhibition may be mounted during the photographer's visit.

A contract ensures that everything goes smoothly. For example, who should pay for framing that the photographer has to have done for an exhibition? Who will pay for transportation to and from the lecture? Who will supply film (and pay developing costs) for a demonstration of technique? Will the photographer have to give one lecture in a day or, as the institution might prefer, many more? Will the photographer have to review portfolios of students? Resolving these kinds of questions, as well as the amount of and time to pay the fee, will make any lecture a more rewarding experience.

Filling in the Form

In the Preamble give the date and the names and addresses of the parties. In Paragraph 1 give the dates when the photographer will lecture, the nature and extent of the services the photographer will perform, and the form in which the photographer is to bring examples of his or her work. In Paragraph 2 specify the fee to be paid to the photographer and when it will be paid during the photographer's visit. In Paragraph 3 give the amounts of expenses to be paid (or state that none or all of these expenses are to be paid), specify which expenses other than travel and food and lodging are covered, and show what will be provided by the sponsor, such as food or lodging. In Paragraph 5 state the interest rate for late payments. In Paragraph 10 give which state's law will govern the contract. Then have

both parties sign the contract. In the Schedule of Photographs list the photographs to be brought to the lecture and their insurance value.

Negotiation Checklist

- □ How long will the photographer have to stay at the sponsoring institution in order to perform the required services? (Paragraph 1)
- □ What are the nature and extent of the services that the photographer will have to perform? (Paragraph 1)
- □ What prints, portfolios, tear sheets, transparencies, or other materials must the photographer bring? (Paragraph 1)
- □ Specify the work facilities which the sponsor will provide the photographer. (Paragraph 2)
- □ Specify the fee to be paid to the photographer. (Paragraph 2)
- Give a time for payment of the fee. (Para-graph 2)
- Consider having part of the fee paid in advance.
- □ Specify the expenses which will be paid by the sponsor, including the time for payment of these expenses. (Paragraph 3)
- □ Indicate what the sponsor may provide in place of paying expenses, such as giving lodging, meals, or a car. (Paragraph 3)
- □ If illness prevents the photographer from coming to lecture, state that an effort will be made to find another date. (Paragraph 4)

- □ If the sponsor must cancel for a reason beyond its control, indicate that the expenses incurred by the photographer must be paid and that an attempt will be made to reschedule. (Paragraph 4)
- □ If the sponsor cancels within 48 hours of the time the photographer is to arrive, consider requiring that the full fee as well as expenses be paid.
- Provide for the payment of interest on late payments by the sponsor. (Paragraph 5)
- Retain for the photographer all rights, including copyrights, in any recordings of any kind which may be made of the photographer's visit. (Paragraph 6)
- □ If the sponsor wishes to use a recording of the photographer's visit, such as a video, require that the sponsor obtain the photographer's written permission and that, if appropriate, a fee be negotiated for this use. (Paragraph 6)
- □ State that the sponsor is strictly responsible for loss or damage to any photographic works from the time they leave the photographer's studio until they are returned there. (Paragraph 7)
- Require the sponsor to insure photographic works and specify the values for insurance. (Paragraph 7)
- Consider which risks may be excluded from the insurance coverage.
- □ Consider whether the photographer should be the beneficiary of the insurance coverage of his or her works.
- State who will pay the cost of packing and shipping the works to and from the sponsor. (Paragraph 8)

- □ Indicate who will take the responsibility to pack and ship the works to and from the sponsor.
- □ Compare the standard provisions in the introductory pages with Paragraphs 9-10.

Photographer's Lecture Contract

	referred to as the "Photographer"), located atan
	(hereinafter referred to as the "Sponsor"
HEREAS,	the Sponsor is familiar with and admires the work of the Photographer; and
	the Sponsor wishes the Photographer to visit the Sponsor to enhance the opportunities for its students to have
	a working professional photographer; and
VHEREAS, ontract may	the Photographer wishes to lecture with respect to his or her work and perform such other services as th y call for;
	REFORE, in consideration of the foregoing premises and the mutual covenants hereinafter set forth and other nsiderations, the parties hereto agree as follows:
. Photogra	apher to Lecture. The Photographer hereby agrees to come to the Sponsor on the following date(s): and perform the following service
	tographer shall use best efforts to make his or her services as productive as possible to the Sponso tographer further agrees to bring examples of his or her own work in the form of
1 the sur Photogra	nt. The Sponsor agrees to pay as full compensation for the Photographer's services rendered under Paragrap m of \$ This sum shall be payable to the Photographer on completion of the day of th apher's residence with the Sponsor.
- Lycus	es. In addition to the payments provided under Paragraph 2, the Sponsor agrees to reimburse th
-	es. In addition to the payments provided under Paragraph 2, the Sponsor agrees to reimburse th apher for the following expenses:
Photogra	
Photogra (A) Trav	apher for the following expenses:
Photogra (A) Trav (B) Foo	apher for the following expenses: /el expenses in the amount of \$ d and lodging expenses in the amount of \$
Photogra (A) Trav (B) Foo (C) Othe The rein Paragra	vel expenses in the amount of \$
Photogra (A) Trav (B) Foo (C) Other The rein Paragra specifie	apher for the following expenses: vel expenses in the amount of \$ d and lodging expenses in the amount of \$ er expenses listed here:in the amount of \$ nbursement for travel expenses shall be made fourteen (14) days prior to the earliest date specified uph 1. The reimbursement for food, lodging, and other expenses shall be made at the date of payme
Photogra (A) Trav (B) Foo (C) Othe The rein Paragra specifie In additio	apher for the following expenses: vel expenses in the amount of \$ d and lodging expenses in the amount of \$ er expenses listed here:in the amount of \$ Inbursement for travel expenses shall be made fourteen (14) days prior to the earliest date specified uph 1. The reimbursement for food, lodging, and other expenses shall be made at the date of payme and in Paragraph 2, unless a contrary date is specified here:
Photogra (A) Trav (B) Foo (C) Othe The rein Paragra specifie In additie (A) Tick	apher for the following expenses: vel expenses in the amount of \$ d and lodging expenses in the amount of \$ er expenses listed here:in the amount of \$ nbursement for travel expenses shall be made fourteen (14) days prior to the earliest date specified uph 1. The reimbursement for food, lodging, and other expenses shall be made at the date of payme and in Paragraph 2, unless a contrary date is specified here: on, the Sponsor shall provide the Photographer with the following:
Photogra (A) Trav (B) Foo (C) Othe The rein Paragra specifie In additie (A) Tick (B) Foo	apher for the following expenses: vel expenses in the amount of \$ d and lodging expenses in the amount of \$ er expenses listed here:in the amount of \$ nbursement for travel expenses shall be made fourteen (14) days prior to the earliest date specified uph 1. The reimbursement for food, lodging, and other expenses shall be made at the date of payme and in Paragraph 2, unless a contrary date is specified here: on, the Sponsor shall provide the Photographer with the following: kets for travel, rental car, or other modes of transportation as follows:

prevented from having the Photographer appear by Acts of God, hurricane, flood, governmental order, or other cause beyond its control, the Sponsor shall be responsible only for the payment of such expenses under Paragraph 3 as the Photographer shall have actually incurred. The Sponsor agrees in such a case to attempt to reschedule the Photographer's appearance at a mutually acceptable future date.

- **5.** Late Payment. The Sponsor agrees that, in the event it is late in making payment of amounts due to the Photographer under Paragraphs 2, 3, or 8, it will pay as additional liquidated damages ______ percent in interest on the amounts it is owing to the Photographer, said interest to run from the date stipulated for payment in Paragraphs 2, 3, or 8 until such time as payment is made.
- 6. Copyrights and Recordings. Both parties agree that the Photographer shall retain all rights, including copyrights, in relation to recordings of any kind made of the appearance or any works shown in the course thereof. The term "recording" as used herein shall include any recording made by electronic transcription, tape recording, wire recording, film, videotape, or other similar or dissimilar method of recording, whether now known or hereinafter developed. No use of any such recording shall be made by the Sponsor without the written consent of the Photographer and, if stipulated therein, additional compensation for such use.
- 7. Insurance and Loss or Damage. The Sponsor agrees that it shall provide wall-to-wall insurance for the works listed on the Schedule of Photography for the values specified therein. The Sponsor agrees that it shall be fully responsible and have strict liability for any loss or damage to the work from the time it leaves the Photographer's residence or studio until such time as it is returned there.
- 8. Packing and Shipping. The Sponsor agrees that it shall fully bear any costs of packing and shipping necessary to deliver the works specified in Paragraph 7 to the Sponsor and return them to the Photographer's residence or studio.
- **9.** Modification. This contract contains the full understanding between the parties hereto and may only be modified in a written instrument signed by both parties.

10. Governing Law. This contract shall be governed by the laws of the State of _

IN WITNESS WHEREOF, the parties hereto have signed this Agreement as of the date first set forth above.

Photographer	Spon	sor		
			Company Name	
	Ву			
Schedule of Photographs			uthorized Signatory, Title	
Title		Description	Size	Value
1				
2				
3				
4				
5				
6				
7				

Licensing Contract to Merchandise Images

icensing is the granting of rights to use images created by the photographer on posters, calendars, greeting cards and stationery, apparel, wallpaper, mugs and other household items, or any of innumerable other applications. Needless to say, this can be very lucrative for the photographer. So many of the products used in everyday life depend on visual qualities to make them attractive to purchasers. These qualities may reside in the design of the product itself or in the use of images on the product. For the photographer to enter the world of manufactured, mass-produced goods necessitates appropriate business arrangements.

The best guide for photographers on the subject of licensing is *Licensing Art & Design* by Caryn Leland (Allworth Press). The potentially large sums of money involved, as well as the possible complexity of licensing agreements, make *Licensing Art & Design* a valuable resource for photographers who either are licensing images or would like to enter the field of licensing.

Form 11, the Licensing Contract to Merchandise Images, is adapted from a short-form licensing agreement which appears in *Licensing Art & Design*.

Filling in the Form

In the Preamble fill in the date and the names and addresses of the parties. In Paragraph 1 indicate whether the rights are exclusive or nonexclusive, give the name and description of the image, state what types of merchandise the image can be used for, specify the geographical area for distribution, and limit the term of the distribution. In Paragraph 3 specify the advance, if any, and the royalty percentage. State the date on which payments and statements of account are to begin in Paragraph 4. Indicate the number of samples to be given to the photographer in Paragraph 6. In Paragraph 13 specify which state's laws will govern the contract. Give addresses for correspondence relating to the contract in Paragraph 14. Have both parties sign the contract.

Negotiation Checklist

- Carefully describe the image to be licensed. (Paragraph 1)
- □ State whether the rights given to the licensee are exclusive or nonexclusive. (Paragraph 1)
- □ Indicate which kinds of merchandise the image is being licensed for. (Paragraph 1)
- □ State the area in which the licensee may sell the licensed products. (Paragraph 1)
- Give a term for the licensing contract. (Paragraph 1)
- □ Reserve all copyrights in the image to the photographer. (Paragraph 2)
- Require that credit and copyright notice in the photographer's name appear on all licensed products. (Paragraph 2)
- Require that credit and copyright notice in the photographer's name appear on packaging, advertising, displays, and all publicity.
- □ Have the right to approve packaging, advertising, displays, and publicity.
- Give the licensee the right to use the photographer's name and, in an appropriate case, picture, provided that any use must be to promote the product using the image and must be dignified.
- Determine whether the royalty should be based on retail price or, as is more commonly the case, on net price (which is what the manufacturer receives). (Paragraph 3)

- □ If any expenses are to reduce the amount upon which royalties are calculated, these expenses must be specified. (Paragraph 3)
- □ Specify the royalty percentage. (Paragraph 3)
- □ Require the licensee to pay an advance against royalties to be earned. (Paragraph 3)
- Indicate that any advance is nonrefundable. (Paragraph 3)
- □ Require minimum royalty payments for the term of the contract, regardless of sales.
- Require monthly or quarterly statements of account, accompanied by any payments which are due. (Paragraph 4)
- □ Specify the information to be contained in the statement of account, such as units sold, to-tal revenues received, special discounts, and the like. (Paragraph 4)
- Give the photographer a right to inspect the books and records of the licensee. (Paragraph 5)
- □ If an inspection of the books and records uncovers an error to the disadvantage of the photographer, and that error is more than 5 percent of the amount owed the photographer, then require the licensee to pay for the cost of the inspection and any related costs.
- Provide for a certain number of samples to be given to the photographer by the manufacturer. (Paragraph 6)
- □ Give the photographer a right to purchase additional samples at manufacturing cost or, at least, at no more than the price paid by wholesalers. (Paragraph 6)
- □ Consider whether the photographer will want the right to sell the products at retail price, rather than being restricted to using the samples and other units purchased for personal use.

- □ Give the photographer a right of approval over the quality of the reproductions in order to protect the photographer's reputation. (Paragraph 7)
- Require that the licensee use best efforts to promote the licensed products. (Paragraph 8)
- □ Specify the amount of money that the licensee must spend on promotion.
- □ Specify the type of promotion that the licensee will provide.
- Reserve all rights to the photographer which are not expressly transferred to the licensee. (Paragraph 9)
- □ If the licensee's usage may create trademark or other rights in the product, it is important that these rights be owned by the photographer after termination of the license.
- □ Require the licensee to indemnify the photographer for any liabilities arising out of the use of the image on the licensed products. (Paragraph 10)
- Have the licensee provide liability insurance, with the photographer as a named beneficiary, to protect against defects in the licensed products.
- □ Forbid assignment by the licensee, but let the photographer assign royalties. (Paragraph 11)
- □ Specify the grounds for terminating the contract, such as the bankruptcy or insolvency of the licensee, failure of the licensee to obey the terms of the contract, cessation of manufacture of the product, or insufficent sales of the licensed products. (This is partially covered in Paragraph 4.)
- □ Compare the standard provisions in the introductory pages with Paragraphs 12-15.

Licensing Contract to Merchandise Images

	red to as the "Photographer"), located at
and	(hereinafter referred to as the "Licensee")
	he use of a certain image created by the Photographer (hereinafter referred to as the "Image") for
	oducts (hereinafter referred to as the "Licensed Products").
	Photographer is a professional photographer of good standing; and
manufacture and	
WHEREAS, the	icensee wishes to use the Image to create a certain product or products for manufacture and sale; and
NHEREAS, bot	parties want to achieve the best possible quality to generate maximum sales;
	DRE, in consideration of the foregoing premises and the mutual covenants hereinafter set forth and othe eration, the parties hereto agree as follows:
to use the	rchandising Rights. The Photographer grants to the Licensee the exclusive nonexclusive right Image, titled and described as, which was created and is the Photographer, as or as part of the following type(s) of merchandise:
	fo
manufactur	e, distribution, and sale by the Licensee in the following geographical area:
	and for the following period of time
the Photogr for the Photo	of Copyright. The Photographer shall retain all copyrights in and to the Image. The Licensee shall identify apher as the creator of the Image on the Licensed Products and shall reproduce thereon a copyright notice ographer which shall include the word "Copyright" or the symbol for copyright, the Photographer's name r date of first publication.
\$ Licensee fu Products. " customary	nd Royalties. Licensee agrees to pay Photographer a nonrefundable advance in the amount ofupon signing this Agreement, which advance shall be recouped from first royalties due hereunder ther agrees to pay Photographer a royalty of (%) percent of the net sales of the Licensed Net Sales" as used herein shall mean sales to customers less prepaid freight and credits for lawful and rolume rebates, actual returns, and allowances. Royalties shall be deemed to accrue when the Licensed e sold, shipped, or invoiced, whichever first occurs.
4. Payments	and Statements of Account. Royalty payments shall be paid monthly on the first day of each month

commencing _______, 19 _____, and Licensee shall with each payment furnish Photographer with a monthly statement of account showing the kinds and quantities of all Licensed Products sold, the prices received therefor, and all deductions for freight, volume rebates, returns, and allowances. The Photographer shall have the right to terminate this Agreement upon thirty (30) days' notice if Licensee fails to make any payment required of it and does not cure this default within said thirty (30) days, whereupon all rights granted herein shall revert immediately to the Photographer.

- **5. Inspection of Books and Records.** Photographer shall have the right to inspect Licensee's books and records concerning sales of the Licensed Products upon prior written notice.
- 6. Samples. Licensee shall give the Photographer ______ samples of the Licensed Products for the Photographer's personal use. The Photographer shall have the right to purchase additional samples of the Licensed Products at the Licensee's manufacturing cost.
- 7. Quality of Reproductions. The Photographer shall have the right to approve the quality of the reproduction of the Image on the Licensed Products, and the Photographer agrees not to withhold approval unreasonably.
- 8. Promotion. Licensee shall use its best efforts to promote, distribute, and sell the Licensed Products.
- **9.** Reservation of Rights. All rights not specifically transferred by this Agreement are reserved to the Photographer.
- **10. Indemnification.** The Licensee shall hold the Photographer harmless from and against any loss, expense, or damage occasioned by any claim, demand, suit, or recovery against the Photographer arising out of the use of the Image for the Licensed Products.
- **11. Assignment.** Neither party shall assign rights or obligations under this Agreement, except that the Photographer may assign the right to receive money due hereunder.
- **12.** Nature of Contract. Nothing herein shall be construed to constitute the parties hereto joint venturers, nor shall any similar relationship be deemed to exist between them.

- **15.** Modifications in Writing. This Agreement constitutes the entire agreement between the parties hereto and shall not be modified, amended, or changed in any way except by a written agreement signed by both parties hereto.
- IN WITNESS WHEREOF, the parties have signed this Agreement as of the date first set forth above.

Photographer____

Licensee____

Company Name

By___

Authorized Signatory, Title

Model Release Pocket Model Release

Photographers often portray people in their photography. Because of this, photographers must be aware of individuals' rights to privacy and publicity. While the intricacies of these laws can be reviewed in *Legal Guide for the Visual Artist*, this summary will help alert the photographer to potential dangers.

The right to privacy can take a number of forms. For example, state laws and court decisions forbid the use of a person's name, portrait, or picture for purposes of advertising or trade. This raises the question of the definitions for the terms "advertising" and "trade." Public display of an image which showed or implied something embarrassing and untrue about someone would also constitute a violation of the right to privacy. And physically intruding into a private space such as a home or office, perhaps to take a photograph for use as a reference, could be an invasion of privacy.

The right of publicity is the right which a celebrity creates in his or her name, image, and voice. To use the celebrity's image for commercial gain violates this right of publicity. And, while the right of privacy generally protects only living people, a number of states have enacted laws to protect the publicity rights of celebrities even after death. These state laws supplement court decisions which held that celebrities who exploited the commercial value of their names and images while alive had publicity rights after death.

On the other hand, use of people's images for newsworthy and editorial purposes is protected by the First Amendment. No releases need be obtained for such uses, which serve the public interest.

What should the photographer do about all this? The wisest course is to obtain a model release from anyone who will be recognizable in a photograph, including people who can be recognized from parts of their body other than the face. Even if reproducing the photographs for an editorial or educational purpose might not create a privacy issue, there is always the possibility that an image will be reproduced in other ways. For example, a photograph from a book can be used for posters, postcards, and T-shirts, all of which are clearly trade uses. Or that image can be used in an advertisement. Only by having a model release can the photographer ensure the right to exploit the commercial value of the image in the future.

Forms 12 and 13 allow the photographer (and others who obtain the photographer's permission) to use the model's image for advertising and trade. The choice of which form to use is a personal decision, since both provide protection. The Pocket Model Release may appear less daunting to the model. While some states may not require written releases or the payment of money for a release, it is always wise to use a written release and make at least a small payment as consideration. By the way, Forms 12 and 13 are intended for use with friends and acquaintances who pose, as well as with professional models.

It is also important to be aware that if the release is intended to cover one use, and the image is then used in a distorted and embarrassing way for a different purpose, the release may not protect the photographer, regardless of what it says. For example: a model signed a model release for a bookstore's advertisement, in which she was to appear in bed reading a book. This advertisement was later changed and used by a bedsheet manufacturer known for its salacious advertisements. The title on the book became pornographic and a leering old man was placed next to the bed looking at the model. This invaded the model's privacy despite her having signed a release.

In general, a minor must have a parent or guardian give consent. While the photographer should check the law in his or her state, the age of majority in most states is eighteen. Both Form 12 and Form 13 can be used for minors.

The photographer should be certain to have

the release signed during the session, since it is easy to forget if left for signing later. Also, releases should be kept systematically so that each one can be related to the photograph in which its signatory appears. A simple numbering system can be used to connect the releases to the photographs. While a witness isn't a necessity, having one can help if a question is later raised about the validity of the release.

If the photographer is asked to use a release form supplied by someone else, the photographer must make certain that the form protects the photographer. The negotiation checklist will be helpful in reviewing the provided form and suggesting changes to strengthen the form.

Filling in the Form

Fill in the dollar amount being paid as consideration for the release. Then fill in the name of the model and the name of the photographer. Have the model and a witness sign the form. Obtain the addresses for both the model and the witness and date the form. If the model is a minor, have the parent or guardian sign. Have the witness sign and give the addresses of the witness and the parent or guardian as well as the date.

Negotiation Checklist

- Be certain that some amount of money, even a token amount, is actually paid as consideration for the release.
- □ Have the release given not only to the photographer, but also to the photographer's estate and anyone else the photographer might want to assign rights to (such as a manufacturer of posters or T-shirts).
- □ State that the grant is irrevocable.
- Cover the use of the name as well as the image of the person.

- □ Include the right to use the image in all forms, media, and manners of use.
- Include the right to make distorted or changed versions of the image as well as composite images.
- □ Allow advertising and trade uses.
- □ Allow any other lawful use.
- □ Have the model waive any right to review the actual use of the photograph, including written copy to accompany the photograph.
- □ Have the model recite that he or she is of full age.
- □ If the model is a minor, have a parent or guardian sign the release.

Model Release

In consideration of	Dollars (\$), and other valuable consideration, receipt of which is
	(print Model's name)
acknowledged, I, do hereby give assigns, licensees, success any fictional name), picture restriction as to changes of derivative works made in any I waive any right to inspect including written copy that r harmless the Photographer, any liability by virtue of any b or otherwise, that may occu the completion of the finishe caused, produced, and pu reproach, scorn, and indign waive any claims I may have limited to claims for either in that this release shall be bin	(print Model's name) (the Photographer), his or her sors in interest, legal representatives, and heirs the irrevocable right to use my name (or e, portrait, or photograph in all forms and in all media and in all manners, without any or alterations (including but not limited to composite or distorted representations or y medium) for advertising, trade, promotion, exhibition, or any other lawful purposes, and or approve the photograph(s) or finished version(s) incorporating the photograph(s), may be created and appear in connection therewith. I hereby release and agree to hold his or her assigns, licensees, successors in interest, legal representatives and heirs from olurring, distortion, alteration, optical illusion, or use in composite form whether intentional r or be produced in the taking of the photographs, or in any processing tending toward ed product, unless it can be shown that they and the publication thereof were maliciously ublished solely for the purpose of subjecting me to conspicuous ridicule, scandal, hity. I agree that the Photographer owns the copyright in these photographs and I hereby the based on any usage of the photographs or works derived therefrom, including but not towasion of privacy or libel. I am of full age* and competent to sign this release. I agree anding on me, my legal representatives, heirs, and assigns. I have read this release and
am fully familiar with its con	itents.
Witness:	Signed:Model
Address:	Address:, 19
	Consent (if applicable) ———————————
, 0	of the minor named above and have the legal authority to execute the above release. d waive any rights in the premises.
Witness:	Signed: Parent or Guardian
Address:	Address:
	Date:, 19
* Delete this sentence if the	e subject is a minor. The parent or guardian must then sign the consent.

Pocket Model Release

			_ Dollars (\$), recei
f which is acknowledged, I,			_ (print Model's nam	ne), do hereby giv
essors in interest, legal representati icture, portrait, or photograph in al epresentations, for advertising, trad ne finished version(s), including wri f full age.* I have read this release	ves, and heirs the ir Il forms and media e, or any other lawfu tten copy that may	revocable right to and in all manne Il purposes, and I be created and a	o use my name (or a ers, including comp waive any right to i appear in connectio	ny fictional name posite or distorte nspect or approv
Witness		Signed	Model	
Address		Address		
	Date	, 19		
am the parent or guardian of the min approve the foregoing and waive a	ny rights in the prei			he above releas
Witness		Signed	Parent or Guardia	n
Address			Parent or Guardia	

Property Release

Property does not have rights of privacy or publicity. A public building, a horse running in a field, and a bowl of fruit are all freely available to be portrayed in photography.

Nonetheless, there may be times when the photographer will want to obtain a release for the use of property belonging to others. This might include personal property, such as jewelry or clothing, or the interiors of private buildings (especially if admission is charged). The most important reason for the release is to have a contract that details the terms of use of the property. Another important reason for the release is that certain clients, especially for advertising usage, will require it.

If the photographer is lent property to use in a commissioned work, and has any intention of using the photographs in some way other than the commission, a release should be obtained. For example, if a photographer were hired to do a portrait of a pet, selling that portrait to a manufacturer of dog food for use as product packaging would be a breach of an implied provision of the contract. Such a use would require the owner's permission, which could be obtained by using Form 14.

If the owner could be identified from the property, especially if the owner might be embarrassed in some way by the association with the photographs, it is wise to have a property release.

As with releases for models, property releases should be signed at the time the property is used, and payment, even if only a token payment, should be made to the owner of the property.

Filling in the Form

Fill in the amount being paid for use of the property, as well as the name and address of the owner and the name of the photographer. Then specify the property which will be used. Finally, have both parties sign the release, obtain a witness to each signature (if possible), and give the date.

Negotiation Checklist

- □ Make some payment, however small, as consideration for the release.
- □ Be certain the release runs in favor of the photographer's assigns and estate as well as the photographer.
- General State that the release is irrevocable.
- □ Include the right to copyright and publish the image made from the property.
- □ Include the right to use the image in all forms, media, and manners of use.
- Permit advertising and trade uses.
- Allow any other lawful use.
- State that the owner has full and sole authority to give the release.
- Retain the right to make distorted or changed versions of the image as well as composite images.
- Allow use of the owner's name or a fictional name in connection with the image of the property.
- Permit color or black and white images, as well as any type of derivative work.
- □ Have the owner waive any right to review the finished photography, including written copy to accompany the photography.
- □ Make certain the owner is of full age and has the capacity to give the release.

Property Release

In consideration of the sum of	Dollars (\$) and other valuable considera-
tion, receipt of which is hereby acknowledged	, l,,
residing at	, do, irrevoca-
bly authorize	(the Photographer), his or her
and media and in all manners for advertising,	al representatives, and heirs to copyright, publish, and use in all forms trade, promotion, exhibition, or any other lawful purpose, images of
) license for such uses, regardless of whether said use is composite use is made in conjunction with my own name or with a fictitious name,
	d white, or otherwise, or other derivative works are made through any
medium.	, , ,
	approve the photograph(s) or finished version(s) incorporating the
I waive any right that I may have to inspect or photographs, including written copy that may I am of full age and have every right to contract	approve the photograph(s) or finished version(s) incorporating the be used in connection therewith. et in my own name with respect to the foregoing matters. I agree that presentatives, heirs, and assigns. I have read the above authorization
I waive any right that I may have to inspect or photographs, including written copy that may I am of full age and have every right to contract this release shall be binding on me, my legal rep	approve the photograph(s) or finished version(s) incorporating the be used in connection therewith. It in my own name with respect to the foregoing matters. I agree that presentatives, heirs, and assigns. I have read the above authorization ly cognizant of its contents.
I waive any right that I may have to inspect or photographs, including written copy that may I am of full age and have every right to contract this release shall be binding on me, my legal rep and release prior to its execution and I am ful	approve the photograph(s) or finished version(s) incorporating the be used in connection therewith. at in my own name with respect to the foregoing matters. I agree that be oresentatives, heirs, and assigns. I have read the above authorization by cognizant of its contents.
I waive any right that I may have to inspect or photographs, including written copy that may I am of full age and have every right to contract this release shall be binding on me, my legal rep and release prior to its execution and I am ful Witness	approve the photograph(s) or finished version(s) incorporating the be used in connection therewith. at in my own name with respect to the foregoing matters. I agree that be oresentatives, heirs, and assigns. I have read the above authorization by cognizant of its contents.
I waive any right that I may have to inspect or photographs, including written copy that may I am of full age and have every right to contract this release shall be binding on me, my legal rep and release prior to its execution and I am ful Witness	approve the photograph(s) or finished version(s) incorporating the be used in connection therewith. at in my own name with respect to the foregoing matters. I agree that be oresentatives, heirs, and assigns. I have read the above authorization by cognizant of its contents.
I waive any right that I may have to inspect or photographs, including written copy that may I am of full age and have every right to contract this release shall be binding on me, my legal rep and release prior to its execution and I am ful Witness	approve the photograph(s) or finished version(s) incorporating the be used in connection therewith. at in my own name with respect to the foregoing matters. I agree that be oresentatives, heirs, and assigns. I have read the above authorization by cognizant of its contents.
I waive any right that I may have to inspect or photographs, including written copy that may I am of full age and have every right to contract this release shall be binding on me, my legal rep and release prior to its execution and I am ful Witness	approve the photograph(s) or finished version(s) incorporating the be used in connection therewith. at in my own name with respect to the foregoing matters. I agree that be oresentatives, heirs, and assigns. I have read the above authorization by cognizant of its contents.

Video Contract

Form 15 is a video contract for use when the client simply wants a copy of the videotape for personal use, such as with a wedding, action portrait, awards ceremony, sporting event, and so on. It can supplement Form 2 and Form 3 if the client wants both still photography and video, or Form 2 and Form 3 could be modified to encompass video. Certainly the photographer (who is sometimes called a videographer) must alter the Standard Price List so that it covers video.

A fee structure is created like that for wedding or portrait photography. It can either be a package fee, which would include a certain number of copies, or a session fee in which case copies would require additional payments. In both pricing methods, extra copies can be ordered for an additional fee. The Standard Price List allows prices to be adjusted from time to time. If extra charges may or will be incurred, such as an additional camera, a lighting technician, travel, editing (beyond what is specified in the Standard Price List as being included), or overtime, the contract must deal with this.

A deposit should be required from the client, with the balance payable either at the session, when the video is reviewed, or when the copies are delivered. The payment schedule should allow the photographer to keep some part of the deposit in the event of a sudden cancellation by the client, unless the photographer can fit someone else into that session time.

The photographer should retain ownership of the copyright as well as of the original videotapes, so the client must return to the photographer for additional copies. Unless the client receives additional rights under Special Usage Requirements, the contract states that the copies are created for the personal use of the client and not for reproduction and sale. The form can be used for the ordering of additional copies. The photographer should reserve the right to make certain promotional uses of the video. The photographer must be protected if forces beyond the photographer's control prevent completion of the video or if the videotape is lost or damaged without the photographer being at fault. Even if the photographer is at fault, the contract should try to establish a limit on the photographer's liability.

An arbitration clause may be helpful, but it should be reviewed with the photographer's attorney. If the local small claims court is better than arbitration, cases for amounts the photographer can sue for in small claims court can be excluded from the arbitration provision.

The photographer who is creating a video for the purpose of a public sale of copies (whether in a fine arts context as a limited edition or for mass distribution), renting copies, or broadcasting the video, should review Form 16. If the client (such as an ad agency, design firm, or corporation) is giving an assignment and purchasing reproduction rights, Form 1 should also be reviewed.

Filling in the Form

Fill in the name, address, and telephone number of the client. Indicate the subject of the video, the location, the time, and the duration of the video with and without editing. Complete any special services to be provided as well as any special usage requirements. Check the format in which copies should be made. Then fill in the fee, including any extra charges (some of which will have to be billed later), subtract the deposit, and show the balance due. On the back of the form fill in the interest rate in Paragraph 1, the number of days for cancellation notices in Paragraph 2, the value of any materials supplied by the client in Paragraph 10, the arbitration provision in Paragraph 11, and which state's laws will control the contract in Paragraph 12. Have the client and the photographer sign the form.

Negotiation Checklist

- Describe the photographic services to be provided in as much detail as possible. (Front of form)
- □ Indicate the format for copies. (Front of form)
- □ If the client wants to use the copies other than for personal use, this should be noted under Special Usage Requirements and the fee adjusted accordingly. (Front of form)
- □ If the fee is for a package, state the package number as well as the fee. (Front of form)
- □ If the fee is without a package, simply state the fee. (Front of form)
- Develop a standard price list. This should show prices for the various packages as well as for copies without packages. It should detail the various services included in the basic fee, such as the degree of editing that will be done.
- □ Whether the basic fee is with or without a package, list charges that might have to be made in addition to the basic fee. Depending on the photographer's policy, this might include special equipment, an extra camera, a lighting technician, overtime, a rush job, or unusual travel. (Front of form)
- □ Have the client sign and give a copy of the contract to the client. (Front of form)
- □ Require a deposit against the fee. (Paragraph 1)
- Detail when the balance of the fee will be paid. The contract specifies that payment will be made when the order is completed, which will vary depending on the payment plan selected (Paragraph 1). Of course, the photographer can choose other payment dates, such as requiring the balance be paid at the session

or be paid in installments (with payments at the session, showing of the edited or unedited videotape, or delivery of the final order).

- □ Decide whether to allow thirty days to elapse after payment is due before the client will be considered in default. (Paragraph 1)
- □ If the client breaches the contract regarding payment, specify an interest rate that will be charged on the balance due until payment is made. Be certain this interest rate is not usurious under state law. (Paragraph 1)
- Consider making the client responsible for collection costs, such as court costs and attorney's fees, if the client breaches the contract.
- Deal with cancellation by the client. The deposit will usually be refunded if the photographer is given notice of cancellation a certain number of days prior to the session date. If less notice is given, some part of the deposit may be kept as liquidated damages. The number of days selected will depend on the photographer's own work situation. Whether to keep part of the deposit, and how much to keep, will vary with the circumstances of the case and the photographer's desire to build good will with the clients and within the community. (Paragraph 2)
- □ Specify that the photographer owns all video materials. (Paragraph 3)
- Require that either the original videotape or any copy be viewed at the studio and only allow removal of copies after payment in full is made to the photographer. (Paragraph 3)
- Reserve all copyrights to the photographer. (Paragraph 4)
- Determine what the photographer can and cannot do with the video, such as promo-

tional displays, brochures, exhibitions, editorial use, and so on. This contract allows the photographer to make certain uses and requires the client's permission for other uses. (Paragraph 4)

- □ If the photographer wishes to use stills or segments of the video, this should be specified.
- Although the client has no right to reproduce the photographs under the copyright law, this should be reinforced by being explicitly stated. (Paragraph 5)
- □ If the Special Usage Requirements space is filled in and allows usage beyond personal use by the client, state that client's usage is limited to those specified uses only. (Paragraph 5)
- □ If the client will make more than a personal use, determine whether additional credit for creating the video should be given to the photographer.
- □ Free the photographer from liability in the event that causes beyond his or her control prevent the creation of the video or the delivery of good quality copies. (Paragraph 6)
- Also exempt the photographer from liability in the event the videotape is lost through a camera malfunction, lost in the mail, and so on. (Paragraph 6)
- □ The photographer should review the studio's insurance coverage with respect to the different ways in which the video materials might be lost or damaged.
- □ If the photographer fails to perform any aspect of the contract without a good excuse, seek to limit liability to the amount that the photographer would have earned from the job. (Paragraph 6)

- □ If the photographer may substitute another photographer to cover the job, whether because of illness or scheduling problems, this should be made clear to the client. (Paragraph 7)
- If a studio does not assign a particular photographer to a session, this should also be brought to the client's attention. If the client's expectation is to have the video done by a particular photographer, a provision should be included in the contract dealing with substitutions in certain specified situations.
- Give the photographer the right to a credit line, specifying where the credit line may appear. (Paragraph 8)
- □ The photographer should develop a standard price list for use with the contract (rather than fixing the prices in the contract). This will allow for future adjustments to the price list. (Paragraph 9)
- □ If the client is giving a videotape or anything else to the photographer for reproduction or other purposes, the photographer should limit his or her liability with respect to the value of the materials given by the client. (Paragraph 10)
- □ Consider whether arbitration would be better than suing in the local courts. If arbitration is desirable, decide whether amounts that can be sued for in small claims court should be excluded from the arbitration provision. Also, specify who will act as arbitrator and where the arbitration will take place. (Paragraph 11)
- □ Specify which state's laws will control the contract. (Paragraph 12)
- □ Compare the standard provisions in the introductory pages with Paragraphs 11-12.

< Photographer's Letterhead >

Video Contract

Client		Telep	none	
address				
		Order	Number_	
Description of Vi	deo Services to be Provided			
Subject for Video_				
Location for Video		Date		Time
Location for Video		Date		Time
Location for Video		Date		Time
Copies to be mad				
	o be taken for Client minutes. Dura			
	if required (including any special equipment)			
Special Usage Re	quirements			
1				
be billed if and wh	 Package Fee (Package number) Pee Without Package Extra Charges Additional copies Cases Additional camera Lighting technician Rush service Editing Overtime 		\$ \$ \$ \$ \$ \$	
	Travel			
	Other		\$	
		Subtotal	\$	
		Sales Tax	\$	_
		Total	\$	_
		Less deposit	\$	
		Balance Due	\$	_
	read both the front and back of this Agreement, a the Agreement signed by both parties.	agree to all its terms, and	acknowle	edge receipt of a
Client			Date	
Photogra	pher (Videographer)		Date	

This Agreement is Subject to All the Terms and Conditions Appearing on the Reverse Side.

Terms and Conditions

- 1. Deposit and Payment. The Client shall make a deposit to retain the Photographer to perform the services specified herein. At such time as this order is completed, the deposit shall be applied to reduce the total cost and Client shall pay the balance due. If the Client refuses delivery of the order or refuses to pay within thirty (30) days of this order, Client shall be in default hereunder and shall pay _____ percent interest on the unpaid balance until payment is made in full.
- 2. Cancellation. If the Client shall cancel this Agreement ______ or more calendar days before the session date, any deposit paid to the Photographer shall be refunded in full. If Client shall cancel within ______ days of the session date and if the Photographer does not obtain another assignment for that time, liquidated damages shall be charged in a reasonable amount not to exceed the deposit.
- **3.** Video Materials. All videotapes created by the Photographer shall be the exclusive property of the Photographer. The Photographer shall make either the unedited or the edited videotape available to the Client for the purpose of review and ordering copies. The Client shall view such videotape at the Photographer's studio only. The Client shall not remove any copy of the videotape from the studio unless payment has been made in full pursuant to this Agreement
- 4. Copyright and Reproductions. The Photographer shall own the copyright in the videotapes created and shall have the exclusive right to make copies of them. The Photographer shall only make copies for the Client or for the Photographer's portfolio, samples, self-promotions, entry in photographic contests or art exhibitions, editorial use, or for viewing within or on the outside of the Photographer's studio. If the Photographer desires to make other uses, the Photographer shall not do so without first obtaining the written permission of the Client.
- 5. Client's Usage. The Client is obtaining copies for personal use only, and shall not sell said copies or authorize any reproductions thereof by parties other than the Photographer. If Client is obtaining copies for sale or reproduction, Photographer authorizes Client to sell or reproduce only as set forth under Special Usage Requirements on the front of this form.
- 6. Failure to Perform. If the Photographer cannot perform this Agreement due to a fire or other casualty, strike, act of God, or other cause beyond the control of the parties, or due to the Photographer's illness, then the Photographer shall return the deposit to the Client but shall have no further liability with respect to the Agreement. This limitation on liability shall also apply in the event that the videotape is lost through camera malfunction, lost in the mail, or otherwise lost or damaged without fault on the part of the Photographer. In the event the Photographer fails to perform pursuant to the terms of this Agreement for any other reason, including but not limited to problems with exposure, editing, duplication, or delivery, Photographer shall not be liable for any amount in excess of the retail value of the Client's order.
- **7. Photographer.** The Photographer may substitute another photographer to take the video in the event of Photographer's illness or scheduling conflicts. In the event of such substitution, Photographer warrants that the photographer taking the video shall be a competent professional.
- 8. Credit. Photographer reserves the right to place a credit line at the beginning or end of the videotape as well as on the cassette or any packaging.
- **9.** Photographer's Standard Price List. The charges in this Agreement are based on the Photographer's Standard Price List. This price list is adjusted periodically and future orders shall be charged at the prices in effect at the time when the order is placed.
- **10. Client's Originals.** If the Client is providing original videotapes to the Photographer for duplication or any other purpose, in the event of loss or damage the Photographer shall not be liable for an amount in excess of \$_____ per videotape.
- **11. Arbitration.** All disputes arising under Agreement shall be submitted to binding arbitration before______ in the following location _______ and the arbitration award may be entered for judgment in any court having jurisdiction thereof. Notwithstanding the foregoing, either party may refuse to arbitrate when the dispute is for a sum less than \$_____.
- **12. Miscellany.** This Agreement incorporates the entire understanding of the parties. Any modifications of this Agreement must be in writing and signed by both parties. Any waiver of a breach or default hereunder shall not be deemed a waiver of a subsequent breach or default of either the same provision or any other provision of this Agreement. This Agreement shall be governed by the laws of the State of ______.

Contract to Create a Video for Transmission, Cassette Sales, or Rentals

Video has opened new markets and new means of promotion for both commercial and fine art photographers. While Form 15 is designed for a client who wants a copy of a videotape for personal use, Form 16 is aimed at the photographer (videographer) who seeks wider distribution through a distributor.

Video lends itself to multiple markets. It can be transmitted into a variety of distribution channels, which include the three major networks, commercial television stations, PBS, educational television, and the numerous other channels which are either free or, in some cases, paid for by the viewer. As a cassette the video can be sold or rented. Each of these arrangements requires different safeguards.

For many photographers, the most likely transmission of video will not be through the major networks, but rather by the many channels which are in competition for programs and have more limited budgets. Channels with subscribers may reach millions of households. One source of information about access to these markets is *MultiChannel News*, a weekly trade journal published by Chilton Publishing.

Some channels buy exclusively from agents and others don't pay for programs, but the possibility to reach large audiences certainly does exist. Even if a channel doesn't pay for a program, the free publicity may be of great value. It can create new clients, bring people to an exhibition, help sell cassettes or books by the photographer, or create students for a workshop.

The sale of cassettes offers another potential source of income. If the video is an artwork, perhaps the number of cassettes will be limited to create extra value in each of the cassettes. If the video is instructional, the photographer may do direct mail, advertise in magazines, or lecture to reach the audience interested in purchasing the cassette. In any case, the sale of a cassette offers the opportunity to sell many units at a relatively low price rather than to receive a single payment for an artwork or workshop. Likewise, the rental of cassettes, which is so common for movies and other entertainment, offers a recurring income flow without requiring new creative efforts on the part of the photographer.

Because video production can be expensive, Form 16 contemplates a commission in which the expenses of creating the work would be paid for. If this isn't the case, the contract can be modified to show that the photographer will create the work at his or her own expense or that the photographer has already created the work. Also, it is quite likely that one distributor will not handle all the possible ways in which a video can be exploited. For example, if a cable station commissions a work, it is unlikely that they will sell or rent cassettes. As always when granting rights, the photographer should give the other party only those rights that party can successfully exploit. The photographer should reserve all other rights.

If the distributor will only transmit the work, only sell cassettes, or only rent cassettes, the contract should be modified accordingly by striking the provisions which don't apply.

Filling in the Form

In the Preamble, fill in the date and the names and addresses of the parties. In Paragraph 1 indicate the title of the work and what production facilities will be made available to the photographer by the distributor. Also show the length and subject of the work. In Paragraph 2 specify the amount of the fee and, also, which expenses will be reimbursed to the photographer. In Paragraph 4 indicate whether the grant of rights is exclusive and how many releases can be made of the video over which period of time and on which station. Specify how many showings of the work, such as two or three, are included in the one week release period. In Paragraph 6 state the value of the master tape for insurance purposes. In Paragraph 7 for sale of cassettes, indicate whether the distributors' rights are exclusive or nonexclusive, specify the area and time period, and give the retail price and royalty payable to the photographer. In Paragraph 8 fill in the same information for rentals as for sales. In Paragraph 14 fill in where arbitration will take place and in Paragraph 15 fill in which state's laws will govern the contract. At the end of the contract have both parties sign, giving the name and title of the authorized signatory for the distributor.

Negotiation Checklist

- □ Specify the facilities to be provided by the distributor, including details as to time of use, equipment, space, and staffing. (Paragraph 1)
- □ Reserve the right to make artistic decisions to the photographer. (Paragraph 1)
- □ Have the distributor indemnify the photographer for liabilities arising from materials inserted in the video at the request of the distributor.
- □ Specify the expenses to be paid by the distributor, and, if necessary, attach a budget listing those expenses. (Paragraph 2)
- □ State that the photographer shall determine when the work is completed. (This is implied in the photographer's right to make all artistic decisions in Paragraph 1, but could be explicitly set forth.)
- □ If any additional services, such as instructing or making personal appearances, are required of the photographer, this should be specified in detail and any fees set forth.
- □ Provide a fee and payment schedule. (Paragraph 2)
- Reserve the photographer's ownership of the copyright and the physical materials embodying the work. (Paragraph 3)

- □ State that all rights not explicitly transferred are reserved to the photographer. (Paragraph 3)
- Require that the commissioning party register the copyright in the photographer's name. (Paragraph 3)
- Determine whether the grant of transmission rights will be exclusive or nonexclusive, which will often depend on the amount paid for use of the work. (Paragraph 4)
- □ Limit the grant of rights as to what stations can use the work, for how long, and how many performances of the work are to be permitted. (Paragraph 4)
- □ Are the credits to be given to the photographer and the commissioning party specified? (Paragraph 5 assumes that the photographer has included a credit and copyright notice, since the photographer has control over what is contained in the video.)
- □ Require that the work not be altered without the photographer's consent. (Paragraph 5)
- □ Allow for excerpts to publicize the work. (Paragraph 5)
- Require a budget and plan for promotion of the work.
- Require insurance sufficient to cover the value of the master tape in the event of damage or loss. (Paragraph 6)
- □ For cassette sales, specify whether the grant of rights is exclusive or nonexclusive, the geographic area for sales, the time period for sales, the price, and the royalty rate. (Paragraph 7)
- □ For cassette rentals, specify whether the grant of rights is exclusive or nonexclusive, the geographic area for sales, the time period for sales, the price, and the royalty rate. (Paragraph 8)

- Limit the types of retail outlets in which sales or rentals of cassettes can be made.
- Provide that the photographer may terminate the right to sell or rent cassettes if certain levels of revenues are not generated during each accounting period.
- Stipulate what restrictions are placed on each sale or rental of a cassette, since duplication can be done so easily. (Paragraph 9)
- Require the distributor to consult with the photographer regarding marketing plans. (Paragraph 9)
- Require detailed statements of account accompanied by payments due on a monthly, quarterly, or semiannual basis. (Paragraph 10)
- □ Give the photographer the right, on reasonable notice, to inspect the books of the distributor as to the data underlying the royalty statements. (Paragraph 10)
- Permit use of the photographer's name and image for publicity, provided the photographer has a right to approve of publicity materials. (Paragraph 11)
- □ If possible, resist giving a warranty and indemnity clause (such as that appearing in Paragraph 12). Ask, for example, whether the distributor carries insurance covering these risks. If so, ask to be added as a named insured on the policy and to be given a certificate of insurance. If there is no insurance and this clause is used, seek to have a maximum limit on what the photographer would be required to pay and have such payments due only in the case of a judgment against which all appeals have been exhausted.
- Cover who will obtain permissions for other authors' copyrighted works, including music, which are used in the video. Will the same party that obtains the permissions also pay for them?

- Provide for termination in the event the work is not transmitted for a certain period of time or in the event the distributor is no longer engaged in the business of distribution or has gone bankrupt. (Paragraph 13)
- □ In the event of termination, provide for all physical copies of the work to be returned to the photographer. (Paragraph 13)
- □ Compare the standard provisions in the introductory pages with Paragraphs 14-15.

Other provisions for use with Form 16:

Videoshow. Video cassettes are not the only means by which a performance can be viewed, but they are by far the most common for home use. Some contracts would contain a broader provision in terms of the form of what the distributor may sell or rent, such as the following:

Videoshow is defined as video cassettes, videodiscs, or any other devices, now or hereafter known or developed, that enable a performance to be perceived visually with or without sound, when used in combination with or as part of a piece of electronic, mechanical, or other apparatus.

□ Home video. Rather than expanding the rights of the distributor, the photographer may wish to limit them by carefully defining the markets into which sales or rentals can be made. The leading market for cassettes is the home video market, which can be defined as follows:

Home Video. Home video is defined as the sale or rental of a cassette solely for the purpose of performance on the screen of a television receiver in private living accommodations at which no admission fee or contribution is charged for viewing.

Contract to Create a Video for Transmission, Cassette Sales, or Cassette Rentals

AC	GREEMENT made as of the day of, 19, between
	ereinafter referred to as the "Distributor"), located at
	d(hereinafter referred to as the "Photographer"), located
	HEREAS, the Photographer is a professional photographer who has produced and created video works; and
	HEREAS, the Photographer wishes to create a new video work for transmission, cassette sales, or cassette rentals; and
	HEREAS, the Distributor has the capacity with respect to video works to either transmit, license for transmission, or sell
	lease cassette copies; and
	HEREAS, the Distributor wishes to commission the Photographer to create a video work.
	DW, THEREFORE, in consideration of the foregoing premises and the mutual covenants hereinafter set forth and other
	luable considerations, the parties hereto agree as follows:
1.	Commission. The Distributor commissions the Photographer to create a video work having as a working title: (hereinafter referred to as "the Work"). In connection with the production of the Work the
	Photographer shall have the right to use the following production facilities
	which shall be provided to the Photographer by the Distributor without charge. The Work shall be approximately minutes in length and deal with the subject of
	All artistic decisions with respect to the Work shall be made by the Photographer.
2.	Payments. In consideration for the rights to transmit the Work granted to the Distributor hereunder, the Photographer shall be paid
	the sum of \$ as a fee for the Photographer's services. This fee shall be paid% upon execution of this
	Agreement,% upon showing of the initial video assembly to Distributor, and the balance within 30 days of the completion of the Work. The Work shall be deemed completed upon delivery of a finished master tape to the Distributor. In connection with
	the creation of the Work, the Distributor will reimburse the Photographer for the following expenses:
3.	Ownership and Copyright. All right, title, and interest in and to the Work and all constituent creative and literary elements shall
	belong solely and exclusively to the Photographer, including ownership of copyrights and the master tape, as well as any copies
	created for purposes of transmission. It is understood that the Distributor shall copyright the Work in the Photographer's name. All
	rights not specifically granted to the Distributor are expressly reserved to the Photographer.
4.	
	releases of the Work on the following station for a period of months commencing with the completion of the Work. A release is defined as performances of the Work in a consecutive seven-day period; such
	consecutive seven-day period beginning with the first day the Work is transmitted.
5.	Integrity of the Work. The Distributor shall not have the right to edit or excerpt from the Work except with the written consent of
	the Photographer. Notwithstanding the foregoing, the Distributor shall have the right to excerpt up to sixty (60) seconds of running
	time from the Work solely for the purpose of advertising the transmission of the Work or publicizing the activities of the Distributor.
	On all other transmissions or performances of the Work, the credit and copyright notice supplied by the Photographer shall be included.
6.	Damage or Loss and Insurance. The Distributor shall be provided with the Master Tape of the Work which it shall hold until
	termination of the license granted to it in Paragraph 4 above (or, if more than one license has been granted, until the termination
	of the last license). The Distributor agrees to take due and proper care of the Master Tape in its possession and insure its loss or damage against all causes for the amount of \$ All insurance proceeds received on account of loss or of damage to the
	Master Tape shall be the property of Photographer and shall be promptly transmitted to Photographer when received by the
	Distributor. Photographer shall receive one copy of the tape of the Work in any tape format selected by the Photographer. The

Distributor agrees to use its best efforts to give the Photographer reasonable notice of scheduled transmission dates of the Work. **7. Sale of Cassettes.** The Distributor shall also have the right to make at its own expense cassette copies of the Work for sale and leasing. The Distributor shall have the www.cassettes.com of the Work for sale and leasing. The Distributor shall have the www.cassettes.com of the Work for sale and leasing. The Distributor shall have the www.cassettes.com of the Work for sale and leasing. The Distributor shall have the www.cassettes.com of the Work for sale and leasing. The Distributor shall have the www.cassettes.com of the following geographic area: www.cassettes.com of the following time period: www.cassettes.com of the retail price of www.cassettes.com of the retail price of www.cassettes.com of the retail price of

\$_____% of the retail price for each cassette sold.

- 8. Rental of Cassettes. The Distributor shall also have the right to rent the cassette copies of the Work which it has made at its own expense. The Distributor shall have the cassette copies of the following geographic area: _______ and for the following time period: _______. Rentals shall be at the retail price of \$_____. The Distributor shall pay the Photographer a royalty of _____% of the retail price for each cassette rented.
- 9. Marketing. Distributor shall not sell or rent any copy of the Work unless the purchaser or renter agrees, in writing, that under no circumstances shall any further copies of the Work be made by the purchaser or renter and that the purchaser or renter shall neither transmit the Work nor permit the charging of admission to view the Work. In no event shall there be a sale or rental consisting of less than the entirety of the Work as described above. The Distributor shall periodically consult with the Photographer concerning the Distributor's marketing program with respect to the Work.
- **10.** Accountings. Distributor shall furnish Photographer quarterly reports during January, April, July, and October of each year showing, for the preceding three months, and cumulatively from the commencement of this Agreement, the number of copies of the Work sold by the Distributor, the number of copies of the Work rented by the Distributor, and the royalties due Photographer. Such report shall be accompanied by payment of all royalties due to Photographer for the period covered by such report. The Photographer shall, upon the giving of written notice, have the right to inspect the Distributor's books of account to verify the accountings. If errors in any such accounting are found to be to the Photographer's disadvantage and represent more than five (5%) percent of the payment to the Photographer pursuant to said accounting, the cost of inspection shall be paid by the Distributor.
- **11. Publicity.** The Photographer authorizes the Distributor to use the Photographer's name, likeness, and biographical material solely in connection with publicizing the transmission of the Work or the activities of the Distributor. The Photographer shall have the right to approve all written promotional material about the Photographer or the Work, which approval shall not be unreasonably withheld.
- 12. Warranty and Indemnity. The Photographer represents that the Photographer is authorized to enter into this Agreement; that material included in the Work is original work of the Photographer or that the Photographer has obtained permission to include the material in the Work or that such permission is not required; that the Work does not violate or infringe upon the rights of others, including but not limited to copyright and right of privacy; and that the Work is not defamatory. The Photographer agrees to indemnify the Distributor against any damages, liabilities, and expenses arising out of the Photographer's breach of the foregoing representations.
- **13. Termination.** In the event the Distributor files for bankruptcy or relief under any state or federal insolvency laws or laws providing for the relief of debtors, or if a petition under such law is filed against the Distributor, or if the Distributor ceases actively to engage in business, then this Agreement shall automatically terminate and all rights theretofore granted to the Distributor shall revert to the Photographer. Similarly, in the event the Work has not been transmitted within one year from the date the Work is completed, then this Agreement shall terminate and all rights granted to the Distributor shall revert to the Photographer. Upon termination of this Agreement or expiration of the license granted to the Distributor under this Agreement, all copies of the Work shall be delivered to the Photographer. Unless renewed by the parties hereto, this Agreement shall terminate at the expiration of the later of the time periods specified in Paragraphs 4, 7, and 8. Upon termination the master tape and all copies of the Work in the Distributor's possession shall be delivered to the Photographer by the Distributor.

or, if no arbitrator can be agreed upon, before the American Arbitration Association, under its rules.

15. Miscellany. This Agreement contains the entire understanding of the parties and may not be modified, amended, or changed except by an instrument in writing signed by both parties. Except as is expressly permitted under this Agreement, neither party may assign this Agreement or rights accruing under this Agreement without the prior written consent of the other party, except that the Photographer may assign rights to receive money without the Distributor's consent. This Agreement shall be binding upon the parties and their respective heirs, successors, and assigns. This Agreement shall be interpreted under the laws of the State of ______.

IN WITNESS WHEREOF, the parties have signed this Agreement as of the date first set forth above.

Photographer___

Distributor____

Company Name

By_

Authorized Signatory, Title

Stock Photography Delivery Memo

ғо**рм**

Stock pictures are extremely valuable and can provide a flow of income long after the creation of the images. To protect the value of the photographer's inventory of stock, images must be carefully inventoried and submissions must be documented. Excellent resources for the stock shooter are *Pricing Photography* by Michal Heron and David MacTavish (Allworth Press); *How to Shoot Stock Photos that Sell* by Michal Heron (Allworth Press); *Negotiating Stock Photo Prices* by Jim Pickerall (Pickerall Marketing, 110A Frederick Avenue, Rockville, MD 20850); and the newsletters mentioned in the discussion of Form 19.

The delivery memo for stock pictures is a more sophisticated version of the general delivery memo that appears as Form 8. Since the stock images are the capital of any stock business, they must be legally protected when submissions are made to prospective clients.

Photographs are defined to include all of the forms in which the images can be perceived or stored. This includes digitized versions and any future systems that may be invented. Ownership of the copyright as well as the photographs is reserved to the photographer. The photographs are given in trust to the client for the limited purpose of reviewing them. Some photographers charge a research fee simply for gathering the images in response to a request, and may then waive the fee if the client gives a large enough order.

The form requires the client to check the count shown on the form for accuracy and object immediately if the count is inaccurate. The client is made liable for loss, theft, or damage in the amount of the value specified on the front of the form. If no value is specified, it will be assumed to be \$1,500 per original transparency. The photographer should specify values, if possible, since this may strengthen his or her position if litigation is necessary. Also, some images are worth more than \$1,500 and this extra value should be noted. Alternatively, it is strongly advised that repro dupes be submitted whenever possible to avoid potential conflicts, a practice that is virtually standard among stock professionals.

Holding fees of \$5 per week for color and \$1 per week for black and white are specified for photographs held more than fourteen days. Although these fees can be waived for a good client, their inclusion suggests the value and urgency of keeping the images in circulation. An extension can be granted to responsible clients who need the extra time. The form also states that a usage fee will be negotiated for those images selected for use by the client.

Copyright notice is required for the photographer unless the parties agree otherwise in the invoice. Damages for failure to include notice are set at three times the usage fee. The client also must provide tear sheets of the use and take responsibility for determining if model or property releases are necessary for the intended use (and, if needed, requesting them from the photographer). The arbitration provision exempts amounts that can be sued for in small claims court.

Filling in the Form

Fill in the name, address, and telephone number of the client, as well as who requested the photographs. Give the date, the photographer's delivery memo number, and the client's purchase order number if a purchase order was issued. Indicate a date for return of the photographs, then, for each image, fill in its value, quantity, format or size, whether it's an original or a dupe, its description or file number, and whether it's in black and white or color. Show a total count for color and for black and white. On the back of the form fill in the information regarding arbitration in Paragraph 6 and in Paragraph 10 indicate which state's laws will govern the delivery memo. If at all possible, the delivery memo should be signed and dated by the client.

Negotiation Checklist

- □ Identify the client and who requested the submission of the photographs. It will be very difficult to win a lawsuit for lost or damaged transparencies if the submission was not asked for by the client. (Front of form)
- Describe the images submitted, including whether or not transparencies are original, specify a value for each image, and give a total count for color and for black and white images. (Front of form)
- □ Ask the client to verify the accuracy of the count shown on the form. (Front of form)
- State that if the client does not object to the count immediately, the client is agreeing that the count is accurate and the photographs are suitable for reproduction. (Front of form)
- □ Indicate that the recipient either is the client (such as an art director who is an employee) or has authority to act for the client (such as a freelance photo researcher). (Front of form)
- Define photographs broadly, including digitization and future ways to store and view images. (Paragraph 1)
- □ State that the purpose of delivering the photographs is for the client's examination and no other purpose. (Paragraph 1)
- □ Reserve the copyright and all reproduction rights to the photographer. (Paragraph 2)
- □ State that the photographs will be held in confidence. (Paragraph 2)
- Prevent the client or a third party from modifying the photographs or combining them with written materials unless the express consent of the photographer is obtained. This will avoid having the images used in a comp

without any payment to the photographer. (Paragraph 2)

- □ Indicate that reproduction by the client will only be allowed with the photographer's permission in which case fees and usage will be agreed to. (Paragraph 2)
- □ In the event the client does select some of the photographs, require payment within thirty days of the invoice date. (Paragraph 2)
- □ Make time of the essence with respect to payment. (Paragraph 2)
- If the client has agreed to pay a research fee, this may be billed at the time the photographs are submitted. If it is not billed at that time, it might be mentioned in the Stock Photography Delivery Memo and billed on the invoice for usage.
- □ State that any terms of the contract not objected to within ten days of receipt will be binding on the parties. (Paragraph 3)
- Require the client to be fully responsible for loss, theft, or damage of the photographs from the time they leave the studio until the time they are returned to the studio. (Paragraph 4)
- Specify that client will pay for the return of the photographs and will use registered mail or a bonded courier which gives proof of receipt. (Paragraph 4)
- □ State that the parties agree the values assigned to the various images are fair and reasonable. (Paragraph 4)
- □ While it is best to assign a value to each image, \$1,500 can be given as the value for any original transparencies that have not had a value assigned. (Paragraph 4)
- □ Have the client agree to pay the assigned val-

ues (or \$1,500 per transparency if no value is assigned) in the event of loss, theft, or damage. (Paragraph 4)

- □ Charge holding fees if the images are kept beyond a specified length of time. (Paragraph 5)
- Determine with the photographer's attorney whether the form's requirement of arbitration would be better than going to court in the event of a dispute. (Paragraph 6)
- Require copyright notice when the images are reproduced, unless the parties agree to the contrary in the invoice. (Paragraph 7)
- □ State that if a required notice for copyright and authorship notice is omitted, the liquidated damages shall be triple the amount of the fee. (Paragraph 7)
- □ Have the client give copies of the finished piece to the photographer for use as samples. (Paragraph 8)
- Place the burden of requesting releases (for models and property) on the client if possible, since the client is dictating the use of the image. (Paragraph 9) Bear in mind, however, that clients routinely expect that most "people" photographs are, in fact, model released and are often asking to see copies of the model release before a license is finalized.
- □ If the client fails to request needed releases, have the client indemnify the photographer against damages and expenses resulting from lawsuits. (Paragraph 9)
- □ Compare Paragraph 10 with the standard provisions in the introductory pages.
- □ Try to have the recipient sign the form, since this is better than having the recipient simply not object to the form.

< Photographer's Letterhead >

Stock Photography Delivery Memo

lient		Date	
		Delivery Memo No	
		Purchase Order No	
er Request of		Telephone	
noto Return Due		Extension Granted	
value qualitity	ormat/ Original lize or Dupe	Description/File Number	BW/Color
* Value is in case of los	s, theft, or damage.	A reproduction fee for specified usage will be nego	btiated.
Total Color		Total Black and White	-
ease count all photographs an	d confirm that the	e count is accurate by returning one signed (copy of this form
pjection is not immediately ma	de by return mai	I, the Client shall be considered to accept the	ne count shown
		are of a quality suitable for reproduction. If the content of the cepting this Delivery Memo and the photogrous the photogrous states the content of the con	
		tographs on behalf of the Client.	
		Data	
Acknowledged and Accepted_		Date	

Subject to All Terms and Conditions Above and on Reverse Side.

Terms and Conditions

- 1. Purpose and Definition. Photographer hereby agrees to entrust the Photographs listed on the front of this form to the Client for the purpose of review and examination only and no other purpose. "Photographs" are defined to include transparencies, prints, negatives, digitized encodations, and any other form in which the images submitted can be stored, incorporated, represented, projected, or perceived, including forms and processes not presently in existence but which may come into being in the future.
- 2. Ownership and Copyright. Copyright and all reproduction rights in the Photographs, as well as the ownership of the physical Photographs themselves, are the property of and reserved to the Photographer. Client acknowledges that the Photographs shall be held in confidence and agrees not to project, copy, store, or modify directly or indirectly any of the Photographs submitted (whether such modification is of the Photograph itself or involves combining the Photograph with other images or graphic or written elements, including but not limited to comping for clients) without the express permission of the Photographer, nor will Client permit any third party to do any of the foregoing. Reproduction shall be allowed only upon Photographer's written permission specifying usage and fees. In the event of the licensing of any usage rights by Client, payment shall be made within thirty (30) days of the date of the Invoice and time shall be of the essence with respect to payment.
- **3.** Acceptance. Client accepts the listing and values set forth for the Photographs as accurate if not objected to in writing by return mail immediately after receipt of the Photographs. Any terms on this form not objected to in writing within 10 days shall be deemed accepted.
- 4. Loss, Theft or Damage. Client agrees to assume full responsibility and be strictly liable as an insurer for loss, theft, or damage to the Photographs and to insure the Photographs fully from the time of shipment from the Photographer to the Client until the time of return receipt by the Photographer. Client further agrees to return all of the Photographs at its own expense by registered mail or bonded courier which provides proof of receipt. Reimbursement for loss, theft, or damage to any Photograph(s) shall be in the amount of the value entered for that Photograph(s) on the front of this form. Both Client and Photographer agree that the specified values represent the fair and reasonable value of the Photographs. Unless the value for an original transparency is specified otherwise on the front of this form, both parties agree that each original transparency has a fair and reasonable value of \$1,500 (Fifteen Hundred Dollars). Client agrees to reimburse Photographer for these fair and reasonable values in the event of loss, theft, or damage.
- 5. Holding Fees. The Photographs are to be returned to the Photographer within fourteen (14) days after delivery to the Client. Each Photograph held beyond fourteen (14) days from delivery shall incur a weekly holding fee of \$5 (Five Dollars) if it is color and \$1 (One Dollar) if it is black and white. These holding fees shall be paid to the Photographer when billed.
- 6. Arbitration. Client and Photographer agree to submit all disputes hereunder in excess of \$_______ to arbitration before _______ at the following location _______ under the rules of the American Arbitration Association. The arbitrator's award shall be final and judgment may be entered on it in any court having jurisdiction thereof.
- 7. Copyright Notice. Copyright notice in the name of the Photographer shall be adjacent to the Photograph(s) when reproduced unless otherwise agreed by both parties and stated in the Invoice. If such copyright notice, which also serves as authorship credit, is required hereunder but is omitted, the Client shall pay as liquidated damages triple the usage fee agreed to between the parties instead of the agreed upon usage fee.
- 8. Tear Sheets. Client shall provide Photographer with two (2) copies of tear sheets of any authorized usage.
- **9.** Releases. Client agrees to indemnify and hold harmless the Photographer against any and all claims, costs, and expenses, including attorney's fees, arising when no model or property release has been provided to the Client by the Photographer or when the uses exceed the uses allowed pursuant to such a release.
- **10. Miscellany.** This Agreement shall be binding upon the parties hereto, their heirs, successors, assigns, and personal representatives. This Agreement constitutes the full understanding between the parties hereto. Its terms may only be modified by a written instrument signed by both parties. A waiver of a breach of any of the provisions of this Agreement shall not be construed as a continuing waiver of other breaches of the same or other provisions hereof. This Agreement shall be governed by the laws of the State of ______.

Stock Photography Invoice

A fter the client reviews the images submitted with the Stock Photography Delivery Memo, the client may retain some of the images for use and will send a purchase order or billing request letter. At this point, the photographer will want to negotiate the linked issues of usage and price and submit the Stock Photography Invoice to the client.

The usage provision states that only nonexclusive rights are granted. This can be changed, of course, but one benefit of stock photography is to be able to sell the image repeatedly. Exclusive rights limit the ability to do this and a grant of exclusive rights is unusual. The nonexclusive rights are then broken down further by specifying the nature of the use; the name of the product, project, or publication for which the image will be used; the territory for the use; the time period or number of uses; and any other limitations (such as use in a hardcover book edition, use for a certain number of copies, use for an Englishlanguage version only, and so on). A common limitation is to give rights only within a certain industry or market, such as corporate or advertising rights. It is also important to reserve electronic rights or specify which electronic rights are being licensed.

The descriptive information, such as whether the use will be in color or black and white and the size and placement of the image, are all important in determining the fee. If research fees or holding fees are owed by the client, these can be shown on the invoice.

The terms of the Stock Photography Invoice are nearly identical to the those of the Stock Photography Delivery Memo, so the negotiation checklist will detail only the additional issues to be covered. The photographer should also review the negotiation checklist for the Stock Photography Delivery Memo.

Filling in the Form

Give the name and address of the client, the date, the invoice number, the client's social security number or employer identification number, the number of any purchase order, the name of the person who requested the images, and that person's telephone number. Detail the usage rights being given to the client. Fill in the identification numbers and descriptions of the photographs. Indicate whether the use will be in color or black and white and the size and placement of the use, after which the fee should be specified. Once the reproduction fees are totaled, research fees (if agreed to and not already paid) and holding fees should be billed. Complete the front of the form by giving the name in which checks should be made payable. On the back of the form, fill in the interest rate in Paragraph 5, the arbitration provision in Paragraph 11, and which state's laws will control the invoice in Paragraph 13.

Negotiation Checklist

- □ Specify that only nonexclusive rights are given to the client. (Front of form)
- □ Limit the nonexclusive grants given by detailing the nature of the use; the particular product, project, or publication; any geographical limitations; any limitations on duration or number of uses; and any other limitations (such as number of copies, different versions of the use, language of use, and so on). (Front of form)
- Return electronic rights unless such rights are explicitly licensed. (Front of form)
- Negotiate the fee based on the client's intended usage. (Front of form)

- □ If a research fee has been agreed to and not already paid, bill this. Of course, this may be waived if the client makes a significant order. (Front of form)
- □ If a holding fee is due and the photographer decides to bill it to the client, it should be shown on the invoice. (Front of form)
- □ Charge sales tax unless the client can show that no sales tax is due. Remember that the photographer remains liable for the sales tax if it should have been collected, even if the client incorrectly thought it did not have to be paid. Bear in mind that in some states a license that does not include all rights is not equivalent to a sale (as long as all physical materials such as prints or transparencies are returned unaltered to the photographer) and sales tax need not be collected. (Front of form)
- State that the photographer has delivered the photographs listed on the front of the form. (Paragraph 1)
- □ Indicate that the rights granted to the client will only be licensed when full payment is received. (Paragraph 2)
- Reserve any rights not expressly granted to the photographer. (Paragraph 3)
- Require an express statement on the front of the form if usage rights include advertising or promotional uses. (Paragraph 3)
- Include as limitations on usage the specifications on the front of the form as to whether the use is in color or black and white and the size and placement of the use. (Paragraph 3)

- Require the client to pay the fee and any sales tax. (Paragraph 4)
- □ Specify when payment is due, such as thirty days after the date of the invoice. (Paragraph 5)
- Give an interest rate for overdue payments, making certain that the interest rate is not usurious under state law. (Paragraph 5)
- □ State that time is of the essence with respect to payment. (Paragraph 5)
- Require the photographer's written consent if the client is to alter the photographs by adding or deleting materials. (Paragraph 7)
- □ State that the photographs remain the property of the photographer. (Paragraph 8)
- □ Limit the right of either party to assign rights or obligations under the contract, except for the right of the photographer to assign monies due. (Paragraph 12)
- □ Compare the standard provisions in the introductory pages with Paragraphs 11-13.
- Review the negotiation checklist for the Stock Photography Delivery Memo.

< Photographer's Letterhead >

Stock Photography Invoice

lient			C	ate	
ddress			Ir	nvoiceNo	
			S	S/EINNo	
			P	urchaseOrderNo	
Per Request of			Т	elephone	
The following no	nexclusive right	s are granted			
oruse in					
For the product, pr	oject, or publicat	ion named			
n the following terr	tory				
or the following tir	ne period or num	ber of uses			
Otherlinsitations					
This grant of right	s does not incluc in v ectronic rights a	de electronic rights, unles which event the usage res re defined as rights in the	s specified to the trictions shown ab digitized form of	contrary here ove shall be applicat works that can be er	ole. For purpo ncoded, stored
This grant of right	s does not incluc in v ectronic rights a h media as comp	de electronic rights, unles which event the usage res	s specified to the trictions shown ab digitized form of	contrary here ove shall be applicat works that can be er	ole. For purpo ncoded, stored
This grant of right his agreement, el retrieved from suc Photo ID	s does not incluc in v ectronic rights an h media as comp #	de electronic rights, unles which event the usage res re defined as rights in the puter disks, CD-ROM, co	s specified to the trictions shown ab digitized form of mputer databases Color/BW	contrary here hove shall be applicate works that can be er , and network servers Size/Placement	ble. For purpo ncoded, stored s. Fee
This grant of right this agreement, el retrieved from suc Photo ID	s does not incluc in v ectronic rights an h media as comp #	de electronic rights, unles which event the usage res re defined as rights in the puter disks, CD-ROM, co Description	s specified to the trictions shown ab digitized form of mputer databases Color/BW	contrary here hove shall be applicate works that can be er , and network servers Size/Placement	ble. For purpo ncoded, stored s. Fee
This grant of right his agreement, el retrieved from suc Photo ID	s does not incluc in v ectronic rights an h media as comp #	de electronic rights, unles which event the usage res re defined as rights in the puter disks, CD-ROM, co Description	s specified to the trictions shown ab digitized form of mputer databases Color/BW	contrary here hove shall be applicate works that can be er , and network servers Size/Placement	ble. For purpo ncoded, stored s. Fee
This grant of right his agreement, el etrieved from suc Photo ID	s does not incluc in v ectronic rights an h media as comp #	de electronic rights, unles which event the usage res re defined as rights in the puter disks, CD-ROM, co Description	s specified to the trictions shown ab digitized form of mputer databases Color/BW	contrary here hove shall be applicate works that can be er , and network servers Size/Placement	ble. For purpo ncoded, stored s. Fee
This grant of right his agreement, el etrieved from suc Photo ID	s does not incluc in v ectronic rights an h media as comp #	de electronic rights, unles which event the usage res re defined as rights in the puter disks, CD-ROM, co Description	s specified to the trictions shown ab digitized form of mputer databases Color/BW	contrary here hove shall be applicate works that can be er , and network servers Size/Placement	ble. For purpo ncoded, stored s. Fee
This grant of right his agreement, el etrieved from suc Photo ID	s does not incluc in v ectronic rights an h media as comp #	de electronic rights, unles which event the usage res re defined as rights in the puter disks, CD-ROM, co Description	s specified to the trictions shown ab digitized form of mputer databases Color/BW	contrary here pove shall be applicat works that can be er , and network servers Size/Placement	ble. For purpo hcoded, stored s. Fee
This grant of right his agreement, el etrieved from suc Photo ID	s does not incluc in v ectronic rights an h media as comp #	de electronic rights, unles which event the usage res re defined as rights in the puter disks, CD-ROM, co Description	s specified to the trictions shown ab digitized form of mputer databases Color/BW	contrary here pove shall be applicate works that can be er , and network servers Size/Placement	ble. For purponcoded, stored ncoded, stored s. Fee
This grant of right his agreement, el etrieved from suc Photo ID	s does not incluc in v ectronic rights an h media as comp #	de electronic rights, unles which event the usage res re defined as rights in the puter disks, CD-ROM, co Description	s specified to the trictions shown ab digitized form of mputer databases Color/BW	contrary here pove shall be applicate works that can be ere , and network servers Size/Placement 	ble. For purponcoded, stored ncoded, stored s. Fee
This grant of right this agreement, el retrieved from suc Photo ID	s does not incluc in v ectronic rights an h media as comp #	de electronic rights, unles which event the usage res re defined as rights in the puter disks, CD-ROM, co Description	s specified to the trictions shown ab digitized form of mputer databases Color/BW	contrary here pove shall be applicate works that can be ere , and network servers Size/Placement 	ble. For purpo acoded, stored s. Fee

Subject to All Terms and Conditions on Reverse Side.

Terms and Conditions

- 1. Delivery and Definition. Photographer has delivered to the Client those Photographs listed on the front of this form. "Photographs" are defined to include transparencies, prints, negatives, digitized encodations, and any other form in which the images submitted can be stored, incorporated, represented, projected, or perceived, including forms and processes not presently in existence but which may come into being in the future.
- 2. Grant of Rights. Upon receipt of full payment, Photographer shall license to the Client the rights set forth on the front of this form for the listed Photographs.
- **3.** Reservation of Rights. All rights not expressly granted are reserved to the Photographer. Without limiting the foregoing, no advertising or promotional usage whatsoever may be made of any Photographs unless such advertising or promotional usage is expressly permitted on the front of this form. Limitations on usage shown on the front of this form include but are not limited to size, placement, and whether usage is in black and white or color.
- **4.** Fee. Client shall pay the fee shown on the front of this form for the usage rights granted. Client shall also pay sales tax, if required.
- 5. Payment. Payment is due to the Photographer within 30 days of the date of this Invoice. Overdue payments shall be subject to interest charges of _____ percent monthly. Time is of the essence with respect to payment.
- 6. Copyright Notice. Copyright notice in the name of the Photographer shall be adjacent to the Photograph(s) when reproduced unless otherwise agreed by both parties and stated in this Invoice. If such copyright notice, which also serves as authorship credit, is required hereunder but is omitted, the Client shall pay as liquidated damages triple the usage fee agreed to between the parties instead of the agreed upon usage fee. Copyright credit must be as shown on the Photograph(s) unless specified to the contrary by the Photographer.
- 7. Alterations. Client shall not make alterations, additions, or deletions to the Photographs, including but not limited to the making of derivative or composite images by the use of computers or other means, without the express, written consent of the Photographer. This prohibition shall include processes not presently in existence but which may come into being in the future.
- 8. Loss, Theft, or Damage. The ownership of the Photographs shall remain with the Photographer. Client agrees to assume full responsibility and be strictly liable as an insurer for loss, theft, or damage to the Photographs and to insure the Photographs fully from the time of shipment from the Photographer to the Client until the time of return receipt by the Photographer. Client further agrees to return all of the Photographs at its own expense by registered mail or bonded courier which provides proof of receipt. Reimbursement for loss, theft, or damage to any Photograph(s) shall be in the amount of the value entered for that Photograph(s) on the front of this form. Both Client and Photographer agree that the specified values represent the fair and reasonable value of the Photographs. Unless the value for an original transparency is specified otherwise on the front of this form, both parties agree that each original transparency has a fair and reasonable value of \$1,500 (Fifteen Hundred Dollars). Client agrees to reimburse Photographer for these fair and reasonable values in the event of loss, theft, or damage.
- 9. Tear Sheets. Client shall provide Photographer with two (2) copies of tear sheets of any authorized usage.
- **10. Releases.** Client agrees to indemnify and hold harmless the Photographer against any and all claims, costs, and expenses, including attorney's fees, arising when no model or property release has been provided to the Client by the Photographer or when the uses exceed the uses allowed pursuant to such a release.
- **11. Arbitration.** All disputes shall be submitted to binding arbitration before _______ in the following location _______ and settled in accordance with the rules of the American Arbitration Association. Judgment upon the arbitration award may be entered in any court having jurisdiction thereof. Disputes in which the amount at issue is less than \$______ shall not be subject to this arbitration provision.
- **12. Assignment.** Neither party shall transfer or assign any rights or obligations hereunder without the consent of the other party, except that the Photographer shall have the right to assign monies due.
- **13. Miscellany.** This Agreement shall be binding upon the parties hereto, their heirs, successors, assigns, and personal representatives. This Agreement constitutes the full understanding between the parties hereto. Its terms may only be modified by a written instrument signed by both parties. A waiver of a breach of any of the provisions of this Agreement shall not be construed as a continuing waiver of other breaches of the same or other provisions hereof. This Agreement shall be governed by the laws of the State of ______.

Stock Agency Agreement

A stock photographer may find a number of advantages in having a stock agency market his or her photographs. The agency is probably better equipped to do the marketing and the photographer will have more time to shoot. The Picture Agency Council of America, which is the trade association for stock agencies, publishes a directory of its members and has a Code of Ethics (PACA, c/o Lonnie Shroeder, P.O. Box 308, Northfield, MN 55057). Other helpful publications about agencies and other areas of interest for stock shooters include Taking Stock (Pickerell Marketing, 110A Frederick Avenue, Rockville, MD 20850); Stock Photo Report, 7432 Lamon Avenue, Skokie, Illinois 60077; and West Light International Report, West Light, 2223 South Carmelina Avenue, Los Angeles, California 90064.

The benefit of having an agency varies greatly, depending on the agency's marketing strengths and its contract. While it would be unusual for an agency to use a contract offered by the photographer, Form 19 offers provisions for the photographer or his or her lawyer to review and compare with the agency's form. The negotiation checklist allows a point-by-point evaluation.

Several trends affect the position of the stock photographer seeking an agency. Stock photography has become far more competitive. It is no longer the realm of assignment outtakes, but far more often the fruit of carefully planned shooting for stock. As photo buyers seek to find immediate solutions or to lower their costs by using more stock, the stock agencies have come to play an ever more important role.

Faced with an increasingly competitive environment, the stock agencies themselves have sought to enhance their marketing programs. The latest innovation in marketing are computer banks of images that potential clients may access either by modem or the use of a storage format supplied by the agency. But the ascendant tool is now the stock catalog (which may be print, CD-ROM, or both). Such catalogs allow the agencies to reach thousands of buyers with an on-shelf reference. For foreign subagents, the catalogs can be overprinted and delivered to the subagent for distribution.

In fact, researching in stock files has come to be largely limited to clients who are in major cities. Many clients are relying on catalogs, which means that the contractual provisions regarding catalog sales are crucial.

One issue is whether — or how much — the agency will charge the photographer to be in a catalog. If there is such a charge, how much of the actual production cost for the photographs appearing in the catalog does it cover? Is there a profit to the agency simply by doing the catalog? If the agency does charge, will it front the necessary funds and recoup them from first proceeds earned through the catalog? The commission rate on catalog sales is becoming a more and more significant issue. If the photographers are paying for the cost of the catalog (or having the cost recouped from proceeds earned), the commission rate should probably remain 50 percent. If the agency pays the production cost, the agency might argue for a higher commission rate and the photographer will have to weigh the costs being underwritten and compare that with what other agencies are offering.

The use of catalogs also plays into the issue of the duration of the relationship with the agency. The photographer does not want too many years for the term in case the agency is not successful. An initial term of three years might be reasonable, although the agency might want five years, after which shorter renewal terms could be agreed to. A crucial aspect, however, is how long it takes to return the photographs after termination and whether the agency has the right to continue selling catalog photographs. If the agency's contract states that it retains the right to sell catalog photographs for a very long time (such as another five years or in perpetuity, which means forever), the photographer must weigh this along with the fact that most of the sales may come from catalog images. So the most valuable stock may be tied up for a very long time, despite termination by the photographer. Certainly the photographer should seek to avoid this, except for catalog images which are given a somewhat different treatment than file images.

Many agencies are trying to represent the photographer exclusively for stock, so neither the photographer nor other agencies can sell the photographer's stock. Certainly the photographer would prefer to give the agency the right to be the only agency to sell the photographs in its files, while retaining the right to make his or her own direct sales and the right to place other photographs with other agencies. A compromise might turn on catalog sales. For example, the photographer might agree not to sell directly or allow other agencies to sell catalog images (or similars), while retaining the right to sell file images directly. In practice, no agency will agree to place an image in a catalog unless it has exclusive rights over that image. The reason stated is that the agency needs to control rights to avoid conflicts among buyers and, in fact, that can be a real problem in an increasingly shrinking international marketplace.

Especially if the agency (or its subagents) cannot sell in a certain area or do not sell a particular type of image, the photographer should limit the rights given to the agency. The basic rule applies here: *never* license rights that the other party cannot effectively market. However, photographers should be aware that more agencies are moving to complete exclusivity.

Another interesting question raised by catalogs arises from the retail sale of such catalogs in bookstores. Should photographers receive some royalty from such sales? This is not the current practice, but perhaps the profit from book sales should reduce any contributions by photographers to the costs of future catalogs. On the other hand, the free distribution of the catalogs may so reduce any potential selling of the catalog as to make this issue moot.

A trap for the unwary photographer can be duping costs. If the agency has many subagents, duping costs can become substantial. These duping costs are often paid by the foreign subagents, but the photographer should make certain of this. Certainly the photographer should have a right of approval over this process, whether by negotiating the amount of any charge for duping or approving the duping itself. Another safeguard might be to require that any duping charges be recouped only from proceeds earned by the agency for the photographer. This would, at least, avoid a situation in which the photographer might have to pay money to the agency for the making of dupes that sold very little.

Other basic provisions include periodic accountings, a definition of gross billings and a time for payment, a right to inspect the books and records of the agency, a term, grounds for termination, the right of the photographer to possession of the photographs during the agreement and upon termination, a warranty about ownership of the images and privacy issues, and a method to deal with any infringements by third parties. The negotiation checklist should help make the photographer's relationship with an agency more satisfying and profitable.

The trend toward catalogs has brought two types of hybrid vehicles into existence. One is the agency which publishes a catalog for photographers it does not otherwise represent. The effect of this is to make all the photographs into catalog photographs. The agency acts as an agency in terms of licensing, collecting money, and making payments to the photographer, and the negotiation checklist that follows can be used to review the contract offered by such an agency.

The other hybrid is the promotional book focused solely on stock photography. These books may be divided into segments based on subject matter, which is the typical format of the stock catalog. The photographer pays a page rate to be in such a book and the publisher guarantees a certain level of free circulation to photography buyers. The publisher does not act as an agency and all inquiries go directly to the photographer who must establish rates, negotiate usage, invoice the clients, and so on. The best known (and presently the only) catalog of this type is Direct Stock (10 East 21st Street, New York, NY 10010) which many photographers use for additional outreach even when some of their work is also included in the catalog of a stock agency. An additional negotiation checklist for such promotion books appears after the negotiation checklist for stock agencies.

Filling in the Form

In the Preamble enter the date and the names and addresses of the parties. In Paragraph 1 fill in when the agency must return photographs that it is not accepting. In Paragraph 2 show in (A) the countries where the agency will market directly; in (B) the countries where the agency will market through subagents; and in (D) a minimum licensing fee. In Paragraph 7 check the box to indicate whether the photographer authorizes the making of dupes. In Paragraph 9 enter the amounts or method of computation of any expenses toward which the photographer will be expected to make a contribution. In Paragraph 10 give the percentage to be paid to the photographer from catalog sales and indicate when volume discounts are permitted. In Paragraph 11 indicate how long each accounting period will be and when the accounting will be given to the photographer after the end of the period. In Paragraph 13 specify the length of the initial term and the length of the renewal terms. In Paragraph 14 fill in a minimum amount of gross receipts, beneath which level termination is allowed. In Paragraph 15 fill in the amounts of time for retrieval of photographs. In Paragraph 16 fill in the dollar amount or percentage to limit the photographer's liability as well as the percentage payable to an escrow fund. In Paragraph 17 specify the percentages for sharing a recovery if the photographer brings the lawsuit alone. In Paragraph 20 fill in the organization and place for arbitration. In Paragraph 23 specify which state's law will be controlling. Finally, both parties should sign the agreement.

Negotiation Checklist

- □ State that the photographer shall submit photographs to the agency from time to time, and any photographs that the agency does not accept shall be returned to the photographer in a reasonable amount of time. (Paragraph 1)
- □ Define photographs to include similars and dupes. (Paragraph 1)
- □ State that all photographs, including dupes made by any party, shall be the property of the photographer. (Paragraphs 1 and 7)
- □ If possible, limit the scope of the agency to licensing of the photographs accepted by the agency. (Paragraph 2)
- Try not to agree that the agency shall have exclusive stock representation of all photographs created by the photographer. This is especially critical with the emergence of new media.
- Give the agency the right to market in countries where it licenses directly to clients. (Paragraph 2[A])
- □ Give the agency the right to use subagents in countries where the agency has such subagents, and list the subagents by name. (Paragraph 2[B])
- A small number of photographers may have developed their own foreign distribution to the extent that they will not want the agency to use any subagents in certain countries. In this

case, the agency would simply sell in the United States and any permitted foreign countries.

- Do not allow the agency to treat any of its branch offices as subagents, since this will cause a diminution in the payments to the photographer. (Paragraph 2[B])
- ❑ Allow the agency to license nonexclusive rights in its discretion, but require that it obtain the photographer's written permission to license exclusive rights. The licensing of exclusive rights could affect the long-term value of the photograph by restricting potential future uses. (Paragraph 2[C])
- □ Specify a minimum licensing fee. If the agency wishes to license for less than this minimum, it must obtain the photographer's permission. The agency is likely to resist this, but more photographers are starting to ask for it. In any case, the photographer should know what the agency's actual practices are with respect to minimum fees. (Paragraph 2[D])
- □ While the agency will usually need exclusivity as to the actual photographs in its files, the photographer may want to keep the right to sell stock directly while agreeing not to sell through other agencies in the territories covered by the agency and its subagents. (Paragraph 2[E]) Agencies will not accept this with respect to catalog images.
- □ If the photographer already has clients who are likely to buy stock, it might be desirable to treat these as House Accounts. Such accounts could be completely excluded from the agency agreement. The photographer would then have the sole right to license to these clients and the agency would have no right to commissions. Another approach, which might be useful if the agency has an exclusive on the photographer rather than on certain images, would be to allow the photog-

rapher and the agency to sell to House Accounts. The photographer would retain all proceeds from sales that he or she made.

- Exclude obtaining assignments from the scope of the agency. If the photographer has an exclusive agent for assignments, letting the stock agency also obtain assignments may be a conflict. (Paragraph 2[F])
- □ If the stock agency does offer the photographer a potential assignment, an agency agreement for assignments should be used between the photographer and the stock agent. Review Form 4 and its negotiation checklist.
- □ If the stock agency is obtaining assignments for the photographer, determine whether all photographs from these assignments must be submitted to the agency as stock.
- Require the agency to use its best efforts to license the photographs and obtain the highest fees. (Paragraph 2[G])
- □ Specify that the agency shall have all subagents act in accordance with the agency's agreement with the photographer. (Paragraph 2[H])
- □ Indicate whether or not the agency will represent the photographer with respect to the sale of electronic rights.
- State that all photographs accepted by the agency shall be kept in the agency's files. (Paragraph 3)
- Determine whether the photographer's consent must be obtained before a photograph can be used in a catalog published by the agency. The photographer will usually want to be included, but may have to pay part of the catalog costs. This makes a case-by-case decision desirable. The photographer can review which photographs are being chosen

and the number of photographs, although in general the photographer will want to rely on the agency's marketing expertise and the benefits of wide exposure. (Paragraph 3)

- □ The photographer will have to provide captions for the photographs. (Paragraph 4)
- □ The agency will be responsible for correctly communicating the caption information to its subagents and clients. (Paragraph 4)
- □ The photographer should specify a copyright notice for each photograph. If this is not done, the agency should place copyright notice on the photographs and require that this copyright notice appear when the photographs are reproduced. (Paragraph 5)
- □ The photographer should advise the agency as to which photographs have model or property releases. (Paragraph 6)
- □ If the agency allows the improper use of photographs that don't have model or property releases, allows uses that exceed what a release permits, or transmits incorrect caption information, the agency should protect the photographer against any claims or lawsuits. (Paragraph 6)
- □ If the agency is authorized to make dupes, the photographer may still want to give written permission each time dupes are made. This lets the photographer keep track of how many dupes have been made and, if the photographer will be charged for dupes, avoids having duping charges become excessive. (Paragraph 7)
- □ State that all duplicates, regardless of who makes them, are the property of the photographer. (Paragraphs 1 and 7)
- □ Require that the agency take reasonable care of the photographs. (Paragraph 8)

- □ Agencies do not insure stock photographs, simply because the volume makes such insurance prohibitively expensive, and the contract reflects this. (Paragraph 8)
- □ If the photographer is to pay expenses, such as charges for dupes or for photographs appearing in catalogs, these charges and their computation should be specified. (Paragraph 9)
- □ Be certain that dupe charges are reasonable and that the amount of duping will not be excessive.
- □ For catalog charges, determine whether the agency is actually making a profit on the charges keeping in mind the related costs of distribution and whether the sharing of expenses is fair in view of the sharing of gross receipts.
- For catalogs that are sold to the book trade, consider the possibility that the photographers should receive a royalty or some reduction of catalog charges. This is not currently a significant market.
- Require that the agency recoup expenses from payments due to the photographer, rather than billing the photographer directly. (Paragraph 9)
- □ Limit the agency recoupment for expenses to a percentage of payments due the photographer in any payment period.
- □ State that if the agency cannot fully recoup expenses from payments due the photographer, then the unpaid expenses shall be waived by the agency. This avoids the horror story of a photographer who is unable to terminate because he or she owes so much expense money to the agency. (Paragraph 9)
- Try to avoid other expense charges, such as filing or introduction fees charged per image

accepted by the agency. This makes the photographer defray overhead expenses which should be paid by the agency. Also, if the photographer has thousands of images, such charges could be substantial.

- □ State that payments due to the photographer will be held in trust by the agency in a separate escrow account. (Paragraph 10)
- Define gross billings. This should include holding fees and interest and be reduced only by bad debts or the cost of converting currency. (Paragraph 10)
- □ Give a time for making payments. If accountings are provided every month or two months, the payment might be made at the time when the accounting is given. (Paragraph 10)
- □ Specify the payment for licenses of file images, which would usually be 50 percent. (Paragraph 10)
- Specify the payment for licenses of catalog images, which should be 50 percent if the photographer contributed to the cost of the catalog. If the agency paid in full for the cost of the catalog, the agency might seek more than 50 percent and this will have to be negotiated. (Paragraph 10)
- □ For photographs sold by subagents, the photographer should receive 50 percent of what the agency receives. The photographer may receive 25 or 30 percent of what the subagent billed, depending on how much the agent receives from the subagent. (Paragraph 10)
- □ Specify when volume discounts may be given. (Paragraph 10)
- □ Require the photographer's prior approval for volume discounts.

- □ A possible limitation on volume discounts would be to allow such discounts only if one photographer has more than a certain number of pictures being licensed to the same project.
- Allow the agency to defer payment if the amount due is less than \$100. If this is permitted, payment should still have to be made at least semiannually regardless of the amount to be paid.
- Require that regular accountings, preferably on a monthly basis, be given to the photographer. (Paragraph 11)
- □ The statements of account (also called sales reports) should identify each photograph, give the name of the client, the rights licensed, the gross billing, and any reductions from the gross billing. (Paragraph 11)
- □ The photographer should have the right to inspect the books and records of the agency. (Paragraph 12)
- □ If the photographer finds a discrepancy of more than five percent from an inspection of the books and records, the agency should pay the costs of the inspection. (Paragraph 12)
- □ The term of the agreement should be stated. The photographer might prefer a shorter term and the agency a longer term. The resulting compromise might be in the range of three to five years. If the relationship is going well, shorter renewal terms (such as a year) can be agreed to. It is far better to have the agency notify the photographer of its desire to renew rather than having the contract automatically renew if neither party terminates. Automatic renewal clauses can be lethal and should never be accepted. Once notice is received, the photographer can terminate if he or she wants to. (Paragraph 13)

- □ The photographer should be able to terminate the agreement if the agency breaches its obligations or fails to generate sufficient gross receipts. The photographer's personal representative should be able to terminate the agreement if the photographer dies or becomes incompetent. Also, the agreement should automatically terminate if the agency becomes insolvent, files a petition in bankruptcy, or assigns its assets for the benefit of its creditors. The photographer should try to evaluate the financial strength of the agency, since the bankruptcy laws may take precedence over the agreement in the event the agency fails. (Paragraph 14)
- □ In the event of termination the photographer should receive back all photographs within as short a time period as possible. If the agency has the right to hold photographs for a long period after termination, it may either effectively lengthen the term (if the agency can continue licensing) or disrupt the photographer's stock business. The photographer might seek to have all images returned within three months of termination, except for those in the possession of clients which might be required to be returned within six months. The agency may seek longer periods of time. (Paragraph 15)
- □ Especially with respect to catalog photographs, the agency and photographer may find agreement difficult with respect to an amount of time for the return of the photographs. One approach might be to make the return within a specified amount of time after termination or within a specified amount of time after publication of the catalog, whichever period is longer. If the agency were licensing some catalog photographs for a period after termination, the terms of the agreement would of course apply.
- □ If the agency does not receive back all photo-

graphs from its clients by the deadline, it should give the photographer a list of the photographs and the names and addresses of the clients which have them. (Paragraph 15)

- □ The photographer should be able to receive back photographs for exhibition, promotion, and related uses. (Paragraph 15)
- □ The photographer should have access to the agency's files to retrieve photographs. This would be on reasonable notice during regular working hours. (Paragraph 15)
- □ The photographer should, if possible, avoid giving a warranty and indemnity. However, the agency may insist that the photographer warrant that he or she created and owns the photographs, that the photographs do not infringe any copyrights, and that the photographs do not libel or violate anyone's privacy. Safeguards to protect the photographer include requiring the photographer to have knowledge of any invasion of privacy or libel; requiring a final judgment and the exhaustion of all appeals in the event of a lawsuit; requiring that there be an actual breach of the warranty (and not merely an alleged breach); allowing the photographer to retain counsel and not pay the agency's legal fees; limiting the warranty so it does not apply to material inserted in the photographs by others; specifying a maximum sum or a percentage of fees paid as the highest amount of the photographer's liability; and limiting the amount of payments that the agency can withhold in the event of a lawsuit. (Paragraph 16)
- If photographs are lost, damaged, or infringed, the photographer and agency should agree as to how a lawsuit will be pursued. One approach is for a joint suit with proceeds split equally. If either party doesn't want to sue, the other party can sue and deduct costs before dividing any damages obtained. If the

photographer must undertake the lawsuit alone, the photographer might demand to receive more than 50 percent of any recovery. (Paragraph 17)

- □ The agreement should state that the parties are independent contractors. (Paragraph 18)
- □ The photographer should allow his or her photographs to be used in promotions that will help sell the photographs. This would include allowing the use of the photographer's name or portrait. (Paragraph 19)
- □ The photographer should ask his or her attorney whether an arbitration provision is wise to include in the contract. This may depend on the nature of the local court system, especially the time and expense involved in pursuing a lawsuit. (Paragraph 20)
- □ The photographer should not allow the agency to assign the agreement for example, to another agency. (Paragraph 21)
- □ The photographer should have the right to assign payments that will be made pursuant to the contract. (Paragraph 21)
- □ A provision is given for notice. Certified mail with return receipt requested is desirable. First-class mail can also be used. (Paragraph 22)
- Compare the standard provisions in the introduction with Paragraph 23.

Promotion Book Negotiation Checklist

The sale of stock photographs through promotional books has become a part of the marketplace. Any promotional book, whether for photographers seeking to sell stock or those seeking assignments, will use a standard form contract. The following negotiation checklist deals with issues that arise in all contracts with promotion books, including the special issues to be dealt with when stock is sold in this way.

- □ Specify the amount of space purchased, the cost for the space, and the payment schedule.
- □ State whether the photographs shall be reproduced in color or in black and white.
- Look for any additional charges, such as for separations in excess of a certain number, design fees, charges for changes to mechanical boards, and insurance.
- Determine where in the book the photographs will appear, and whether any additional charges are made for preferred placement (such as toward the front of a section).
- Ascertain whether the photographer receives one or more free copies of the promotional book.
- Ascertain how many "free" reprints are included in the cost for the space, and what charges will be made if the photographer wants additional reprints or special reprints, such as an eight- or sixteen-page signature with a special cover designed for the photographer.
- Determine whether the photographer will review proofs of the page.
- Find out if there are any penalties for late delivery of photographs (if the publisher is designing the page) or of mechanicals (if the photographer is designing the page).
- Check what responsibility the publisher will take for reproduction that is unsatisfactory to the photographer — either in the book or the reprints.

- Determine the liability of the publisher for giving incorrect information, such as placing the wrong address for the photographer either in the ad or in the listings of advertisers.
- □ Find out what will happen in the event that the publisher is late in printing and distributing the book. For example, will the photographer be entitled to a full or partial refund?
- Determine the publisher's liability if the book is never published or never distributed. This might vary, depending on whether publication is prevented by Acts of God or simply by some failure on the part of the publisher.
- Review exactly who will receive the book. How are the names of these photography buyers compiled? Is the distribution audited? Is foreign distribution guaranteed or is the publisher only promising to make its best efforts?
- □ Carefully review any provision in which the publisher requires an indemnification from the photographer with respect to lawsuits brought for copyright infringements, invasion of privacy, or libel due to the inclusion of the photographs in the book.
- □ See if the publisher makes insurance available for photographs. If so, consider taking advantage of this by specifying the value of the photographs in the event of loss or damage. Of course, there may be a charge for such insurance — or for insurance over a certain amount per original transparency.
- If the publisher has a duping program for foreign agents, determine carefully how this works and who bears the expense of the dupes.
- □ For leading photographers whose photographs or files of photographs are too valu-

able to let dupes be entrusted to a foreign agent (because the nature of the images makes them susceptible to infringement), consider requiring that the foreign agents contact the photographer directly.

- □ If the photographer already has foreign agents and should not advertise in certain countries, be certain that the book allows for the removal of the photographs when the book is distributed to those countries where the photographer is represented.
- □ See whether the contract prohibits the use of certain photographs, such as those that have been in a catalog in the last several years.
- Determine what penalties the photographer may face if he or she wants to withdraw from the book. This will probably vary, depending on the time and reason for the withdrawal.
- Require the return of the photographs as soon as they are no longer needed in the production process.
- □ If the photographer has a United States stock agency, review the contract with the agency to make certain advertising in the promotional book does not create a conflict.

Stock Agency Agreement

AGREEMENT, entered into as of this	day of	, 19, between
	, located at	
(hereinafter referred to as the "Agency"), and		, located
at	(hereinafter referr	red to as the "Photographer").

WHEREAS, the Photographer is a professional photographer who has created and owns stock photography; and WHEREAS, the Agency is familiar with the stock photography of the Photographer and wishes to represent such work; and

WHEREAS, the parties wish to have said representation performed subject to the mutual obligations, covenants, and conditions herein.

NOW, THEREFORE, in consideration of the foregoing premises and the mutual covenants hereinafter set forth and other valuable considerations, the parties hereto agree as follows:

- 1. Submission and Acceptance of Photographs. The Photographer shall, from time to time during the term of this Agreement, submit his or her photography (hereinafter referred to as the "Photographs") to the Agency which shall have the right to accept such photographs as it chooses and shall return any photographs not accepted to the Photographer within _____ days of receipt by the Agency. Photographs are defined to include "Similars," which are shots of the same subject taken in the same manner, and "Dupes," which are duplicates of a photograph. All Photographs shall remain the property of the Photographer, including Dupes made by any party.
- **2.** Scope of Agency. With respect to Photographs accepted by the Agency pursuant to Paragraph 1, the Agency shall have the right to license certain limited rights as follows:

(A) The Agency shall market directly in the following countries ____

(B) The Agency may market through the Subagents listed for the following countries_

Additional Subagents may be added from time to time by the written agreement of the parties. The Agency shall not treat as Subagents other offices of the Agency, whether located in the United States or abroad.

(C) The Agency shall license nonexclusive rights only in the Photographs and shall do so at its own discretion. If the Agency wishes to license exclusive rights, it shall request the Photographer's permission which shall be obtained in writing.

(D) The Agency shall obtain the Photographer's written approval for any license of a Photograph for \$_____ or less.

(E) The Photographer may market the Photographs directly but shall not, during the term of this Agreement, market through any other agent or representative in the territories listed in (A) and (B).

(F) This Agreement shall not apply to assignment photography. In the event that the Agency has the opportunity to obtain any assignment for the Photographer, it shall offer that assignment to the Photographer who shall be free to accept or reject the assignment. In the event the Photographer wishes to accept the assignment, the Photographer and Agency shall negotiate a mutually acceptable Assignment Agency Agreement at that time.

(G) The Agency shall use its best efforts to license the Photographs on behalf of the Photographer and obtain the best possible licensing fees.

(H) The Agency shall require all Subagents to act in accordance with the Agency's obligations pursuant to this Agreement.

(I) Electronic rights are \Box outside the scope of this agency contract \Box covered by this agency contract insofar as the sale of such rights is incidental to the sale of nonelectronic rights \Box covered by this agency contract. For purposes of this agreement, electronic rights are defined as rights in the digitized form of works that can be

encoded, stored, and retrieved from such media as computer disks, CD-ROM, computer databases, and network servers.

- **3.** Files and Catalogs. All Photographs accepted by the Agency shall be kept in the Agency's files. In the event that the Agency wishes to include one or more Photographs in a catalog, the Agency shall obtain the Photographer's written approval.
- 4. Captions. The Photographer shall place captions on the Photographs. These captions shall provide as much information regarding the subject matter of the Photographs as can reasonably be expected under industry standards. The Agency shall be responsible to convey accurate caption information to its subagents and clients.
- **5.** Copyright Notice. The Photographer shall place copyright notice on all Photographs. If the Photographer does not place such notice on any of the Photographs, the Agency is authorized and required to do so. Copyright notice in the Photographer's name shall appear on all Photographs licensed by the Agency.
- 6. Model and Property Releases. When delivering the Photographs, the Photographer shall indicate which Photographs have model or property releases, and, if requested by the Agency, shall give copies of the releases to the Agency. If the Photographer does not indicate the existence of a model or property release, if the Agency allows uses beyond the scope of a model or property release, or if the Agency fails to convey accurate caption information as required by Paragraph 4, the Agency assumes full responsibility for uses of the Photograph that may violate the rights of any parties and indemnifies the Photographer against any resulting claims, damages, and expenses (including but not limited to court costs and reasonable attorney's fees).
- **7.** Duplicates. The Photographer \Box does \Box does not authorize the Agency to create dupes of the Photographs. If the Agency is authorized to create dupes, clients of the Agency shall not be allowed to make dupes without the Photographer's written approval. All duplicates, whether created by the Photographer, the Agency, a subagent, or any other party, shall be the property of the Photographer and, as stated in Paragraph 1, are included within the definition of Photographs.
- **8.** Duty of Care. The Agency shall exercise reasonable care of the Photographs. The Photographer acknowledges that the Agency shall not be required to insure the Photographs.
- **9.** Expenses. The Photographer shall not pay any expenses to the Agency, unless such expenses are specified here or written approval is given by the Photographer at a later date.
 - Dupes _____
 - Catalogs ____
 - Dther_

Any such expenses shall be charged against payments due under Paragraph 10. Any amount of expenses which cannot be recouped in this manner shall be waived by the Agency.

10. Payments. The Agency shall hold in trust in a separate escrow account all payments due to the Photographer until payment is made. For Photographs sold from the Agency's files, the Photographer shall receive fifty (50%) percent of gross billings. For Photographs sold from the Agency's catalogs, the Photographer shall receive (___%) percent of gross billings. For Photographs sold by subagents, the Photographer shall receive fifty (50%) percent of the gross billings received by the Agency. Gross billings shall be defined to include all payments from licensings, holding fees, and interest on late payments, but shall not include service fees. Gross billings shall be reduced by actual bad debts and the reasonable cost of currency conversions. Volume discounts shall be allowed only as follows ______. The Agency shall

make all payments due the Photographer at the time of giving the accountings required by Paragraph 11.

11. Accountings. Commencing as of the date of this Agreement, the Agency shall report every _____ months to the Photographer. The report shall be given by the _____ day of the following month after the close of the period accounted for. The accounting shall show for that period each Photograph licensed, the client, the license of rights, the date of receipt of payment, the gross billing, and any reductions in the gross billing.

- **12. Right of Inspection.** The Photographer shall, upon the giving of written notice, have the right to inspect the Agency's books of account to verify the accountings. If errors in any such accounting are found to be to the Photographer's disadvantage and represent more than five (5%) percent of the payment to the Photographer pursuant to the said accounting, the cost of inspection shall be paid by the Agency which shall immediately remit to the Photographer all payments due plus interest at the current prime rate.
- **13. Term**. The term shall be _____ years from the date of entering into this Agreement. Sixty (60) days prior to the end of the initial or any subsequent term the Agency shall notify the Photographer if it wishes to renew for an additional term of _____ years. If the Photographer does not reject such additional term by written notice to the Agency prior to the end of the present term, in which case this Agreement shall terminate, then such additional term shall be subject to the terms and conditions of this Agreement.
- 14. Termination. The Photographer shall have the right to terminate this Agreement by written notice: (1) if the Agency fails to make payments pursuant to Paragraph 10; (2) if the Agency fails to give statements of account pursuant to Paragraph 11; (3) if the Agency otherwise defaults in its obligations hereunder and does not, within ten (10) days of receiving notice from the Photographer, cure such default; (4) if the Agency fails to generate \$______ of gross receipts during any twelve-month period; or (5) by rejecting the Agency's offer given sixty (60) days prior to the end of a term to continue for an additional term, in which case the termination shall be as of the last day of the existing term. The Photographer's personal representative shall have the right to terminate this Agreement by written notice in the event of the Photographer's death or incompetency. This Agreement shall automatically terminate in the event of the Agency's insolvency, filing of a petition in bankruptcy or for reorganization, assignment of assets for the benefit of creditors, or appointment of a trustee or similar custodian for all or part of the Agency's property. In the event of termination of the Agreement, the Agency shall immediately cease its licensing activities and all Photographs shall be returned as provided in Paragraph 15.
- **15.** Retrieval of Photographs. The Agency shall file and maintain the Photographs indexed by the Photographer's name so that any Photograph may be located within ______ days of Photographer's request and returned to the Photographer within ______ days of such request. In the event of termination pursuant to Paragraph 14, the Agency shall return the Photographs within ______ months for Photographs in the files of the Agency and ______ months for Photographs at the Agency during regular working hours upon the giving of reasonable notice and may retrieve such Photographs as the Agency has failed to return in a timely manner. During the term of this Agreement, the Photographer shall have the right to retrieve the Photographs for purposes including but not limited to self-promotion and exhibitions. If the Agency is unable to return Photographs held by clients within the specified time period after termination, it shall continue its efforts and, in addition, give the Photographs.
- 16. Warranty and Indemnity. The Photographer warrants and represents that he or she is the sole creator of the Work and owns all rights to be licensed by the Agency under this Agreement, that the Work does not infringe any other person's copyrights or rights of literary property, nor, to his or her knowledge, does it violate the rights of privacy of, or libel, other persons. The Photographer agrees to indemnify the Agency against any final judgment for damages (after all appeals have been exhausted) in any lawsuit based on an actual breach of the foregoing warranties. In addition, the Photographer shall pay the Agency's reasonable costs and attorney's fees incurred in defending such a lawsuit, unless the Photographer chooses to retain his or her own attorney to defend such lawsuit. The Photographer makes no warranties and shall have no obligation to indemnify the Agency with respect to materials inserted in the Work by a party other than the Photographer. Notwithstanding any of the foregoing, in no event shall the Photographer under this Agreement, whichever is the lesser. In the event a lawsuit is brought which may result in the Photographer having breached his or her warranties under this Paragraph, the Agency shall have the right to withhold and place in an escrow account _______ percent of sums payable to the Photographer having breached his or her warranties under this paragraph, the Agency shall have the right to withhold and place in an escrow account _______ percent of sums payable to the Photographer having breached his or her warranties under the damages alleged in the complaint.

- **17.** Litigation. In the event of the loss, damage, or infringement of any of the Photographs accepted by the Agency, the Agency and the Photographer shall have the right to sue jointly and, after deducting the expenses of bringing suit, to share equally in any recovery. If the Photographer chooses not to join in the suit, the Agency may proceed and, after deducting all the expenses of bringing the suit, any recovery shall be shared equally between the parties. If the Agency chooses not to join in the suit, the Photographer may proceed and, after deducting all the expenses of bringing the suit, any recovery shall be shared: _____ percent to the Photographer and ___ percent to the Agency.
- 18. Relationship of Parties. The Photographer and Agency are independent contractors and nothing contained herein shall be construed to be inconsistent with this independent contractor relationship.
- **19.** Promotion. The Photographer consents to the use without charge of the Photographs in brochures, advertisements, and other promotions of the Agency reasonably designed to enhance the marketing of the Photographs, and the Photographer further consents to the use of his or her name, portrait, or picture in connection with the promotion and advertising of the Photographs, provided such use is dignified and consistent with the Photographer's reputation.
- 20.Arbitration. All disputes arising under this Agreement shall be submitted to binding arbitration before in the following location and

shall be settled in accordance with the rules of the American Arbitration Association. Judgment upon the arbitration award may be entered in any court having jurisdiction thereof.

- **21.** Assignment. This Agreement may not be assigned by either party without the written consent of the other party hereto, except that the Photographer shall retain the right to assign payments due hereunder without obtaining the Agency's consent.
- **22.Notice.** Where written notice is required hereunder, it may be given by use of certified mail, return receipt requested, addressed to the Photographer or Agency at the addresses given at the beginning of this Agreement. Said addresses for notice may be changed by giving written notice of any new address to the other party.
- 23. Miscellany. This Agreement shall be binding on the parties and their respective heirs, representatives, administrators, successors and assigns. This Agreement constitutes the entire understanding between the parties. Its terms can be modified only by an instrument in writing signed by both parties. Any waiver of a breach or default hereunder shall not be deemed a waiver of a subsequent breach or default of either the same provision or any other provision of this Agreement. This Agreement shall be governed by the laws of the State of_____

Photographer _____ Agency _____

Company Name

By___

Authorized Signatory, Title

Contract with an Independent Contractor

Photographers often hire independent contractors, such as a first assistant, second assistant, stylist, stylist's assistant, location scout, set builder, or carpenter. Independent contractors run their own businesses and hire out on a job by job basis. They are not employees, which saves the photographer in terms of employee benefits, payroll taxes, and paperwork. By not being an employee, the independent contractor does not have to have taxes withheld and is able to deduct all business expenses directly against income.

A contract with an independent contractor serves two purposes. First, it shows the intention of the parties to have the services performed by an independent contractor. Second, it shows the terms on which the parties will do business.

As to the first purpose of the contract — showing the intention to hire an independent contractor, not an employee, the contract can be helpful if the Internal Revenue Service (IRS) decides to argue that the independent contractor was an employee. The tax law automatically classifies as independent contractors physicians, lawyers, general building contractors, and others who follow an independent trade, business, or profession, in which they offer their services to the public on a regular basis. However, many people don't fall clearly into this group. Since IRS reclassification from independent contractor to employee can have harsh consequences for the hiring party, including payment of back employment taxes, penalties, and jeopardy to qualified pension plans, the IRS has promulgated guidelines for who is an employee.

Basically, an employee is someone who is under the control and direction of the employer to accomplish work. The employee is not only told what to do, but how to do it. On the other hand, an independent contractor is controlled or directed only as to the final result, not as to the means and method to accomplish that result. Some twenty factors enumerated by the IRS dictate the conclusion as to whether someone is an employee or an independent contractor, and no single factor is controlling. Factors suggesting someone is an independent contractor would include that the person supplies his or her own equipment and facilities; that the person works for more than one party (and perhaps employs others at the same time); that the person can choose the location to perform the work; that the person is not supervised during the assignment; that the person receives a fee or commission rather than an hourly or weekly wage; that the person can make a loss or a profit; and that the person can be forced to terminate the job for poor performance but cannot be dismissed like an employee. The photographer should consult his or her accountant to resolve any doubts about someone's status.

The second purpose of the contract is to specify the terms agreed to between the parties. What services will the contractor provide and when will the services be performed? On what basis and when will payment be made by the photographer? Will there be an advance, perhaps to help defray expenses?

The photographer should consult with his or her insurance agent with respect to the insurance the photographer should carry when dealing with independent contractors. Certainly the photographer should make sure there is adequate coverage for property damage or liability arising from lawsuits for injuries. The contractor should definitely have its own liability policy as well as workers' compensation and any state disability coverage.

Independent contractors can perform large

jobs or render a day's services. Form 20 is designed to help photographers deal with small independent contractors who are performing a limited amount of work. The negotiation checklist is also directed toward this situation, such as hiring an assistant, stylist, or carpenter. However, some further discussion is necessary to cover the issues arising when the photographer has a larger project to complete, such as a major studio renovation.

If the photographer were dealing with a substantial renovation to the studio or other construction, the contract would have to be more complex. First, it's always wise to have references for a contractor who is new to the photographer. Keep deposits small, since it can be hard to get a deposit back if the contractor doesn't perform. There should also be clarity as to the quality and perhaps even the brands of any materials to be used.

The contractor can be asked to post a surety bond, which is a bond to guarantee full performance. However, many small contractors may have difficulty obtaining such a bond, since the insurance company may require the posting of collateral. In any event, the photographer might explore with his or her own insurance agent the feasibility of demanding this from the contractor. A point to keep in mind is that the contractor's failure to pay subcontractors or suppliers of material can result in a lien against the photographer's property for work done to that property. A lien is like a mortgage on a building; it must be satisfied or removed before the property can be sold. A surety bond would avoid problems with liens.

A contractor should be required to give a bid. That bid will be the basis for the terms of the contract. The contractor may want to wait until after completing the work to determine a fee. Obviously this is unacceptable. The contractor may want to charge a fee for labor, but charge cost plus a markup for materials. This is probably also unacceptable, since the photographer has a budget and needs to know that budget can be met. Another variation is for the contractor to allow for a ten percent variation in the bid or the costs of materials based on what actually happens. This should be carefully evaluated by the photographer, but is less desirable than a firm fee.

The fee and the job description should only be modified by a written amendment to the contract. If this isn't required, disputes are likely to result.

The photographer should, if possible, require the contractor to warrant a number of facts, such as the contractor being licensed if necessary, the materials being new and of good quality, the contractor being responsible for any damages arising from its work, and any construction being guaranteed for some period of time. The contractor would agree to protect the photographer (by paying losses, damages, and any attorney's fees) in the event any of these warranties were breached.

Keep in mind that Form 20 is designed for day-to-day dealings with freelancers, not the hiring of builders for major renovations.

Filling in the Form

In the preamble fill in the date and the names and addresses of the parties. In Paragraph 1 show in detail what services are to be performed. Attach another sheet of description or a list of procedures, diagram, or a plan to the contract, if needed. In Paragraph 2 give a schedule. In Paragraph 3 deal with the fee and expenses. In Paragraph 4 specify a time for payment. In Paragraph 5 indicate how cancellations will be handled. In Paragraph 6(E) fill in any special criteria that the contractor should warrant as true. In Paragraph 7 fill in any insurance the contractor must carry. In Paragraph 10 specify who will arbitrate, where the arbitration will take place, and, if a local small claims court would be better than arbitration, give amounts under the small claims court dollar limit as an exclusion from arbitration. In Paragraph 11 give the state whose laws will govern the contract. Have both parties sign the contract.

Negotiation Checklist

- Carefully detail the services to be performed. If necessary, attach an additional sheet of description, a list of procedures, or a plan or diagram. (Paragraph 1)
- Give a schedule for performance. (Paragraph 2)
- □ State the method for computing the fee. (Paragraph 3)
- □ If the contractor is to bill for expenses, limit which expenses may be charged. (Paragraph 3)
- Require full documentation of expenses in the form of receipts and invoices. (Paragraph 3)
- □ Place a maximum amount on the expenses that can be incurred. (Paragraph 3)
- Pay an advance against expenses, if the amount of the expenses are too much for the contractor to wait to receive back at the time of payment for the entire job. (Paragraph 3)
- □ State a time for payment. (Paragraph 4)
- Deal with payment for cancellations. (Paragraph 5)
- □ If expenses are billed for, consider whether any markup should be allowed.
- Require warranties that the contractor is legally able to perform the contract, that all services will be done in a professional manner, that any subcontractor or employee hired by the contractor will be professional, that the contractor will pay all taxes for the contractor and his or her employees, and any other criteria for the proper performance of the services. (Paragraph 6)

- Review insurance coverage with the photographer's insurance agent.
- Specify what insurance coverage the contractor must have. (Paragraph 7)
- □ State that the parties are independent contractors and not employer-employee. (Paragraph 8)
- Do not allow assignment of rights or obligations under the contract. (Paragraph 9)
- □ The photographer should check with his or her attorney as to whether arbitration is better than suing in the local courts, and whether small claims court might be better than arbitration. (Paragraph 10)
- Allow for an oral modification of either the fee or expense agreement, if such oral change is necessary to move the project forward quickly. (Paragraph 11)
- □ Compare Paragraph 11 with the standard provisions in the introduction.

AGREEMENT entered into as of the		(hereinafter referred to as the "	'Photographer") and
hereinafter referred to as the "Contractor"			
he Parties hereto agree as follows:			
I. Services to be Rendered. The Co	ontractor agree:	s to perform the following services fo	or the Photographe
If needed, a list of procedures, diagram	n, or plan for the s	ervices shall be attached to and made pa	art of this Agreement
Schedule. The Contractor shall complet	e the services pu	rsuant to the following schedule	
 Day rate \$ Travel days \$ Weather days Other The Photographer shall reimburse the stall reimburse the stall	/ day \$/ day	\$ Ily for the expenses listed here	
•	vance of \$a	provide full documentation for any expens against expenses shall be paid to the Cont	
• Payment. Payment shall be made: □ days of Photographer's receipt of Con			t 🗅 within thirty (30)
5. Cancellation. In the event of cancella stances and in the amount specified		her shall pay a cancellation fee under t	
6. Warranties. The Contractor warrants a	as follows:		
(B) All services shall be performed in(C) If employees or subcontractors a	n a professional are to be hired b local, state, or	its obligations pursuant to this Agreen manner. by Contractor they shall be competent federal taxes, including but not limited t	professionals. o withholding taxes

(E) Any other criteria for performance are as follows:

- 7. Insurance. The Contractor shall maintain in force the following insurance____
- 8. Relationship of Parties. Both parties agree that the Contractor is an independent contractor. This Agreement is not an employment agreement, nor does it constitute a joint venture or partnership between the Photographer and Contractor. Nothing contained herein shall be construed to be inconsistent with this independent contractor relationship.
- **9.** Assignment. This Agreement may not be assigned by either party without the written consent of the other party hereto.
- **10. Arbitration.** All disputes shall be submitted to binding arbitration before ______ in the following location ______ and settled in accordance with the rules of the American Arbitration Association. Judgment upon the arbitration award may be entered in any court having jurisdiction thereof. Disputes in which the amount at issue is less than \$_____ shall not be subject to this arbitration provision.
- 11. Miscellany. This Agreement constitutes the entire agreement between the parties. Its terms can be modified only by an instrument in writing signed by both parties, except that oral authorizations of additional fees and expenses shall be permitted if necessary to speed the progress of work. This Agreement shall be binding on the parties, their heirs, successors, assigns, and personal representatives. A waiver of a breach of any of the provisions of this Agreement shall not be construed as a continuing waiver of other breaches of the same or other provisions hereof. This Agreement shall be governed by the laws of the State of ______.

IN WITNESS WHEREOF, the parties hereto have signed this as of the date first set forth above.

Photographer___

_____ Contractor___

Ву_____

Company Name

Authorized Signatory

Permission Form

^{FORM}

Some projects require obtaining permission from the owners of copyrighted materials such as illustrations, paintings, articles, or books. The photographer ignores obtaining such permissions at great peril. Not only is it unethical to use someone else's work without permission, it can also lead to liability for copyright infringement and breach of contract.

Of course, some copyrighted works have entered the public domain, which means that they can be freely copied by anyone. For works published by United States authors on or before December 31, 1977, the maximum term of copyright protection was 75 years. If such a work is more than 75 years old, it should be in the public domain in the United States (but may have a different term of protection in other countries).

For works published on or after January 1, 1978, the term of protection is usually the life of the creator plus 50 years, so these works would only be in the public domain if copyright notice had been omitted or improper. This complicated topic is discussed fully in Legal Guide for the Visual Artist. The absence of a copyright notice on works published between January 1, 1978 and February 28, 1989 (when the United States joined the Berne Copyright Union) does not necessarily mean the work entered the public domain. On or after March 1, 1989, copyright notice is no longer required to preserve copyright protection, although such notice does confer some benefits under the copyright law. A basic rule would be to obtain permission for any work published on or after January 1, 1978, unless the photographer is certain the work is in the public domain.

Fair use offers another way in which the photographer may avoid having to obtain a permission, even though the work is protected by a valid copyright. The copyright law states that copying "for purposes such as criticism, comment, news reporting, teaching (including multiple copies for classroom use), scholarship, or research, is not an infringement of copyright." To evaluate whether a use is a fair use depends on four factors set forth in the law: "(1) the purpose and character of the use, including whether such use is of a commercial nature or is for nonprofit educational purposes; (2) the nature of the copyrighted work; (3) the amount and substantiality of the portion used...and (4) the effect of the use upon the potential market for or value of the copyrighted work." These guidelines have to be applied on a case-by-case basis. If there is any doubt, it is best to seek permission to use the work.

One obstacle to obtaining permissions is locating the person who owns the rights. A good starting point, of course, is to contact the publisher of the material, since the publisher may have the right to grant permissions. If the owner's address is available, the owner can be contacted directly. In some cases, permissions may have to be obtained from more than one party. Authors' societies and agents may be helpful in tracking down the owners of rights.

For an hourly fee, the Copyright Office will search its records to aid in establishing the copyright status of a work. Copyright Office Circular R22, "How to Investigate the Copyright Status of a Work," explains more fully what the Copyright Office can and cannot do. Circulars and forms can be ordered from the Copyright Office by calling (202) 707-9100.

Obtaining permissions can be time-consuming, so starting early in a project is wise. A log should be kept of each request for a permission. In the log, each request is given a number. The log describes the material to be used, lists the name and address of the owner of the rights, shows when the request was made and when any reply was received, indicates if a fee must be paid, and includes any special conditions required by the owner.

Fees may very well have to be paid for certain

permissions. The standard book publishing agreement does not provide for the publisher to pay these fees, although the photographer can negotiate for such a contribution. Also, publisher's agreements usually make the photographer liable if lawsuits develop for permissions which should have been obtained by the photographer. In any case, the photographer should keep in mind that permission fees are negotiable and vary widely in amount. For a project that will require many permissions, advance research as to the amount of the fees is a necessity.

Filling in the Form

The form should be accompanied by a cover letter requesting that two copies of the form be signed and one copy returned. The name and address of the photographer, the title of the photographer's book (or other project), and the name of the photographer's publisher or client, should be filled in. Then the nature of the material should be specified, such as text, photograph, illustration, poem, and so on. The source should be described along with an exact description of the material. If available, fill in the date of publication, the publisher, and the author. Any copyright notice or credit line to accompany the material should be shown. State after other provisions any special limitations on the rights granted and also indicate the amount of any fee to be paid. If all the rights are not controlled by the person giving the permission, then that person will have to indicate who else to contact. If more than one person must approve the permission, make certain there are enough signature lines. If the rights are owned by a corporation, add the company name and the title of the authorized signatory. A stamped, self-addressed envelope and a photocopy of the material to be used might make a speedy response more likely.

Negotiation Checklist

- □ State that the permission extends not only to the photographer, but also to the photographer's successors and assigns. Certainly the permission must extend to the photographer's publisher (or client).
- □ Specify how the material will be used, whether for a book, a product, or some other use.
- Describe the material to be used carefully, including a photocopy if that would help.
- Obtain the right to use the material in future editions and revisions, as well as in the present use.
- State that nonexclusive world rights in all languages are being granted.
- □ In an unusual situation, seek exclusivity for certain uses of the material. This form does not seek exclusivity.
- Negotiate a fee, if requested. Whether a fee is appropriate, and its amount, will depend on whether the project is likely to earn a substantial return.
- □ If a fee is paid, add a provision requiring the party giving the permission to warrant that the material does not violate any copyright or other rights and to indemnify the photographer against any losses caused if the warranty is incorrect.
- Keep a log on all correspondence relating to permission forms and be certain one copy of each signed permission has been returned for the photographer's files.

Permission Form

The Undersigned hereby grant(s) permission to	(hereinafter
referred to as the "Photographer"). located at	
and to the Photographer's successors and assigns, to u	use the material specified in this Permission Form for the following
This permission is for the following material:	
Nature of material	
Source	
Exact description of material, including page numbers_	
If published, date of publicati	ion
Publisher	
Author(s)	
This material may be used in the Photographer's bo derivations, editions, or electronic versions thereof, inc	ook, product, or use named above and in any future revisions cluding nonexclusive world rights in all languages.
It is understood that the grant of this permission shall ir or others authorized by the Undersigned.	n no way restrict republication of the material by the Undersigned
If specified here, the material shall be accompanied on pu	ublication by a copyright notice as follows
and a credit line as follows	
Other provisions, if any:	
If specified here, the requested rights are not controlled be contacted:	in their entirety by the Undersigned and the following owners mus
One copy of this Permission Form shall be returned to the	e Photographer and one copy shall be retained by the Undersigned
Authorized Signatory	Date
Authorized Signatory	Date

Nondisclosure Agreement for Submitting Ideas

What can be more frustrating than having a great idea and not being able to share it with anyone? If the idea has commercial value, sharing it is often the first step on the way to realizing the remunerative potential of the concept. The photographer wants to show the idea to a publisher, manufacturer, or producer. But how can the idea be protected?

Ideas are not protected by copyright, because copyright only protects the concrete expression of an idea. The idea to photograph the White House is not copyrightable, while a photograph of the White House certainly is protected by copyright. The idea to have a television series in which each program would have a photographer teach photography by shooting a wellknown landmark in his or her locale is not copyrightable, but each program would be protected by copyright. Of course, copyright is not the only form of legal protection. An idea might be patentable or lead to the creation of a trademark, but such cases are less likely and certainly require expert legal assistance. How does a photographer disclose an idea for an image, a format, a product, or other creations without risking that the listener, or potential business associate, will simply steal the idea?

This can be done by the creation of an express contract, an implied contract (revealed by the course of dealing between the parties), or a fiduciary relationship (in which one party owes a duty of trust to the other party). Form 22, the Nondisclosure Agreement, creates an express contract between the party disclosing the idea and the party receiving it. Form 22 is adapted from a letter agreement in *Licensing Art & Design* by Caryn Leland (Allworth Press).

What should be done if a company refuses to sign a nondisclosure agreement or, even worse, has its own agreement for the photographer to sign? Such an agreement might say that the company will not be liable for using a similar idea and will probably place a maximum value on the idea (such as a few hundred dollars). At this point, the photographer has to evaluate the risk. Does the company have a good reputation or is it notorious for appropriating ideas? Are there other companies, which could be approached with the idea, that would be willing to sign a nondisclosure agreement? If not, taking the risk may make more sense than never exploiting the idea at all. A number of steps, set out in the negotiation checklist, should then be taken to try and gain some protection. The photographer will have to make these evaluations carefully on a case-by-case basis.

Filling in the Form

In the Preamble fill in the date and the names and addresses of the parties. In Paragraph 1 describe the information to be disclosed without giving away what it is. Have both parties sign the agreement.

Negotiation Checklist

- Disclose what the information concerns without giving away what is new or innovative. For example, "an idea for a new format for a series to teach photography" might interest a producer but would not give away the particulars of the idea (i.e., using different photographers teaching at landmarks in different locales). (Paragraph 1)
- □ State that the recipient is reviewing the information to decide whether to embark on commercial exploitation. (Paragraph 2)
- □ Require the recipient to agree not to use or transfer the information. (Paragraph 3)

- □ State that the recipient receives no rights in the information. (Paragraph 3)
- Require the recipient to keep the information confidential. (Paragraph 4)
- □ State that the recipient acknowledges that disclosure of the information would cause irreparable harm to the photographer. (Paragraph 4)
- Require good faith negotiations if the recipient wishes to use the information after disclosure. (Paragraph 5)
- Allow no use of the information unless agreement is reached after such good faith negotiations. (Paragraph 5)

If the photographer wishes to disclose the information despite the other party's refusal to sign the photographer's nondisclosure form, the photographer should take a number of steps:

- First, before submission, the idea should be sent to a neutral third party (such as a notary public or professional photography society) to be held in confidence.
- Anything submitted should be marked with copyright and trademark notices, when appropriate. For example, the idea may not be copyrightable, but the written explanation of the idea certainly is. The copyright notice could be for that explanation, but might make the recipient more hesitant to steal the idea.
- □ If an appointment is made, confirm it by letter in advance and sign any log for visitors.
- □ After any meeting, send a letter that covers

what happened at the meeting (including any disclosure of confidential information and any assurances that information will be kept confidential) and, if at all possible, have any proposal or follow-up from the recipient be in writing.

Nondisclosure Agreement for Submitting Ideas

	ereinafter referred to as the "Photographer"), lo	
		(hereinafter referred to as the "Recipient"),
WH Phi WH Infe WH WH	otographer deems confidential (hereinafter re HEREAS, the Recipient is in the business of ormation; and HEREAS, the Photographer wishes to disclos HEREAS, the Recipient is willing not to disclos	e using such Information for its projects and wishes to review the se this Information to the Recipient; and use this Information, as provided in this Agreement. agoing premises and the mutual covenants hereinafter set forth and
1.	Disclosure. Photographer shall disclose to	the Recipient the Information, which concerns
2.	Purpose. Recipient agrees that this disclose its interest in the commercial exploitation of	ure is only for the purpose of the Recipient's evaluation to determine f the Information.
3.	disclosed Information in any way whatsoev	to manufacture, sell, deal in, or otherwise use or appropriate the ver, including but not limited to adaptation, imitation, redesign, or seement shall be deemed to give Recipient any rights whatsoever in
4.	Recipient to others would irreparably damag of this Information, the Recipient shall keep	d agrees that the unauthorized disclosure of the Information by the e the Photographer. As consideration and in return for the disclosure o secret and hold in confidence all such Information and treat the n proprietary property by not disclosing it to any person or entity.
5.	exploitation thereof, Recipient agrees to en	of the evaluation of the Information, Recipient wishes to pursue the nter into good faith negotiations to arrive at a mutually satisfactory unless such an agreement is entered into, this nondisclosure
6.	Miscellany. This Agreement shall be binding legal representatives, successors, and ass	g upon and shall inure to the benefit of the parties and their respective igns.
IN	WITNESS WHEREOF, the parties have sign	ed this Agreement as of the date first set forth above.
	Photographer	Recipient Company Name
		Company Name
		By Authorized Signatory, Title
		- ,

Copyright Transfer Form

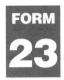

he copyright law defines a transfer of copyright as an assignment "of a copyright or of any of the exclusive rights comprised in a copyright, whether or not it is limited in time or place of effect, but not including a nonexclusive license." A transfer is, in some way, exclusive. The person receiving a transfer has a right to do what no one else can do. For example, the transfer might be of the right to make copies of the work in the form of posters for distribution in the United States for a period of one year. While this transfer is far less than all rights in the copyright, it is nonetheless exclusive within its time and place of effect.

Any transfer of an exclusive right must be in writing, and signed either by the owner of the rights being conveyed or by the owner's authorized agent. While not necessary to make the assignment valid, notarization of the signature is *prima facie* proof that the assignment was signed by the owner or agent.

Form 23 can be used in a variety of situations. If the photographer wanted to receive back rights which had been transferred in the past, the photographer could take an all-rights transfer. If the photographer enters into a contract involving the transfer of an exclusive right, the parties may not want to reveal all the financial data and other terms contained in the contract. Form 23 could then be used as a short form to be executed along with the contract for the purpose of recordation in the Copyright Office. The assignment in Form 23 should conform exactly to the assignment in the contract itself.

Recordation of copyright transfers with the Copyright Office can be quite important. Any transfer should be recorded within thirty days if executed in the United States, or within sixty days if executed outside the United States. Otherwise, a later conflicting transfer, if recorded first and taken in good faith without knowledge of the earlier transfer, will prevail over the earlier transfer. Simply put, if the same exclusive rights are sold twice and the first buyer doesn't record the transfer, it is quite possible that the second buyer who does record the transfer will be found to own the rights.

Any document relating to a copyright, whether a transfer of an exclusive right or only a nonexclusive license, can be recorded with the Copyright Office. Such recordation gives constructive notice to the world about the facts in the document recorded. Constructive notice means that a person will be held to have knowledge of the document even if, in fact, he or she did not know about it. Recordation gives constructive notice only if (1) the document (or supporting materials) identifies the work to which it pertains so that the recorded document would be revealed by a reasonable search under the title or registration number of the work, and (2) registration has been made for the work.

Another good reason to record exclusive transfers is that a nonexclusive license, whether recorded or not, can have priority over a conflicting exclusive transfer. If the nonexclusive license is written and signed and was taken before the execution of the transfer or taken in good faith before recordation of the transfer and without notice of the transfer, it will prevail over the transfer.

A fee must be paid to record documents. Once paid, the Register of Copyrights will record the document and return a certificate of recordation.

Filling in the Form

Give the name and address of the party giving the assignment (the assignor) and the name and address of the party receiving the assignment. Specify the rights transferred. Describe the work or works by title, registration number, and the nature of the work. Date the transfer and have the assignor sign it. If the assignor is a corporation, use a corporate form for the signature.

Negotiation Checklist

- Be certain that consideration (something of value, whether a promise or money) is actually given to the assignor.
- □ Have the transfer benefit the successors in interest of the assignee.
- □ If the photographer is making the transfer, limit the rights transferred as narrowly as possible.
- Describe the works as completely as possible, including title, registration number, and the nature of the work.
- □ Have the assignor or the authorized agent of the assignor sign the assignment.
- Notarize the assignment so that the signature will be presumed valid.
- If the assignment is to the photographer, such as an assignment back to the photographer of rights previously conveyed, an all-rights provision can be used. (See other provisions)

Other Provisions that can be added to Form 23:

Rights transferred. When indicating the rights transferred, the following provision could be used if the photographer is to receive all rights. Obviously, the photographer should avoid giving such a transfer to another party.

Rights Transferred. All right, title, and interest, including any statutory copyright together with the right to secure renewals and extensions of such copyright throughout the world, for the full term of said copyright or statutory copyright and any renewal or extension of same that is or may be granted throughout the world.

OR VALUABLE CONSIDERATION	, the receipt of whic	h is hereby acknowledged,		
nereinafter referred to as the "Assigr				
oes hereby transfer and assign to _				
				ators, a
ssigns, the following rights:			in the	copvria
the works described as follows:				
Title		Registration Number	Nature of Work	
N WITNESS WHEREOF, the Assig	nor has executed			
	Assignor_			

Application for Copyright Registration of Photography

o register photography, the photographer must send a completed Form VA, a \$20 nonrefundable filing fee, and a nonreturnable deposit portraying the photography to be registered. These three items should be sent together to the Register of Copyrights, Copyright Office, Library of Congress, Washington, D.C. 20559.

The instructions for filling in Form VA are provided by the Copyright Office and are reproduced here with Form VA. A Short Form VA may be used by living photographers for work that is new (not previously published or registered), not work for hire, and solely owned by the photographer. Short Form VA and its instructions are also reproduced here.

The Copyright Office also makes available a free Copyright Information Kit. This includes copies of Form VA and other Copyright Office circulars and is worth requesting. To expedite receiving forms or circulars, the Forms and Circulars Hotline number can be used: (202) 707-9100. Photographers with the proper software can download copyright forms from the Copyright Office home page (http://lcweb.loc.gov/copyright).

Because of budget constraints, the Copyright Office will accept reproductions of Form VA such as the tear-out form in this book. If the photographer wishes to make copies, however, the copies must be clear, legible, on a good grade of white paper, and printed on a single sheet of paper so that when the sheet is turned over the top of page 2 is directly behind the top of page 1.

It is wise to register any work that the photographer feels may be infringed. Registration has a number of values, the most important of which is to establish proof that a particular photograph was created by the photographer as of a certain date. Both published and unpublished photographs can be registered. In fact, unpublished photographs can be registered in groups for a single application fee. Published works which appeared as contributions to periodicals may qualify for group registration, in which case Form GR/CP would be used with Form VA. For published photographs, the proper deposit is usually two complete copies of the work. For unpublished photographs, one complete copy would be correct. Since the purpose of registering is to protect what the photographer has created, it is important that the material deposited fully show what is copyrightable.

Obviously, unique transparencies cannot be sent along with the application for purposes of identifying themselves, so the Copyright Office accepts other identifying materials. These are usually contact sheets, photographs, photostats, slides, drawings, or other two-dimensional representations of the work. The photographer should provide as much identifying material as is necessary to show the copyrightable content of the photographs, including any copyright notice which has been used. The proper form for presenting notice of copyright is © or Copyright or Copr., followed by the photographer's name, and the year of first publication. However, as discussed with respect to Form 21 the absence of a copyright notice is not such a problem as it once was.

The preferable size for identifying materials (other than transparencies) is 8×10 inches, but anything from 3×3 inches to 9×12 inches will be acceptable. Also, at least one piece of the identifying material must give an exact measurement of one or more dimensions of the work and give the title on its front, back, or mount.

For a full review of registration and its requirements, the photographer can consult Copyright Office Circular 40, *Copyright Registration for Works* of the Visual Arts, and Circular 40a, Deposit Requirements of Claims to Copyright in Visual Arts Material.

A copyright registration is effective as of the date that the Copyright Office receives the application, fee, and deposit materials in an acceptable form, regardless of how long it takes to send back the certificate of registration. It may take 120 days before the certificate of registration is sent to the photographer. To ensure that the Copyright Office receives the materials, the photographer should send them by registered or certified mail with a return receipt requested from the post office. A photographer can request information as to the status of an application. However, a fee will be charged by the Copyright Office if such a status report must be given within 120 days of the submission of the application.

For a more extensive discussion of the legal aspects of copyright, the photographer can consult *Legal Guide for the Visual Artist.*

PACA Copyright Commandments

The Picture Agency Council of America (PACA) has developed a ten-point list to ensure professional handling of copyrighted photographs. The PACA Copyright Commandments appear here by permission of PACA.

- 1. When it's created, it's copyrighted. Use the copyright notice.
- 2. The photographer or his/her agency has the exclusive right to exploit the copyright in each image. That right is for the life of the photographer plus 50 years.
- 3. Permission to use a copyrighted photograph for any purpose whatsoever must be obtained in advance in writing to avoid possible violation of the federal law on copyright.
- 4. Any unauthorized use of a photograph constitutes an infringement.
- 5. *Penalties for infringement are monetary and can be severe.*
- 6. Combining, altering or scanning photographs or any part thereof, including electronically, is an exclusive right held by the photographer and permission to combine or alter should be obtained in writing prior to any such changes or uses.
- 7. Exceeding the terms of a license has been held to be an infringement. A new license is required prior to additional use.

- 8. An artist's rendering of a photograph in another medium is a derivative use of an image and does require the written permission of the copyright owner prior to use.
- 9. Re-creating a copyrighted photograph is a derivative use and therefore requires the permission of the copyright holder of the original image.
- 10. Reference use of a photograph or any part thereof requires the permission of the copyright holder.

Filling Out Application Form VA

Detach and read these instructions before completing this form. Make sure all applicable spaces have been filled in before you return this form.

BASIC INFORMATION

When to Use This Form: Use Form VA for copyright registration of published or unpublished works of the visual arts. This category consists of "pictorial, graphic, or sculptural works," including two-dimensional and three-dimensional works of fine, graphic, and applied art, photographs, prints and art reproductions, maps, globes, charts, technical drawings, diagrams, and models.

What Does Copyright Protect? Copyright in a work of the visual arts protects those pictorial, graphic, or sculptural elements that, either alone or in combination, represent an "original work of authorship." The statute declares: "In no case does copyright protection for an original work of authorship extend to any idea, procedure, process, system, method of operation, concept, principle, or discovery, regardless of the form in which it is described, explained, illustrated, or embodied in such work."

Works of Artistic Craftsmanship and Designs: "Works of artistic craftsmanship" are registrable on Form VA, but the statute makes clear that protection extends to "their form" and not to "their mechanical or utilitarian aspects." The "design of a useful article" is considered copyrightable "only if, and only to the extent that, such design incorporates pictorial, graphic, or sculptural features that can be identified separately from, and are capable of existing independently of, the utilitarian aspects of the article."

Labels and Advertisements: Works prepared for use in connection with the sale or advertisement of goods and services are registrable if they contain "original work of authorship." Use Form VA if the copyrightable material in the work you are registering is mainly pictorial or graphic; use Form TX if it consists mainly of text. NOTE: Words and short phrases such as names, titles, and slogans cannot be protected by copyright, and the same is true of standard symbols, emblems, and other commonly used graphic designs that are in the public domain. When used commercially, material of that sort can sometimes be protected under state laws of unfair competition or under the Federal trademark laws. For information about trademark registration, write to the Commissioner of Patents and Trademarks, Washington, D.C. 20231. Architectural Works: Copyright protection extends to the design of buildings created for the use of human beings. Architectural works created on or after December 1, 1990, or that on December 1, 1990, were unconstructed and embodied only in unpublished plans or drawings are eligible. Request Circular 41 for more information.

Deposit to Accompany Application: An application for copyright registration must be accompanied by a deposit consisting of copies representing the entire work for which registration is to be made.

Unpublished Work: Deposit one complete copy.

Published Work: Deposit two complete copies of the best edition.

Work First Published Outside the United States: Deposit one complete copy of the first foreign edition.

Contribution to a Collective Work: Deposit one complete copy of the best edition of the collective work.

The Copyright Notice: For works first published on or after March 1, 1989, the law provides that a copyright notice in a specified form "may be placed on all publicly distributed copies from which the work can be visually perceived." Use of the copyright notice is the responsibility of the copyright owner and does not require advance permission from the Copyright Office. The required form of the notice for copies generally consists of three elements: (1) the symbol "©", or the word "Copyright," or the abbreviation "Copr."; (2) the year of first publication; and (3) the name of the owner of copyright. For example: "© 1995 Jane Cole." The notice is to be affixed to the copies "in such manner and location as to give reasonable notice of the claim of copyright." Works first published prior to March 1, 1989, **must** carry the notice or risk loss of copyright protection.

For information about notice requirements for works published before March 1, 1989, or other copyright information, write: Information Section, LM-401, Copyright Office, Library of Congress, Washington, D.C. 20559-6000.

LINE-BY-LINE INSTRUCTIONS Please type or print using black ink.

SPACE 1: Title

Title of This Work: Every work submitted for copyright registration must be given a title to identify that particular work. If the copies of the work bear a title (or an identifying phrase that could serve as a title), transcribe that wording *completely* and *exacily* on the application. Indexing of the registration and future identification of the work will depend on the information you give here. For an architectural work that has been constructed, add the date of construction after the title; if unconstructed at this time, add "not yet constructed."

Previous or Alternative Titles: Complete this space if there are any additional titles for the work under which someone searching for the registration might be likely to look, or under which a document pertaining to the work might be recorded.

Publication as a Contribution: If the work being registered is a contribution to a periodical, serial, or collection, give the title of the contribution in the "Title of This Work" space. Then, in the line headed "Publication as a Contribution, give information about the collective work in which the contribution appeared.

Nature of This Work: Briefly describe the general nature or character of the pictorial, graphic, or sculptural work being registered for copyright. Examples: "Oil Painting"; "Charcoal Drawing"; "Etching"; "Sculpture"; "Map"; "Photograph"; "Scale Model"; "Lithographic Print"; "Jewelry Design"; "Fabric Design."

2 SPACE 2: Author(s)

General Instruction: After reading these instructions, decide who are the "authors" of this work for copyright purposes. Then, unless the work is a "collective work," give the requested information about every "author" who contributed any appreciable amount of copyrightable matter to this version of the work. If you need further space, request Continuation Sheets. In the case of a collective work, such as a catalog of paintings or collection of cartoons by various authors, give information about the author of the collective work as a whole.

Name of Author: The fullest form of the author's name should be given. Unless the work was "made for hire," the individual who actually created the work is its "author." In the case of a work made for hire, the statute provides that "the employer or other person for whom the work was prepared is considered the author."

What is a "Work Made for Hire"? A "work made for hire" is defined as: (1) "a work prepared by an employee within the scope of his or her employment"; or (2) " a work specially ordered or commissioned for use as a contribution to a collective work, as a part of a motion picture or other audiovisual work, as a translation, as a supplementary work, as a compilation, as an instructional text, as a test, as answer material for a test, or as an atlas, if the parties expressly agree in a written instrument signed by them that the work shall be considered a work made for hire." If you have checked "Yes" to indicate that the work was "made for hire," you must give the full legal name of the employer (or other person for whom the work was prepared). You may also include the name of the employee along with the name of the employer (for example: "Elster Publishing Co., employer for hire of John Ferguson").

"Anonymous" or "Pseudonymous" Work: An author's contribution to a work is "anonymous" if that author is not identified on the copies or phonorecords of the work. An author's contribution to a work is "pseudonymous" if that author is identified on the copies or phonorecords under a fictitious name. If the work is "anonymous" you may: (1) leave the line blank; or (2) state "anonymous" on the line; or (3) reveal the author's identity. If the work is "pseudonym mous" you may: (1) leave the line blank; or (2) give the pseudonym and identify it as such (for example: "Huntley Haverstock, pseudonym"; or (3) reveal the author's name, making clear which is the real name and which is the pseudonym (for example: "Henry Leek, whose pseudonym is Priam Farrel"). However, the citizenship or domicile of the author **must** be given in all cases.

Dates of Birth and Death: If the author is dead, the statute requires that the year of death be included in the application unless the work is anonymous or pseudonymous. The author's birth date is optional but is useful as a form of identification. Leave this space blank if the author's contribution was a "work made for hire."

Author's Nationality or Domicile: Give the country of which the author is a citizen or the country in which the author is domiciled. Nationality or domicile **must** be given in all cases.

Nature of Authorship: Catagories of pictorial, graphic, and sculptural authorship are listed below. Check the box(es) that best describe(s) each author's contribution to the work.

3-Dimensional sculptures: fine art sculptures, toys, dolls, scale models, and sculptural designs applied to useful articles.

2-Dimensional artwork: watercolor and oil paintings; pen and ink drawings; logo illustrations; greeting cards; collages; stencils; patterns; computer graphics; graphics appearing in screen displays; artwork appearing on posters, calendars, games, commercial prints and labels, and packaging, as well as 2dimensional artwork applied to useful articles.

Reproductions of works of art: reproductions of preexisting artwork made by, for example, lithography, photoengraving, or etching.

Maps: cartographic representations of an area such as state and county maps, atlases, marine charts, relief maps, and globes.

Photographs: pictorial photographic prints and slides and holograms.

Jewelry designs: 3-dimensional designs applied to rings, pendants, earrings, necklaces, and the like.

Designs on sheetlike materials: designs reproduced on textiles, lace, and other fabrics; wallpaper; carpeting; floor tile; wrapping paper; and clothing.

Technical drawings: diagrams illustrating scientific or technical information in linear form such as architectural blueprints or mechanical drawings.

Text: textual material that accompanies pictorial, graphic, or sculptural works such as comic strips, greeting cards, games rules, commercial prints or labels, and maps.

Architectural works: designs of buildings, including the overall form as well as the arrangement and composition of spaces and elements of the design. NOTE: Any registration for the underlying architectural plans must be applied for on a separate Form VA, checking the box "Technical drawing."

3 SPACE 3: Creation and Publication

General Instructions: Do not confuse "creation" with "publication." Every application for copyright registration must state "the year in which creation of the work was completed." Give the date and nation of first publication only if the work has been published.

Creation: Under the statute, a work is "created" when it is fixed in a copy orphonorecord for the first time. Where a work has been prepared over a period of time, the part of the work existing in fixed form on a particular date constitutes the created work on that date. The date you give here should be the year in which the author completed the particular version for which registration is now being sought, even if other versions exist or if further changes or additions are planned.

Publication: The statute defines "publication" as "the distribution of copies or phonorecords of a work to the public by sale or other transfer of ownership, or by rental, lease, or lending"; a work is also "published" if there has been an "offering to distribute copies or phonorecords to a group of persons for purposes of further distribution, public performance, or public display." Give the full date (month, day, year) when, and the country where, publication first occurred. If first publication took place simultaneously in the United States and other countries, it is sufficient to state "U.S.A."

4 SPACE 4: Claimant(s)

Name(s) and Address(es) of Copyright Claimant(s): Give the name(s) and address(es) of the copyright claimant(s) in this work even if the claimant is the same as the author. Copyright in a work belongs initially to the author of the work (including, in the case of a work make for hire, the employer or other person for whom the work was prepared). The copyright claimant is either the author of the work or a person or organization to whom the copyright initially belonging to the author has been transferred.

Transfer: The statute provides that, if the copyright claimant is not the author, the application for registration must contain "a brief statement of how the claimant obtained ownership of the copyright." If any copyright claimant named in space 4 is not an author named in space 2, give a brief statement explaining how the claimant(s) obtained ownership of the copyright. Examples: "By written contract"; "Transfer of all rights by author"; "Assignment"; "By will." Do not attach transfer documents or other attachments or

5 SPACE 5: Previous Registration

General Instructions: The questions in space 5 are intended to find out whether an earlier registration has been made for this work and, if so, whether

there is any basis for a new registration. As a rule, only one basic copyright registration can be made for the same version of a particular work.

Same Version: If this version is substantially the same as the work covered by a previous registration, a second registration is not generally possible unless: (1) the work has been registered in unpublished form and a second registration is now being sought to cover this first published edition; or (2) someone other than the author is identified as a copyright claimant in the earlier registration, and the author is now seeking registration in his or her own name. If either of these two exceptions apply, check the appropriate box and give the earlier registration number and date. Otherwise, do not submit Form VA; instead, write the Copyright Office for information about supplementary registration or recordation of transfers of copyright ownership.

Changed Version: If the work has been changed and you are now seeking registration to cover the additions or revisions, check the last box in space 5, give the earlier registration number and date, and complete both parts of space 6 in accordance with the instruction below.

Previous Registration Number and Date: If more than one previous registration has been made for the work, give the number and date of the latest registration.

6 SPACE 6: Derivative Work or Compilation

General Instructions: Complete space 6 if this work is a "changed version," "compilation," or "derivative work," and if it incorporates one or more earlier works that have already been published or registered for copyright, or that have fallen into the public domain. A "compilation" is defined as "a work formed by the collection and assembling of preexisting materials or of data that are selected, coordinated, or arranged in such a way that the resulting work as a whole constitutes an original work of authorship." A "derivative work" is " a work based on one or more preexisting works." Examples of derivative works include reproductions of works of art, sculptures based on drawings, lithographs based on paintings, maps based on previously published sources, or "any other form in which a work may be recast, transformed, or adapted." Derivative works also include works "consisting of editorial revisions, annotations, or other modifications" if these changes, as a whole, represent an original work of authorship.

Preexisting Material (space 6a): Complete this space and space 6b for derivative works. In this space identify the preexisting work that has been recast, transformed, or adapted. Examples of preexisting material might be "Grunewald Altarpiece" or "19th century quilt design." Do not complete this space for compilations.

Material Added to This Work (space 6b): Give a brief, general statement of the additional new material covered by the copyright claim for which registration is sought. In the case of a derivative work, identify this new material. Examples: "Adaptation of design and additional artistic work", "Reproduction of painting by photolithography"; "Additional cartographic material"; "Compilation of photographs." If the work is a compilation, give a brief, general statement describing both the material that has been compiled and the compilation itself. Example: "Compilation of 19th century political cartoons."

7,8,9 SPACE 7,8,9: Fee, Correspondence, Certification, Return Address

Deposit Account: If you maintain a Deposit Account in the Copyright Office, identify it in space 7. Otherwise leave the space blank and send the fee of \$20 with your application and deposit.

Correspondence (space 7): This space should contain the name, address, area code, and telephone number of the person to be consulted if correspondence about this application becomes necessary.

Certification (space 8): The application cannot be accepted unless it bears the date and the handwritten signature of the author or other copyright claimant, or of the owner of exclusive right(s), or of the duly authorized agent of the author, claimant, or owner of exclusive right(s).

Address for Return of Certificate (space 9): The address box must be completed legibly since the certificate will be returned in a window envelope.

PRIVACY ACT ADVISORY STATEMENT Required by the Privacy Act of 1974 (P.L. 93 - 579) The authority for requesting this information is tille 17, U.S.C., secs. 409 and 410. Furnishing the requested information is voluntary. But if the information is not furnished, it may be necessary to delay or refuse registration and you may not be entitled to certain relief, remedies, and benefits provided in chapters 4 and 5 of title 17, U.S.C. The principal uses of the requested information are the establishment and maintenance of a public

The principal uses of the requested information are the establishment and maintenance of a public record and the examination of the application for compliance with legal requirements. Other routine uses include public inspection and copying, preparation of public indexes, preparation of public catalogs of copyright registrations, and preparation of search reports upon request.

of public caladegs of copyright registrations, and preparation of search reports upon request. NOTE: No other advisory statement will be given in connection with this application. Please keep this statement and refer to if we communicate with your regarding this application.

						1 VA the Visual Arts ES COPYRIGHT	OFFICE
					REGISTRATION	NUMBER	
						and the second	/AU
					EFFECTIVE DAT	E OF REGISTRAT	ION
					Month	Day	Year
	DO NOT WRITE ABOVE THIS L	NE. IF YOU NE	ED MORE SPACE, US	SE A SEPARATE (CONTINUATION	N SHEET.	
1	TITLE OF THIS WORK $lacksquare$				NATURE OF 1	THIS WORK ♥ s	See instructions
	PREVIOUS OR ALTERNATIVE	TITLES V					
	PUBLICATION AS A CONTRIE collective work in which the contribut	BUTION If this v ion appeared.	vork was published as a co Title of Collective Work		dical, serial, or coll	ection, give informa	ation about the
	If published in a periodical or serial gi	ve: Volume ▼	Number V		Issue Date V	On Pa	ages V
2 a	NAME OF AUTHOR ▼				DATES OF BIR Year Born ▼	RTH AND DEAT Year Died	
	Was this contribution to the work a "work made for hire"? □ Yes	AUTHOR'S N Name of Country OR Citizen o	NATIONALITY OR D	OMICILE	WAS THIS AU THE WORK Anonymous?	THOR'S CONT	RIBUTION TO If the answer to either of these questions is "Yes," see detailed
NOTE		Domicile			Pseudonymous?	🗆 Yes 🗌 No	instructions.
NOTE Under the law, the "author" of a "work made for hire" is generally the employer, not	NATURE OF AUTHORSHIP CL 3-Dimensional sc 2-Dimensional ar Reproduction of Design on sheetli	ulpture twork work of art	ox(es). See instruction Map Photograph Jewelry design	 Technical drav Text Architectural 	0		
(see instruc- tions). For any part of this work that was	NAME OF AUTHOR V	544644544545454545454545454545454545454			DATES OF BIR Year Born ▼	RTH AND DEAT Year Died	
'made for hire" check "Yes" in he space provided, give the employer	Was this contribution to the work a	AUTHOR'S N Name of Country OR Citizen o Domicile		OMICILE	THE WORK Anonymous?	THOR'S CONT	If the answer to either of these questions is "Yes," see detailed
or other person for whom the work	NATURE OF AUTHORSHIP CH			18	Pseudonymous?	🗆 Yes 🗌 No	instructions.
was prepared) as "Author" of that part, and leave the space for dates of birth and death blank.	3-Dimensional sc 2-Dimensional ar Reproduction of Design on sheetli	twork work of art	 Map Photograph Jewelry design 	 Technical draw Text Architectural v 			
3 a	YEAR IN WHICH CREATION C WORK WAS COMPLETED THI	DF THIS	DATE AND NATIO Complete this information ONLY if this work has been published.	N OF FIRST PUBL	ICATION OF T		
4	COPYRIGHT CLAIMANT(S) Na the author given in space 2. ▼	ime and address m	nust be given even if the cl	aimant is the same as		TION RECEIVED	
See instructions before completing this space.					ES TWO DEP	OSITS RECEIVE	ED
	TRANSFER If the claimant(s) name space 2, give a brief statement of how					ECEIVED	
	MORE ON BACK · Complete all · See detailed		imbers 5-9) on the reverse sid • Sign the form at line 8		I	Р	DO NOT WRITE HERE

APPLICATION FOR COPYRIGHT REGISTRATION OF PHOTOGRAPHY

		EXAMINED BY	FORM VA
		CHECKED BY	-
			FOR COPYRIGHT OFFICE USE ONLY
c	DO NOT WRITE ABOVE THIS LINE. IF YOU NEED MORE SP	ACE, USE A SEPARATE CONTINUATION SHEET.	
□ Yes □ No a. □ This is the b. □ This is the c. □ This is a c	REGISTRATION Has registration for this work, or for an earlier versi If your answer is "Yes," why is another registration being sought? (Che le first published edition of a work previously registered in unpublished is the first application submitted by this author as copyright claimant. changed version of the work, as shown by space 6 on this application. is "Yes," give: Previous Registration Number ▼ Yea	ck appropriate box) 🔻	-5
DERIVATIV a. Preexisting N	VE WORK OR COMPILATION Complete both space 6a and 6b for Material Identify any preexisting work or works that this work is based	r a derivative work; complete only 6b for a compilation. on or incorporates. ▼	- See instructions
b. Material Ad	dded to This Work Give a brief, general statement of the material that ha	s been added to this work and in which copyright is claimed. 🔻	before completin this space.
			_
		A U. L. Lindle Constants Office arise some and sumber of Account	
	CCOUNT If the registration fee is to be charged to a Deposit Account of Acc	stablished in the Copyright Office, give name and number of Account. ount Number ▼	
Name ▼	CCOUNT If the registration fee is to be charged to a Deposit Account Account Account of	ount Number V	=
Name ▼	Acc	ount Number V	Be sure to give your daytime phor
Name ▼	Acc	ount Number V	
Name ▼ CORRESPOI CERTIFICA [*] check only one author other copyri	Acc DNDENCE Give name and address to which correspondence about this Area Code and Telephone Number ► Area Code and Telephone Number ► Area Code and Telephone Number ► ight claimant cclusive right(s)	ount Number V	give your daytime phor
Name ▼ CORRESPOI CORRESPOI CERTIFICA check only one author other copyri owner of exc of the work ide of the work ide	Acc DNDENCE Give name and address to which correspondence about this Area Code and Telephone Number ► TTION* I, the undersigned, hereby certify that I am the e ▼ right claimant cclusive right(s) agent of	ount Number V	give your daytime phor
CORRESPOI	Acc DNDENCE Give name and address to which correspondence about this Area Code and Telephone Number ► ArTION* I, the undersigned, hereby certify that I am the e ▼ right claimant cclusive right(s) agent of	application should be sent. Name/Address/Apt/City/State/ZIP	give your daytime phor
Name ▼ CORRESPOI CORRESPOI CERTIFICA Check only one author other copyri owner of exc authorized a of the work ide by me in this a Typed or print	Acc DNDENCE Give name and address to which correspondence about this Area Code and Telephone Number ► Area Code and Telephone Number ► Aright claimant I, the undersigned, hereby certify that I am the e ▼ right claimant cclusive right(s) agent of	application should be sent. Name/Address/Apt/City/State/ZIP	give your daytime phor
Name ▼ CORRESPOI CORRESPOI CERTIFICA Check only one author other copyri owner of exc authorized a of the work ide by me in this a Typed or print	Acc DNDENCE Give name and address to which correspondence about this Area Code and Telephone Number ► TION* I, the undersigned, hereby certify that I am the e ▼ right claimant cclusive right(s) agent of	application should be sent. Name/Address/Apt/City/State/ZIP▼ application should be sent. Name/Address/Apt/City/State/ZIP▼ ace 3, do not sign and submit it before that date. Date▶ VOUMUST: Complete all necessary spaces Sign your application in space 8 SEND ALL 3 FLEMENTS The SAME PACKAGE:	give your daytime phor
Name ▼ CORRESPOI CORRESPOI CERTIFICA Check only one author other copyri owner of exc authorized a of the work idd by me in this a Typed or print C Mail Certificate	Acc DNDENCE Give name and address to which correspondence about this Area Code and Telephone Number ► Area Code and Telephone Number ► Aright claimant I, the undersigned, hereby certify that I am the e ▼ right claimant cclusive right(s) agent of	application should be sent. Name/Address/Apt/City/State/ZIP▼	give your daytime phor

March 1995-300,000

INSTRUCTIONS FOR SHORT FORM VA

For pictorial, graphic, and sculptural works

USE THIS FORM IF-

- you are the only author and copyright owner of 1. this work; and
- 2. the work was not made for hire, and
- 3. the work is completely new (does not contain a substantial amount of material that has been previously published or registered or is in the public domain).

If any of the above does not apply, you must use standard Form VA. NOTE: Short Form VA is not appropriate for an anonymous author who does not wish to reveal his or her identity.

Title of This Work

You must give a title. If there is no title, state "UNTITLED." If you are registering an unpublished collection, give the collection title you want to appear in our records (for example: "Jewelry by Josephine, 1995 Volume"). Alternative title: If the work is known by two titles, you also may give the second title. If the work has been published as part of a larger work (including a periodical), give the title of that larger work instead of an alter-native title.

Name and Address of 4 Author/Owner of the Copyright

Give your name and mailing address. (You may include your pseudonym followed by "pseud.") Also, give the nation of which you are a citizen or where you have your domicile (i.e., permanent residence). Please give daytime phone and fax numbers, if available.

Year of Creation

Give the year in which you completed the work you are registering at this time. (A work is "created" when it is "fixed" in a tangible form. Examples: drawn on paper, molded in clay, stored in a computer.)

Publication Δ

If the work has been published (i.e., if copies have been distributed to the public), give the complete date of publication (month, day, and year) and the nation where the publication first took place.

Type of Authorship in This Work

Check the box or boxes that describe the kind of material you are registering. Check only the authorship included in the copy you are sending

MAIL WITH THE FORM-

• a \$20.00 filing fee in the form of a check or money order (no cash) payable to "Register of Copyrights," and

• one or two copies of the work or identifying material consisting of photographs or drawings showing the work. See table below for the requirements for most works. Note: Inquire about the requirements for other works or for any work first published before 1978. Copies submitted become the property of the U.S. Government.

you are registering	And the work is unpublished, send	And the work is <i>published</i> , send
-dimensional artwork in a book, map, oster, or print	one complete copy or identifying material	two copies of the best published edition
dimensional sculpture, T-shirt design	identifying material	identifying material
greeting card, pattern, commercial print r label, fabric, wallpaper	one complete copy or identifying material	one copy of the best published edition
fail everything (application form, cop	1	Register of Copyrights Library of Congress Washington, D.C. 20559-6000

Questions? Call (202) 707-3000 between 8:30 a.m. and 5:00 p.m. Eastern Time, Monday through Friday. For forms, call (202) 707-9100 24 hours a day, 7 days a week.

HOW TO COMPLETE SHORT FORM VA

- Type or print in black ink.
- Be clear and legible. (Your certificate of registration will be copied from your form.)
- Give only the information requested.
- Do not use continuation sheets or any other attachments.

with the application. For example, if you are registering illustrations but have not written the story yet, check only the box for "2-dimensional artwork"

Signature of Author D

Sign the application in black ink.

Person to Contact for Rights and Permissions

This space is optional. You may give the name and address of the person or organization to contact for permission to use the work. You may also provide phone, fax, or e-mail information.

Mail Certificate to O

This space must be completed. Your certificate of registration will be mailed in a window envelope to this address. Also, if the Copyright Office needs to contact you, we will write to this address.

Complete this space only if you currently maintain a deposit account in the Copyright Office.

PRIVACY ACT ADVISORY STATEMENT Required by the Privacy Act of 1974 (P.L. 93-579) The authority for requesting this information is title 17 U.S.C., secs. 409 and 410. Furnishing the requested information is voluntary. But if the information is not furnished, it may be necessary to delay or refuse registration and you may not be entitled to certain relief, remedies, and benefits provided in chapters 4 and 5 of title 17 U.S.C. The principal uses of the requested information are the establishment and maintenance of a public record and the examination of the application for compliance with legal requirements. Other routine uses include public inspection and copying, preparation of public indexes, prepara-tion of public catalogs of copyright registrations, and preparation of search reports upon request. NOTE: No other advisory statement will be given in connection with this application. Please keep this statement and refer to it if we communicate with you regarding this application.

			SHORT FORM VA
			REGISTRATION NUMBER
			VA VAU
			Effective Date of Registration
			Month Day Year
		Examined By	Application Received
			Deposit Received
		Correspondence	One Two
TYPE OR PRINT IN BLACK INK.	DO NOT WRITE		
Title of This W	Vork:		
Alternative title or title of larger	work		
in which this work was pub	lished:		
Name and Ad of Author/O of the Copyr	wner 🦾		
Nationality or dom	vicile		
Phone and Fax num		Phone ()	Fax ()
Year of Crea	ntion: 3		
<i>If work has been publi</i> Date and N of Publica	ation	a. Date(Month) b. Nation	(Month, day, and year all required)
Ty Autho in This V (Check all that	Vork:	3-Dimensional sculpture 2-Dimensional artwork Technical drawing	□ Photograph □ Map □ Jewelry design □ Text □ Architectural work □ Text
Sign of Au	ature thor: 6	I certify that the statements made by me in thi	s application are correct to the best of my knowledge.*
Name and Ad	dress 7	Check here if same as #2 above	
to Contact for Rights Phone and Fax num E mail add	erson		
Permiss	ions:		
Phone and Fax num E-mail add		Phone () E-mail	Fax ()
0			
Name ▼ MAIL			Oeposit Account # Name
CERTIFICATE TO Number/Street/Apartmen	it Number 🔻		-
Certificate will be mailed in window envelope			
		ntation of a material fact in the application for copyright registration p	rovided for by section 409, or in any written statement filed in connection with ± 0.8 . COPYRIGHT OFFICE WWW FORM: 1995

License of Rights License of Electronic Rights

f there is one striking change in the world of photography since Business and Legal Forms for *Photographers* first appeared in 1991, it is the growing importance of electronic rights (electronic works being digitized versions that can be stored or retrieved from such media as computer disks, CD-ROM, computer databases, and network servers). Photographers have always stood to profit by not giving up all rights when dealing with clients. This has been the reason that the battle over work-forhire contracts has been fought with such ferocity in contractual negotiations, legislative proposals, and litigation. The desire of users for extensive rights must constantly clash with the desire of creators to give only limited rights. As work for hire offered the most potent path for users to gain all rights (including rights which such users had no intention or ability to exercise), so electronic rights have become the latest frontier where users seek to extend their domains at the expense of creators.

Forms 25 and 26, the License of Rights and the License of Electronic Rights, have similarities to other forms in this book. Both Form 1, the Assignment Estimate/Confirmation/Invoice, and Form 5, the Book Publishing Contract, effectively license rights, but they do so for works to be created in the future rather than for works that already exist. On the other hand, Forms 17 and 18, the Stock Photography Delivery Memo and the Stock Photography Invoice, contemplate licensing rights in photographs that have already been created. However, the photographer who does not usually sell stock might be reluctant to use these forms.

Forms 25 and 26 seek to maximize the opportunities of the photographer for residual income. To use these forms, of course, the photographer must first limit the rights which he or she grants to the first users of work. Assuming the photographer has retained all usage rights that the initial client did not actually need, that photographer then becomes the potential beneficiary of income from further sales of the work to other users.

Forms 25 and 26 are almost identical. However, for both didactic and practical reasons, the distinction between electronic and nonelectronic rights is important enough to justify two forms. Just as traditional rights have come to have generally accepted definitions and familiar divisions between creators and users as to control and sharing of income, so electronic rights may someday find similar clarification and customary allocation. Today that crystallization is far from a reality. In addition, the constant evolution of new storage and delivery media for electronic works (most recently the Internet) means that definitions must also be adaptable and constantly scrutinized to ascertain accuracy.

An electronic work might first be a computer file, then transmitted as e-mail, then incorporated into a multimedia product (along with text, video, and a sound track), then uploaded to a site on the World Wide Web, and finally downloaded into the computer of someone cruising in cyberspace. Such digital potential for shape-shifting makes contractual restrictions both more challenging to engineer and absolutely essential to negotiate. The License of Rights and the License of Electronic Rights are designed for when a potential user approaches the photographer directly to use work that has already been distributed. That previous distribution might have been in traditional media or, as is becoming ever more likely, in electronic media.

Because many of the concerns with both Forms 25 and 26 are the same as for commissioned works or stock sales, the negotiation checklist refers to the checklists for Forms 1, 17, and 18. One key point addressed in the form is the narrow specification of the nature of the usage as well as the retention of all other rights. When electronic rights are being granted, it is important if possible to try to limit the form of the final use (such as CD-ROM) and whether consumers can make copies (as is possible with material on the World Wide Web).

Filling in the Forms

Fill in the date and the names and addresses for the client and the photographer. In Paragraph 1 describe the work in detail and indicate the form in which it will be delivered. In Paragraph 2 give the delivery date. In Paragraph 3 specify the limitations as to which rights are granted, including the nature of the use (magazine, book, advertising, CD-ROM, etc.), the language, the name of the product or publication, the territory, and the time period of use. In an unusual case, the usage might be specified to be exclusive. Also, give an outside date for the usage to take place, after which the right will terminate. For Form 26, indicate whether consumers may copy the work or whether the electronic rights granted are for display (viewing but not copying) use only. In Paragraph 5 give the fee or the advance against a royalty and how that royalty will be computed. If alteration of the work is permitted, give guidelines for this in Paragraph 7. In Paragraph 8 give a monthly interest charge for late payments. In Paragraph 9 specify the reimbursement value for original transparencies that are lost or damaged. Specify in Paragraph 10 whether the photographer will receive samples. Show in Paragraph 11 whether copyright notice must appear in the photographer's name and in Paragraph 12 whether authorship credit will be given. In Paragraph 14 specify who will arbitrate disputes, where this will be done, and give the maximum amount which can be sued for in small claims court. In Paragraph 15 give the state whose laws will govern the contract. Both parties should then sign the contract.

Negotiation Checklist

- Review the negotiation checklists for Form 1, Form 17, and Form 18.
- □ To limit the grant of rights, carefully specify the type of use (by market or industry), language, name of the product or publication, territory, and time period for the use. (Paragraph 3)
- Since rights are being licensed in preexisting work, do not grant exclusive rights or limit the exclusivity to very narrow and precisely described uses. (Paragraph 3)
- □ If electronic rights are licensed, try to limit the form of final use (such as a particularly named CD-ROM or site on the World Wide Web). (Paragraph 3)
- □ For electronic rights indicate whether consumers or end users may only see a display of the work or will actually have a right to download a copy of the work. (Paragraph 3)
- □ Limit the time period for the use and specify a date by which all usage must be completed and all rights automatically revert to the photographer. (Paragraph 3)
- □ If royalties are to be paid, specify that all rights will revert if the income stream falls below a certain level.

- □ For Form 25, reserve all electronic rights to the photograph (Paragraph 4)
- For Form 26, reserve all traditional (nonelectronic rights) to the photographer. (Paragraph 4)
- □ If royalties are agreed to for Paragraph 5, review pages 41-43 with respect to the computation of royalties in the negotiation checklist for Form 5.
- □ For electronic rights especially, negotiate the right of the client to change the work or combine the work with other works. (Paragraph 7)
- □ Request samples if appropriate. (Paragraph 10)
- □ For Form 26, require the client to use the best available technology to prevent in-fringements.
- □ Review the standard provisions in the introductory pages.

Other provisions which can be added to Forms 25 and 26:

□ Statements of Account. Another problem which could be addressed by Forms 25 and 26 deals with book publishing, but might also apply to other licenses. This is the widely publicized inability of publishers to determine who should receive payments that are sent to the publishers by licensees. This may seem a bizarre problem to the author/photographer who only has one or a few works to license, but for large publishing houses with hundreds or thousands of licensed works the problem is of a different magnitude. Authors and agents have complained that many publishers simply can't keep track of income from licensing. The effect of this failure is that the publishers enrich themselves at the expense of authors. The suggested paragraph below requires that licensees provide certain information that will avoid this problem. The required information is similar to that in the "Subsidiary Rights Payment Advice Form" promulgated by the Book Industry Study Group, Inc. (212 929-1393) in the hope that widespread adoption of the form by publishers will cause licensees to give the needed information for proper accounting.

- □ **Statements of Account**. The payments due pursuant to this license shall be made by Client to Photographer whose receipt of same shall be a full and valid discharge of the Client's obligations hereunder only if accompanied by the following information: (a) amount remitted; (b) check or wire transfer number and date, as well as the bank and account number to which funds were deposited by wire transfer; (c) Client's name as payor; (d) title of the work for which payment is being made; (f) author(s) of the work; (g) the identifying number, if any, for the work, or the ISBN, if any; (g) the period which the payment covers; (h) the reason for the payment, the payment's currency, and the details of any withholdings from the payment (such as for taxes, commissions, or bank charges).
- Minimum Payments. If the license is on a royalty basis, it may be desirable to require that minimum payments be made in order to keep the license in effect. The provision about termination in Paragraph 3 might be reworded as follows:

If the Client does not complete its usage under this Paragraph 3 by the following date_____, or if payments to be made hereunder fall to less than \$_____ every _____ months, all rights granted shall without further notice revert to the Photographer without prejudice to the Photographer's right to retain sums previously paid and collect additional sums due.

License of Rights

cated at				(hereinafter refe	red to as the "Client
	as the "Photographer") aph(s) (hereinafter refer			ensing of certain none	lectronic rights in th
-	k. The Client wishes to I ad which is described as		rtain nonelec	tronic rights in the Worl	< which the Photogr
Title				Number of in	nages
Subject matter					
Form in which work	shall be delivered		omputer file (s	pecify format	
original transpare	ncy (size)	🖵 d	upe (size)	
. Delivery Date. The I	Photographer agrees to c	deliver the	Work within _	days after the sign	ing of this Agreeme
. Grant of Rights. Up in the Work:	oon receipt of full paymer	nt, Photogi	rapher grants	to the Client the followin	g nonelectronic righ
For use as				in the	langua
For the product or p	ublication named				-
In the following territe	pry				
For the following time	e period				
	usage shown above, the				
serial rights only unl	e as a contribution to a ess specified to the cor	ntrary abo	ve.	-	
	complete its usage unde	er this Par	agraph 3 by th	ne following date	
If the Client does not				ert to the Photographe	
If the Client does not all rights granted bu					
all rights granted bu	right to retain sums prev	viously pa	id and collec		
all rights granted but the Photographer's	right to retain sums prev hts. All rights not expres	ssly grant	ed hereunder	are reserved to the Ph	
 all rights granted but the Photographer's Reservation of Rig but not limited to al 	right to retain sums prev hts. All rights not expres I rights in preliminary m	ssly grant	ed hereunder nd all electro	are reserved to the Ph nic rights. For purpos	es of this agreeme
 all rights granted but the Photographer's Reservation of Rig but not limited to al electronic rights are 	right to retain sums prev hts. All rights not expres	ssly grant aterials a digitized	ed hereunder nd all electro form of works	are reserved to the Ph nic rights. For purpos that can be encoded,	es of this agreeme stored, and retrieve
 all rights granted but the Photographer's Reservation of Rig but not limited to al electronic rights are from such media as Fee. Client agrees to 	right to retain sums prev hts. All rights not expres I rights in preliminary m defined as rights in the	ssly grant aterials a digitized DM, comp	ed hereunder nd all electro form of works outer databas for the usag	are reserved to the Ph nic rights. For purpos that can be encoded, es, and network server rights granted, or a	es of this agreeme stored, and retrieve s. an advance of \$

- 7. Alteration. Client shall not make or permit any alterations, whether by adding or removing material from the Work, without the permission of the Photographer. Alterations shall be deemed to include the addition of any illustrations, photographs, sound, text, or computerized effects, unless specified to the contrary here_____
- Payment. Client agrees to pay the Photographer within thirty days of the date of Photographer's billing, which shall be dated as of the date of delivery of the Work. Overdue payments shall be subject to interest charges of _____ percent monthly.
- 9. Loss, Theft, or Damage. The ownership of the Work shall remain with the Photographer. Client agrees to assume full responsibility and be strictly liable as an insurer for loss, theft, or damage to the Work and to insure the Work fully from the time of shipment from the Photographer to the Client until the time of return receipt by the Photographer. Client further agrees to return all of the Work at its own expense by registered mail or bonded courier which provides proof of receipt. Reimbursement for loss, theft, or damage to any Work shall be in the following amount:

Both Client and Photographer agree that these specified value(s) represent the fair and reasonable value of the Work. Unless the value for an original transparency is specified otherwise in this paragraph, both parties agree that each original transparency has a fair and reasonable value of \$1,500 (Fifteen Hundred Dollars). Client agrees to reimburse Photographer for these fair and reasonable values in the event of loss, theft, or damage.

- 10. Samples. Client shall provide Photographer with _____ samples of the final use of the Work.
- **11. Copyright Notice.** Copyright notice in the name of the Photographer shall shall shall not accompany the Work when it is reproduced.
- **12. Credit.** Credit in the name of the Photographer \Box shall \Box shall not accompany the Work when it is reproduced. If the Work is used as a contribution to a magazine or for a book, credit shall be given unless specified to the contrary in the preceding sentence.
- **13. Releases.** The Client agrees to indemnify and hold harmless the Photographer against any and all claims, costs, and expenses, including attorney's fees, due to uses for which no release was requested, uses which exceed the uses allowed pursuant to a release, or uses based on alterations not allowed pursuant to Paragraph 7.
- **14.** Arbitration. All disputes arising under this Agreement shall be submitted to binding arbitration before _______ in the following location _______

and settled in accordance with the rules of the American Arbitration Association. Judgment upon the arbitration award may be entered in any court having jurisdiction thereof. Disputes in which the amount at issue is less than \$______ shall not be subject to this arbitration provision.

15. Miscellany. This Agreement shall be binding upon the parties hereto, their heirs, successors, assigns, and personal representatives. This Agreement constitutes the entire understanding between the parties. Its terms can be modified only by an instrument in writing signed by both parties, except that the Client may authorize expenses or revisions orally. A waiver of a breach of any of the provisions of this Agreement shall not be construed as a continuing waiver of other breaches of the same or other provisions hereof. This Agreement shall be governed by the laws of the State of ______.

In Witness Whereof, the parties hereto have signed this Agreement as of the date first set forth above.

Photographer	Client
	Company Name
	Bv:
	Authorized Signatory, Title

License of Electronic Rights

pcated at				(hereinafter referred to as the "Client
nd		, locate	ed at	
hereinafter referred to hotographer's photog				icensing of certain electronic rights in th
	r k. The Client wishes nich is described as fo		ertain electroni	c rights in the Work which the Photograph
Title				Number of images
Subject matter				
Form in which work	shall be delivered		computer file (s	pecify format
original transpare	ency (size	_) 🗖 (dupe (size)
2. Delivery Date. The	Photographer agrees	to deliver the	e Work within	days after the signing of this Agreemer
5. Grant of Rights. Uthe Work:	Jpon receipt of full pay	rment, Photo	ographer grants	to the Client the following electronic rights
For use as				in thelanguag
For the product or p	ublication named			
In the following territ	ory			
For the following tim	e period			
				y users of the product or publication unles
	-			exclusive rights unless specified to the co
Other limitations				
If the Client does no	t complete its usage u	nder this Pa	ragraph 3 by th	e following date
all rights granted b	ut not exercised shall	without fur	ther notice reve	ert to the Photographer without prejudice additional sums due.
but not limited to all electronic rights are	rights in preliminary r e defined as rights in t	naterials an he digitized	d all nonelectro form of works	are reserved to the Photographer, includir onic rights. For purposes of this agreemer that can be encoded, stored, and retrieve es, and network servers.
. Fee. Client agrees	to pay the following:	\$	for the usa	ge rights granted.
. Additional Usage.	If Client wishes to ma	ake any ado	ditional uses of	the Work, Client agrees to seek permission

- 7. Alteration. Client shall not make or permit any alterations, whether by adding or removing material from the Work, without the permission of the Photographer. Alterations shall be deemed to include the addition of any illustrations, photographs, sound, text, or computerized effects, unless specified to the contrary here_____
- Payment. Client agrees to pay the Photographer within thirty days of the date of Photographer's billing, which shall be dated as of the date of delivery of the Work. Overdue payments shall be subject to interest charges of _____ percent monthly.
- 9. Loss, Theft, or Damage. The ownership of the Work shall remain with the Photographer. Client agrees to assume full responsibility and be strictly liable as an insurer for loss, theft, or damage to the Work and to insure the Work fully from the time of shipment from the Photographer to the Client until the time of return receipt by the Photographer. Client further agrees to return all of the Work at its own expense by registered mail or bonded courier which provides proof of receipt. Reimbursement for loss, theft, or damage to any Work shall be in the following amount:

Both Client and Photographer agree that these specified value(s) represent the fair and reasonable value of the Work. Unless the value for an original transparency is specified otherwise in this paragraph, both parties agree that each original transparency has a fair and reasonable value of \$1,500 (Fifteen Hundred Dollars). Client agrees to reimburse Photographer for these fair and reasonable values in the event of loss, theft, or damage.

- **10.** Samples. Client shall provide Photographer with _____ samples of the final use of the Work.
- **11. Copyright Notice.** Copyright notice in the name of the Photographer shall shall shall not accompany the Work when it is reproduced.
- **12.** Credit. Credit in the name of the Photographer \Box shall \Box shall not accompany the Work when it is reproduced. If the work is used as a contribution to a magazine or for a book, credit shall be given unless specified to the contrary in the preceding sentence.
- **13. Releases.** The Client agrees to indemnify and hold harmless the Photographer against any and all claims, costs, and expenses, including attorney's fees, due to uses for which no release was requested, uses which exceed the uses allowed pursuant to a release, or uses based on alterations not allowed pursuant to Paragraph 7.
- **14.** Arbitration. All disputes arising under this Agreement shall be submitted to binding arbitration before ________ in the following location ________

and settled in accordance with the rules of the American Arbitration Association. Judgment upon the arbitration award may be entered in any court having jurisdiction thereof. Disputes in which the amount at issue is less than \$______ shall not be subject to this arbitration provision.

- 15. Miscellany. This Agreement shall be binding upon the parties hereto, their heirs, successors, assigns, and personal representatives. This Agreement constitutes the entire understanding between the parties. Its terms can be modified only by an instrument in writing signed by both parties, except that the Client may authorize expenses or revisions orally. A waiver of a breach of any of the provisions of this Agreement shall not be construed as a continuing waiver of other breaches of the same or other provisions hereof. This Agreement shall be governed by the laws of the State of ______.
- In Witness Whereof, the parties hereto have signed this Agreement as of the date first set forth above.

Photographer	Client
	Company Name
	Bv:
	Authorized Signatory, Title

THE FORMS

TEAR-OUT SECTION

The Forms on CD-ROM

In addition to the Forms in this tear-out section which are intended for use or photocopying, the Forms are also provided on a CD-ROM found at the back of this book. The CD-ROM is compatible with both Windows and Macintosh operating systems. The Adobe Acrobat Reader is also included on the CD-ROM so that you can view, copy, and paste the forms into your word processing program. For more details, open the ReadMe.First file on the CD-ROM.

Assignment Estimate/Confirmation/Invoice

Client	Date
Address	
	D. Confirmation
Client Purchase Order Number	
Client Contact	Job Number
Assignment Description	
	Due Date

Grant of Rights. Upon receipt of full payment, Photographer shall grant to the Client the following exclusive rights: For use as

For the product, project, or publication named _____

In the following territory ____

For the following time period or number of uses_____

Other limitations

This grant of rights does not include electronic rights, unless specified to the contrary here_____

in which event the usage restrictions shown above shall be applicable. For purposes of this agreement, electronic rights are defined as rights in the digitized form of works that can be encoded, stored, and retrieved from such media as computer disks, CD-ROM, computer databases, and network servers.

Credit. The Photographer shall shall not

receive adjacent credit in the following form on reproduction____

Fee/Expenses. The Client shall pay the Balance Due, including reimbursement of the expenses as shown below, within thirty days of receipt of an invoice. A reuse fee of \$______ shall be paid in the following circumstances:______

Expenses	Fees	
Assistants	\$ Photography fee	\$
Casting	\$ Other fees	
Crews/Special Technicians	\$ Preproduction \$/day;	\$
Equipment Rentals	\$ Travel \$/day;	\$
Film and Processing	\$ Weather days \$/day	\$
Insurance	\$ Space or Use Rate (if applicable)	\$
Location	\$ Cancellation fee	\$
Messengers	\$ Reshoot fee	\$
Models	\$ Fee subtotal	\$
Props/Wardrobe	\$ Plus total expenses	\$
Sets	\$	
Shipping	\$ Subtotal	\$
Styling	\$ Sales tax	\$
Travel/Transportation	\$ Total	\$
Telephone	\$ Less advances	\$
Other expenses	\$ Balance due	
subtotal	\$ Balance due	\$
(Plus% markup)	\$	
Total expenses	\$ Client	
	Company Name	
Photographer	Ву	
	Authorized Signatory, Title	e

Subject to All Terms and Conditions Above and on Reverse Side

Terms and Conditions

- 1. Payment. Client shall pay the Photographer within thirty days of the date of Photographer's billing, which shall be dated as of the date of delivery of the Assignment. The Client shall be responsible for and pay any sales tax due. Time is of the essence with respect to payment. Overdue payments shall be subject to interest charges of _____ percent monthly.
- 2. Advances. Prior to Photographer's commencing the Assignment, Client shall pay Photographer the advance shown on the front of this form, which advance shall be applied against the total due.
- 3. Reservation of Rights. Unless specified to the contrary on the front of this form any grant of rights shall be limited to the United States for a period of one year from the date of the invoice and, if the grant is for magazine usage, shall be first North American serial rights only. All rights not expressly granted shall be reserved to the Photographer, including but not limited to all copyrights and ownership rights in photographic materials, which shall include but not be limited to transparencies, negatives, and prints. Client shall not modify directly or indirectly any of the photographic materials, whether by digitized encodations or any other form or process now in existence or which may come into being in the future, without the express, written consent of the Photographer.
- 4. Value and Return of Originals. All photographic materials shall be returned to the Photographer by registered mail or bonded courier (which provides proof of receipt) within thirty days of the Client's completing its use thereof and, in any event, within ______ days of Client's receipt thereof. Time is of the essence with respect to the return of photographic materials. Unless a value is specified for a particular image either on the front of this form or on a Delivery Memo given to the Client by the Photographer, the parties agree that a reasonable value for an original transparency is \$1,500. Client agrees to be solely responsible for and act as an insurer with respect to loss, theft, or damage of any image from the time of its shipment by Photographer to Client until the time of return receipt by Photographer.
- 5. Additional Usage. If Client wishes to make any additional uses, Client shall seek permission from the Photographer and pay an additional fee to be agreed upon.
- 6. Authorship Credit. Authorship credit in the name of the Photographer, including copyright notice if specified by the Photographer, shall accompany the photograph(s) when it is reproduced, unless specified to the contrary on the front of this form. If required authorship credit is omitted, the parties agree that liquidated damages for the omission shall be three times the invoiced amount.
- 7. Expenses. If this form is being used as an Estimate, all estimates of expenses may vary by as much as ten (10%) percent in accordance with normal trade practices. In addition, the Photographer may bill the Client in excess of the estimates for any overtime which must be paid by the Photographer to assistants and freelance staff for a shoot that runs more than eight (8) consecutive hours.
- 8. Reshoots. If Photographer is required by the Client to reshoot the Assignment, Photographer shall charge in full for additional fees and expenses, unless (a) the reshoot is due to Acts of God or is due to an error by a third party, in which case the Client shall only pay additional expenses but no fees; or (b) if the Photographer is paid in full by the Client, including payment for the expense of special contingency insurance, then Client shall not be charged for any expenses covered by such insurance in the event of a reshoot. The Photographer shall be given the first opportunity to perform any reshoot.
- 9. Cancellation. In the event of cancellation by the Client, the Client shall pay all expenses incurred by the Photographer and, in addition, shall pay the full fee unless notice of cancellation was given at least _____ hours prior to the shooting date, in which case fifty (50%) percent of the fee shall be paid. For weather delays involving shooting on location, Client shall pay the full fee if Photographer is on location and fifty (50%) percent of the fee if Photographer has not yet left for the location.
- **10. Releases.** The Client shall indemnify and hold harmless the Photographer against any and all claims, costs, and expenses, including attorney's fees, due to uses for which no release was requested or uses which exceed the uses allowed pursuant to a release.
- 11. Samples. Client shall provide the Photographer with two copies of any authorized usage.
- **12. Assignment.** Neither this Agreement nor any rights or obligations hereunder shall be assigned by either of the parties, except that the Photographer shall have the right to assign monies due hereunder. Both Client and any party on whose behalf Client has entered into this Agreement shall be bound by this Agreement and shall be jointly and severally liable for full performance hereunder, including but not limited to payments of monies due to the Photographer.
- **13.** Arbitration. All disputes shall be submitted to binding arbitration before ______ in the following location ______ and settled in accordance with the rules of the American Arbitration Association. Judgment upon the arbitration award may be entered in any court having jurisdiction thereof. Disputes in which the amount at issue is less than \$______ shall not be subject to this arbitration provision.
- **14. Miscellany.** The terms and conditions of this Agreement shall be binding upon the parties, their heirs, successors, assigns, and personal representatives; this Agreement constitutes the entire understanding between the parties; its terms can be modified only by an instrument in writing signed by both parties, except that the Client may authorize additional fees and expenses orally; a waiver of a breach of any of its provisions shall not be construed as a continuing waiver of other breaches of the same or other provisions hereof; and the relationship between the Client and Photographer shall be governed by the laws of the State of

Portrait Photography Contract

Client	Telephone
address	_
	Order number
Description of Photographic Services to be Provided	
Portrait of	
Location for Photography	
Date	Time
Number of previews or proofs to be shown to Client	Black and White
Special Services, if required	
Special Usage Requirements	
Charges. The package fee is based on the Photographer's Standard Price therein. If the fee is not based on a package but is a session fee, all photog in accordance with the Standard Price List. In addition to either the package forth below shall be billed if and when incurred.	graphs shall be billed in addition to the fee and
Package Fee (Package number)	. \$
General Fee Without Package	\$
Extra Charges	
Additional prints	
Resitting	
Special retouching	
Special finishes	
Rush service	
Unreturned previews	
Overtime	
Travel	
Other	
	\$
	\$
Total	\$
Less deposit	
Balance Due	\$
The parties have read both the front and back of this Agreement, agree complete copy of the Agreement signed by both parties.	to all its terms, and acknowledge receipt of a
Client	Date
Photographer	Date

This Agreement is subject to all the terms and conditions appearing on the reverse side.

Terms and Conditions

- Deposit and Payment. The Client shall make a deposit to retain the Photographer to perform the services specified herein. At such time as this order is completed, the deposit shall be applied to reduce the total cost and Client shall pay the balance due. If the Client refuses delivery of the order or refuses to pay within thirty (30) days of this order, Client shall be in default hereunder and shall pay _____ percent interest on the unpaid balance until payment is made in full.
- 2. Cancellation. If the Client shall cancel this Agreement ______ or more calendar days before the session date, any deposit paid to the Photographer shall be refunded in full. If Client shall cancel within ______ days of the session date and if the Photographer does not obtain another assignment for that time, liquidated damages shall be charged in a reasonable amount not to exceed the deposit.
- **3.** Photographic Materials. All photographic materials, including but not limited to negatives, transparencies, proofs, and previews, shall be the exclusive property of the Photographer. The Photographer shall make proofs and previews available to the Client for the purpose of selecting photographs, but such proofs and previews shall be on loan and, if they are not returned within fourteen (14) days of receipt by the Client, shall be charged to the Client at the same rate as finished prints of the same size.
- 4. Copyright and Reproductions. The Photographer shall own the copyright in all images created and shall have the exclusive right to make reproductions. The Photographer shall only make reproductions for the Client or for the Photographer's portfolio, samples, self-promotions, entry in photographic contests or art exhibitions, editorial use, or for display within or on the outside of the Photographer's studio. If the Photographer desires to make other uses, the Photographer shall not do so without first obtaining the written permission of the Client.
- 5. Client's Usage. The Client is obtaining prints for personal use only, and shall not sell said prints or authorize any reproductions thereof by parties other than the Photographer. If Client is obtaining a print for reproduction, Photographer authorizes Client to reproduce the print only as set forth under Special Usage Requirements on the front of this form. In such event, Client shall request that a credit for the Photographer be placed adjacent to the photograph on publication, but shall have no liability if the publication refuses or omits to do so.
- 6. Failure to Perform. If the Photographer cannot perform this Agreement due to a fire or other casualty, strike, act of God, or other cause beyond the control of the parties, or due to the Photographer's illness, then the Photographer shall return the deposit to the Client but shall have no further liability with respect to the Agreement. This limitation on liability shall also apply in the event that photographic materials are damaged in processing, lost through camera malfunction, lost in the mail, or otherwise lost or damaged without fault on the part of the Photographer. In the event the Photographer fails to perform for any other reason, the Photographer shall not be liable for any amount in excess of the retail value of the Client's order.
- **7. Photographer.** The Photographer may substitute another photographer to take the photographs in the event of Photographer's illness or scheduling conflicts. In the event of such substitution, Photographer warrants that the photographer taking the photographs shall be a competent professional.
- 8. Inherent Qualities. Client is aware that color dyes in photography may fade or discolor over time due to the inherent qualities of dyes, and Client releases Photographer from any liability for any claims whatsoever based upon fading or discoloration due to such inherent qualities.
- **9.** Photographer's Standard Price List. The charges in this Agreement are based on the Photographer's Standard Price List. This price list is adjusted periodically and future orders shall be charged at the prices in effect at the time when the order is placed.
- **10.** Client's Originals. If the Client is providing original prints, negatives, or transparencies owned by the Client to the Photographer for duplication, framing, reference, or any other purpose, in the event of loss or damage the Photographer shall not be liable for an amount in excess of \$_____ per image.
- 11. Arbitration. All disputes arising under Agreement shall be submitted to binding arbitration before ______ in the following location ______ and the arbitration award may be entered for judgment in any court having jurisdiction thereof. Notwithstanding the foregoing, either party may refuse to arbitrate when the dispute is for a sum less than \$______.
- 12. Miscellany. This Agreement incorporates the entire understanding of the parties. Any modifications of this Agreement must be in writing and signed by both parties. Any waiver of a breach or default hereunder shall not be deemed a waiver of a subsequent breach or default of either the same provision or any other provision of this Agreement. This Agreement shall be governed by the laws of the State of ______.

Photographer—Agent Contract for Assignments

nc	einafter referred to as the "Pho		(hereinafter referred to as the "Agent
	ated at		
	EREAS, the Photographer is an	established photographer o	f proven talents: and
	, 0 1		him or her in marketing certain rights enumerated herei
		es to have an agent represent	
		f markating the photography	produced by the Photographer; and
	EREAS, the Agent wishes to re		produced by the r hotographer, and
			and the mutual covenants hereinafter set forth and oth
III	able consideration, the parties	nereto agree as follows:	
	Agency. The Photographer a	appoints the Agent to act as	his or her representative to obtain assignments:
	(A) in the following geographic		
	(A) In the following geographic	ai alea	
	(B) for the following markets:	Advertising	Corporate
		Book publishing	Magazines
		Other, specified as	
	(D) Electronic rights are □ ou as the sale of such rights is For purposes of this agree	Itside the scope of this agend s incidental to the sale of nor ement, electronic rights are o	agent in the area and markets indicated. cy contract covered by this agency contract insolution nelectronic rights covered by this agency contract defined as rights in the digitized form of works that computer disks. CD-BOM computer databases and
	(D) Electronic rights are □ ou as the sale of such rights is For purposes of this agree	Itside the scope of this agend s incidental to the sale of nor ement, electronic rights are o	cy contract Covered by this agency contract insof nelectronic rights Covered by this agency contract
	(D) Electronic rights are □ ou as the sale of such rights is For purposes of this agree be encoded, stored, and r	Itside the scope of this agend s incidental to the sale of nor ement, electronic rights are of retrieved from such media as	cy contract Covered by this agency contract insoft nelectronic rights Covered by this agency contract defined as rights in the digitized form of works that co s computer disks, CD-ROM, computer databases, and
	 (D) Electronic rights are ou as the sale of such rights is For purposes of this agree be encoded, stored, and r network servers. Any rights not granted to the A 	Itside the scope of this agend s incidental to the sale of nor ement, electronic rights are of retrieved from such media as Agent are reserved to the Pho	cy contract Covered by this agency contract insoft nelectronic rights Covered by this agency contract defined as rights in the digitized form of works that co s computer disks, CD-ROM, computer databases, an otographer.
1	 (D) Electronic rights are ou as the sale of such rights is For purposes of this agree be encoded, stored, and r network servers. Any rights not granted to the A Best Efforts. The Agent agree of securing assignments for the 	itside the scope of this agend s incidental to the sale of nor ement, electronic rights are of retrieved from such media as Agent are reserved to the Pho es to use his or her best effort e Photographer. The Agent sh	cy contract Covered by this agency contract insof nelectronic rights Covered by this agency contract defined as rights in the digitized form of works that co computer disks, CD-ROM, computer databases, an otographer. Is in submitting the Photographer's work for the purpor nall negotiate the terms of any assignment that is offere
	 (D) Electronic rights are ou as the sale of such rights is For purposes of this agree be encoded, stored, and rights not granted to the A network servers. Any rights not granted to the A Best Efforts. The Agent agree of securing assignments for the but the Photographer may rejected as a server of the securing assignment for the securing assignment for the securing assignments for the securing	Itside the scope of this agend s incidental to the sale of nor ement, electronic rights are of retrieved from such media as Agent are reserved to the Pho es to use his or her best effort e Photographer. The Agent sh ect any assignment if he or sh	cy contract covered by this agency contract insof helectronic rights covered by this agency contract defined as rights in the digitized form of works that co s computer disks, CD-ROM, computer databases, and otographer. Is in submitting the Photographer's work for the purpon hall negotiate the terms of any assignment that is offered the finds the terms thereof unacceptable.
	 (D) Electronic rights are out as the sale of such rights is For purposes of this agree be encoded, stored, and r network servers. Any rights not granted to the A Best Efforts. The Agent agree of securing assignments for the but the Photographer may reje Samples. The Photographer servers 	Itside the scope of this agend s incidental to the sale of nor ement, electronic rights are of retrieved from such media as Agent are reserved to the Pho es to use his or her best effort e Photographer. The Agent sh ect any assignment if he or sh shall provide the Agent with so	cy contract covered by this agency contract insoft nelectronic rights covered by this agency contract defined as rights in the digitized form of works that co computer disks, CD-ROM, computer databases, and tographer. Is in submitting the Photographer's work for the purport nall negotiate the terms of any assignment that is offered the finds the terms thereof unacceptable. Such samples of work as are from time to time necessar
	 (D) Electronic rights are out as the sale of such rights is For purposes of this agree be encoded, stored, and r network servers. Any rights not granted to the A Best Efforts. The Agent agree of securing assignments for the but the Photographer may reje Samples. The Photographer s for the purpose of securing as 	Itside the scope of this agend s incidental to the sale of nor ement, electronic rights are of retrieved from such media as Agent are reserved to the Pho es to use his or her best effort e Photographer. The Agent sh ect any assignment if he or sh shall provide the Agent with so ssignments. These samples	cy contract covered by this agency contract insof helectronic rights covered by this agency contract defined as rights in the digitized form of works that co s computer disks, CD-ROM, computer databases, and otographer. Is in submitting the Photographer's work for the purpor hall negotiate the terms of any assignment that is offered the finds the terms thereof unacceptable.
	 (D) Electronic rights are ou as the sale of such rights is For purposes of this agree be encoded, stored, and r network servers. Any rights not granted to the A Best Efforts. The Agent agree of securing assignments for the but the Photographer may reje Samples. The Photographer s for the purpose of securing a returned on termination of this 	Itside the scope of this agend s incidental to the sale of nor ement, electronic rights are of retrieved from such media as Agent are reserved to the Pho es to use his or her best effort e Photographer. The Agent sh ect any assignment if he or sh shall provide the Agent with so ssignments. These samples Agreement. The Agent shall	cy contract covered by this agency contract insoft nelectronic rights covered by this agency contract defined as rights in the digitized form of works that co a computer disks, CD-ROM, computer databases, and atographer. Is in submitting the Photographer's work for the purport nall negotiate the terms of any assignment that is offered the finds the terms thereof unacceptable. Such samples of work as are from time to time necessar shall remain the property of the Photographer and
•	 (D) Electronic rights are ou as the sale of such rights is For purposes of this agree be encoded, stored, and r network servers. Any rights not granted to the A Best Efforts. The Agent agree of securing assignments for the but the Photographer may reje Samples. The Photographer s for the purpose of securing a returned on termination of this or damage, but shall be liable 	Itside the scope of this agend s incidental to the sale of nor ement, electronic rights are of retrieved from such media as Agent are reserved to the Pho es to use his or her best effort e Photographer. The Agent sh ect any assignment if he or sh shall provide the Agent with si ssignments. These samples Agreement. The Agent shall for such loss or damage only	cy contract covered by this agency contract insoft nelectronic rights covered by this agency contract defined as rights in the digitized form of works that co s computer disks, CD-ROM, computer databases, and otographer. Is in submitting the Photographer's work for the purpor nall negotiate the terms of any assignment that is offered the finds the terms thereof unacceptable. Such samples of work as are from time to time necessar shall remain the property of the Photographer and take reasonable efforts to protect the samples from lo
•	 (D) Electronic rights are ou as the sale of such rights is For purposes of this agree be encoded, stored, and r network servers. Any rights not granted to the A Best Efforts. The Agent agree of securing assignments for the but the Photographer may reje Samples. The Photographer s for the purpose of securing a returned on termination of this or damage, but shall be liable 	Itside the scope of this agend s incidental to the sale of nor ement, electronic rights are of retrieved from such media as Agent are reserved to the Pho es to use his or her best effort e Photographer. The Agent sh ect any assignment if he or sh shall provide the Agent with si ssignments. These samples Agreement. The Agent shall for such loss or damage only ke effect as of the date first se	cy contract covered by this agency contract insoft helectronic rights covered by this agency contract defined as rights in the digitized form of works that co accomputer disks, CD-ROM, computer databases, and atographer. Is in submitting the Photographer's work for the purport hall negotiate the terms of any assignment that is offered the finds the terms thereof unacceptable. Such samples of work as are from time to time necessar shall remain the property of the Photographer and take reasonable efforts to protect the samples from loc y if caused by the Agent's negligence.
	 (D) Electronic rights are out as the sale of such rights is For purposes of this agree be encoded, stored, and r network servers. Any rights not granted to the A Best Efforts. The Agent agree of securing assignments for the but the Photographer may reje Samples. The Photographer s for the purpose of securing as returned on termination of this or damage, but shall be liable Term. This Agreement shall tak of one year, unless terminated 	tside the scope of this agend s incidental to the sale of nor ement, electronic rights are of retrieved from such media as Agent are reserved to the Photographer. The Agent sh ect any assignment if he or sh shall provide the Agent with su ssignments. These samples Agreement. The Agent shall for such loss or damage only ke effect as of the date first se a sprovided in Paragraph 1	cy contract covered by this agency contract insoft nelectronic rights covered by this agency contract defined as rights in the digitized form of works that co a computer disks, CD-ROM, computer databases, and atographer. Is in submitting the Photographer's work for the purport nall negotiate the terms of any assignment that is offered the finds the terms thereof unacceptable. Such samples of work as are from time to time necessar shall remain the property of the Photographer and take reasonable efforts to protect the samples from loc y if caused by the Agent's negligence. torth above, and remain in full force and effect for a te 1.
	 (D) Electronic rights are out as the sale of such rights is For purposes of this agree be encoded, stored, and retwork servers. Any rights not granted to the A Best Efforts. The Agent agree of securing assignments for the but the Photographer may reje Samples. The Photographer s for the purpose of securing areturned on termination of this or damage, but shall be liable Term. This Agreement shall tak of one year, unless terminated Commissions. The Agent shall shall be liable 	Itside the scope of this agend s incidental to the sale of nor ement, electronic rights are of retrieved from such media as Agent are reserved to the Pho es to use his or her best effort e Photographer. The Agent sh ect any assignment if he or sh shall provide the Agent with su ssignments. These samples Agreement. The Agent shall for such loss or damage only ke effect as of the date first se a sprovided in Paragraph 1 Il be entitled to the following c	cy contract covered by this agency contract insoft nelectronic rights covered by this agency contract defined as rights in the digitized form of works that co s computer disks, CD-ROM, computer databases, and otographer. Is in submitting the Photographer's work for the purpor nall negotiate the terms of any assignment that is offered the finds the terms thereof unacceptable. Such samples of work as are from time to time necessar shall remain the property of the Photographer and take reasonable efforts to protect the samples from lo y if caused by the Agent's negligence. It forth above, and remain in full force and effect for a te 1. commissions: (A) On assignments obtained by the Agent
	 (D) Electronic rights are out as the sale of such rights is For purposes of this agreed be encoded, stored, and renetwork servers. Any rights not granted to the A Best Efforts. The Agent agreed of securing assignments for the but the Photographer may rejets Samples. The Photographer safor the purpose of securing asreturned on termination of this or damage, but shall be liable Term. This Agreement shall tak of one year, unless terminated Commissions. The Agent share during the term of this Agreement share a start of the safe term of th	Itside the scope of this agend s incidental to the sale of nor ement, electronic rights are of retrieved from such media as Agent are reserved to the Pho es to use his or her best effort e Photographer. The Agent sh ect any assignment if he or sh shall provide the Agent with su ssignments. These samples Agreement. The Agent shall for such loss or damage only ke effect as of the date first se d as provided in Paragraph 1 Il be entitled to the following c ment, percent of the billi	cy contract Covered by this agency contract insoft helectronic rights Covered by this agency contract defined as rights in the digitized form of works that co is computer disks, CD-ROM, computer databases, and otographer. Is in submitting the Photographer's work for the purpor hall negotiate the terms of any assignment that is offered he finds the terms thereof unacceptable. Such samples of work as are from time to time necessar shall remain the property of the Photographer and take reasonable efforts to protect the samples from lo y if caused by the Agent's negligence. It forth above, and remain in full force and effect for a te and the finds in the property of the photographer and the terms are from time to the samples from lo y if caused by the Agent's negligence.
	 (D) Electronic rights are □ out as the sale of such rights is For purposes of this agree be encoded, stored, and r network servers. Any rights not granted to the A Best Efforts. The Agent agree of securing assignments for the but the Photographer may reje Samples. The Photographer s for the purpose of securing as returned on termination of this or damage, but shall be liable Term. This Agreement shall tak of one year, unless terminated Commissions. The Agent share during the term of this Agreement For purposes of this Agreement for the purpose of this Agreement for the purpose of this Agreement for purposes of this Agreement for the purpose of this Agreement for purposes of the purpose of the purposes of the purpose o	Agent are reserved to the Photographer. The Agent with sugary assignment if he or shall provide the Agent with sugary assignments. These samples Agreement. The Agent shall provide the Agent with sugary assignments are samples and the transformed and the transformed at the first set of the transformed at the first set of the transformed at the transforme	cy contract Covered by this agency contract insoft helectronic rights Covered by this agency contract defined as rights in the digitized form of works that co a computer disks, CD-ROM, computer databases, and tographer. Is in submitting the Photographer's work for the purpor hall negotiate the terms of any assignment that is offered the finds the terms thereof unacceptable. Uch samples of work as are from time to time necessar shall remain the property of the Photographer and take reasonable efforts to protect the samples from loc y if caused by the Agent's negligence. It forth above, and remain in full force and effect for a te 1. commissions: (A) On assignments obtained by the Agen g. (B) On house accounts, percent of the billin d as accounts obtained by the Photographer at any tir
•	 (D) Electronic rights are □ out as the sale of such rights is For purposes of this agree be encoded, stored, and r network servers. Any rights not granted to the A Best Efforts. The Agent agree of securing assignments for the but the Photographer may reje Samples. The Photographer s for the purpose of securing as returned on termination of this or damage, but shall be liable Term. This Agreement shall tak of one year, unless terminated Commissions. The Agent share during the term of this Agreement or obtained by another agent returned by a by	Agent are reserved to the Photographer. The Agent with substraining the Agent shall provide the Agent with substraining the Agent shall for such loss or damage only the effect as of the date first set as provided in Paragraph 1 and the agent of the billing the Agent are the Agent of the billing the Agent and the Agent and the Agent shall be accounts are define the Agent of the billing the Agent as provided to the following content, percent of the billing the Agent and the Agent and the Agent as a count as a count as a count as a count and the Agent as a count as a count as a count as a count and the Agent as a count as a count as a count and the Agent as a count as a count and the Agent as a count as a count and the Agent as a count and the Agent as a count a	cy contract covered by this agency contract insoft nelectronic rights covered by this agency contract defined as rights in the digitized form of works that co a computer disks, CD-ROM, computer databases, and atographer. Is in submitting the Photographer's work for the purpor hall negotiate the terms of any assignment that is offered the finds the terms thereof unacceptable. Such samples of work as are from time to time necessar shall remain the property of the Photographer and take reasonable efforts to protect the samples from loc y if caused by the Agent's negligence. It forth above, and remain in full force and effect for a te 1. commissions: (A) On assignments obtained by the Agen ng. (B) On house accounts, percent of the billing d as accounts obtained by the Photographer at any time er prior to the commencement of this Agreement and a
	 (D) Electronic rights are out as the sale of such rights is For purposes of this agreed be encoded, stored, and retwork servers. Any rights not granted to the A Best Efforts. The Agent agreed of securing assignments for the but the Photographer may rejet Samples. The Photographer set for the purpose of securing asreturned on termination of this or damage, but shall be liable Term. This Agreement shall take of one year, unless terminated Commissions. The Agent shall during the term of this Agreement or obtained by another agent relisted in the Schedule of House 	Agent are reserved to the Photographer. The Agent with substitutional provide the Agent shall provide the Agent with substitutional provide the Agent shall for such loss or damage only the effect as of the date first set as provided in Paragraph 1 and the protographer. The best set as provided in Paragraph 1 and the protographer are reserved to the billing the Photographer are define the protographer are define the protographer are defined to the following chant, percent of the billing the Photographer and the photographer are defined to the photographer accounts attached to this Agreement.	cy contract Covered by this agency contract insoft nelectronic rights Covered by this agency contract defined as rights in the digitized form of works that co computer disks, CD-ROM, computer databases, and atographer. Is in submitting the Photographer's work for the purpor nall negotiate the terms of any assignment that is offered the finds the terms thereof unacceptable. Such samples of work as are from time to time necessar shall remain the property of the Photographer and take reasonable efforts to protect the samples from loc y if caused by the Agent's negligence. It forth above, and remain in full force and effect for a ter 1. commissions: (A) On assignments obtained by the Agen ing. (B) On house accounts, percent of the billing d as accounts obtained by the Photographer at any time er prior to the commencement of this Agreement and a eement. (C) For books which the Photographer authors
<u>.</u> 3.	 (D) Electronic rights are out as the sale of such rights is For purposes of this agreed be encoded, stored, and renetwork servers. Any rights not granted to the ABEST Efforts. The Agent agreed of securing assignments for the but the Photographer may rejective Samples. The Photographer set for the purpose of securing asreturned on termination of this or damage, but shall be liable. Term. This Agreement shall tak of one year, unless terminated Commissions. The Agent shall during the term of this Agreement or obtained by another agent reliable in the Schedule of House coauthors, percent of the rest. 	Agreement. The Agent shall for such loss or damage only as provided in Paragraph 1 Il be entitled to the following c entry percent of the best of the the following c house has or her best effort any assignment if he or shall provide the Agent with su ssignments. These samples Agreement. The Agent shall for such loss or damage only the effect as of the date first set as provided in Paragraph 1 Il be entitled to the following c hent, percent of the billint, house accounts are define accounts attached to this Agreement attached to this Agreement. The Agent shall for such loss or damage only the effect as of the date first set as provided in Paragraph 1 Il be entitled to the following c hent, percent of the billint, house accounts are define accounts attached to this Agreement.	cy contract covered by this agency contract insoft helectronic rights covered by this agency contract defined as rights in the digitized form of works that co- s computer disks, CD-ROM, computer databases, and atographer. Is in submitting the Photographer's work for the purpor- hall negotiate the terms of any assignment that is offered the finds the terms thereof unacceptable. Such samples of work as are from time to time necessar shall remain the property of the Photographer and take reasonable efforts to protect the samples from loc y if caused by the Agent's negligence. It forth above, and remain in full force and effect for a te 1. commissions: (A) On assignments obtained by the Agen ing. (B) On house accounts, percent of the billing d as accounts obtained by the Photographer at any time er prior to the commencement of this Agreement and a geement. (C) For books which the Photographer or its licensed
i.	 (D) Electronic rights are out as the sale of such rights is For purposes of this agreed be encoded, stored, and renetwork servers. Any rights not granted to the A Best Efforts. The Agent agreed of securing assignments for the but the Photographer may rejective Samples. The Photographer shore the purpose of securing astronation of this or damage, but shall be liable. Term. This Agreement shall tak of one year, unless terminated Commissions. The Agent shall during the term of this Agreement or obtained by another agent relisted in the Schedule of House coauthors, percent of the rest of the purpose of the purpose of the purpose of the purpose of the purposes of this Agreement or obtained by another agent relisted in the Schedule of House coauthors, percent of the rest of the purpose of the pur	Agreement. The Agent shall for such loss or damage only as provided in Paragraph 1 Il be entitled to the following c percent of the billint, house accounts are define a proceeds arties that no commissions sharts or damage only as provided to the following c percent of the billint, house accounts attached to this Agreement attached to this Agreement. The Agent shall for such loss or damage only as provided in Paragraph 1 Il be entitled to the following c percent of the billint, house accounts are define a first set attached to this Agreement attached to the attached to	cy contract Covered by this agency contract insoft nelectronic rights Covered by this agency contract defined as rights in the digitized form of works that co computer disks, CD-ROM, computer databases, and atographer. Is in submitting the Photographer's work for the purpor nall negotiate the terms of any assignment that is offered the finds the terms thereof unacceptable. Such samples of work as are from time to time necessar shall remain the property of the Photographer and take reasonable efforts to protect the samples from loc y if caused by the Agent's negligence. It forth above, and remain in full force and effect for a ter 1. commissions: (A) On assignments obtained by the Agen ing. (B) On house accounts, percent of the billing d as accounts obtained by the Photographer at any time er prior to the commencement of this Agreement and a eement. (C) For books which the Photographer authors

the Photographer in performing the assignment, whether or not such expenses are reimbursed by the client. In the event that a flat fee is paid by the client, it shall be reduced by the amount of expenses incurred by the Photographer in performing the assignment, and the Agent's commission shall be payable only on the fee as reduced for expenses.

- 6. Billing. The D Photographer D Agent shall be responsible for all billings.
- 7. Payments. The party responsible for billing shall make all payments due within ______ days of receipt of any fees covered by this Agreement. Such payments due shall be deemed trust funds and shall not be intermingled with funds belonging to the party responsible for billing and payment. Late payments shall be accompanied by interest calculated at the rate of _____ percent per month thereafter.
- 8. Promotional Expenses. Promotional expenses, including but not limited to promotional mailings and paid advertising, shall be mutually agreed to by the parties and paid _____ percent by the Agent and _____ percent by the Photographer. The Agent shall bear the expenses of shipping, insurance, and similar marketing expenses.
- **9.** Accountings. The party responsible for billing shall send copies of invoices to the other party when rendered. If requested, that party shall also provide the other party with semiannual accountings showing all assignments for the period, the clients' names and addresses, the fees paid, expenses incurred by the Photographer, the dates of payment, the amounts on which the Agent's commissions are to be calculated, and the sums due less those amounts already paid.
- **10.** Inspection of the Books and Records. The party responsible for the billing shall keep the books and records with respect to payments due each party at his or her place of business and permit the other party to inspect these books and records during normal business hours on the giving of reasonable notice.
- 11. Termination. This Agreement may be terminated by either party by giving thirty (30) days' written notice to the other party. If the Photographer receives assignments after the termination date from clients originally obtained by the Agent during the term of this Agreement, the commission specified in Paragraph 5(A) shall be payable to the Agent under the following circumstances: If the Agent has represented the Photographer for _____ months or less, the Agent shall receive a commission on such assignments received by the Photographer within ______ days of the date of termination. This period shall increase by thirty (30) days for each additional _____ months that the Agent has represented the Photographer, but in no event shall such period exceed ______ days. In the event of the bankruptcy or insolvency of the Agent, this Agreement shall also terminate. The rights and obligations under Paragraphs 3, 6, 7, 8, 9, and 10 shall survive termination.
- **12.** Assignment. This Agreement shall not be assigned by either of the parties hereto. It shall be binding on and inure to the benefit of the successors, administrators, executors, or heirs of the Agent and Photographer.
- **13.** Arbitration. Any disputes arising under this Agreement shall be settled by arbitration before __________ under the rules of the American Arbitration Association in the City of _________, except that the parties shall have the right to go to court for claims of \$_______ or less. Any award rendered by the arbitrator may be entered in any court having jurisdiction thereof.
- 14. Notices. All notices shall be given to the parties at their respective addresses set forth above.
- **15. Independent Contractor Status.** Both parties agree that the Agent is acting as an independent contractor. This Agreement is not an employment agreement, nor does it constitute a joint venture or partnership between the Photographer and Agent.
- **16.** Amendments and Merger. All amendments to this Agreement must be written. This Agreement incorporates the entire understanding of the parties.
- 17. Governing Law. This Agreement shall be governed by the laws of the State of _____

IN WITNESS WHEREOF, the parties have signed this Agreement as of the date set forth above.

Photographer____

Agent____

Book Publishing Contract

	ated at		atha "Dhataaraahar"
nd		(hereinatter reterred to a	as the Photographer
cated at	te e beek en the publicat	t of	(boroinaft)
HEREAS, the Photographer wishes to crea	Ite a book on the subject	L OI	
ferred to as the "Work")		and wishes to publish a boo	k by the Photographe
HEREAS, the Publisher is familiar with the w	ork of the Photographera	and wishes to publish a bool	k by the Photographe
nd	whilestion performed a	ubject to the mutual obliga	tions covenants ar
HEREAS, the parties wish to have said p	sublication performed st	abject to the mutual obliga	
onditions herein. OW, THEREFORE, in consideration of the fo	progoing promises and th	no mutual covenants herein:	after set forth and oth
aluable considerations, the parties hereto ag	gree as follows.		
Grant of Rights. The Photographer grar	ate convove and transfe	ers to the Publisher in that u	npublished Work title
		, certain limited, exc	
(A) To publish the Work in the form of			
		he	
and (D) For a term of			0 0
. Reservation of Rights. All rights not spec		blisher are reserved to the Pl	hotographer, includi
but not limited to electronic rights which ar			
and retrieved from such media as comp			
	o dav of	19 the Photo	grapher shall deliver
 Delivery of Manuscript. On or before the the Publisher a complete manuscript of a 			
and content to the Publisher and in confe			
The manuscript shall be delivered as \Box			
The manuscript shall include the addition			
by the Photographer, it shall be delivere			
galleys). If the Photographer fails to delive			
Publisher of failure to deliver on time, the			
from the Photographer all monies adv Photographer delivers a manuscript whic			
days to complete such revisions, i			
Photographer pursuant to Paragraphs 4,			
repaid to the Publisher only in the ev	ent the Photographer su	bsequently signs a contract	i with another publisi
for the Work.	المعام والمعالية والمعام والمعام	but the Dhotographer	
Additional Materials. The following mat	tenais snall be provided	by the Photographer	
		The	e cost of providing the
additional materials shall be borne by the	- Photographer provide		
this Agreement shall give a nonrefundab			
this Agreement shall give a nonrelundab	ne payment or \$	to assist the Photogra	
costs, which payment shall not be deen			
• Permissions. The Photographer agree			
copyrighted by others. The cost of pro			
however, that the Publisher at the time of			
assist the Photographer in defraying thes and shall not be recouped as such. Pe			
and shall not be recoursed as such Po	rmiccione chall he obtain	ned in writing and conies s	nail he nrovided to

Publisher when the manuscript is delivered.

- 6. Duty to Publish. The Publisher shall publish the Work within ______ months of the delivery of the complete manuscript. Failure to so publish shall give the Photographer the right to terminate this Agreement ninety days after giving written notice to the Publisher of the failure to make timely publication. In the event of such termination, the Photographer shall have no obligation to return monies received pursuant to Paragraphs 4, 5, and 9.
- 7. Royalties. The Publisher shall pay the Photographer the following royalties: _____ percent of the suggested retail price on the first 5,000 copies sold; _____ percent of the suggested retail price on the next 5,000 copies sold; and _____ percent of the suggested retail price on all copies sold thereafter. These royalty rates shall be discounted only in the following circumstances: _____

All copies sold shall be cumulated for purposes of escalations in the royalty rates, including revised editions, except for editions in a different form (such as a paperback reprint of a hardcover original) which shall be cumulated separately. Copies sold shall be reduced by copies returned in the same royalty category in which the copies were originally reported as sold.

In the event the Publisher has the right pursuant to Paragraph 1(A) to publish the Work in more than one form, the royalty rates specified above shall apply to publication in the form of a ______ book and the royalty rates for other forms shall be specified here:______

8. Subsidiary Rights. The following subsidiary rights may be licensed by the party indicated and the proceeds divided as specified herein:

Subsidiary Right	Right to I	License	Division of Pr	oceeds
	Photographer	Publisher	Photographer	Publisher
			· · · · · · · · · · · · · · · · · · ·	
	·			

If the division of proceeds for any subsidiary right changes after the sale of a certain number of copies, indicate which right, the number of copies required to be sold, and the new division of proceeds _____

The Publisher shall have no rights pursuant to this Paragraph 8 if Publisher is in default of any of its obligations under this Agreement. The right to license any subsidiary right not set forth in this Paragraph is retained by the Photographer. Licensing income shall be divided as specified herein without any reductions for expenses.

Licensing income shall be collected by the party authorized to license the right and the appropriate percentage remitted by that party to the other party within ten days of receipt. Copies of all licenses shall be provided to both parties immediately upon receipt.

- **9.** Advances. The Publisher shall, at the time of signing this Agreement, pay to the Photographer a nonrefundable advance of \$_____, which advance shall be recouped by the Publisher from payments due to the Photographer pursuant to Paragraph 11 of this Agreement.
- 10. Accountings. Commencing as of the date of publication, the Publisher shall report every _____ months to the Photographer, showing for that period and cumulatively to date the number of copies printed and bound, the number of copies sold and returned for each royalty rate, the number of copies distributed free for publicity purposes, the number of copies remaindered, destroyed, or lost, and the royalties paid to and owed to the

Photographer. If the Publisher sets up a reserve against returns of books, the reserve may only be set up for the four accounting periods following the first publication of the Work and shall in no event exceed 15 percent of royalties due to the Photographer in any period.

- **11.** Payments. The Publisher shall pay the Photographer all monies due Photographer pursuant to Paragraph 10 within thirty days of the close of each accounting period.
- **12. Right of Inspection.** The Photographer shall, upon the giving of written notice, have the right to inspect the Publisher's books of account to verify the accountings. If errors in any such accounting are found to be to the Photographer's disadvantage and represent more than 5 percent of the payment to the Photographer pursuant to the said accounting, the cost of inspection shall be paid by the Publisher.
- **13.** Copyright and Authorship Credit. The Publisher shall, as an express condition of receiving the grant of rights specified in Paragraph 1, take the necessary steps to register the copyright on behalf of the Photographer and in the Photographer's name and shall place copyright notice in the Photographer's name on all copies of the Work. The Photographer shall receive authorship credit as follows: ______.
- 14. Warranty and Indemnity. The Photographer warrants and represents that he or she is the sole creator of the Work and owns all rights granted under this Agreement, that the Work is an original creation and has not previously been published (indicate any parts that have been previously published), that the Work does not infringe any other person's copyrights or rights of literary property, nor, to his or her knowledge, does it violate the rights of privacy of, or libel, other persons. The Photographer agrees to indemnify the Publisher against any final judgment for damages (after all appeals have been exhausted) in any lawsuit based on an actual breach of the foregoing warranties. In addition, the Photographer shall pay the Publisher's reasonable costs and attorney's fees incurred in defending such a lawsuit, unless the Photographer chooses to retain his or her own attorney to defend such lawsuit. The Photographer makes no warranties and shall have no obligation to indemnify the Publisher with respect to materials inserted in the Work at the Publisher's request. Notwithstanding any of the foregoing, in no event shall the Photographer under this Agreement, whichever is the lesser. In the event a lawsuit is brought which may result in the Photographer having breached his or her warranties under this Paragraph, the Publisher shall have the right to withhold and place in an escrow account

_____ percent of sums payable to the Photographer pursuant to Paragraph 11, but in no event may said withholding exceed the damages alleged in the complaint.

15. Artistic Control. The Photographer and Publisher shall consult with one another with respect to the title of the Work, the price of the Work, the method and means of advertising and selling the Work, the number and destination of free copies, the number of copies to be printed, the method of printing and other publishing processes, the exact date of publication, the form, style, size, type, paper to be used, and like details, how long the plates or film shall be preserved and when they shall be destroyed, and when new printings of the Work shall be made. In the event of disagreement after consultation, the Publisher shall have final power of decision over all the foregoing matters except the following, which shall be controlled by the Photographer______.

_. No changes shall be made in the complete

manuscript of the Work by persons other than the Photographer, except for reasonable copyediting, unless the Photographer consents to such changes. Publisher shall provide the Photographer with galleys and proofs which the Photographer shall review and return to the Publisher within thirty (30) days of receipt. If the cost of the Photographer's alterations (other than for typesetting errors or unavoidable updating) exceeds _____ percent of the cost of the typography, the Publisher shall have the right to deduct such excess from royalties due Photographer hereunder.

- **16.** Original Materials. Within thirty days after publication, the Publisher shall return the original manuscript and all additional materials to the Photographer. The Publisher shall provide the Photographer with a copy of the page proofs, if the Photographer requests them prior to the date of publication.
- **17. Free Copies.** The Photographer shall receive _____ free copies of the Work as published, after which the Photographer shall have the right to purchase additional copies at a _____ percent discount from the retail price.

- **18.** Revisions. The Photographer agrees to revise the Work on request by the Publisher. If the Photographer cannot revise the Work or refuses to do so absent good cause, the Publisher shall have the right to have the Work revised by a person competent to do so and shall charge the costs of said revision against payments due the Photographer under Paragraph 11 for such revised edition. In no event shall such revision costs exceed \$
- 19. Successors and Assigns. This Agreement may not be assigned by either party without the written consent of the other party hereto. The Photographer, however, shall retain the right to assign payments due hereunder without obtaining the Publisher's consent. This Agreement shall be binding on the parties and their respective heirs, administrators, successors, and assigns.
- 20. Infringement. In the event of an infringement of the rights granted under this Agreement to the Publisher, the Publisher and the Photographer shall have the right to sue jointly for the infringement and, after deducting the expenses of bringing suit, to share equally in any recovery. If either party chooses not to join in the suit, the other party may proceed and, after deducting all the expenses of bringing the suit, any recovery shall be shared equally between the parties.
- 21. Termination. The Photographer shall have the right to terminate this Agreement by written notice if: (A) the Work goes out-of-print and the Publisher, within ninety days of receiving notice from the Photographer that the Work is outof-print, does not place the Work in print again. A work shall be deemed out-of-print if the work is not available for sale in reasonable quantities in normal trade channels; (B) if the Publisher fails to provide statements of account pursuant to Paragraph 10; (C) if the Publisher fails to make payments pursuant to Paragraphs 4, 5, 9, or 11; or (D) if the Publisher fails to publish in a timely manner pursuant to Paragraph 6. The Publisher shall have the right to terminate this Agreement as provided in Paragraph 3. This Agreement shall automatically terminate in the event of the Publisher's insolvency, bankruptcy, or assignment of assets for the benefit of creditors. In the event of termination of the Agreement, the Publisher shall grant, convey, and transfer all rights in the Work back to the Photographer.
- 22. Production Materials and Unbound Copies. Upon any termination, the Photographer may, within sixty days of notification of such termination, purchase the plates, offset negatives, or computer drive tapes (if any) at their scrap value and any remaining copies at the lesser of cost or remainder value.
- 23. Promotion. The Photographer consents to the use of his or her name, portrait, or picture for promotion and advertising of the Work, provided such use is dignified and consistent with the Photographer's reputation.
- 24. Arbitration. All disputes arising under this Agreement shall be submitted to binding arbitration before _ _ in the following location ______ and shall be settled in accordance with the rules of the American Arbitration Association. Judgment upon the arbitration award may be entered in any court having jurisdiction thereof.
- 25. Notice. Where written notice is required hereunder, it may be given by use of first-class mail addressed to the Photographer or Publisher at the addresses given at the beginning of this Agreement and shall be deemed received five days after mailing. Said addresses for notice may be changed by giving written notice of any new address to the other party.
- 26. Modifications in Writing. All modifications of this Agreement must be in writing and signed by both parties.
- 27. Waivers and Defaults. Any waiver of a breach or default hereunder shall not be deemed a waiver of a subsequent breach or default of either the same provision or any other provision of this Agreement.
- **28.** Governing Law. This Agreement shall be governed by the laws of State.

IN WITNESS WHEREOF, the parties have signed this Agreement as of the date first set forth above.

Photographer_____Publisher_____

Company Name

Ву_____

Authorized Signatory, Title

Collaboration Contract

nd			,, <u></u>		(hereinafter refe	rred to as	the "Coauthor")
HERE	EAS, each pa	arty is familiar with	and respects the	work of the oth	ner; and		
/HERE	EAS, the par				t tentatively titled		
					er referred to as the "		
		ties wish to have	the creation of th	ie Work gover	med by the mutual c	bligations,	covenants, and
	ons herein; THEBEEOBE	in consideration	of the foregoing pr	emises and the	e mutual covenants he	ereinafter s	et forth and othe
			ereto agree as follo				
. De	escription. Th	e Work shall be ap	proximately	_words on the	subject of		
					and shall include_		photographs
Ma	aterials other	than text and pho	otographs include				· · · · · · · · · · · · · · · · · · ·
Δ	□ schedule	🗆 outline 🗆 svn	opsis is attached t	o and made p	art of this agreement		
А	🗅 schedule	🗅 outline 🕒 syn	opsis is attached t	o and made p	art of this agreement		
					art of this agreement ting approximately		graphs to accom
2. Re	esponsibilitie		her shall be respo				graphs to accom
2. Re	esponsibilitie	es. The Photograp lescribed more ful	her shall be respo lly as follows:	nsible for crea	ting approximately	photog	graphs to accom
2. Re	esponsibilitie	es. The Photograp lescribed more ful Subject	her shall be respo lly as follows:	nsible for crea	ting approximately	photo(graphs to accom
2. Re	esponsibilitie	es. The Photograp lescribed more ful Subject Number of color	her shall be respo lly as follows: photographs	nsible for crea	ting approximately	photog	graphs to accom
2. Re	esponsibilitie	es. The Photograp lescribed more ful Subject Number of color	her shall be respo lly as follows: photographs	nsible for crea	ting approximately	photog	graphs to accom
2. Re	esponsibilitie	es. The Photograp lescribed more ful Subject Number of color Format/Reproduc	her shall be respo ly as follows: photographs ction size	nsible for crea	ting approximately	photog	graphs to accom
2. Re	esponsibilitie	es. The Photograp lescribed more ful Subject Number of color Format/Reproduc Number of black	her shall be respondent ly as follows: photographs ction size and white photogr	nsible for crea	ting approximately	photog	graphs to accom
2. Re	esponsibilitie	es. The Photograp lescribed more ful Subject Number of color Format/Reproduc Number of black Format/Reproduc	her shall be respondent ly as follows: photographs ction size and white photograph ction size	nsible for crea	ting approximately	photos	graphs to accom
2. Re	esponsibilitie	es. The Photograp lescribed more ful Subject Number of color Format/Reproduc Number of black Format/Reproduc	her shall be respondent ly as follows: photographs ction size and white photograph ction size	nsible for crea	ting approximately	photos	graphs to accor
2. Re	esponsibilitie	es. The Photograp lescribed more ful Subject Number of color Format/Reproduc Number of black Format/Reproduc	her shall be respondent ly as follows: photographs ction size and white photograph ction size	nsible for crea	ting approximately	photos	graphs to accom
2. Re	esponsibilitie	es. The Photograp lescribed more ful Subject Number of color Format/Reproduc Number of black Format/Reproduc	her shall be respondent ly as follows: photographs ction size and white photograph ction size	nsible for crea	ting approximately	photos	graphs to accom
2. Re	esponsibilitie any the text, d	es. The Photograp lescribed more ful Subject Number of color Format/Reproduc Number of black Format/Reproduc Other specificatio	her shall be respondent ly as follows: photographs ction size and white photographs ction size ons	nsible for crea	ting approximately	photos	
2. Re	esponsibilitie any the text, d	es. The Photograp lescribed more ful Subject Number of color Format/Reproduc Number of black Format/Reproduc Other specificatio	her shall be respondent ly as follows: photographs ction size and white photographs ction size ons	nsible for crea	ting approximately	photos	
2. Re	esponsibilitie any the text, d	es. The Photograp lescribed more ful Subject Number of color Format/Reproduc Number of black Format/Reproduc Other specificatio	her shall be respondent ly as follows: photographs ction size and white photographs ction size ons	nsible for crea	ting approximately	photos	
2. Re	esponsibilitie any the text, d	es. The Photograp lescribed more ful Subject Number of color Format/Reproduc Number of black Format/Reproduc Other specificatio	her shall be respondent ly as follows: photographs ction size and white photographs ction size ons	nsible for crea	ting approximately	photos	
Pa	esponsibilitie any the text, d ne Photograp	es. The Photograp lescribed more ful Subject Number of color Format/Reproduc Number of black Format/Reproduc Other specificatio	her shall be respondly as follows:	nsible for crea	ting approximately	photos	
Pa	esponsibilitie any the text, d ne Photograp	es. The Photograp lescribed more ful Subject Number of color Format/Reproduc Number of black Format/Reproduc Other specificatio	her shall be respondly as follows:	nsible for crea	ting approximately	photos	
Pa	esponsibilitie any the text, d ne Photograp	es. The Photograp lescribed more ful Subject Number of color Format/Reproduc Number of black Format/Reproduc Other specificatio	her shall be respondly as follows:	nsible for crea	ting approximately	photos	
Pa	esponsibilitie any the text, d ne Photograp	es. The Photograp lescribed more ful Subject Number of color Format/Reproduc Number of black Format/Reproduc Other specificatio	her shall be respondly as follows:	nsible for crea	ting approximately	photos	
2. Re pa	esponsibilitie any the text, d ne Photograp	es. The Photograp lescribed more ful Subject Number of color Format/Reproduc Number of black Format/Reproduc Other specification	her shall be respondly as follows:	nsible for crea	ting approximately	photos	g parts of the tex

- 3. Due Date. Both Photographer and Coauthor shall complete their portions of the Work by ______, 19 _____, or by the date for delivery of the manuscript as specified in a publishing contract entered into pursuant to Paragraph 4. If such a publishing contract requires preliminary materials prior to the date for delivery of the manuscript, the party responsible for same shall provide it to the publisher. In the event either party fails to complete his or her portion of the Work by the due date for reasons other than death or disability, the parties may agree to an extension of the due date or agree to allow a nondefaulting party to complete the Work as if the other party were deceased or disabled. If no agreement can be reached, the arbitrator may award a nondefaulting party the right to complete the Work as if the other party were deceased or disabled or may convey to each party the rights of copyright in that party's completed portion of the Work and specify how the parties shall contribute to any expenses incurred and repay any advances.
- 4. Contracts and Licenses. If a contract for the Work has not already been entered into with a publisher, both Photographer and Coauthor agree to seek such a contract. Such publishing contract shall be entered into in the names of and signed by both the Photographer and the Coauthor, each of whom shall comply with and perform all required contractual obligations. If a mutually agreeable publishing contract for initial publication of the Work is not entered into with a Publisher by _______, 19_____, then either party may terminate this Agreement by giving written notice to the other party prior to such time as a mutually agreeable publishing contract for initial publications for such a publishing contract or with respect to the negotiation of any other licenses or contracts pursuant to this Agreement. The disposition of any right, including the grant of any license, shall require written agreement between both parties hereto. Each party shall receive a copy of any contract, license, or other document relating to this Agreement.
- 5. Copyright, Trademarks, and Other Proprietary Rights. Photographer and Coauthor agree that the Work shall be copyrighted in both their names, and that upon completion of the Work it is their intention that their respective contributions shall be merged into a joint work with a jointly owned copyright, unless provided to the contrary here: _______. If either party does not com-

plete their portion of the Work, the nature of copyright ownership shall be governed by Paragraph 3. It is further agreed that trademarks, rights in characters, titles, and similar ongoing rights shall be owned by both parties who shall both participate in any sequels under the terms of this Agreement, unless provided to the contrary here:______. A sequel is defined as a work closely

related to the Work in that it is derived from the subject matter of the Work, is similar in style and format to the Work, and is directed toward the same audience as that for the Work. Material of any and all kinds developed or obtained in the course of creating the work shall be jointly owned the property of the party who developed or obtained it.

6. Income and Expenses. Net proceeds generated by the Work shall be divided as set forth in this Paragraph. Net proceeds are defined as gross proceeds from the sale or license of book rights throughout the world (including but not limited to serializations, condensations, and translations), including advances, minus reasonable expenses. Such expenses shall include agents' fees and the parties' expenses incurred in the creation of the Work, provided that the parties' expenses shall be supported by appropriate verification and shall not exceed \$_____ for the Photographer and \$_____ for the Coauthor. Each party shall provide verification for expenses to the other party within ten days of a written request. Unless otherwise provided, the parties' expenses shall be reimbursed from first proceeds received, including but not limited to advances.

Net proceeds from the sale or license of publishing rights shall be divided _____ percent to the Photographer and _____ percent to the Coauthor.

Net proceeds from the sale or license of electronic publishing rights shall be divided _____ percent to the Photographer and _____ percent to the Coauthor. For purposes of this agreement, electronic rights are defined as rights in the digitized form of works that can be encoded, stored, and retrieved from such media as computer disks, CD-ROM, computer databases, and network servers.

Net proceeds from the sale or license of nonpublishing rights in the Work (including but not limited to audio, merchandising, motion picture, stage play, or television rights to the Work), whether such sale or license occurs before or after initial publication of the Work, shall be divided ______ percent to the Photographer and ______ percent to the Coauthor, unless provided to the contrary here, in which case the following rights shall be treated with respect to division of net proceeds and control or disposition as follows:______

If possible, net proceeds shall be paid directly to each party in accordance with the divisions set forth in this Paragraph. If either party is designated to collect such net proceeds, that party shall make immediate payment to the other party of such amounts as are due hereunder.

- 7. Agent. If the parties have entered into an agency agreement with respect to the Work, it is with the following agent: ________. If a contract for the Work has not already been entered into with an agent, both Photographer and Coauthor agree □ to seek such a contract □ not to seek such a contract. Any agency contract shall be mutually acceptable to and entered into in the names of and signed by both the Photographer and the Coauthor, each of whom shall comply with and perform all required contractual obligations.
- 8. Authorship Credit. The credit line for the Work shall be as follows wherever authorship credit is given in the Work or in promotion, advertising, or other ancillary uses:_____

_____. The color and type size for such authorship credit shall be the same for both authors unless provided to the contrary here:_____

9. Artistic Control. Each party shall have artistic control over his or her portion of the Work, unless provided to the contrary here in which case artistic control of the entire Work shall be exercised by ______

_____. The parties shall share ideas and make their work in progress available to the other party for discussion and coordination purposes. Except as provided in Paragraphs 3 and 12, neither party shall at any time make any changes in the portion of the Work created by the other party.

- **10. Warranty and Indemnity.** Photographer and Coauthor each warrant and represent to the other that the respective contributions of each to the Work are original (or that appropriate releases have been obtained and paid for) and do not libel or otherwise violate any right of any person or entity, including but not limited to rights of copyright or privacy. Photographer and Coauthor each indemnify and hold the other harmless from and against any and all claims, actions, liability, damages, costs, and expenses, including reasonable legal fees and expenses, incurred by the other as a result of the breach of such warranties, representations, and undertakings.
- **11. Assignment.** This Agreement shall not be assignable by either party hereto, provided, however, that after completion of the Work, either party may assign the right to receive money pursuant to Paragraph 6 by giving written notice to the other party.

- **12. Death or Disability.** In the event that either party dies or suffers a disability that will prevent completion of his or her respective portion of the Work, or of a revision thereof or a sequel thereto, the other party shall have the right to complete that portion or to hire a third party to complete that portion and shall adjust the authorship credit to reflect the revised authorship arrangements. The deceased or disabled party shall receive payments pursuant to Paragraph 6 pro rata to the proportion of his or her work completed or, in the case of a revision or sequel, shall receive payments pursuant to Paragraph 6 pro rata to the proportion of his or her work completed or, in the case of a revision or sequel, shall receive payments pursuant to Paragraph 6 after deduction for the cost of revising or creating the sequel with respect to his or her portion of the Work. The active party shall have the sole power to license and contract with respect to the Work, and approval of the personal representative, heirs, or conservator of the deceased or disabled party shall not be required. If all parties are deceased, the respective heirs or personal representatives shall take the place of the parties for all purposes.
- **13.** Arbitration. All disputes arising under this Agreement shall be submitted to binding arbitration before ______ in the following location ______ and

shall be settled in accordance with the rules of the American Arbitration Association. Judgment upon the arbitration award may be entered in any court having jurisdiction thereof.

- **14. Term.** The term for this Agreement shall be the duration of the copyright, plus any renewals or extensions thereof.
- **15. Independent Parties.** The parties to this Agreement are independent of one another, and nothing contained in this Agreement shall make a partnership or joint venture between them.
- **16.** Competitive Works. If the parties wish to restrict future activities to avoid competition with the Work, any such restrictions must be stated here: _____
- 17. Infringement. In the event of an infringement of the Work, the Photographer and Coauthor shall have the right to sue jointly for the infringement and, after deducting the expenses of bringing suit, to share in any recovery as follows:_______. If either party chooses not to join in the suit, the other party may proceed and, after deducting all the expenses of bringing the suit, any recovery shall be shared between the parties as stated in the preceding sentence.

18. Miscellany. This Agreement shall be binding upon the parties hereto, their heirs, successors, assigns, and personal representatives. This Agreement constitutes the entire understanding between the parties. Its terms can be modified only by an instrument in writing signed by both parties. Each party shall do all acts and sign all documents required to effectuate this Agreement. A waiver of any breach of any of the provisions of this Agreement shall not be construed as a continuing waiver of other breaches of the same or other provisions hereof. This Agreement shall be governed by the laws of the State of ______.

IN WITNESS WHEREOF, the parties hereto have signed this Agreement as of the date first set forth above.

Photographer___

Coauthor___

Contract for the Sale of Fine Art Photography

(hereinafter refe	ed to as the "Photographer"), located at
	, and (hereinafter referred to as the "Collecto
	, with respect to
	k (hereinafter referred to as the "Work").
	Photographer has created the Work and has full right, title, and interest therein; and
,	Photographer wishes to sell the Work; and
	Collector has viewed the Work and wishes to purchase it;
	DRE, in consideration of the foregoing premises and the mutual obligations, covenants, and conditional states are a follows:
	rth, and other valuable considerations, the parties hereto agree as follows: of Work. The Photographer describes the Work as follows:
 Description 	Title
	Medium
	Size
	Framing or Mounting
	Year of Creation
	Signed by Photographer: 🛛 Yes 🗳 No
	The Photographer warrants that this work is unique (one of a kind): \Box Yes \Box No
numbered editions	 _; how many multiples are signed; how many are unsigned; how many; how many are unnumbered; how many proofs exist; the quantity of any p; and whether the master image has been cancelled or destroyed □ yes □ no. notographer hereby agrees to sell the Work to the Collector. Title shall pass to the Collector at such t ent is received by the Photographer pursuant to Paragraph 4 hereof. ollector agrees to purchase the Work for the agreed upon price of \$, and shall also pay ales or transfer taxes. Payment shall be made in full upon the signing of this Agreement. e □ Photographer □ Collector shall arrange for delivery to the following location: no later than, 19 The expenses of delivery (included to, insurance and transportation) shall be paid by
loss or d	nage shall be the responsibility of the Collector from the time of
tory copyr whatsoev following 3. Miscellar represent only by an shall not b	and Reproduction. The Photographer reserves all reproduction rights, including the right to claim st ht, in the Work. The Work may not be photographed, sketched, painted, or reproduced in any mar without the express, written consent of the Photographer. All approved reproductions shall bear pyright notice: © by (Photographer's name) 19 This Agreement shall be binding upon the parties hereto, their heirs, successors, assigns, and perso ves. This Agreement constitutes the entire understanding between the parties. Its terms can be modi strument in writing signed by both parties. A waiver of any breach of any of the provisions of this Agreem construed as a continuing waiver of other breaches of the same or other provisions hereof. This Agreem verned by the laws of the State of
IN WITNESS	HEREOF, the parties hereto have signed this Agreement as of the date first set forth above.
Photographe	Collector

Delivery Memo

Delivery Memo No
Telephone Inted b/File Number BW/Color
n/File Number BW/Color
n/File Number BW/Color
n/File Number BW/Color
eft, or damage.
Black and White
te by returning one signed copy of this for hall be considered to accept the count show
y suitable for reproduction.
Date
a

Subject to All Terms and Conditions Above and on Reverse Side

- 1. Purpose. Photographer hereby agrees to entrust the photographs listed on the front of this form to the Recipient for the purpose specified. "Photographs" are defined to include transparencies, prints, negatives, digitized encodations, and any other form in which the images can be stored, incorporated, represented, projected, or perceived, including forms and processes not presently in existence but which may come into being in the future.
- 2. Acceptance. Recipient accepts the listing and values as accurate if not objected to in writing by return mail immediately after receipt of the photographs. If Recipient has not signed this form, any terms on this form not objected to in writing within 10 days shall be deemed accepted.
- **3.** Ownership and Copyright. Copyright and all reproduction rights in the photographs, as well as the ownership of the physical photographs themselves, are the property of and reserved to the Photographer. Recipient acknowledges that the photographs shall be held in confidence and agrees not to display, copy, or modify directly or indirectly any of the photographs submitted, nor will Recipient permit any third party to do any of the foregoing. Reproduction, display, sale, or rental shall be allowed only upon Photographer's written permission specifying usage and fees.
- **5. Insurance.** Recipient does does not agree to insure the photographs for all risks from the time of shipment from the Photographer until the time of delivery to the Photographer for the values shown on the front of this form.
- 6. Holding Fees. The photographs are to be returned to the Photographer within _____ days after delivery to the Recipient. Each photograph held beyond _____ days from delivery shall incur the following weekly holding fee: \$_____ which shall be paid to the Photographer when billed.
- 7. Arbitration. Recipient and Photographer agree to submit all disputes hereunder in excess of \$______ to arbitration before ______ at the following location ______ under the rules of the American Arbitration Association. The arbitrator's award shall be final and judgment may be entered on it in any court having jurisdiction thereof.
- Miscellany. This Agreement contains the full understanding between the parties hereto and may only be modified by a written instrument signed by both parties. It shall be governed by the laws of the State of______.

Photographer—Gallery Contract with Record of Consignment and Statement of Account

(hereinafter referred to as the "Photographer"), located at and		
at		dallory), locator
WHEREAS, the Photographer is a professional photographer of good s	standing; and	
WHEREAS, the Photographer wishes to have certain artworks represer	nted by the Gallery, and	
WHEREAS, the Gallery wishes to represent the Photographer under the	e terms and conditions of this	Agreement,
NOW, THEREFORE, in consideration of the foregoing premises and the	e mutual covenants hereinafter	set forth and othe
valuable consideration, the parties hereto agree as follows:		
1. Scope of Agency. The Photographer appoints the Gallery to act a		
gallery in the following geographic area artworks in the following media		
completed by the Photographer while this Agreement is in force a	nd shall apply only to physica	l artworks, not the
licensing of reproduction rights (whether for an assignment client, sto document receipt of all works consigned hereunder by signing a		
Consignment in the form annexed to this contract as Appendix A.		
2. Term and Termination. This Agreement shall have a term of	years and may be terminat	ted by either party
giving sixty days' written notice to the other party. The Agreement s		
Photographer, the death or termination of employment of		-
of the area of, or if the Gallery becomes bankrupt o	r insolvent. On termination, al	I WORKS CONSIGNED
hereunder shall immediately be returned to the Photographer at the	e expense of the Gallery.	
	e expense of the Gallery. grapher of days betwe	en
hereunder shall immediately be returned to the Photographer at the 3. Exhibitions. The Gallery shall provide a solo exhibition for the Photographer	e expense of the Gallery. grapher of days betwe which shall be exclusive	een ely devoted to th
 hereunder shall immediately be returned to the Photographer at the Exhibitions. The Gallery shall provide a solo exhibition for the Photographer at and in the exhibition space located at Photographer's exhibition for the specified time period. The Photographer of his or her work and the quality of reproduction of such work for pro- 	e expense of the Gallery. grapher of days betwe which shall be exclusive apher shall have artistic control motional or advertising purpos	een ely devoted to the over the exhibition
 hereunder shall immediately be returned to the Photographer at the Exhibitions. The Gallery shall provide a solo exhibition for the Photographer at and in the exhibition space located at Photographer's exhibition for the specified time period. The Photographer at the photographer at the specified time period. The Photographer's exhibition for the specified time period. 	e expense of the Gallery. grapher of days betwe which shall be exclusive apher shall have artistic control motional or advertising purpos	een ely devoted to the over the exhibition
 hereunder shall immediately be returned to the Photographer at the Exhibitions. The Gallery shall provide a solo exhibition for the Photographer at and in the exhibition space located at Photographer's exhibition for the specified time period. The Photographer of his or her work and the quality of reproduction of such work for pro- 	e expense of the Gallery. grapher of days betwe which shall be exclusive apher shall have artistic control motional or advertising purpos	een ely devoted to the over the exhibition
 hereunder shall immediately be returned to the Photographer at the Exhibitions. The Gallery shall provide a solo exhibition for the Photographer and in the exhibition space located at Photographer's exhibition for the specified time period. The Photographer of his or her work and the quality of reproduction of such work for proof the exhibition shall be paid for in the respective percentages shows Exhibition Expenses 	e expense of the Gallery. grapher of days betwee which shall be exclusive apher shall have artistic control protional or advertising purpose own below: Photographer	een ely devoted to the over the exhibition ses. The expenses
 hereunder shall immediately be returned to the Photographer at the Exhibitions. The Gallery shall provide a solo exhibition for the Photographer and in the exhibition space located at Photographer's exhibition for the specified time period. The Photographer of his or her work and the quality of reproduction of such work for proof the exhibition shall be paid for in the respective percentages shows the specified time period. The Photographer's exhibition for the specified time period. The Photographer's exhibition shall be paid for in the respective percentages shows the specified time period. 	e expense of the Gallery. grapher of days betwe which shall be exclusive apher shall have artistic control motional or advertising purpos own below: Photographer	een ely devoted to the over the exhibition ses. The expenses
 hereunder shall immediately be returned to the Photographer at the Exhibitions. The Gallery shall provide a solo exhibition for the Photographer and in the exhibition space located at Photographer's exhibition for the specified time period. The Photographer of his or her work and the quality of reproduction of such work for proof the exhibition shall be paid for in the respective percentages shows Exhibition Expenses 	e expense of the Gallery. grapher of days betwe which shall be exclusive apher shall have artistic control motional or advertising purpos own below: Photographer	een ely devoted to the over the exhibition ses. The expenses
 hereunder shall immediately be returned to the Photographer at the Exhibitions. The Gallery shall provide a solo exhibition for the Photographer at the and in the exhibition space located at Photographer's exhibition for the specified time period. The Photographer's exhibition for the specified time period. The Photographer's exhibition shall be paid for in the respective percentages she Exhibition Expenses Transporting work to gallery (including insurance and packing) 	e expense of the Gallery. grapher of days betwe which shall be exclusive apher shall have artistic control motional or advertising purpos own below: Photographer	een ely devoted to the over the exhibition ses. The expenses
 hereunder shall immediately be returned to the Photographer at the Exhibitions. The Gallery shall provide a solo exhibition for the Photogrand in the exhibition space located at Photographer's exhibition for the specified time period. The Photographer's exhibition for the specified time period. The Photographer's exhibition shall be paid for in the respective percentages she Exhibition Expenses Transporting work to gallery (including insurance and packing)	e expense of the Gallery. grapher of days betwe which shall be exclusive apher shall have artistic control motional or advertising purpos own below: Photographer	een ely devoted to the over the exhibition ses. The expenses
 hereunder shall immediately be returned to the Photographer at the 3. Exhibitions. The Gallery shall provide a solo exhibition for the Photogrand in the exhibition space located at Photographer's exhibition for the specified time period. The Photographer's of his or her work and the quality of reproduction of such work for proof the exhibition shall be paid for in the respective percentages shall Exhibition Expenses Transporting work to gallery (including insurance and packing)	e expense of the Gallery. grapher of days betwe which shall be exclusive apher shall have artistic control motional or advertising purpos own below: Photographer	een ely devoted to the over the exhibition ses. The expenses
 hereunder shall immediately be returned to the Photographer at the Exhibitions. The Gallery shall provide a solo exhibition for the Photogrand in the exhibition space located at Photographer's exhibition for the specified time period. The Photographer's of his or her work and the quality of reproduction of such work for proof the exhibition shall be paid for in the respective percentages showed by the exhibition for the gallery (including insurance and packing) Advertising	e expense of the Gallery. grapher of days betwe which shall be exclusive apher shall have artistic control motional or advertising purpos own below: Photographer 	een ely devoted to the over the exhibition ses. The expenses
 hereunder shall immediately be returned to the Photographer at the Exhibitions. The Gallery shall provide a solo exhibition for the Photogrand in the exhibition space located at Photographer's exhibition for the specified time period. The Photographer's of his or her work and the quality of reproduction of such work for proof the exhibition shall be paid for in the respective percentages showed by the exhibition for the gallery (including insurance and packing) Exhibition Expenses Transporting work to gallery (including insurance and packing) Advertising Catalogs Announcements Frames Special installations Photographing work 	e expense of the Gallery. grapher of days betwe which shall be exclusive apher shall have artistic control motional or advertising purpos own below: Photographer 	een ely devoted to th over the exhibitio ses. The expense
 hereunder shall immediately be returned to the Photographer at the Exhibitions. The Gallery shall provide a solo exhibition for the Photogrand in the exhibition space located at Photographer's exhibition for the specified time period. The Photographer's of his or her work and the quality of reproduction of such work for proof the exhibition shall be paid for in the respective percentages showed by the statement of the gallery (including insurance and packing)	e expense of the Gallery. grapher of days betwe which shall be exclusive apher shall have artistic control motional or advertising purpos own below: Photographer 	een ely devoted to the over the exhibition ses. The expenses
 hereunder shall immediately be returned to the Photographer at the Exhibitions. The Gallery shall provide a solo exhibition for the Photogrand in the exhibition space located at Photographer's exhibition for the specified time period. The Photographer's of his or her work and the quality of reproduction of such work for proof the exhibition shall be paid for in the respective percentages showed by the exhibition for the gallery (including insurance and packing) Exhibition Expenses Transporting work to gallery (including insurance and packing) Advertising	e expense of the Gallery. grapher of days betwe which shall be exclusive apher shall have artistic control motional or advertising purpos own below: Photographer 	een ely devoted to the over the exhibition ses. The expense

No expense which is to be shared shall be incurred by either party without the prior written consent of the other party as to the amount of the expense. After the exhibition, the frames, photographs, negatives, and any other tangible property created in the course of the exhibition shall be the property of

- 4. Commissions. The Gallery shall receive a commission of _____ percent of the retail price of each work sold. In the case of discount sales, the discount shall be deducted from the Gallery's commission. If the Gallery's agency is exclusive, then the Gallery shall receive a commission of _____ percent of the retail price for each studio sale by the Photographer that falls within the scope of the Gallery's exclusivity. Works done on a commissioned basis by the Photographer □ shall □ shall not be considered studio sales on which the Gallery may be entitled to a commission.
- **5. Prices.** The Gallery shall sell the works at the retail prices shown on the Record of Consignment, subject to the Gallery's right to make customary trade discounts to such purchasers as museums and designers.
- 6. Payments. The Gallery shall pay the Photographer all proceeds due to the Photographer within thirty days of sale. No sales on approval or credit shall be made without the Photographer's written consent and, in such cases, the first proceeds received by the Gallery shall be paid to the Photographer until the Photographer has been paid all proceeds due.
- 7. Accounting. The Gallery shall furnish the Photographer with an accounting every _____ months in the form attached hereto as Appendix B, the first such accounting to be given on the first day of ______, 19_____. Each accounting shall state for each work sold during the accounting period the following information: the title of the work, the date of sale, the sale price, the name and address of the purchaser, the amounts due the Gallery and the Photographer, and the location of all works consigned to the Gallery that have not been sold. An accounting shall be provided in the event of termination of this Agreement.
- 8. Inspection of Books. The Gallery shall maintain accurate books and documentation with respect to all transactions entered into for the Photographer. On the Photographer's written request, the Gallery will permit the Photographer or the Photographer's authorized representative to examine these books and documentation during normal business hours of the Gallery.
- 9. Loss or Damage. The Gallery shall be responsible for the safekeeping of all consigned artworks. The Gallery shall be strictly liable for loss or damage to any consigned artwork from the date of delivery to the Gallery until the work is returned to the Photographer or delivered to a purchaser. In the event of loss or damage that cannot be restored, the Photographer shall receive the same amount as if the work had been sold at the retail price listed in the Record of Consignment. If restoration is undertaken, the Photographer shall have a veto power over the choice of the restorer.
- **10. Insurance.** The Gallery shall insure the work for _____ percent of the retail price shown in the Record of Consignment.
- **11. Copyright.** The Gallery shall take all steps necessary to ensure that the Photographer's copyright in the consigned works is protected, including but not limited to requiring copyright notices on all reproductions of the works used for any purpose whatsoever.
- **12. Security Interest.** Title to and a security interest in any works consigned or proceeds of sale under this Agreement are reserved to the Photographer. In the event of any default by the Gallery, the Photographer shall have all the rights of a secured party under the Uniform Commercial Code and the works shall not be subject to claims by the Gallery's creditors. The Gallery agrees to execute and deliver to the Photographer, in the form requested by the Photographer, a financing statement and such other documents which the Photographer may require to perfect its security interest in the works. In the event of the purchase of any work by a party other than the Gallery, title shall pass directly from the Photographer to the Other party. In the event of the purchase of any work by the Gallery, title shall pass only upon full payment to the Photographer of all sums due hereunder. The Gallery agrees not to pledge or encumber any works in its possession, nor to incur any charge or obligation in connection therewith for which the Photographer may be liable.

- **13. Assignment.** This Agreement shall not be assignable by either party hereto, provided, however, that the Photographer shall have the right to assign money due him or her hereunder.
- **14.** Arbitration. All disputes arising under this Agreement shall be submitted to binding arbitration before _______ in the following location _______

and the arbitration award may be entered for judgment in any court having jurisdiction thereof. Notwithstanding the foregoing, either party may refuse to arbitrate when the dispute is for a sum of less than \$_____.

- **15.** Modifications. All modifications of this Agreement must be in writing and signed by both parties. This Agreement constitutes the entire understanding between the parties hereto.
- 16. Governing Law. This Agreement shall be governed by the laws of the State of _____

IN WITNESS WHEREOF, the parties hereto have signed this Agreement as of the date first set forth above.

Photograph	ner	Gallery	
		,	Company Name
		Ву	
			Authorized Signatory, Title
APPENDIX A:	Record of Consignment		

This is to acknowledge receipt of the following works of art on consignment:

Title	Medium	Description	Retail Price
1			<u> </u>
2			
3			
4			
5			
6			
7			
8			
9			
	Gallery	0	
		Company Name	
	Ву		
		Authorized Signatory, Title	

APPENDIX B: Statement of Account

Date							
accounting for Period					19		
he following works w	were sold durir	ng this peri	od:				
Title		Date Sold	Purchaser's and Addi		Sale Price	Gallery's Commission	Due Photographer
1							
2							
3							
4							
The total due you of	\$	is enclose	ed with this State	ment of Acco			
The following work							
	s remain on c	onsignine	ant with the gain	ery:			
	Title				Locatio	n	
l					Locatio	n	
1							
1 2							
1 2 3							
1 2 3 4 5							
1 2 3 4 5 3							
1 2 3 4 5 5 5 7							
1 2 3 4 5 6 7 3							
1 2 3 4 5 6 7 3							
1 2 3 4 5 6 7 8							
1 2 3 4 5 6 7 8							

Photographer's Lecture Contract

 S, the Sponsor is familiar with and admires the work of the Photographer; and S, the Sponsor wishes the Photographer to visit the Sponsor to enhance the opportunities for its students to have ith a working professional photographer; and S, the Photographer wishes to lecture with respect to his or her work and perform such other services as the nay call for; EREFORE, in consideration of the foregoing premises and the mutual covenants hereinafter set forth and ot considerations, the parties hereto agree as follows: grapher to Lecture. The Photographer hereby agrees to come to the Sponsor on the following date(s): and perform the following service
 S, the Sponsor wishes the Photographer to visit the Sponsor to enhance the opportunities for its students to have ith a working professional photographer; and S, the Photographer wishes to lecture with respect to his or her work and perform such other services as the nay call for; EREFORE, in consideration of the foregoing premises and the mutual covenants hereinafter set forth and ot considerations, the parties hereto agree as follows: grapher to Lecture. The Photographer hereby agrees to come to the Sponsor on the following date(s): and perform the following service
ith a working professional photographer; and S , the Photographer wishes to lecture with respect to his or her work and perform such other services as to hay call for; EREFORE , in consideration of the foregoing premises and the mutual covenants hereinafter set forth and ot considerations, the parties hereto agree as follows: grapher to Lecture. The Photographer hereby agrees to come to the Sponsor on the following date(s): and perform the following service Photographer shall use best efforts to make his or her services as productive as possible to the Sponsor
 S, the Photographer wishes to lecture with respect to his or her work and perform such other services as the nay call for; EREFORE, in consideration of the foregoing premises and the mutual covenants hereinafter set forth and ot considerations, the parties hereto agree as follows: grapher to Lecture. The Photographer hereby agrees to come to the Sponsor on the following date(s): and perform the following service
hay call for; EREFORE, in consideration of the foregoing premises and the mutual covenants hereinafter set forth and ot considerations, the parties hereto agree as follows: grapher to Lecture. The Photographer hereby agrees to come to the Sponsor on the following date(s): and perform the following servic Photographer shall use best efforts to make his or her services as productive as possible to the Sponsor
considerations, the parties hereto agree as follows: grapher to Lecture. The Photographer hereby agrees to come to the Sponsor on the following date(s): and perform the following servic
and perform the following servic
The Sponsor agrees to pay as full compensation for the Photographer's services rendered under Paragras sum of \$ This sum shall be payable to the Photographer on completion of the day of grapher's residence with the Sponsor. nses. In addition to the payments provided under Paragraph 2, the Sponsor agrees to reimburse
grapher for the following expenses:
ravel expenses in the amount of \$
ood and lodging expenses in the amount of \$
Other expenses listed here:in the amount of \$
eimbursement for travel expenses shall be made fourteen (14) days prior to the earliest date specifier graph 1. The reimbursement for food, lodging, and other expenses shall be made at the date of paym ified in Paragraph 2, unless a contrary date is specified here:
dition, the Sponsor shall provide the Photographer with the following:
ickets for travel, rental car, or other modes of transportation as follows:
ood and lodging as follows:
Other hospitality as follows:

prevented from having the Photographer appear by Acts of God, hurricane, flood, governmental order, or other cause beyond its control, the Sponsor shall be responsible only for the payment of such expenses under Paragraph 3 as the Photographer shall have actually incurred. The Sponsor agrees in such a case to attempt to reschedule the Photographer's appearance at a mutually acceptable future date.

- **5.** Late Payment. The Sponsor agrees that, in the event it is late in making payment of amounts due to the Photographer under Paragraphs 2, 3, or 8, it will pay as additional liquidated damages ______ percent in interest on the amounts it is owing to the Photographer, said interest to run from the date stipulated for payment in Paragraphs 2, 3, or 8 until such time as payment is made.
- 6. Copyrights and Recordings. Both parties agree that the Photographer shall retain all rights, including copyrights, in relation to recordings of any kind made of the appearance or any works shown in the course thereof. The term "recording" as used herein shall include any recording made by electronic transcription, tape recording, wire recording, film, videotape, or other similar or dissimilar method of recording, whether now known or hereinafter developed. No use of any such recording shall be made by the Sponsor without the written consent of the Photographer and, if stipulated therein, additional compensation for such use.
- 7. Insurance and Loss or Damage. The Sponsor agrees that it shall provide wall-to-wall insurance for the works listed on the Schedule of Photography for the values specified therein. The Sponsor agrees that it shall be fully responsible and have strict liability for any loss or damage to the work from the time it leaves the Photographer's residence or studio until such time as it is returned there.
- 8. Packing and Shipping. The Sponsor agrees that it shall fully bear any costs of packing and shipping necessary to deliver the works specified in Paragraph 7 to the Sponsor and return them to the Photographer's residence or studio.
- **9.** Modification. This contract contains the full understanding between the parties hereto and may only be modified in a written instrument signed by both parties.

10. Governing Law. This contract shall be governed by the laws of the State of ____

IN WITNESS WHEREOF, the parties hereto have signed this Agreement as of the date first set forth above.

Photographer		Spor	isor		
				Company Name	
		By			
			A	uthorized Signatory, Title	2
Schedule of Phot	ographs				
	Title		Description	Size	Value
1					
2					
	<i>r</i>				

Licensing Contract to Merchandise Images

(hei	reinafter referred to as the "Photographer"), located at
and	(hereinafter referred to as the "Licensee")
002	ated at
nar	n respect to the use of a certain image created by the Photographer (hereinafter referred to as the "Image") for hufactured products (hereinafter referred to as the "Licensed Products").
	EREAS, the Photographer is a professional photographer of good standing; and
	EREAS, the Photographer has created the Image which the Photographer wishes to license for purposes of nufacture and sale; and
WН	EREAS, the Licensee wishes to use the Image to create a certain product or products for manufacture and sale; and
NН	IEREAS, both parties want to achieve the best possible quality to generate maximum sales;
	W, THEREFORE, in consideration of the foregoing premises and the mutual covenants hereinafter set forth and othe Jable consideration, the parties hereto agree as follows:
1.	Grant of Merchandising Rights. The Photographer grants to the Licensee the exclusive nonexclusive rights to use the Image, titled and described a, which was created and i
	owned by the Photographer, as or as part of the following type(s) of merchandise:
	fc
	manufacture, distribution, and sale by the Licensee in the following geographical area:
	and for the following period of time
2.	Ownership of Copyright. The Photographer shall retain all copyrights in and to the Image. The Licensee shall identif the Photographer as the creator of the Image on the Licensed Products and shall reproduce thereon a copyright notic for the Photographer which shall include the word "Copyright" or the symbol for copyright, the Photographer's name and the year date of first publication.
3.	Advance and Royalties. Licensee agrees to pay Photographer a nonrefundable advance in the amount of \$ upon signing this Agreement, which advance shall be recouped from first royalties due hereunder Licensee further agrees to pay Photographer a royalty of (%) percent of the net sales of the Licensee Products. "Net Sales" as used herein shall mean sales to customers less prepaid freight and credits for lawful an customary volume rebates, actual returns, and allowances. Royalties shall be deemed to accrue when the Licensee Products are sold, shipped, or invoiced, whichever first occurs.
4.	Payments and Statements of Account. Royalty payments shall be paid monthly on the first day of each mont

4. Payments and Statements of Account. Royalty payments shall be paid monthly on the first day of each monthly commencing _________, 19 _______, and Licensee shall with each payment furnish Photographer with a monthly statement of account showing the kinds and quantities of all Licensed Products sold, the prices received therefor, and all deductions for freight, volume rebates, returns, and allowances. The Photographer shall have the right to terminate this Agreement upon thirty (30) days' notice if Licensee fails to make any payment required of it and does not cure this default within said thirty (30) days, whereupon all rights granted herein shall revert immediately to the Photographer.

- 5. Inspection of Books and Records. Photographer shall have the right to inspect Licensee's books and records concerning sales of the Licensed Products upon prior written notice.
- 6. Samples. Licensee shall give the Photographer ______ samples of the Licensed Products for the Photographer's personal use. The Photographer shall have the right to purchase additional samples of the Licensed Products at the Licensee's manufacturing cost.
- 7. Quality of Reproductions. The Photographer shall have the right to approve the quality of the reproduction of the Image on the Licensed Products, and the Photographer agrees not to withhold approval unreasonably.
- 8. Promotion. Licensee shall use its best efforts to promote, distribute, and sell the Licensed Products.
- 9. Reservation of Rights. All rights not specifically transferred by this Agreement are reserved to the Photographer.
- 10. Indemnification. The Licensee shall hold the Photographer harmless from and against any loss, expense, or damage occasioned by any claim, demand, suit, or recovery against the Photographer arising out of the use of the Image for the Licensed Products.
- 11. Assignment. Neither party shall assign rights or obligations under this Agreement, except that the Photographer may assign the right to receive money due hereunder.
- 12. Nature of Contract. Nothing herein shall be construed to constitute the parties hereto joint venturers, nor shall any similar relationship be deemed to exist between them.
- **13.** Governing Law. This Agreement shall be construed in accordance with the laws of Licensee consents to the jurisdiction of the courts of _____.
- 14. Addresses. All notices, demands, payments, royalty payments, and statements shall be sent to the Photographer at the following address _____ and to the Licensee at
- 15. Modifications in Writing. This Agreement constitutes the entire agreement between the parties hereto and shall not be modified, amended, or changed in any way except by a written agreement signed by both parties hereto.
- IN WITNESS WHEREOF, the parties have signed this Agreement as of the date first set forth above.

Photographer_____ Licensee___

Company Name

By____

Authorized Signatory, Title

Model Release

In consideration of	Dollars (\$), and other valuable consideration, receipt of which is
acknowledged, I,		(print Model's name)
do hereby give assigns, licensees, succe any fictional name), pictu restriction as to changes derivative works made in a I waive any right to inspe including written copy tha harmless the Photographe any liability by virtue of any or otherwise, that may oct the completion of the finis caused, produced, and reproach, scorn, and indi- waive any claims I may ha limited to claims for eithe	essors in interest, legal repr ure, portrait, or photograph is or alterations (including any medium) for advertising ect or approve the photogra at may be created and appe er, his or her assigns, license y blurring, distortion, alterati cur or be produced in the ta hed product, unless it can be published solely for the p gnity. I agree that the Photo ave based on any usage of r invasion of privacy or libe binding on me, my legal rep	(the Photographer), his or her esentatives, and heirs the irrevocable right to use my name (or in all forms and in all media and in all manners, without any but not limited to composite or distorted representations or , trade, promotion, exhibition, or any other lawful purposes, and aph(s) or finished version(s) incorporating the photograph(s), ear in connection therewith. I hereby release and agree to hold ees, successors in interest, legal representatives and heirs from ion, optical illusion, or use in composite form whether intentional aking of the photographs, or in any processing tending toward be shown that they and the publication thereof were maliciously purpose of subjecting me to conspicuous ridicule, scandal, grapher owns the copyright in these photographs and I hereby the photographs or works derived therefrom, including but not I. I am of full age* and competent to sign this release. I agree presentatives, heirs, and assigns. I have read this release and
Witness:		_ Signed: Model
Address:		Address:
		Date:, 19
	Conse	nt (if applicable)
	ian of the minor named abo and waive any rights in the	ove and have the legal authority to execute the above release. premises.
Witness:		Signed: Parent or Guardian
Address:		Address:
		Date:, 19
* Delete this sentence if	the subject is a minor. The	e parent or guardian must then sign the consent.

Pocket Model Release

consideration of		Dollars (\$), receip
which is acknowledged, I,		(print Model's nar	me), do hereby giv
essors in interest, legal represe cture, portrait, or photograph presentations, for advertising, e finished version(s), including	(the Photogr ntatives, and heirs the irrevocable rig in all forms and media and in all m trade, or any other lawful purposes, a g written copy that may be created a ease and am fully familiar with its co	ght to use my name (or a anners, including com and I waive any right to and appear in connecti	any fictional name posite or distorte inspect or approv
Witness	Signed_	Model	
Address			
	Date, 19		
m the parent or guardian of the approve the foregoing and wai	minor named above and have the leg ve any rights in the premises.	gal authority to execute	the above releas
	ve any rights in the premises.		
pprove the foregoing and wai	ve any rights in the premises. Signed_		an
approve the foregoing and wai	ve any rights in the premises. Signed_	Parent or Guardia	an
pprove the foregoing and wai Witness Address	ve any rights in the premises. Signed_ Address	Parent or Guardia	an
pprove the foregoing and wai Witness Address	ve any rights in the premises. Signed_ Address Date, 19	Parent or Guardia	an
pprove the foregoing and wai Witness Address	ve any rights in the premises. Signed_ Address Date, 19	Parent or Guardia	an
pprove the foregoing and wai Witness Address	ve any rights in the premises. Signed_ Address Date, 19	Parent or Guardia	an

Property Release

	Dollars (\$) and other valuable considera-
	,
	, do, irrevoca, do, irrevoca-
	(the Photographer), his or her
assigns, licensees, successors in interest, legal represen and media and in all manners for advertising, trade, pro the following property:	ntatives, and heirs to copyright, publish, and use in all forms protion, exhibition, or any other lawful purpose, images of
	or such uses, regardless of whether said use is composite
or distorted in character or form, whether said use is made	le in conjunction with my own name or with a fictitious name, otherwise, or other derivative works are made through any
I waive any right that I may have to inspect or approve photographs, including written copy that may be used i	the photograph(s) or finished version(s) incorporating the in connection therewith.
I am of full age and have every right to contract in my ow this release shall be binding on me, my legal representativ and release prior to its execution and I am fully cogniza	vn name with respect to the foregoing matters. I agree that ives, heirs, and assigns. I have read the above authorization ant of its contents.
Witness	Signed
Address	Address
Date, 19	

Video Contract

Client	_ Telephone_	
address	_	
	Order Num	ber
Description of Video Services to be Provided		
Subject for Video		
Location for Video		
Location for Video	Date	Time
Location for Video	Date	Time
Copies to be made in 🛛 🖵 VHS 🗖 8mm 🗖 O	Other	
Duration of video to be taken for Client minutes. Duration of edite	ed video for Client _	minute
Special Services, if required (including any special equipment)		
Charges. The package fee is based on the Photographer's Standard Price List a If the fee is not based on a package but is a session fee, all copies shall be billed with the Standard Price List. In addition to either the package fee or the session fee be billed if and when incurred.	d in addition to the fe fee, the extra charge	ee and in accordanc es set forth below sha
If the fee is not based on a package but is a session fee, all copies shall be billed with the Standard Price List. In addition to either the package fee or the session fee billed if and when incurred.	d in addition to the fe fee, the extra charge	ee and in accordanc es set forth below sha
If the fee is not based on a package but is a session fee, all copies shall be billed with the Standard Price List. In addition to either the package fee or the session f be billed if and when incurred. Package Fee (Package number) Fee Without Package	d in addition to the fe fee, the extra charge	ee and in accordanc es set forth below sha
If the fee is not based on a package but is a session fee, all copies shall be billed with the Standard Price List. In addition to either the package fee or the session f be billed if and when incurred. Package Fee (Package number) Fee Without Package Extra Charges	d in addition to the fe fee, the extra charge \$\$	ee and in accordanc es set forth below sha
If the fee is not based on a package but is a session fee, all copies shall be billed with the Standard Price List. In addition to either the package fee or the session f be billed if and when incurred. Package Fee (Package number) Fee Without Package Extra Charges Additional copies	d in addition to the fe fee, the extra charge \$ \$ \$ \$	ee and in accordanc es set forth below sha
If the fee is not based on a package but is a session fee, all copies shall be billed with the Standard Price List. In addition to either the package fee or the session f be billed if and when incurred. Package Fee (Package number) Fee Without Package Extra Charges Additional copies Cases	d in addition to the fe fee, the extra charge \$ \$ \$ \$ \$	ee and in accordanc es set forth below sha
If the fee is not based on a package but is a session fee, all copies shall be billed with the Standard Price List. In addition to either the package fee or the session f be billed if and when incurred. Package Fee (Package number) Fee Without Package Extra Charges Additional copies	d in addition to the fe fee, the extra charge \$	ee and in accordanc es set forth below sha
If the fee is not based on a package but is a session fee, all copies shall be billed with the Standard Price List. In addition to either the package fee or the session f be billed if and when incurred. Package Fee (Package number) Fee Without Package Extra Charges Additional copies Cases Additional camera Lighting technician Rush service	d in addition to the fe fee, the extra charge \$\$ \$\$ \$\$ \$\$ \$\$ \$\$ \$\$	ee and in accordanc es set forth below sha
If the fee is not based on a package but is a session fee, all copies shall be billed with the Standard Price List. In addition to either the package fee or the session f be billed if and when incurred. Package Fee (Package number) Fee Without Package Extra Charges Additional copies Cases Additional camera Lighting technician Rush service Editing	d in addition to the fe fee, the extra charge \$\$ \$\$ \$\$ \$\$ \$	ee and in accordanc es set forth below sha
If the fee is not based on a package but is a session fee, all copies shall be billed with the Standard Price List. In addition to either the package fee or the session f be billed if and when incurred. Package Fee (Package number) Fee Without Package Extra Charges Additional copies Cases Additional camera Lighting technician Rush service Overtime	d in addition to the fe fee, the extra charge \$	ee and in accordanc es set forth below sha
If the fee is not based on a package but is a session fee, all copies shall be billed with the Standard Price List. In addition to either the package fee or the session f be billed if and when incurred. Package Fee (Package number) Fee Without Package. Extra Charges Additional copies. Cases Additional camera. Lighting technician. Rush service Editing Overtime. Travel.	d in addition to the fe fee, the extra charge \$	ee and in accordanc es set forth below sha
If the fee is not based on a package but is a session fee, all copies shall be billed with the Standard Price List. In addition to either the package fee or the session f be billed if and when incurred. Package Fee (Package number) Fee Without Package Extra Charges Additional copies Cases Additional camera Lighting technician Rush service Overtime	d in addition to the fe fee, the extra charge \$\$\$ \$\$\$ \$\$ \$\$ \$\$ \$\$ \$	ee and in accordanc es set forth below sha
If the fee is not based on a package but is a session fee, all copies shall be billed with the Standard Price List. In addition to either the package fee or the session f be billed if and when incurred. Package Fee (Package number) Fee Without Package. Extra Charges Additional copies. Cases Additional camera. Lighting technician. Rush service Editing Overtime. Travel.	d in addition to the fe fee, the extra charge \$\$ \$\$ \$\$ \$\$ \$\$ \$\$ Subtotal \$\$ \$\$	ee and in accordanc es set forth below sha
If the fee is not based on a package but is a session fee, all copies shall be billed with the Standard Price List. In addition to either the package fee or the session f be billed if and when incurred. Package Fee (Package number) Fee Without Package. Extra Charges Additional copies. Cases Additional camera. Lighting technician. Rush service Editing Overtime. Travel.	d in addition to the fe fee, the extra charge \$\$\$ \$\$\$ \$\$\$ \$\$ \$\$ \$\$ Subtotal \$ Sales Tax \$	ee and in accordanc es set forth below sha
If the fee is not based on a package but is a session fee, all copies shall be billed with the Standard Price List. In addition to either the package fee or the session f be billed if and when incurred. Package Fee (Package number) Fee Without Package. Extra Charges Additional copies. Cases Additional camera. Lighting technician. Rush service Editing Overtime. Travel.	d in addition to the fe fee, the extra charge \$\$ \$\$ \$\$ \$\$ \$\$ \$\$ Subtotal \$\$ \$\$	ee and in accordanc es set forth below sha
If the fee is not based on a package but is a session fee, all copies shall be billed with the Standard Price List. In addition to either the package fee or the session f be billed if and when incurred. Package Fee (Package number) Fee Without Package Extra Charges Additional copies Cases Additional camera Lighting technician Rush service Editing Overtime Travel Other	d in addition to the fe fee, the extra charge \$\$ \$\$ \$\$ \$\$ \$\$ \$\$ \$\$ Subtotal \$ Sales Tax \$ Total \$	ee and in accordances set forth below sha

 Client_____
 Date_____

 Photographer (Videographer)_____
 Date ______

This Agreement is Subject to All the Terms and Conditions Appearing on the Reverse Side.

Terms and Conditions

- 1. Deposit and Payment. The Client shall make a deposit to retain the Photographer to perform the services specified herein. At such time as this order is completed, the deposit shall be applied to reduce the total cost and Client shall pay the balance due. If the Client refuses delivery of the order or refuses to pay within thirty (30) days of this order, Client shall be in default hereunder and shall pay _____ percent interest on the unpaid balance until payment is made in full.
- 2. Cancellation. If the Client shall cancel this Agreement _____ or more calendar days before the session date, any deposit paid to the Photographer shall be refunded in full. If Client shall cancel within _____ days of the session date and if the Photographer does not obtain another assignment for that time, liquidated damages shall be charged in a reasonable amount not to exceed the deposit.
- **3.** Video Materials. All videotapes created by the Photographer shall be the exclusive property of the Photographer. The Photographer shall make either the unedited or the edited videotape available to the Client for the purpose of review and ordering copies. The Client shall view such videotape at the Photographer's studio only. The Client shall not remove any copy of the videotape from the studio unless payment has been made in full pursuant to this Agreement
- **4. Copyright and Reproductions.** The Photographer shall own the copyright in the videotapes created and shall have the exclusive right to make copies of them. The Photographer shall only make copies for the Client or for the Photographer's portfolio, samples, self-promotions, entry in photographic contests or art exhibitions, editorial use, or for viewing within or on the outside of the Photographer's studio. If the Photographer desires to make other uses, the Photographer shall not do so without first obtaining the written permission of the Client.
- 5. Client's Usage. The Client is obtaining copies for personal use only, and shall not sell said copies or authorize any reproductions thereof by parties other than the Photographer. If Client is obtaining copies for sale or reproduction, Photographer authorizes Client to sell or reproduce only as set forth under Special Usage Requirements on the front of this form.
- 6. Failure to Perform. If the Photographer cannot perform this Agreement due to a fire or other casualty, strike, act of God, or other cause beyond the control of the parties, or due to the Photographer's illness, then the Photographer shall return the deposit to the Client but shall have no further liability with respect to the Agreement. This limitation on liability shall also apply in the event that the videotape is lost through camera malfunction, lost in the mail, or otherwise lost or damaged without fault on the part of the Photographer. In the event the Photographer fails to perform pursuant to the terms of this Agreement for any other reason, including but not limited to problems with exposure, editing, duplication, or delivery, Photographer shall not be liable for any amount in excess of the retail value of the Client's order.
- 7. Photographer. The Photographer may substitute another photographer to take the video in the event of Photographer's illness or scheduling conflicts. In the event of such substitution, Photographer warrants that the photographer taking the video shall be a competent professional.
- 8. Credit. Photographer reserves the right to place a credit line at the beginning or end of the videotape as well as on the cassette or any packaging.
- **9.** Photographer's Standard Price List. The charges in this Agreement are based on the Photographer's Standard Price List. This price list is adjusted periodically and future orders shall be charged at the prices in effect at the time when the order is placed.
- **10. Client's Originals.** If the Client is providing original videotapes to the Photographer for duplication or any other purpose, in the event of loss or damage the Photographer shall not be liable for an amount in excess of \$_____ per videotape.
- **11. Arbitration.** All disputes arising under Agreement shall be submitted to binding arbitration before______ in the following location _______ and the arbitration award may be entered for judgment in any court having jurisdiction thereof. Notwithstanding the foregoing, either party may refuse to arbitrate when the dispute is for a sum less than \$______.
- **12. Miscellany.** This Agreement incorporates the entire understanding of the parties. Any modifications of this Agreement must be in writing and signed by both parties. Any waiver of a breach or default hereunder shall not be deemed a waiver of a subsequent breach or default of either the same provision or any other provision of this Agreement. This Agreement shall be governed by the laws of the State of ______.

Contract to Create a Video for Transmission, Cassette Sales, or Cassette Rentals

(herei	nafter referred to as the "Distributor"), located at
and	(hereinafter referred to as the "Photographer"), located
	(
	REAS, the Photographer is a professional photographer who has produced and created video works; and
	REAS, the Photographer wishes to create a new video work for transmission, cassette sales, or cassette rentals; and
	REAS, the Distributor has the capacity with respect to video works to either transmit, license for transmission, or sel
	se cassette copies; and
WHE	REAS, the Distributor wishes to commission the Photographer to create a video work.
NOW	THEREFORE, in consideration of the foregoing premises and the mutual covenants hereinafter set forth and other
valual	ple considerations, the parties hereto agree as follows:
1. C	ommission. The Distributor commissions the Photographer to create a video work having as a working title
	(hereinafter referred to as "the Work"). In connection with the production of the Work the
Pł	notographer shall have the right to use the following production facilities
he	which shall be provided to the Photographer by the Distributor without charge. The Work shal approximately minutes in length and deal with the subject of
	artistic decisions with respect to the Work shall be made by the Photographer.
	syments. In consideration for the rights to transmit the Work granted to the Distributor hereunder, the Photographer shall be paid
	e sum of \$ as a fee for the Photographer's services. This fee shall be paid% upon execution of this
Aç	greement,% upon showing of the initial video assembly to Distributor, and the balance within 30 days of the completion
of	the Work. The Work shall be deemed completed upon delivery of a finished master tape to the Distributor. In connection with
th	e creation of the Work, the Distributor will reimburse the Photographer for the following expenses:
3. 0	wnership and Copyright. All right, title, and interest in and to the Work and all constituent creative and literary elements shal
be	long solely and exclusively to the Photographer, including ownership of copyrights and the master tape, as well as any copies
cr	eated for purposes of transmission. It is understood that the Distributor shall copyright the Work in the Photographer's name. Al
	ths not specifically granted to the Distributor are expressly reserved to the Photographer.
	rant of Transmission Rights. The Photographer grants the Distributor the 🖸 exclusive 🗋 nonexclusive right to have
	leases of the Work on the following station for a period of months commencing the completion of the Work. A release is defined as performances of the Work in a consecutive seven-day period; such
	In the completion of the work. A release is defined as performances of the work in a consecutive seven-day period; such Insecutive seven-day period beginning with the first day the Work is transmitted.
	tegrity of the Work. The Distributor shall not have the right to edit or excerpt from the Work except with the written consent of
	e Photographer. Notwithstanding the foregoing, the Distributor shall have the right to excerpt up to sixty (60) seconds of running
tin	ne from the Work solely for the purpose of advertising the transmission of the Work or publicizing the activities of the Distributor.
0	n all other transmissions or performances of the Work, the credit and copyright notice supplied by the Photographer shall be
	cluded.
	mage or Loss and Insurance. The Distributor shall be provided with the Master Tape of the Work which it shall hold unti
	mination of the license granted to it in Paragraph 4 above (or, if more than one license has been granted, until the termination
	the last license). The Distributor agrees to take due and proper care of the Master Tape in its possession and insure its loss or
	amage against all causes for the amount of \$ All insurance proceeds received on account of loss or of damage to the aster Tape shall be the property of Photographer and shall be promptly transmitted to Photographer when received by the
	stributor. Photographer shall receive one copy of the tape of the Work in any tape format selected by the Photographer. The
	stributor. Photographer shall be the copy of the tape of the work in any tape format selected by the Photographer. The stributor agrees to use its best efforts to give the Photographer reasonable notice of scheduled transmission dates of the Work.
	le of Cassettes. The Distributor shall also have the right to make at its own expense cassette copies of the Work for sale and
	asing. The Distributor shall have the 🛛 exclusive 🖓 nonexclusive right to sell such cassettes in the following geographic area:
	and for the following time period: Sales shall be at the retail price of

\$_____% of the retail price for each cassette sold.

8. Rental of Cassettes. The Distributor shall also have the right to rent the cassette copies of the Work which it has made at its own expense. The Distributor shall have the acclusive nonexclusive right to rent such cassettes in the following geographic area: ______ and for the following time period: ______. Rentals shall be at the retail price of \$_____. The Distributor shall pay the Photographer a royalty of _____% of the retail price for each cassette rented.

9. Marketing. Distributor shall not sell or rent any copy of the Work unless the purchaser or renter agrees, in writing, that under no circumstances shall any further copies of the Work be made by the purchaser or renter and that the purchaser or renter shall neither transmit the Work nor permit the charging of admission to view the Work. In no event shall there be a sale or rental consisting of less than the entirety of the Work as described above. The Distributor shall periodically consult with the Photographer concerning the Distributor's marketing program with respect to the Work.

- **10.** Accountings. Distributor shall furnish Photographer quarterly reports during January, April, July, and October of each year showing, for the preceding three months, and cumulatively from the commencement of this Agreement, the number of copies of the Work sold by the Distributor, the number of copies of the Work rented by the Distributor, and the royalties due Photographer. Such report shall be accompanied by payment of all royalties due to Photographer for the period covered by such report. The Photographer shall, upon the giving of written notice, have the right to inspect the Distributor's books of account to verify the accountings. If errors in any such accounting are found to be to the Photographer's disadvantage and represent more than five (5%) percent of the payment to the Photographer pursuant to said accounting, the cost of inspection shall be paid by the Distributor.
- **11. Publicity.** The Photographer authorizes the Distributor to use the Photographer's name, likeness, and biographical material solely in connection with publicizing the transmission of the Work or the activities of the Distributor. The Photographer shall have the right to approve all written promotional material about the Photographer or the Work, which approval shall not be unreasonably withheld.
- **12. Warranty and Indemnity.** The Photographer represents that the Photographer is authorized to enter into this Agreement; that material included in the Work is original work of the Photographer or that the Photographer has obtained permission to include the material in the Work or that such permission is not required; that the Work does not violate or infringe upon the rights of others, including but not limited to copyright and right of privacy; and that the Work is not defamatory. The Photographer agrees to indemnify the Distributor against any damages, liabilities, and expenses arising out of the Photographer's breach of the foregoing representations.
- **13. Termination.** In the event the Distributor files for bankruptcy or relief under any state or federal insolvency laws or laws providing for the relief of debtors, or if a petition under such law is filed against the Distributor, or if the Distributor ceases actively to engage in business, then this Agreement shall automatically terminate and all rights theretofore granted to the Distributor shall revert to the Photographer. Similarly, in the event the Work has not been transmitted within one year from the date the Work is completed, then this Agreement shall terminate and all rights granted to the Distributor shall revert to the Photographer. Upon termination of this Agreement or expiration of the license granted to the Distributor under this Agreement, all copies of the Work shall be delivered to the Photographer. Unless renewed by the parties hereto, this Agreement shall terminate at the expiration of the later of the time periods specified in Paragraphs 4, 7, and 8. Upon termination the master tape and all copies of the Work in the Distributor's possession shall be delivered to the Photographer by the Distributor.
- **14.** Arbitration. Distributor and Photographer agree to arbitrate any claim, dispute, or controversy arising out of or in connection with this Agreement, or any breach thereof, before an agreed-upon arbitrator in the city of ______,

or, if no arbitrator can be agreed upon, before the American Arbitration Association, under its rules.

15. Miscellany. This Agreement contains the entire understanding of the parties and may not be modified, amended, or changed except by an instrument in writing signed by both parties. Except as is expressly permitted under this Agreement, neither party may assign this Agreement or rights accruing under this Agreement without the prior written consent of the other party, except that the Photographer may assign rights to receive money without the Distributor's consent. This Agreement shall be binding upon the parties and their respective heirs, successors, and assigns. This Agreement shall be interpreted under the laws of the State of ______.

IN WITNESS WHEREOF, the parties have signed this Agreement as of the date first set forth above.

Photographer____

Distributor

Company Name

By_

Authorized Signatory, Title

Stock Photography Delivery Memo

ient	Date
	Delivery Memo No
	Purchase Order No
r Request of	Telephone
oto Return Due	Extension Granted
Value* Quantity Format/ Original Size or Dupe	Description/File Number BW/Color
* Value is in case of loss, theft, or damage.	A reproduction fee for specified usage will be negotiated.
Total Color	Total Black and White
ase count all photographs and confirm that the	e count is accurate by returning one signed copy of this forr
s form as accurate and that the photographs a	I, the Client shall be considered to accept the count shown are of a quality suitable for reproduction. If the recipient of
e recipient has the authority to receive the pho	cepting this Delivery Memo and the photographs warrants to tographs on behalf of the Client.
	Date

Subject to All Terms and Conditions Above and on Reverse Side.

Terms and Conditions

- 1. Purpose and Definition. Photographer hereby agrees to entrust the Photographs listed on the front of this form to the Client for the purpose of review and examination only and no other purpose. "Photographs" are defined to include transparencies, prints, negatives, digitized encodations, and any other form in which the images submitted can be stored, incorporated, represented, projected, or perceived, including forms and processes not presently in existence but which may come into being in the future.
- 2. Ownership and Copyright. Copyright and all reproduction rights in the Photographs, as well as the ownership of the physical Photographs themselves, are the property of and reserved to the Photographer. Client acknowledges that the Photographs shall be held in confidence and agrees not to project, copy, store, or modify directly or indirectly any of the Photographs submitted (whether such modification is of the Photograph itself or involves combining the Photograph with other images or graphic or written elements, including but not limited to comping for clients) without the express permission of the Photographer, nor will Client permit any third party to do any of the foregoing. Reproduction shall be allowed only upon Photographer's written permission specifying usage and fees. In the event of the licensing of any usage rights by Client, payment shall be made within thirty (30) days of the date of the Invoice and time shall be of the essence with respect to payment.
- **3.** Acceptance. Client accepts the listing and values set forth for the Photographs as accurate if not objected to in writing by return mail immediately after receipt of the Photographs. Any terms on this form not objected to in writing within 10 days shall be deemed accepted.
- **4.** Loss, Theft or Damage. Client agrees to assume full responsibility and be strictly liable as an insurer for loss, theft, or damage to the Photographs and to insure the Photographs fully from the time of shipment from the Photographer to the Client until the time of return receipt by the Photographer. Client further agrees to return all of the Photographs at its own expense by registered mail or bonded courier which provides proof of receipt. Reimbursement for loss, theft, or damage to any Photograph(s) shall be in the amount of the value entered for that Photograph(s) on the front of this form. Both Client and Photographer agree that the specified values represent the fair and reasonable value of the Photographs. Unless the value for an original transparency is specified otherwise on the front of this form, both parties agree that each original transparency has a fair and reasonable value of \$1,500 (Fifteen Hundred Dollars). Client agrees to reimburse Photographer for these fair and reasonable values in the event of loss, theft, or damage.
- 5. Holding Fees. The Photographs are to be returned to the Photographer within fourteen (14) days after delivery to the Client. Each Photograph held beyond fourteen (14) days from delivery shall incur a weekly holding fee of \$5 (Five Dollars) if it is color and \$1 (One Dollar) if it is black and white. These holding fees shall be paid to the Photographer when billed.
- 7. Copyright Notice. Copyright notice in the name of the Photographer shall be adjacent to the Photograph(s) when reproduced unless otherwise agreed by both parties and stated in the Invoice. If such copyright notice, which also serves as authorship credit, is required hereunder but is omitted, the Client shall pay as liquidated damages triple the usage fee agreed to between the parties instead of the agreed upon usage fee.
- 8. Tear Sheets. Client shall provide Photographer with two (2) copies of tear sheets of any authorized usage.
- **9. Releases.** Client agrees to indemnify and hold harmless the Photographer against any and all claims, costs, and expenses, including attorney's fees, arising when no model or property release has been provided to the Client by the Photographer or when the uses exceed the uses allowed pursuant to such a release.
- **10. Miscellany.** This Agreement shall be binding upon the parties hereto, their heirs, successors, assigns, and personal representatives. This Agreement constitutes the full understanding between the parties hereto. Its terms may only be modified by a written instrument signed by both parties. A waiver of a breach of any of the provisions of this Agreement shall not be construed as a continuing waiver of other breaches of the same or other provisions hereof. This Agreement shall be governed by the laws of the State of ______.

Stock Photography Invoice

Client	D	ate	
Address	Ir	voice No	
	S	S/EIN No	
	Р	urchaseOrderNo	
Per Request of	T	elephone	
The following nonexclusive rights are granted			
For use in			
For the product, project, or publication named			
n the following territory			
For the following time period or number of uses			
Other limitations			
	zed form of	ove shall be applicab works that can be en	coded, stored
this agreement, electronic rights are defined as rights in the digitiz retrieved from such media as computer disks, CD-ROM, computer Photo ID# Description	zed form of r databases Color/BW	ove shall be applicab works that can be en , and network servers Size/Placement	ble. For purpos icoded, stored 3. Fee
his agreement, electronic rights are defined as rights in the digitiz retrieved from such media as computer disks, CD-ROM, computer	zed form of r databases Color/BW	ove shall be applicab works that can be en , and network servers Size/Placement	ble. For purpos icoded, stored s. Fee
this agreement, electronic rights are defined as rights in the digitiz retrieved from such media as computer disks, CD-ROM, computer Photo ID# Description	zed form of r databases Color/BW	ove shall be applicab works that can be en , and network servers Size/Placement	ble. For purpos icoded, stored s. Fee
his agreement, electronic rights are defined as rights in the digitiz retrieved from such media as computer disks, CD-ROM, computer Photo ID# Description	zed form of r databases Color/BW	ove shall be applicab works that can be en , and network servers Size/Placement	ble. For purpos icoded, stored s. Fee
his agreement, electronic rights are defined as rights in the digitiz retrieved from such media as computer disks, CD-ROM, computer Photo ID# Description	zed form of r databases Color/BW	ove shall be applicab works that can be en , and network servers Size/Placement	Icoded, stored Icode, stored Icode, stored Icode, stored Icode, store Icode, stor
his agreement, electronic rights are defined as rights in the digitiz retrieved from such media as computer disks, CD-ROM, computer Photo ID# Description	zed form of r databases Color/BW	ove shall be applicab works that can be en , and network servers Size/Placement 	Icoded, stored Icode, stored Icode, stored Icode, store Icode, sto
his agreement, electronic rights are defined as rights in the digitiz retrieved from such media as computer disks, CD-ROM, computer Photo ID# Description	zed form of r databases Color/BW	ove shall be applicab works that can be en , and network servers Size/Placement 	Image: Point purpos Image: Point purp
this agreement, electronic rights are defined as rights in the digitiz retrieved from such media as computer disks, CD-ROM, computer Photo ID# Description	zed form of r databases Color/BW	ove shall be applicable works that can be en , and network servers Size/Placement Total Repro Fee Research Fee Holding Fee	Image: Point purpos Image: Point purp
this agreement, electronic rights are defined as rights in the digitiz retrieved from such media as computer disks, CD-ROM, computer Photo ID# Description	zed form of r databases Color/BW	ove shall be applicab works that can be en , and network servers Size/Placement 	Image: Point purpos Image: Point purp
this agreement, electronic rights are defined as rights in the digitiz retrieved from such media as computer disks, CD-ROM, computer Photo ID# Description	zed form of r databases Color/BW	ove shall be applicable works that can be en , and network servers Size/Placement Total Repro Fee Research Fee Holding Fee Subtotal	Image: For purpos Image: Coded, stored Image: Fee

Subject to All Terms and Conditions on Reverse Side.

Terms and Conditions

- 1. Delivery and Definition. Photographer has delivered to the Client those Photographs listed on the front of this form. "Photographs" are defined to include transparencies, prints, negatives, digitized encodations, and any other form in which the images submitted can be stored, incorporated, represented, projected, or perceived, including forms and processes not presently in existence but which may come into being in the future.
- **2.** Grant of Rights. Upon receipt of full payment, Photographer shall license to the Client the rights set forth on the front of this form for the listed Photographs.
- **3.** Reservation of Rights. All rights not expressly granted are reserved to the Photographer. Without limiting the foregoing, no advertising or promotional usage whatsoever may be made of any Photographs unless such advertising or promotional usage is expressly permitted on the front of this form. Limitations on usage shown on the front of this form include but are not limited to size, placement, and whether usage is in black and white or color.
- **4.** Fee. Client shall pay the fee shown on the front of this form for the usage rights granted. Client shall also pay sales tax, if required.
- 5. Payment. Payment is due to the Photographer within 30 days of the date of this Invoice. Overdue payments shall be subject to interest charges of _____ percent monthly. Time is of the essence with respect to payment.
- 6. Copyright Notice. Copyright notice in the name of the Photographer shall be adjacent to the Photograph(s) when reproduced unless otherwise agreed by both parties and stated in this Invoice. If such copyright notice, which also serves as authorship credit, is required hereunder but is omitted, the Client shall pay as liquidated damages triple the usage fee agreed to between the parties instead of the agreed upon usage fee. Copyright credit must be as shown on the Photograph(s) unless specified to the contrary by the Photographer.
- 7. Alterations. Client shall not make alterations, additions, or deletions to the Photographs, including but not limited to the making of derivative or composite images by the use of computers or other means, without the express, written consent of the Photographer. This prohibition shall include processes not presently in existence but which may come into being in the future.
- 8. Loss, Theft, or Damage. The ownership of the Photographs shall remain with the Photographer. Client agrees to assume full responsibility and be strictly liable as an insurer for loss, theft, or damage to the Photographs and to insure the Photographs fully from the time of shipment from the Photographer to the Client until the time of return receipt by the Photographer. Client further agrees to return all of the Photographs at its own expense by registered mail or bonded courier which provides proof of receipt. Reimbursement for loss, theft, or damage to any Photograph(s) shall be in the amount of the value entered for that Photograph(s) on the front of this form. Both Client and Photographer agree that the specified values represent the fair and reasonable value of the Photographs. Unless the value for an original transparency is specified otherwise on the front of this form, both parties agree that each original transparency has a fair and reasonable value of \$1,500 (Fifteen Hundred Dollars). Client agrees to reimburse Photographer for these fair and reasonable values in the event of loss, theft, or damage.
- 9. Tear Sheets. Client shall provide Photographer with two (2) copies of tear sheets of any authorized usage.
- **10. Releases.** Client agrees to indemnify and hold harmless the Photographer against any and all claims, costs, and expenses, including attorney's fees, arising when no model or property release has been provided to the Client by the Photographer or when the uses exceed the uses allowed pursuant to such a release.
- 11. Arbitration. All disputes shall be submitted to binding arbitration before _______ in the following location _______ and settled in accordance with the rules of the American Arbitration Association. Judgment upon the arbitration award may be entered in any court having jurisdiction thereof. Disputes in which the amount at issue is less than \$______ shall not be subject to this arbitration provision.
- **12. Assignment.** Neither party shall transfer or assign any rights or obligations hereunder without the consent of the other party, except that the Photographer shall have the right to assign monies due.
- **13. Miscellany.** This Agreement shall be binding upon the parties hereto, their heirs, successors, assigns, and personal representatives. This Agreement constitutes the full understanding between the parties hereto. Its terms may only be modified by a written instrument signed by both parties. A waiver of a breach of any of the provisions of this Agreement shall not be construed as a continuing waiver of other breaches of the same or other provisions hereof. This Agreement shall be governed by the laws of the State of ______.

Stock Agency Agreement

AGREEMENT, entered into as of this	day of	, 19, between
	, located at	
(hereinafter referred to as the "Agency"), and		, located
at	(hereinafter referred	to as the "Photographer").

WHEREAS, the Photographer is a professional photographer who has created and owns stock photography; and WHEREAS, the Agency is familiar with the stock photography of the Photographer and wishes to represent such work; and

WHEREAS, the parties wish to have said representation performed subject to the mutual obligations, covenants, and conditions herein.

NOW, **THEREFORE**, in consideration of the foregoing premises and the mutual covenants hereinafter set forth and other valuable considerations, the parties hereto agree as follows:

- 1. Submission and Acceptance of Photographs. The Photographer shall, from time to time during the term of this Agreement, submit his or her photography (hereinafter referred to as the "Photographs") to the Agency which shall have the right to accept such photographs as it chooses and shall return any photographs not accepted to the Photographer within _____ days of receipt by the Agency. Photographs are defined to include "Similars," which are shots of the same subject taken in the same manner, and "Dupes," which are duplicates of a photograph. All Photographs shall remain the property of the Photographer, including Dupes made by any party.
- **2.** Scope of Agency. With respect to Photographs accepted by the Agency pursuant to Paragraph 1, the Agency shall have the right to license certain limited rights as follows:

(A) The Agency shall market directly in the following countries ____

(B) The Agency may market through the Subagents listed for the following countries_

Additional Subagents may be added from time to time by the written agreement of the parties. The Agency shall not treat as Subagents other offices of the Agency, whether located in the United States or abroad.

(C) The Agency shall license nonexclusive rights only in the Photographs and shall do so at its own discretion. If the Agency wishes to license exclusive rights, it shall request the Photographer's permission which shall be obtained in writing.

(D) The Agency shall obtain the Photographer's written approval for any license of a Photograph for \$_____ or less.

(E) The Photographer may market the Photographs directly but shall not, during the term of this Agreement, market through any other agent or representative in the territories listed in (A) and (B).

(F) This Agreement shall not apply to assignment photography. In the event that the Agency has the opportunity to obtain any assignment for the Photographer, it shall offer that assignment to the Photographer who shall be free to accept or reject the assignment. In the event the Photographer wishes to accept the assignment, the Photographer and Agency shall negotiate a mutually acceptable Assignment Agency Agreement at that time.

(G) The Agency shall use its best efforts to license the Photographs on behalf of the Photographer and obtain the best possible licensing fees.

(H) The Agency shall require all Subagents to act in accordance with the Agency's obligations pursuant to this Agreement.

(I) Electronic rights are \Box outside the scope of this agency contract \Box covered by this agency contract insofar as the sale of such rights is incidental to the sale of nonelectronic rights \Box covered by this agency contract. For purposes of this agreement, electronic rights are defined as rights in the digitized form of works that can be

encoded, stored, and retrieved from such media as computer disks, CD-ROM, computer databases, and network servers.

- **3.** Files and Catalogs. All Photographs accepted by the Agency shall be kept in the Agency's files. In the event that the Agency wishes to include one or more Photographs in a catalog, the Agency shall obtain the Photographer's written approval.
- **4. Captions.** The Photographer shall place captions on the Photographs. These captions shall provide as much information regarding the subject matter of the Photographs as can reasonably be expected under industry standards. The Agency shall be responsible to convey accurate caption information to its subagents and clients.
- **5.** Copyright Notice. The Photographer shall place copyright notice on all Photographs. If the Photographer does not place such notice on any of the Photographs, the Agency is authorized and required to do so. Copyright notice in the Photographer's name shall appear on all Photographs licensed by the Agency.
- 6. Model and Property Releases. When delivering the Photographs, the Photographer shall indicate which Photographs have model or property releases, and, if requested by the Agency, shall give copies of the releases to the Agency. If the Photographer does not indicate the existence of a model or property release, if the Agency allows uses beyond the scope of a model or property release, or if the Agency fails to convey accurate caption information as required by Paragraph 4, the Agency assumes full responsibility for uses of the Photograph that may violate the rights of any parties and indemnifies the Photographer against any resulting claims, damages, and expenses (including but not limited to court costs and reasonable attorney's fees).
- **7. Duplicates.** The Photographer does does not authorize the Agency to create dupes of the Photographs. If the Agency is authorized to create dupes, clients of the Agency shall not be allowed to make dupes without the Photographer's written approval. All duplicates, whether created by the Photographer, the Agency, a subagent, or any other party, shall be the property of the Photographer and, as stated in Paragraph 1, are included within the definition of Photographs.
- **8.** Duty of Care. The Agency shall exercise reasonable care of the Photographs. The Photographer acknowledges that the Agency shall not be required to insure the Photographs.
- **9. Expenses.** The Photographer shall not pay any expenses to the Agency, unless such expenses are specified here or written approval is given by the Photographer at a later date.
 - Dupes _____
 - Catalogs ____
 - Other _

Any such expenses shall be charged against payments due under Paragraph 10. Any amount of expenses which cannot be recouped in this manner shall be waived by the Agency.

10. Payments. The Agency shall hold in trust in a separate escrow account all payments due to the Photographer until payment is made. For Photographs sold from the Agency's files, the Photographer shall receive fifty (50%) percent of gross billings. For Photographs sold from the Agency's catalogs, the Photographer shall receive _____

(___%) percent of gross billings. For Photographs sold by subagents, the Photographer shall receive fifty (50%) percent of the gross billings received by the Agency. Gross billings shall be defined to include all payments from licensings, holding fees, and interest on late payments, but shall not include service fees. Gross billings shall be reduced by actual bad debts and the reasonable cost of currency conversions. Volume discounts shall be allowed only as follows ______. The Agency shall

make all payments due the Photographer at the time of giving the accountings required by Paragraph 11.

11. Accountings. Commencing as of the date of this Agreement, the Agency shall report every _____ months to the Photographer. The report shall be given by the _____ day of the following month after the close of the period accounted for. The accounting shall show for that period each Photograph licensed, the client, the license of rights, the date of receipt of payment, the gross billing, and any reductions in the gross billing.

- **12. Right of Inspection.** The Photographer shall, upon the giving of written notice, have the right to inspect the Agency's books of account to verify the accountings. If errors in any such accounting are found to be to the Photographer's disadvantage and represent more than five (5%) percent of the payment to the Photographer pursuant to the said accounting, the cost of inspection shall be paid by the Agency which shall immediately remit to the Photographer all payments due plus interest at the current prime rate.
- **13. Term**. The term shall be _____ years from the date of entering into this Agreement. Sixty (60) days prior to the end of the initial or any subsequent term the Agency shall notify the Photographer if it wishes to renew for an additional term of _____ years. If the Photographer does not reject such additional term by written notice to the Agency prior to the end of the present term, in which case this Agreement shall terminate, then such additional term shall be subject to the terms and conditions of this Agreement.
- 14. Termination. The Photographer shall have the right to terminate this Agreement by written notice: (1) if the Agency fails to make payments pursuant to Paragraph 10; (2) if the Agency fails to give statements of account pursuant to Paragraph 11; (3) if the Agency otherwise defaults in its obligations hereunder and does not, within ten (10) days of receiving notice from the Photographer, cure such default; (4) if the Agency fails to generate \$______ of gross receipts during any twelve-month period; or (5) by rejecting the Agency's offer given sixty (60) days prior to the end of a term to continue for an additional term, in which case the termination shall be as of the last day of the existing term. The Photographer's personal representative shall have the right to terminate this Agreement by written notice in the event of the Photographer's death or incompetency. This Agreement shall automatically terminate in the event of the Agency's insolvency, filing of a petition in bankruptcy or for reorganization, assignment of assets for the benefit of creditors, or appointment of a trustee or similar custodian for all or part of the Agency's property. In the event of termination of the Agreement, the Agency shall immediately cease its licensing activities and all Photographs shall be returned as provided in Paragraph 15.
- **15.** Retrieval of Photographs. The Agency shall file and maintain the Photographs indexed by the Photographer's name so that any Photograph may be located within ______ days of Photographer's request and returned to the Photographer within ______ days of such request. In the event of termination pursuant to Paragraph 14, the Agency shall return the Photographs within ______ months for Photographs in the files of the Agency and ______ months for Photographs at the Agency during regular working hours upon the giving of reasonable notice and may retrieve such Photographs as the Agency has failed to return in a timely manner. During the term of this Agreement, the Photographer shall have the right to retrieve the Photographs for purposes including but not limited to self-promotion and exhibitions. If the Agency is unable to return Photographs held by clients within the specified time period after termination, it shall continue its efforts and, in addition, give the Photographer a list of the Photographs.
- 16. Warranty and Indemnity. The Photographer warrants and represents that he or she is the sole creator of the Work and owns all rights to be licensed by the Agency under this Agreement, that the Work does not infringe any other person's copyrights or rights of literary property, nor, to his or her knowledge, does it violate the rights of privacy of, or libel, other persons. The Photographer agrees to indemnify the Agency against any final judgment for damages (after all appeals have been exhausted) in any lawsuit based on an actual breach of the foregoing warranties. In addition, the Photographer shall pay the Agency's reasonable costs and attorney's fees incurred in defending such a lawsuit, unless the Photographer chooses to retain his or her own attorney to defend such lawsuit. The Photographer makes no warranties and shall have no obligation to indemnify the Agency with respect to materials inserted in the Work by a party other than the Photographer. Notwithstanding any of the foregoing, in no event shall the Photographer under this Agreement, whichever is the lesser. In the event a lawsuit is brought which may result in the Photographer having breached his or her warranties under this Paragraph, the Agency shall have the right to withhold and place in an escrow account _______ percent of sums payable to the Photographer having breached his or her warranties under this Paragraph, the Agency shall have the right to withhold and place in an escrow account _______ percent of sums payable to the Photographer having breached his or her warranties under this Paragraph, the Agency shall have the right to withhold and place in an escrow account ________ percent of sums payable to the Photographer having breached his or her warranties under this Paragraph, the Agency shall have the right to withhold and place in an escrow account ________ percent of sums payable to the Photographer.

- **17.** Litigation. In the event of the loss, damage, or infringement of any of the Photographs accepted by the Agency. the Agency and the Photographer shall have the right to sue jointly and, after deducting the expenses of bringing suit, to share equally in any recovery. If the Photographer chooses not to join in the suit, the Agency may proceed and, after deducting all the expenses of bringing the suit, any recovery shall be shared equally between the parties. If the Agency chooses not to join in the suit, the Photographer may proceed and, after deducting all the expenses of bringing the suit, any recovery shall be shared: ______ percent to the Photographer and percent to the Agency.
- **18. Relationship of Parties.** The Photographer and Agency are independent contractors and nothing contained herein shall be construed to be inconsistent with this independent contractor relationship.
- **19.** Promotion. The Photographer consents to the use without charge of the Photographs in brochures, advertisements, and other promotions of the Agency reasonably designed to enhance the marketing of the Photographs, and the Photographer further consents to the use of his or her name, portrait, or picture in connection with the promotion and advertising of the Photographs, provided such use is dignified and consistent with the Photographer's reputation.
- 20.Arbitration. All disputes arising under this Agreement shall be submitted to binding arbitration before in the following location and

shall be settled in accordance with the rules of the American Arbitration Association. Judgment upon the arbitration award may be entered in any court having jurisdiction thereof.

- **21.Assignment.** This Agreement may not be assigned by either party without the written consent of the other party hereto, except that the Photographer shall retain the right to assign payments due hereunder without obtaining the Agency's consent.
- **22.Notice.** Where written notice is required hereunder, it may be given by use of certified mail, return receipt requested, addressed to the Photographer or Agency at the addresses given at the beginning of this Agreement. Said addresses for notice may be changed by giving written notice of any new address to the other party.
- 23. Miscellany. This Agreement shall be binding on the parties and their respective heirs, representatives, administrators, successors and assigns. This Agreement constitutes the entire understanding between the parties. Its terms can be modified only by an instrument in writing signed by both parties. Any waiver of a breach or default hereunder shall not be deemed a waiver of a subsequent breach or default of either the same provision or any other provision of this Agreement. This Agreement shall be governed by the laws of the State of

Photographer_____ Agency___

Company Name

By___

Authorized Signatory, Title

Contract with an Independent Contractor

	(hereinafter referred to as the "Photographer") a
	, located at
ereinafter referre	d to as the "Contractor").
e Parties hereto	agree as follows:
Services to b	e Rendered. The Contractor agrees to perform the following services for the Photograph
If needed, a list	of procedures, diagram, or plan for the services shall be attached to and made part of this Agreeme
Schedule. The	Contractor shall complete the services pursuant to the following schedule
Fee and Expe	nses. The Photographer shall pay the Contractor as follows:
	Project rate \$
	Day rate \$/ day
	Travel days \$/ day
	Weather days \$/ day
	□ Other\$
The Photograp	oher shall reimburse the Contractor only for the expenses listed here
including recei	I not exceed \$ The Contractor shall provide full documentation for any expenses to be reimburse pts and invoices. An advance of \$ against expenses shall be paid to the Contractor and recoup
when payment	t is made pursuant to Paragraph 4.
Payment. Pay	ment shall be made: 📮 at the end of each day 📮 upon completion of the project 📮 within thirty (3
	ment shall be made: \Box at the end of each day \Box upon completion of the project \Box within thirty (3 grapher's receipt of Contractor's invoice.
days of Photog	grapher's receipt of Contractor's invoice.
days of Photog	grapher's receipt of Contractor's invoice. In the event of cancellation, Photographer shall pay a cancellation fee under the following circu
days of Photog	grapher's receipt of Contractor's invoice.
days of Photog	grapher's receipt of Contractor's invoice. In the event of cancellation, Photographer shall pay a cancellation fee under the following circu
days of Photog Cancellation. stances and in	grapher's receipt of Contractor's invoice. In the event of cancellation, Photographer shall pay a cancellation fee under the following circu
days of Photog Cancellation. stances and in Warranties. T (A) Contracto	grapher's receipt of Contractor's invoice. In the event of cancellation, Photographer shall pay a cancellation fee under the following circu the amount specified he Contractor warrants as follows: r is fully able to enter into and perform its obligations pursuant to this Agreement.
 days of Photog Cancellation. stances and in Warranties. T (A) Contracto (B) All service 	grapher's receipt of Contractor's invoice. In the event of cancellation, Photographer shall pay a cancellation fee under the following circu the amount specified he Contractor warrants as follows: r is fully able to enter into and perform its obligations pursuant to this Agreement. es shall be performed in a professional manner.
 days of Photos Cancellation. stances and in Warranties. Tr (A) Contracto (B) All service (C) If employee 	grapher's receipt of Contractor's invoice. In the event of cancellation, Photographer shall pay a cancellation fee under the following circu the amount specified he Contractor warrants as follows: r is fully able to enter into and perform its obligations pursuant to this Agreement.

(E) Any other criteria for performance are as follows:

7. Insurance. The Contractor shall maintain in force the following insurance____

- 8. Relationship of Parties. Both parties agree that the Contractor is an independent contractor. This Agreement is not an employment agreement, nor does it constitute a joint venture or partnership between the Photographer and Contractor. Nothing contained herein shall be construed to be inconsistent with this independent contractor relationship.
- **9.** Assignment. This Agreement may not be assigned by either party without the written consent of the other party hereto.
- **10. Arbitration.** All disputes shall be submitted to binding arbitration before ______ in the following location ______ and settled in accordance with the rules of the American Arbitration Association. Judgment upon the arbitration award may be entered in any court having jurisdiction thereof. Disputes in which the amount at issue is less than \$_____ shall not be subject to this arbitration provision.
- 11. Miscellany. This Agreement constitutes the entire agreement between the parties. Its terms can be modified only by an instrument in writing signed by both parties, except that oral authorizations of additional fees and expenses shall be permitted if necessary to speed the progress of work. This Agreement shall be binding on the parties, their heirs, successors, assigns, and personal representatives. A waiver of a breach of any of the provisions of this Agreement shall not be construed as a continuing waiver of other breaches of the same or other provisions hereof. This Agreement shall be governed by the laws of the State of ______.

IN WITNESS WHEREOF, the parties hereto have signed this as of the date first set forth above.

Photographer___

_____Contractor___

By___

Company Name

Authorized Signatory

Permission Form

The Undersigned hereby grant(s) permission to	(hereinafter
referred to as the "Photographer"), located at	
and to the Photographer's successors and assigns, to use the material spec	
book, product, or use	
for use by the following publisher or client	
This permission is for the following material:	
Nature of material	
Nature of material	
Source	0
Exact description of material, including page numbers	
Exact description of material, including page numbers	
If published, date of publication	
Publisher	
Author(s)	
This material may be used in the Photographer's book, product, or used derivations, editions, or electronic versions thereof, including nonexclusive It is understood that the grant of this permission shall in no way restrict rep or others authorized by the Undersigned.	e world rights in all languages. Sublication of the material by the Undersigned
If specified here, the material shall be accompanied on publication by a copyrig	ght notice as follows
and a credit line as follows	
Other provisions, if any:	
If specified here, the requested rights are not controlled in their entirety by the contacted:	ne Undersigned and the following owners must
One copy of this Permission Form shall be returned to the Photographer and o	one copy shall be retained by the Undersigned.
Authorized Signatory	Date
Admonized eighterery	
Authorized Signatory	Date

Nondisclosure Agreement for Submitting Ideas

AGREEMENT entered into as of this day of, 19, between
(hereinafter referred to as the "Photographer"), located at, and (hereinafter referred to as the "Recipient"),
Notated at
Information; and WHEREAS, the Photographer wishes to disclose this Information to the Recipient; and WHEREAS, the Recipient is willing not to disclose this Information, as provided in this Agreement. NOW, THEREFORE, in consideration of the foregoing premises and the mutual covenants hereinafter set forth and other valuable considerations, the parties hereto agree as follows:
1. Disclosure. Photographer shall disclose to the Recipient the Information, which concerns
2. Purpose. Recipient agrees that this disclosure is only for the purpose of the Recipient's evaluation to determine its interest in the commercial exploitation of the Information.
3. Limitation on Use. Recipient agrees not to manufacture, sell, deal in, or otherwise use or appropriate the

- **3.** Limitation on Use. Recipient agrees not to manufacture, sell, deal in, or otherwise use of appropriate the disclosed Information in any way whatsoever, including but not limited to adaptation, imitation, redesign, or modification. Nothing contained in this Agreement shall be deemed to give Recipient any rights whatsoever in and to the Information.
- 4. Confidentiality. Recipient understands and agrees that the unauthorized disclosure of the Information by the Recipient to others would irreparably damage the Photographer. As consideration and in return for the disclosure of this Information, the Recipient shall keep secret and hold in confidence all such Information and treat the Information as if it were the Recipient's own proprietary property by not disclosing it to any person or entity.
- 5. Good Faith Negotiations. If, on the basis of the evaluation of the Information, Recipient wishes to pursue the exploitation thereof, Recipient agrees to enter into good faith negotiations to arrive at a mutually satisfactory agreement for these purposes. Until and unless such an agreement is entered into, this nondisclosure Agreement shall remain in force.
- 6. Miscellany. This Agreement shall be binding upon and shall inure to the benefit of the parties and their respective legal representatives, successors, and assigns.

IN WITNESS WHEREOF, the parties have signed this Agreement as of the date first set forth above.

Photographer____

Recipient_

Company Name

By___

Authorized Signatory, Title

FORM VA For a Work of the Visual Arts UNITED STATES COPYRIGHT OFFICE

REGISTRATION NUMBER

	VA	V	/AU	
	EFFECTIVE DATE OF REGIS			
	Month	Day	Year	
DO NOT WRITE ABOVE THIS LINE. IF YOU NEED MORE SPACE, USE A SEPARATE C		,,,,,,,,,,,,,,,,,,,,,,,,,,,,,,,,,,,,,,,		
TITLE OF THIS WORK ▼	NATURE OF T	HIS WORK ▼ s	See instructions	
PREVIOUS OR ALTERNATIVE TITLES ▼			2. s	
PUBLICATION AS A CONTRIBUTION If this work was published as a contribution to a period collective work in which the contribution appeared. Title of Collective Work ▼	lical, serial, or colle	ction, give informa	ation about the	
If published in a periodical or serial give: Volume ▼ Number ▼	Issue Date ▼	On Pa	ages V	
NAME OF AUTHOR ▼	DATES OF BIR Year Born ▼	TH AND DEAT Year Died		
Was this contribution to the work a "work made for hire"? Yes	WAS THIS AU THE WORK Anonymous?	THOR'S CONT	If the answer to either of these questions is "Yes," see detailed	
□ No Domiciled in	Pseudonymous?	🗌 Yes 🗌 No	instructions.	
NATURE OF AUTHORSHIP Check appropriate box(es). See instructions 3-Dimensional sculpture Map Technical draw Photograph Text Reproduction of work of art Jewelry design Architectural 				
NAME OF AUTHOR V	DATES OF BIR Year Born ▼	TH AND DEAT Year Died		
Was this contribution to the work a "work made for hire"? Yes No No Was this contribution to the work a "work made for hire"? OR Citizen of Domiciled in Country	WAS THIS AU THE WORK Anonymous? Pseudonymous?	THOR'S CONT	'RIBUTION TO If the answer to either of these questions is "Yes," see detailed instructions.	
NATURE OF AUTHORSHIP Check appropriate box(es). See instructions				
□ 3-Dimensional sculpture □ Map □ Technical drav	ving			
2-Dimensional artwork Photograph Text Reproduction of work of art Iewelry design Architectural v	work			
 Reproduction of work of art Jewelry design Architectural to Design on sheetlike material 	WOIK			
YEAR IN WHICH CREATION OF THIS DATE AND NATION OF FIRST PUBL	LICATION OF T	THIS PARTICU		
COPYRIGHT CLAIMANT(S) Name and address must be given even if the claimant is the same as the author given in space 2. ▼				
		OSIT RECEIVE		
TRANSFER If the claimant(s) named here in space 4 is (are) different from the author(s) named in space 2, give a brief statement of how the claimant(s) obtained ownership of the copyright.				

a

NOTE

Under the law, the "author" of a "work made for hire" is generally the employer, not the employee (see instruc-tions). For any

tions). For any part of this

work that was "made for hire" check "Yes" in the space

provided, give the employer (or other person for

person for whom the work was prepared) as "Author" of that part, and leave the

space for dates of birth and death blank.

а

		EXAMINED BY	FORM VA
		CHECKED BY	_
			FOR COPYRIGHT OFFICE USE ONLY
	DO NOT WRITE ABOVE THIS LINE. IF YOU NEED MO	RE SPACE, USE A SEPARATE CONTINUATION SHEET.	
PREVIOUS Yes No a. This is th b. This is th c. This is a d		er version of this work, already been made in the Copyright Office? at? (Check appropriate box) ▼ elished form.	5
DERIVATIV a. Preexisting	/E WORK OR COMPILATION Complete both space 6a and Material Identify any preexisting work or works that this work is	d 6b for a derivative work; complete only 6b for a compilation. s based on or incorporates. ▼	See instructions
b. Material Ad	Ided to This Work Give a brief, general statement of the material	that has been added to this work and in which copyright is claimed. $lacksquare$	this space.
Name V		account established in the Copyright Office, give name and number of Account. Account Number ▼ 	7
	Area Code and Telephone Number ►		Be sure to give your daytime phone ◀ number
CERTIFICA	TION* I, the undersigned, hereby certify that I am the		
check only one author other copyri owner of exc authorized a	ght claimant clusive right(s)	(s) ▲	8
of the work ide by me in this a	entified in this application and that the statements made pplication are correct to the best of my knowledge.		-
	ted name and date ♥ If this application gives a date of publication	n in space 3, do not sign and submit it before that date. Date	-
	Iandwritten signature (X) ▼		
Mail certificate to:	Name V	YOU MUST: • Complete all necessary spaces • Sign your application in space 8 SEND ALL 3 ELEMENTS	9
Certificate will be mailed in	Number/Street/Apt ▼	IN THE SAME PACKAGE: 1. Application form 2. Nonrefundable \$20 filing fee in check or money order payable to <i>Register of Copyrights</i> 3. Deposit material	
window envelope	City/State/ZIP ▼	A sepost material A sepost material	

*17 U.S.C. § 506(e): Any person who knowingly makes a false representation of a material fact in the application for copyright registration provided for by section 409, or in any written statement filed in connection with the application, shall be fined not more than \$2,500.

-

MINSTRUCTIONS FOR SHORT FORM VA

For pictorial, graphic, and sculptural works

USE THIS FORM IF—

- 1. you are the only author and copyright owner of this work; and
- 2. the work was not made for hire, and
- 3. the work is completely new (does not contain a substantial amount of material that has been previously published or registered or is in the public domain).

If any of the above does not apply, you must use standard Form VA.

NOTE: Short Form VA is not appropriate for an anonymous author who does not wish to reveal his or her identity.

Title of This Work

You must give a title. If there is no title, state "UNTITLED." If you are registering an unpublished collection, give the collection title you want to appear in our records (for example: "Jewelry by Josephine, 1995 Volume"). Alternative title: If the work is known by two titles, you also may give the second title. If the work has been published as part of a larger work (including a periodical), give the title of that larger work instead of an alternative title.

Name and Address of Author/Owner of the Copyright

Give your name and mailing address. (You may include your pseudonym followed by "pseud.") Also, give the nation of which you are a citizen or where you have your domicile (i.e., permanent residence). Please give daytime phone and fax numbers, if available

Year of Creation

Give the year in which you completed the work you are registering at this time. (A work is "created" when it is "fixed" in a tangible form. Examples: drawn on paper, molded in clay, stored in a computer.)

Publication

If the work has been published (i.e., if copies have been distributed to the public), give the complete date of publication (month, day, and year) and the nation where the publication first took place.

Type of Authorship in This Work

Check the box or boxes that describe the kind of material you are registering. Check only the authorship included in the copy you are sending

MAIL WITH THE FORM-

a \$20.00 filing fee in the form of a check or money order (no cash) payable to "Register of Copyrights," and

• one or two copies of the work or identifying material consisting of photographs or drawings showing the work. See table below for the requirements for most works. Note: Inquire about the requirements for other works or for any work first published before 1978. Copies submitted become the property of the U.S. Government.

If you are registering	And the work is unpublished, send	And the work is <i>published</i> , send
2-dimensional artwork in a book, map, poster, or print	one complete copy or identifying material	two copies of the best published edition
3-dimensional sculpture, T-shirt design	identifying material	identifying material
a greeting card, pattern, commercial print or label, fabric, wallpaper	one complete copy or identifying material	one copy of the best published edition

Mail everything (application form, copy or copies, and fee) in one package to:

egister of Copyrights Library of Congress Washington, D.C. 20559-6000

Questions? Call (202) 707-3000 between 8:30 a.m. and 5:00 p.m. Eastern Time, Monday through Friday. For forms, call (202) 707-9100 24 hours a day, 7 days a week.

HOW TO COMPLETE SHORT FORM VA

- Type or print in black ink.
- Be clear and legible. (Your certificate of registration will be copied from your form.)
- Give only the information requested.
- Do not use continuation sheets or any other attachments.

with the application. For example, if you are registering illustrations but have not written the story yet, check only the box for "2-dimensional artwork"

Signature of Author

Sign the application in black ink.

Person to Contact for Rights and Permissions

This space is optional. You may give the name and address of the person or organization to contact for permission to use the work. You may also provide phone, fax, or e-mail information.

Mail Certificate to

This space must be completed. Your certificate of registration will be mailed in a window envelope to this address. Also, if the Copyright Office needs to contact you, we will write to this address.

Deposit Account

Complete this space only if you currently maintain a deposit account in the Copyright Office.

PRIVACY ACT ADVISORY STATEMENT Required by the Privacy Act of 1974 (P.L. 93-579) The authority for requesting this information is title 17 U.S.C., secs.409 and 410. Furnishing the requested information is voluntary. But if the information is not furnished, it may be necessary to delay or refuse registration and you may not be entitled to certain relief, remedies, and benefits provided in chapters 4 and 5 of title 17 U.S.C.

The principal uses of the requested information are the establishment and maintenance of a public record and the examination of the application for compliance with legal requirements. Other routine uses include public inspection and copying, preparation of public indexes, prepara-

tion of public catalogs of copyright registrations, and preparation of search reports upon request

NOTE: No other advisory statement will be given in connection with this application. Please keep this statement and refer to it if we communicate with you regarding this application.

SHORT FORM VA

REGISTRATION NUMBER

				VA VAU
				Effective Date of Registration
				Month Day Year
				Application Received
			Examined By	
				Deposit Received One Two
			Correspondence	Fee Received
TYPE OR PR	NT IN BLACK INK. DO NO	r write A		
	Title of This Work:	1		
Alternative in which	title or title of larger work this work was published:		<i>"</i>	
	Name and Address of Author/Owner of the Copyright:	2		
Na	tionality or domicile:			
	one and Fax numbers:		Phone ()	Fax ()
The	ne una rux numbers.			Tux ()
	Year of Creation:	3		
If wor	k has been published, Date and Nation of Publication:	4	a. Date (Month) b. Nation	(Month, da and year (Day) (Year) all required
	Type of Authorship in This Work: (Check all that apply.	5	2-Dimensional artwork	Photograph I Map Jewelry design I Text Architectural work
	Signature of Author:	6	I certify that the statements made by me in this a	pplication are correct to the best of my knowledge
F	Name and Address of Person ontact for Rights and Permissions:	7	Check here if same as #2 above	
e Pho	one and Fax numbers: E-mail address:		Phone () E-mail	Fax ()
0			<u>м</u>	-
MAIL	Name 🔻			Oeposit Account # Name
CERTIFICATE TO	Number/Street/Apartment Number	•		
Certificate will be mailed in window	City/State/ZIP V			
envelope *17 U.S.C. § 506(): Any person who knowingly makes a	false represe	ntation of a material fact in the application for copyright registration provid	led for by section 409, or in any written statement filed in connection v

*17 U.S.C. § 506(e): Any person who knowingly make the application, shall be fined not more than \$2,500. September 1995—100,000

License of Rights

	reinafter referred to as the "Photographer") with respect to the licensing of certain nonelectronic rights in the otographer's photograph(s) (hereinafter referred to as the "Work").
۱.	Description of Work. The Client wishes to license certain nonelectronic rights in the Work which the Photographer has created and which is described as follows:
	TitleNumber of images
	Subject matter
	Form in which work shall be delivered Group computer file (specify format
	□ original transparency (size) □ dupe (size)
	Delivery Date. The Photographer agrees to deliver the Work within days after the signing of this Agreement
8.	Grant of Rights. Upon receipt of full payment, Photographer grants to the Client the following nonelectronic right in the Work:
	For use asin thelanguage
	For the product or publication named
	In the following territory
	For the following time period
	With respect to the usage shown above, the Client shall have nonexclusive rights unless specified to the cortrary here
	If the Work is for use as a contribution to a magazine, the grant of rights shall be for one time North America serial rights only unless specified to the contrary above. Other limitations
	If the Client does not complete its usage under this Paragraph 3 by the following date all rights granted but not exercised shall without further notice revert to the Photographer without prejudice t the Photographer's right to retain sums previously paid and collect additional sums due.
4.	Reservation of Rights. All rights not expressly granted hereunder are reserved to the Photographer, includin but not limited to all rights in preliminary materials and all electronic rights. For purposes of this agreemen electronic rights are defined as rights in the digitized form of works that can be encoded, stored, and retrieve from such media as computer disks, CD-ROM, computer databases, and network servers.
	Fee. Client agrees to pay the following: □ \$ for the usage rights granted, or □ an advance of \$ to be recouped against royalties computed as follows

- 7. Alteration. Client shall not make or permit any alterations, whether by adding or removing material from the Work, without the permission of the Photographer. Alterations shall be deemed to include the addition of any illustrations, photographs, sound, text, or computerized effects, unless specified to the contrary here_____
- 8. Payment. Client agrees to pay the Photographer within thirty days of the date of Photographer's billing, which shall be dated as of the date of delivery of the Work. Overdue payments shall be subject to interest charges of _____ percent monthly.
- 9. Loss, Theft, or Damage. The ownership of the Work shall remain with the Photographer. Client agrees to assume full responsibility and be strictly liable as an insurer for loss, theft, or damage to the Work and to insure the Work fully from the time of shipment from the Photographer to the Client until the time of return receipt by the Photographer. Client further agrees to return all of the Work at its own expense by registered mail or bonded courier which provides proof of receipt. Reimbursement for loss, theft, or damage to any Work shall be in the following amount:

Both Client and Photographer agree that these specified value(s) represent the fair and reasonable value of the Work. Unless the value for an original transparency is specified otherwise in this paragraph, both parties agree that each original transparency has a fair and reasonable value of \$1,500 (Fifteen Hundred Dollars). Client agrees to reimburse Photographer for these fair and reasonable values in the event of loss, theft, or damage.

- **10.** Samples. Client shall provide Photographer with _____ samples of the final use of the Work.
- **11. Copyright Notice.** Copyright notice in the name of the Photographer shall shall shall not accompany the Work when it is reproduced.
- **12.** Credit. Credit in the name of the Photographer \Box shall \Box shall not accompany the Work when it is reproduced. If the Work is used as a contribution to a magazine or for a book, credit shall be given unless specified to the contrary in the preceding sentence.
- **13. Releases.** The Client agrees to indemnify and hold harmless the Photographer against any and all claims, costs, and expenses, including attorney's fees, due to uses for which no release was requested, uses which exceed the uses allowed pursuant to a release, or uses based on alterations not allowed pursuant to Paragraph 7.
- **14.** Arbitration. All disputes arising under this Agreement shall be submitted to binding arbitration before _______ in the following location ______

15. Miscellany. This Agreement shall be binding upon the parties hereto, their heirs, successors, assigns, and personal representatives. This Agreement constitutes the entire understanding between the parties. Its terms can be modified only by an instrument in writing signed by both parties, except that the Client may authorize expenses or revisions orally. A waiver of a breach of any of the provisions of this Agreement shall not be construed as a continuing waiver of other breaches of the same or other provisions hereof. This Agreement shall be governed by the laws of the State of ______.

In Witness Whereof, the parties hereto have signed this Agreement as of the date first set forth above.

	0		
Photographer_	 	Client	
			Company Name
		Ву:	
		A	Authorized Signatory, Title

License of Electronic Rights

greement as of the day of ocated at			(hereinafter referred t	o as the "Client")
nd	, loca	ted at		
nereinafter referred to as the "Phot hotographer's photograph(s) (herein			censing of certain electro	nic rights in the
• Description of Work. The Client has created and which is describ		certain electronio	c rights in the Work which t	he Photographe
Title			Number of image	S
Subject matter				
Form in which work shall be deliv	ered 📮	computer file (sp	pecify format)
original transparency (size) 🛛	dupe (size)	
. Delivery Date. The Photographer				
Grant of Rights. Upon receipt of the Work:	full payment, Phot	tographer grants	to the Client the following e	lectronic rights ir
For use as			in the	language
For the product or publication nan	ned			
In the following territory				
For the following time period				
For display purposes only withou specified to the contrary here				
With respect to the usage shown trary here				
Other limitations				
If the Client does not complete its all rights granted but not exercise the Photographer's right to retain	ed shall without fu	rther notice reve	ert to the Photographer wit	
I. Reservation of Rights. All rights but not limited to all rights in preli electronic rights are defined as ri from such media as computer dis	minary materials a ghts in the digitize	nd all nonelectro ed form of works	nic rights. For purposes c that can be encoded, stor	f this agreement
,			a rights granted	
5. Fee. Client agrees to pay the follo	owing: \$	for the usag	ge fights granted.	

- 7. Alteration. Client shall not make or permit any alterations, whether by adding or removing material from the Work, without the permission of the Photographer. Alterations shall be deemed to include the addition of any illustrations, photographs, sound, text, or computerized effects, unless specified to the contrary here_____
- Payment. Client agrees to pay the Photographer within thirty days of the date of Photographer's billing, which shall be dated as of the date of delivery of the Work. Overdue payments shall be subject to interest charges of _____ percent monthly.
- 9. Loss, Theft, or Damage. The ownership of the Work shall remain with the Photographer. Client agrees to assume full responsibility and be strictly liable as an insurer for loss, theft, or damage to the Work and to insure the Work fully from the time of shipment from the Photographer to the Client until the time of return receipt by the Photographer. Client further agrees to return all of the Work at its own expense by registered mail or bonded courier which provides proof of receipt. Reimbursement for loss, theft, or damage to any Work shall be in the following amount:

Both Client and Photographer agree that these specified value(s) represent the fair and reasonable value of the Work. Unless the value for an original transparency is specified otherwise in this paragraph, both parties agree that each original transparency has a fair and reasonable value of \$1,500 (Fifteen Hundred Dollars). Client agrees to reimburse Photographer for these fair and reasonable values in the event of loss, theft, or damage.

- 10. Samples. Client shall provide Photographer with _____ samples of the final use of the Work.
- **11. Copyright Notice.** Copyright notice in the name of the Photographer \Box shall \Box shall not accompany the Work when it is reproduced.
- **12.** Credit. Credit in the name of the Photographer I shall I shall not accompany the Work when it is reproduced. If the work is used as a contribution to a magazine or for a book, credit shall be given unless specified to the contrary in the preceding sentence.
- **13. Releases.** The Client agrees to indemnify and hold harmless the Photographer against any and all claims, costs, and expenses, including attorney's fees, due to uses for which no release was requested, uses which exceed the uses allowed pursuant to a release, or uses based on alterations not allowed pursuant to Paragraph 7.
- **14.** Arbitration. All disputes arising under this Agreement shall be submitted to binding arbitration before ______ in the following location ______

and settled in accordance with the rules of the American Arbitration Association. Judgment upon the arbitration award may be entered in any court having jurisdiction thereof. Disputes in which the amount at issue is less than \$______ shall not be subject to this arbitration provision.

15. Miscellany. This Agreement shall be binding upon the parties hereto, their heirs, successors, assigns, and personal representatives. This Agreement constitutes the entire understanding between the parties. Its terms can be modified only by an instrument in writing signed by both parties, except that the Client may authorize expenses or revisions orally. A waiver of a breach of any of the provisions of this Agreement shall not be construed as a continuing waiver of other breaches of the same or other provisions hereof. This Agreement shall be governed by the laws of the State of ______.

In Witness Whereof, the parties hereto have signed this Agreement as of the date first set forth above.

Photographer_____

Client_

Company Name

By:____

Authorized Signatory, Title

INDEX

A

Accountings (statements of account). See also Inspection of books and records by agents, 36 book publishing contract, 44 gallery-photographer contract, 74 licensing contract to merchandise images, 86 Additional usage rights. See Usage rights Address changes, provision on, 10 Advances assignment estimate/confirmation/invoice, 16.17 book publishing contract, 39, 44, 48 collaboration contract, 56 licensing contract to merchandise images, 86 wedding photography contract, 21 Advertising agencies, 18 Advertising and trade usage model releases, 89, 90 portrait photography contract, 27 property release, 93 Advertising Photographers of America, 11 Advertising Photographers of New York, 11 Agents book publishing contract, 48 collaboration contract, 54, 57 foreign, 123 photographer-agent contract for assignments, 33-38 stock agency agreement, 115-16 value of, 33 All rights, selling, 15 Amendment, provision on, 7 American Society of Media Photographers, 11 Code of Ethics, 12 Application for copyright registration of photography, 142 Approval, right of: licensing contract to merchandise images, 86 Approval, sales on, 74 Arbitration assignment estimate/confirmation/invoice, 18 collaboration contract, 54, 57 independent contractor contract, 130 photographer-agent contract for assignments, 36 portrait photography contract, 27, 29-30

provision on, 7-8 stock agency agreement, 121-22 stock photography delivery memo, 108 video contract for personal use, 95, 97 wedding photography contract, 22, 24 Artistic control book publishing contract, 39, 46 collaboration contract, 57 gallery-photographer contract, 73 video contract for transmission, cassette sales, or rentals, 102 Assignment estimate/confirmation/invoice, 13-20 Assignment of contract collaboration contract, 57 photographer-agent contract for assignments, 36 provision on, 8 Assignment of money due assignment estimate/confirmation/invoice, 18 collaboration contract, 57 licensing contract to merchandise images, 86 photographer-agent contract for assignments, 36 stock agency agreement, 122 Assignment of rights assignment estimate/confirmation/invoice, 18 book publishing contract, 47 collaboration contract, 56 copyright transfer form, 139-41 licensing contract to merchandise images, 86 stock photography invoice, 112 Authors' alterations, 46 Authorship credit. See also Credit, name book publishing contract, 45, 47 collaboration contract, 54, 57 В

Bankruptcy or insolvency agent's, 36 of gallery, 71 provision on, 8 Barter, transfers by, 74 Best efforts by gallery, 73, 76 licensing contract to merchandise images, 86

stock agency agreement, 118 Bids by independent contractors, 129 Billing services, agent's, 33 Book clubs, 44 Book publishing contract, 35, 36, 39-52 obtained by agents, 33 Buyout, in assignment estimate/confirmation/ invoice, 15

С

California Lawyers for the Arts, 10 Canadian rights, 40 Cancellation by client deposit and, 23 lecture contract, 82 portrait photography contract, 28-29 video contract for personal use, 96 Cancellation fees, assignment estimate/ confirmation/invoice, 16 Captions for photographs, 118 Catalogs, 115-16, 118-20 Changes in the work collaboration contract, 57 stock photography delivery memo, 107 stock photography invoice, 112 Changes of address, provision on, 10 Changes or amendments in the contract, provision on, 9 Code of Ethics, 12 Collaboration contract, 53-62 Collection costs, 23 portrait photography contract, 28 video contract for personal use, 96 Commissions to agents, 33, 34-35 gallery, 71, 73-74 "complete understanding" provision, 8 Computer uses, 44 Confidentiality, agent-photographer, 34 Confirmation of assignment, 13-20 Consignment, gallery-photographer contract with, 71-80 Construction of expensive pieces, in galleryphotographer contract, 73 Consultation, right of, in book publishing contract, 46 Contracts defined, 5

letter, 6-7 negotiation and, 5-6 oral, 6 standard provisions (boilerplate), 7-10 Copies of the published photograph, in assignment estimate/confirmation/invoice, 18 Copyright application for copyright registration of photography, 142 book publishing contract, 45 collaboration contract, 53, 56 delivery memo, 68 licensing contract to merchandise images, 85 permissions, 133 -portrait photography contract, 27, 29 stock photography delivery memo, 106, 107 transfer form, 139-41 video contract for personal use, 95, 96 video contract for transmission, cassette sales, or rentals, 102 wedding photography contract, 21, 23, 24 Copyrighted materials, releases or licenses to use, in collaboration contract, 57 Copyright notice licensing contract to merchandise images, 85 permissions, 133 stock agency agreement, 118 stock photography delivery memo, 106, 108 Copyright Office, 133 recordation of copyright transfers with, 139 registration of photographs with, 142 Count of images, stock photography delivery memo, 107 Credit, name. See also Authorship credit assignment estimate/confirmation/invoice, 15 for editorial work, 17-18 licensing contract to merchandise images, 85 video contract for personal use, 97 video contract for transmission, cassette sales, or rentals, 102 wedding photography contract, 22, 24 Credit, sales on, 74 "cumulative rights" provision, 8

D

Day rate, in assignment estimate/confirmation/ invoice, 15-16 Deadlines. See Due date Death or disability of the author

collaboration contract, 53, 57 gallery-photographer contract, 73 lecture contract, 81-82 provision on, 8-9 Default, when client can be considered in portrait photography contract, 28 Delays, in confirmation of assignment, 14 Delivery memo, 17, 67-70 stock photography, 106-10 Deposit portrait photography contract, 27, 28 video contract for personal use, 95, 96 wedding photography contract, 21, 23 Description of images submitted, stock photography delivery memo, 107 Description of services collaboration contract, 55 independent contractor contract, 130 lecture contract, 81 portrait photography contract, 28 video contract for personal use, 96 wedding photography contract, 22 Discounts gallery-photographer contract, 74 volume, in stock agency agreement, 120 Due date assignment estimate/confirmation/invoice, 14 book publishing contract, 41 collaboration contract, 55

collaboration contract, 55 Dupes, stock agency agreement, 119

Ε

Editorial work authorship credit for, 17-18 Electronic rights in author-agent contract, 34 in book publishing contract, 44 in collaboration contract, 56 in confirmation of assignment, 15 in estimate, 15 in invoice, 15 in licenses, 150-152 in permission form, 135 in stock photo invoice, 111 Estimate, 13-20 Excerpts of video, 102 Exclusive vs. nonexclusive representation by an agent, 34 stock agency agreement, 117

Exclusive vs. nonexclusive rights assignment estimate/confirmation/invoice, 14 book publishing contract, 40-41 collaboration contract, 58 copyright transfers, 139 gallery-photographer contract, 72 licensing contract to merchandise images, 85 permissions, 134 stock agency agreement, 117, 117-18 stock photography invoice, 111 video contract for transmission, cassette sales, or rentals, 102 Exhibition rights, in sale of fine art photography, 64-65 Expenses assignment estimate/confirmation/invoice, 16 collaboration contract, 53, 56 gallery-photographer contract, 73 independent contractor contract, 130 lecture contract, 81 photographer-agent contract for assignments, 35 stock agency agreement, 119 video contract for transmission, cassette sales, or rentals, 101, 102

F

Facilities to be provided, video contract for transmission, cassette sales, or rentals, 102 Fading of color photographs, in portrait photography contract, 29 Failure to complete assignment. See also Death or disability of photographer book publishing contract, 48 collaboration contract, 53, 55 portrait photography contract, 27, 29 video contract for personal use, 95, 97 wedding photography contract, 22, 24 Fair use, 133 Fees. See also Advances; Cancellation fees; Holding fees; Payments; Price list, standard; Research fee assignment estimate/confirmation/invoice, 15-18 lecture contract, 81 for permissions, 133-34 portrait photography contract, 27 video contract for personal use, 95, 96

wedding photography contract, 21-23 Final title of book, 46 Flat fee, book publishing contract, 41 "force majeure" provision, 9 Form VA, 142 Framing gallery-photographer contract, 73 materials given to photographer for, 24, 29 stock photography invoice, 112 Free copies of book, 46 Freight pass-through, 42

G

Gallery-photographer contract with record of consignment and statement of account, 71-80 Geographic limitation assignment estimate/confirmation/invoice, 14 gallery-photographer contract, 72 licensing contract to merchandise images, 85 portrait photography contract, 33, 34 Gift, transfers by, 74 "governing law" provision, 9 portrait photography contract, 30 wedding photography contract, 24 Grant of rights. See also Assignment of rights; Usage rights assignment estimate/confirmation/invoice, 14, 15 video contract for transmission, cassette sales, or rentals, 102 Gross billings, stock agency agreement, 119

Η

Holding fees delivery memo, 67, 68 stock photography delivery memo, 106, 108 stock photography invoice, 111 Home video, 103 House accounts, 33, 35 stock agency agreement, 118

I

Ideas, nondisclosure agreement for submitting, 136-38 Identity of the client stock photography delivery memo, 107 wedding photography contract, 22 Identities of purchasers, gallery-photographer contract, 71 "Indemnify and hold harmless" provision, 9 Independent contractor contract, 128-32 Index, book, 41 Infringement book publishing contract, 47 collaboration contract, 58 stock agency agreement, 121 Inspection of books and records book publishing contract, 45 licensing contract to merchandise images, 86 photographer-agent contract for assignments, 36 stock agency agreement, 120 video contract for transmission, cassette sales, or rentals, 103 Insurance. See also Liability insurance assignment estimate/confirmation/invoice, 17 delivery memo, 68 gallery-photographer contract, 75 independent contractors and, 128, 130 lecture contract, 82 photographer-agent contract for assignments, 34 portrait photography contract, 29 video contract for personal use, 97 Integrity and attribution provision, sale of fine art photography, 64 Interest on late payments, 16 lecture contract, 82 portrait photography contract, 28 stock photography invoice, 112 video contract for personal use, 96 Invoice, 13-20 photographer-agent contract for assignments, 35 stock photography, 111-14

J

Joint bank account, 56

L

Lawyers, volunteer, 10-11 Lawyers for the Creative Arts, 11 Lecture contract, 81-84 *Legal Guide for the Visual Artist,* 11 Letter contracts, 6-7 Liability insurance licensing contract to merchandise images, 86 publisher's, 18 License of Electronic Rights, 150-152 License of Rights, 150-152 Licensing book publishing contract, 44 collaboration contract, 53, 55 Licensing Art & Design, 85 Licensing contract to merchandise images, 85-88 Licensing fee, stock agency agreement, 117-18 Liens, 129 Liquidated damages, provision on, 9 Loss or damage to materials or equipment delivery memo, 68 gallery-photographer contract, 74-75 lecture contract, 82 portrait photography contract, 27, 29 stock agency agreement, 121 stock photography delivery memo, 107-8 video contract for personal use, 97 wedding photography contract, 24

Μ

Magazines, assignment estimate/confirmation/ invoice, 15 Mailing list for promotion, gallery-photographer contract, 73 Manuscript date for delivery of, 41 rejection of, 41 return of, 46 satisfactoriness of, 41 unsatisfactory to publisher, 48 Marketing collaboration contract, 57 photographer-agent contract for assignments, video contract for transmission, cassette sales, or rentals, 103 Marking up expenses, assignment estimate/ confirmation/invoice, 16 Mediation, in collaboration contract, 57 Merged portions, in collaboration contract, 55 Microfilm, 44 Minors as clients, in wedding photography contract, 22 model releases for, 89, 90 Model releases, 89-92 stock agency agreement, 118-19 stock photography delivery memo, 108

Ν

National Press Photographers Association, 11 Negotiation, 5-6 over the telephone, 6 win-win, 6 written notes on, 6 Negotiation checklists, using, 11 Noncompetition clause book publishing contract, 48 collaboration contract, 54, 55, 58 Nondestruction provision, in sale of fine art photography, 64 Nondisclosure agreement for submitting ideas, 136-38 Nonexclusive rights. See Exclusive vs. nonexclusive rights Number of uses, assignment estimate/confirmation/invoice, 15

0

One-time use, assignment estimate/confirmation/invoice, 15 Option for photographer's next book, 48 Oral contracts, 6 Ordering of additional copies video contract for personal use, 95 wedding photography contract, 21 Organizations for photographers, 11 Out-of-print book, 47 Overtime, for reshoots, 18 Ownership of photographs or materials collaboration contract, 56 delivery memo, 68 portrait photography contract, 29 stock agency agreement, 117 stock photography invoice, 112 video contract for personal use, 96 video contract for transmission, cassette sales, or rentals, 102 wedding photography contract, 23

Package fee video contract for personal use, 95, 96 wedding photography contract, 21, 22 Packing and shipping costs, in lecture contract, 82 Paperback original, 44 Paperback version of a book, 43 Partnership, 53 Payments. See also Interest on late payments

assignment estimate/confirmation/invoice, 16 dates for, 23 gallery-photographer contract, 74 independent contractor contract, 130 late, 23 photographer-agent contract for assignments, 35 responsibility for wedding photography contract, 22 stock agency agreement, 119-20 stock photography delivery memo, 107 times for, 28 video contract for personal use, 95, 96 wedding photography contract, 23 Permissions, 133-35 video contract for transmission, cassette sales, or rentals, 103 Photographer-agent contract for assignments, 33-38 Photographic materials assignment estimate/confirmation/invoice, 17 ownership of. See Ownership of photographs or materials Pocket model releases, 89-92 Portrait photography contract, 27-32 Poses wedding photography contract, 22, 23 Power of attorney for agents, 34 collaboration contract, 55-56 Previews. See proofs and previews Price list, standard, 23 portrait photography contract, 29 video contract for personal use, 96, 97 wedding photography contract, 24 Prints, ordering, in wedding photography contract, 21 Privacy rights, 45 model releases, 89 Professional Photographers of America, 11 Promotion, 33 book publishing contract, 46, 48 collaboration contract, 57 gallery-photographer contract, 73 licensing contract to merchandise images, 85,86 photographer-agent contract for assignments, 35 stock agency agreement, 121 video contract for transmission, cassette sales, or rentals, 102 Promotional books, 122-23

stock photography, 116 Proofs and previews portrait photography contract, 28, 29 wedding photography contract, 22, 23 Property release, 93-94 stock agency agreement, 118-19 stock photography delivery memo, 108 Publication. See also Book publishing contract assignment estimate/confirmation/invoice, 14 portrait photography contract, 28 time period for, 41 wedding photography contract, 22 Publicity. See also Promotion right of, 89 video contract for transmission, cassette sales, or rentals, 102, 103 Recordings, lecture contract, 82

R

Release. See Model releases; Property releases assignment estimate/confirmation/invoice, 18 Reproduction, materials given to photographer for, 24 video contract for personal use, 97 Reproduction rights. See also Usage rights delivery memo, 68 portrait photography contract, 29 stock photography delivery memo, 107 video contract for personal use, 97 wedding photography contract, 24 Resale proceeds, sale of fine art photography, 65 Research fee stock photography delivery memo, 106, 107 stock photography invoice, 111 Reservation of rights assignment estimate/confirmation/invoice, 17 licensing contract to merchandise images, 86 stock photography invoice, 112 video contract for transmission, cassette sales, or rentals, 102 Reserve against returns of books, 44-45 Reshoots, assignment estimate/confirmation/ invoice, 16, 18 Restoration gallery-photographer contract, 75 sale of fine art photography, 65 Return of materials assignment estimate/confirmation/invoice, 17 book publishing contract, 46 gallery-photographer contract, 73

stock agency agreement, 117, 121 stock photography delivery memo, 107 wedding photography contract, 23 Reversion of rights to author assignment estimate/confirmation/invoice, 17 book publishing contract, 48 Review copies of book, 46 Revisions, book publishing contract, 41, 47 Royalties book publishing contract, 39, 41, 42-43, 47 licensing contract to merchandise images, 85-86

S

Sales by photographer gallery-photographer contract, 74 licensing contract to merchandise images, 86 book publishing contract, 46-47 Sales of videocassettes, contract for, 101-5 Sales tax assignment estimate/confirmation/invoice, 16-17 stock photography invoice, 111-12 Samples for agents, 34 licensing contract to merchandise images, 86 stock photography delivery memo, 108 Security interest book publishing contract, 48 delivery memo, 68 gallery-photographer contract, 75 sale of fine art photography, 64 Sequels, collaboration contract, 54, 56 Serial rights assignment estimate/confirmation/invoice, 15 book publishing contract, 44 Signature on contracts letter contracts, 7 book publishing contract, 48 Small claims court, 27 Society of Photographer and Artist Representatives (SPAR), 33 Space rates, assignment estimate/confirmation/ invoice, 15 Speculation, work on, 16 Standard of care, assignment estimate/confirmation/invoice, 17 Standard provisions (boilerplate), 7-10 Stipend, gallery-photographer contract, 71, 74-76 Stock agency agreement, 115-27 Stock photography delivery memo, 106-10 Stock photography invoice, 111-14

Subagents, in stock agency agreement, 117, 118, 120 Subsidiary rights, in book publishing contract, 39, 43, 44, 47 Substitution of another photographer portrait photography contract, 29 video contract for personal use, 97 wedding photography contract, 22, 24 Successors and assigns book publishing contract, 47 permissions, 134 property release, 93 provision on, 10 Surety bond, 45, 129

т

Termination book publishing contract, 47-48 collaboration contract, 55 gallery-photographer contract, 72-73 licensing contract to merchandise images, 86 photographer-agent contract for assignments, 34, 36 stock agency agreement, 120-21 video contract for transmission, cassette sales, or rentals, 103 Term of contract gallery-photographer contract, 71, 72 photographer-agent contract for assignments, 34 stock agency agreement, 120 Territory. See Geographic limitation "Time is of the essence" provision, 10 assignment estimate/confirmation/invoice, 17 stock photography invoice, 112 Time period of use, in assignment estimate/ confirmation/invoice, 14 Title to work, gallery-photographer contract, 75 Trademarks collaboration contract, 56 licensing contract to merchandise images, 86 Transfer copyright, 139-41 Transfer of usage rights, in assignment estimate/confirmation/invoice, 18 Transparencies, in assignment estimate/confirmation/invoice, 17

Transportation, in delivery memo, 68

U

Uniqueness provision, in sale of fine art photography, 65 Usage rights. See also Reproduction rights additional, 17

assignment estimate/confirmation/invoice, 17 portrait photography contract, 27, 28, 29

property release, 93

stock photography invoice, 112

video contract for personal use, 95, 96-97 wedding photography contract, 21, 23-24

Values of images, in stock photography delivery memo, 107-8 Verbal authorization, for additional fees and expenses, 18 Veto right in book publishing contract, 46 in collaboration contract, 55 Video contract for personal use, 95-99 for transmission, cassette sales, or rentals, 101-5 Video recording, in lecture contract, 82 Videoshow, 103 Volume discounts, in stock agency agreement, 120 Volunteer lawyers for the arts, 10-11 Volunteer Lawyers for the Arts, 11

W

Waivers provision on, 10 of right to review the use of the photograph, in releases, 90, 93 Warranties, provision on, 10 Warranty and indemnity provision assignment estimate/confirmation/invoice, 18 book publishing contract, 39-40, 45

Books from Allworth Press

Legal Guide for the Visual Artist, Third Edition *by Tad Crawford* (softcover, 8 1/2 x 11, 256 pages, \$19.95)

The Photographer's Guide to Marketing and Self-Promotion, Second Edition *by Maria Piscopo* (softcover, 6 3/4 x 10, 176 pages, \$18.95)

Pricing Photography, Revised Edition *by Michal Heron and David MacTavish* (softcover, 11 x 8 1/2, 144 pages, \$24.95)

How to Shoot Stock Photos That Sell, Revised Edition *by Michal Heron* (softcover, 8 x 10, 208 pages, \$19.95)

Stock Photography Business Forms *by Michal Heron* (softcover, 8 1/2 x 11, 128 pages, \$18.95)

The Law (in Plain English) for Photographers *by Leonard DuBoff* (softcover, 6 x 9, 208 pages, \$18.95)

Mastering Black-and-White Photography by *Bernhard J Suess* (softcover, 6 3/4 x 10, 240 pages, \$18.95)

The Digital Imaging Dictionary *by Joe Farace* (softcover, 6 x 9, 256 pages, \$19.95)

The Photographer's Internet Handbook *by Joe Farace* (softcover, 6 x 9, 224 pages, \$18.95)

Overexposure: Health Hazards in Photography, Second Edition *by Susan D. Shaw and Monona Rossol* (softcover, 6 3/4 x 10, 320 pages, \$18.95)

The Copyright Guide by Lee Wilson (softcover, 6 x 9, 192 pages, \$18.95)

Licensing Art and Design, Revised Edition *by Caryn Leland* (softcover, 6 x 9, 128 pages, \$16.95)

The Secret Life of Money *by Tad Crawford* (softcover, 5 1/2 x 8 1/2, 304 pages, \$14.95)

Please write to request our free catalog. If you wish to order a book, send your check or money order to Allworth Press, 10 East 23rd Street, Suite 210, New York, NY 10010. Include \$5 for shipping and handling for the first book ordered and \$1 for each additional book. Ten dollars plus \$1 for each additional book if ordering from Canada. New York State residents must add sales tax.

To see our online catalog, visit the Allworth Press Web site at www.allworth.com

Wedding Photography Contract

Client		Date	
Address			
		Order Num	oer
Bride's Name	Groom's Nama		
Address			
4001655			
Couple's future address			
Description of Photographic Services to be Provid	ded		
Black and White print for Newspapers	Bride only	de and Groom	1
Number of previews or proofs to be shown to C			ck and White
Locations for Photography	Studio	Date	Time
Home, address		Date	
Rehearsal, address		Date	Time
Ceremony, address		Date	Time
Reception, address		Date	
Special Services, if required			
therein. If the fee is not based on a package but is a s in accordance with the Standard Price List. In additio forth below shall be billed if and when incurred. Package Fee (Package number) Fee Without Package	n to either the package fe	ee or the sessic	n fee, the extra charges s
n accordance with the Standard Price List. In additio orth below shall be billed if and when incurred. Package Fee (Package number)	n to either the package fe	ee or the session \$ \$ \$ \$ \$ \$ \$	n fee, the extra charges s - - - - - - -
 accordance with the Standard Price List. In addition on the below shall be billed if and when incurred. Package Fee (Package number) Fee Without Package	n to either the package fe	ee or the session \$ \$ \$. \$. \$ \$ \$ \$	n fee, the extra charges : - - - - - - - -
n accordance with the Standard Price List. In addition orth below shall be billed if and when incurred. Package Fee (Package number) Fee Without Package Extra Charges Additional prints Resitting Special retouching Special finishes Rush service Unreturned previews Overtime	n to either the package fe	ee or the session \$ \$ \$ \$ \$ \$ \$ \$ \$	n fee, the extra charges :
n accordance with the Standard Price List. In additio orth below shall be billed if and when incurred. Package Fee (Package number) Fee Without Package Extra Charges Additional prints Resitting Special retouching Special finishes Rush service Unreturned previews Overtime Travel	n to either the package fe	ee or the session \$	n fee, the extra charges : - - - - - - - - - - - - - - -
n accordance with the Standard Price List. In additio orth below shall be billed if and when incurred. Package Fee (Package number) Fee Without Package Extra Charges Additional prints Resitting Special retouching Special finishes Rush service Unreturned previews Overtime Travel	n to either the package fe	ee or the session \$ \$ \$ \$ \$ \$ \$ \$ \$ \$ \$	n fee, the extra charges : - - - - - - - - - - - - - - -
n accordance with the Standard Price List. In additio orth below shall be billed if and when incurred. Package Fee (Package number) Fee Without Package Extra Charges Additional prints Resitting Special retouching Special finishes Rush service Unreturned previews Overtime Travel	n to either the package fe	ee or the session \$	n fee, the extra charges : - - - - - - - - - - - - - - - - -
n accordance with the Standard Price List. In additio orth below shall be billed if and when incurred. Package Fee (Package number) Fee Without Package Extra Charges Additional prints Resitting Special retouching Special finishes Rush service Unreturned previews Overtime Travel	n to either the package fe	ee or the session \$	n fee, the extra charges : - - - - - - - - - - - - - - - -
n accordance with the Standard Price List. In additio orth below shall be billed if and when incurred. Package Fee (Package number) Fee Without Package Extra Charges Additional prints Resitting Special retouching Special finishes Rush service. Unreturned previews Overtime Travel.	n to either the package fe	ee or the sessions \$ \$ \$ \$ \$ \$ \$ \$ \$ \$ all \$ x \$ e \$	n fee, the extra charges : - - - - - - - - - - - - - - - -
n accordance with the Standard Price List. In additio forth below shall be billed if and when incurred. Package Fee (Package number) Fee Without Package Extra Charges Additional prints Resitting Special retouching Special finishes Rush service. Unreturned previews Overtime Travel	n to either the package fe Subtota Sales ta Total Du Less depos Balance Du s Agreement, agree to al ies. Each person signing	ee or the sessions \$	n fee, the extra charges s
n accordance with the Standard Price List. In additio orth below shall be billed if and when incurred. Package Fee (Package number) Fee Without Package Extra Charges Additional prints Resitting Special retouching Special finishes Rush service Unreturned previews Overtime Travel Other The parties have read both the front and back of this complete copy of the Agreement signed by both part	n to either the package fe Subtota Sales ta Total Du Less depos Balance Du s Agreement, agree to al ies. Each person signing e terms of this Agreemen	ee or the session \$ \$ \$ \$ \$ \$ \$ \$ \$ \$ al \$ e \$ e \$ g as Client belocht.	on fee, the extra charges s
 n accordance with the Standard Price List. In addition orth below shall be billed if and when incurred. Package Fee (Package number) Fee Without Package	n to either the package fe Subtota Sales ta Total Du Less depos Balance Du s Agreement, agree to al ies. Each person signing e terms of this Agreemen	ee or the session \$ 	on fee, the extra charges

This Agreement is subject to all the terms and conditions appearing on the reverse side.

Terms and Conditions

- 1. Exclusive Photographer. The Photographer shall be the exclusive photographer retained by the Client for the purpose of photographing the wedding. Family and friends of the Client shall be permitted to photograph the wedding as long as they shall not interfere with the Photographer's duties and do not photograph poses arranged by the Photographer.
- 2. Deposit and Payment. The Client shall make a deposit to retain the Photographer to perform the services specified herein. At such time as this order is completed, the deposit shall be applied to reduce the total cost and Client shall pay the balance due. If the Client refuses delivery of the order or refuses to pay within thirty (30) days of this order, Client shall be in default hereunder and shall pay _____ percent interest on the unpaid balance until payment is made in full.
- 3. Cancellation. If the Client shall cancel this Agreement thirty (30) or more calendar days before the wedding date, any deposit paid to the Photographer shall be refunded in full. If Client shall cancel within thirty days of the wedding date and if the Photographer does not obtain another assignment for that date, liquidated damages shall be charged in a reasonable amount not to exceed the deposit.
- 4. Photographic Materials. All photographic materials, including but not limited to negatives, transparencies, proofs, and previews, shall be the exclusive property of the Photographer. The Photographer shall make proofs and previews available to the Client for the purpose of selecting photographs, but such proofs and previews shall be on loan and, if they are not returned within fourteen (14) days of receipt by the Client, shall be charged to the Client at the same rate as finished prints of the same size.
- 5. Copyright and Reproductions. The Photographer shall own the copyright in all images created and shall have the exclusive right to make reproductions. The Photographer shall only make reproductions for the Client or for the Photographer's portfolio, samples, self-promotions, entry in photographic contests or art exhibitions, editorial use, or for display within or on the outside of the Photographer's studio. If the Photographer desires to make other uses, the Photographer shall not do so without first obtaining the written permission of the Client.
- 6. Client's Usage. The Client is obtaining prints for personal use only, and shall not sell said prints or authorize any reproductions thereof by parties other than the Photographer. If Client is obtaining a print for newspaper announcement of the wedding, Photographer authorizes Client to reproduce the print in this manner. In such event, Client shall request that the newspaper run a credit for the Photographer adjacent to the photograph, but shall have no liability if the newspaper refuses or omits to do so.
- 7. Failure to Perform. If the Photographer cannot perform this Agreement due to a fire or other casualty, strike, act of God, or other cause beyond the control of the parties, or due to Photographer's illness, then the Photographer shall return the deposit to the Client but shall have no further liability with respect to the Agreement. This limitation on liability shall also apply in the event that photographic materials are damaged in processing, lost through camera malfunction, lost in the mail, or otherwise lost or damaged without fault on the part of the Photographer. In the event the Photographer fails to perform for any other reason, the Photographer shall not be liable for any amount in excess of the retail value of the Client's order.
- 8. Photographer. The Photographer may substitute another photographer to take the photographs in the event of Photographer's illness or of scheduling conflicts. In the event of such substitution, Photographer warrants that the photographer taking the photographs shall be a competent professional.
- 9. Inherent Qualities. Client is aware that color dyes in photography may fade or discolor over time due to the inherent qualities of dyes, and Client releases Photographer from any liability for any claims whatsoever based upon fading or discoloration due to such inherent qualities.
- **10.** Photographer's Standard Price List. The charges in this Agreement are based on the Photographer's Standard Price List. This price list is adjusted periodically and future orders shall be charged at the prices in effect at the time when the order is placed.
- **11.** Client's Originals. If the Client is providing original prints, negatives, or transparencies owned by the Client to the Photographer for duplication, framing, reference, or any other purpose, in the event of loss or damage the Photographer shall not be liable for an amount in excess of \$_____ per image.
- 12. Arbitration. All disputes arising under this Agreement shall be submitted to binding arbitration before ______ in the following location ______ and the arbitration award may be entered for judgment in any court having jurisdiction thereof. Notwithstanding the foregoing, either party may refuse to arbitrate when the dispute is for a sum less than \$_____.
- 13. Miscellany. This Agreement incorporates the entire understanding of the parties. Any modifications of this Agreement must be in writing and signed by both parties. Any waiver of a breach or default hereunder shall not be deemed a waiver of a subsequent breach or default of either the same provision or any other provision of this Agreement. This Agreement shall be governed by the laws of the State of ______.